THE

ARTIST'S

WAY

AT

WORK

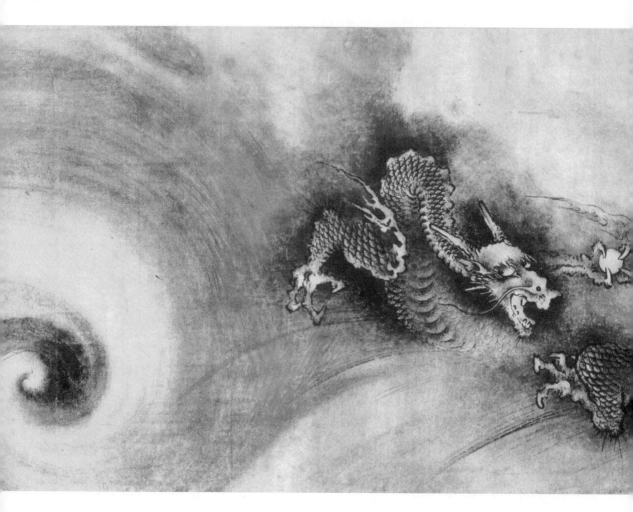

MARK BRYAN with JULIA CAMERON and CATHERINE ALLEN

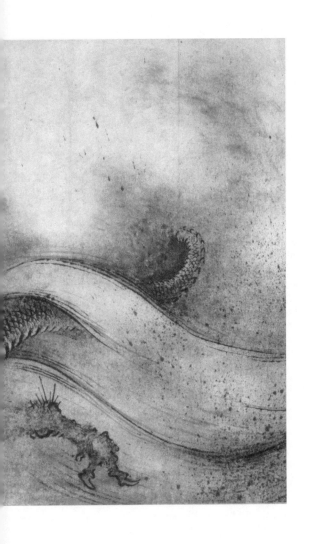

THE
ARTIST'S
WAY
AT
WORK

RIDING THE DRAGON

WILLIAM MORROW AND COMPANY, INC.

NEW YORK

Library of Congress Cataloging-in-Publication Data
Bryan, Mark A.
 The artist's way at work : riding the dragon / Mark Bryan and
Julia Cameron ; with Catherine Allen.
 p. cm.
 Includes bibliographical references and index.
 ISBN 0–688–15788–2
 1. Creative ability in business. I. Cameron, Julia. II. Allen,
Catherine A. III. Title.
HD53.B79 1998
650.1—dc21
 98–10310
 CIP

Printed in the United States of America

First Edition

1 2 3 4 5 6 7 8 9 10

BOOK DESIGN BY JO ANNE METSCH

Interior art details on pp. iv–v, xxiii–1, 22–23, 50–51, 72–73, 92–93, 110–111,
128–129, 156–157, 192–193, 208–209, 226–227, and 250–251 from:
Nine Dragons
Chen Rong, active 1st half of 13th century
China, Southern Song Dynasty, dated 1244
Handscroll; ink and touches of red on paper 46.3 × 1096.4 cm
Francis Gardner Curtis Fund
Courtesy, Museum of Fine Arts, Boston

www.williammorrow.com

*This book is dedicated to our students—who are
our teachers—past, present, and future*

I am not a businessman, I am an artist.

—WARREN BUFFETT

I know a bird can fly, a fish can swim, and an animal
can run. For that which runs, a net can be fashioned;
for that which swims, a line can be strung. But the
ascent of a Dragon on the wind into heaven is something
that is beyond my knowledge.

—CONFUCIUS

CONTENTS

■

INTRODUCTION / *xv*
Tool: Entering the Gate / *xxi*

The First Transformation: Part One
WEEK ONE ■ EMERGENCE / *2*
Tools: Morning Pages *5* / Creative Colleague *10*
Secret Selves *11* / Listening to the Chorus *14*
Inner Mentor *16* / Check-in *20* / Creativity Contract *20*

The First Transformation: Part Two / *22*
WEEK TWO ■ THE ROAR OF AWAKENING / *24*
Tools: Time-out *29* / The Dialogue *30*
Archaeology, Round One *34* / Archaeology, Round Two *36*
The Us and Them List *38* / Imaginary Lives *40*
Affirmations and Blurts *41* / Customized Affirmations *43*
Dumping the Albatross *47* / Walking Your Wisdom *49*
Check-in *49*

The Second Transformation / *50*
WEEK THREE ■ SOARING / *52*
Tools: Secrets *53* / Watching the Rapids *55* / Wish List *57*
Leadership Quiz *59* / Explore a Sacred Space *62*
Secretly, I'd Like to . . . *65* / Watch the Picture Without the
Sound *67*
Filling the Form *69* / Check-in *70*

The Third Transformation: Part One / *72*
WEEK FOUR ■ THE ABYSS / *74*
Tools: Admitting Our Emotions *76* / Anger as Map *78*

Metabolism 78 / Footholds for Optimism 79 / Countering Our
Critics 80
True Confessions 80 / Define Your Inner Wall 83 / Workaholism
Quiz 85
Bottom Line 87 / Signposts 87
The "Fraudian Slip" 89 / Check-in 90

The Third Transformation: Part Two / 92
WEEK FIVE ▪ SURVIVING THE ABYSS / 94
Tools: Personal Accounting 96 / Emotional Solvency 96
Counting 97 / Luxury 100 / Lapping Up Luxury 100
Nasty Rules 101 / The Dream Account 103
Explore Your Feelings About God 106 / Going to Take a
Miracle 106
Wondering 108 / Check-in 109

The Fourth Transformation / 110
WEEK SIX ▪ THE PEARL OF WISDOM / 112
Tools: Body English 114 / At the Wheel of a New Machine 114
A Letter to the Self 117 / Positive/Negative Poles 120
Media Deprivation 124 / Reconnecting the Dots: Detective
Work 124
Beyond Price 126 / Meeting the Inner Rebel 126
Check-in 127

The Fifth Transformation / 128
WEEK SEVEN ▪ LEARNING (AND TEACHING) / 130
Tools: Being a Beginner 132 / The Jealousy Map 133
Creativity Quiz 134 / Feel, Think, Wish 137 / Getting
Current 139
The Hidden Résumé 141 / Becoming Right-Sized 146
Taking Note 148 / Nurturing Nutrients 151
The Forest Environment 152 / Check-in 154

The Sixth Transformation / 156
WEEK EIGHT ▪ TEACHING (AND LEARNING) / 158
Tools: Roles 161 / Biosketches 163 / Family Functions 169
Containment 172 / The Power Dance 173 / Unmasking
Machiavelli 177

Practicing the Present *177* / Mentor Magic *180* / Going
Sane *184*
"Dear Boss" *186* / Stopping the Spiral *188*
Releasing Resentments *190* / Check-in *191*

The Seventh Transformation / *192*
WEEK NINE ▪ OWNING OUR AMBITION / *194*
Tools: Clearing Fear *195* / Contacting Clark Kent *199*
Local Color *201* / The Resentment Résumé *201*
Blasting Through Blocks *202* / Succeeding with Success *206*
Framing Our Lives *207* / Check-in *207*

The Eighth Transformation / *208*
WEEK TEN ▪ LIVING WITH PASSION / *210*
Tools: Positive Inventory *212* / Laugh or Lament *213*
Box Seats *215* / Heartbreak Hotel—Loss as a Lesson *220*
The Net of Nurturing *224* / Check-in *225*

The Ninth Transformation: Part One / *226*
WEEK ELEVEN ▪ THE LEDGE OF AUTHENTICITY / *228*
Tools: Name Your Poison *232* / Creative U-turns *233*
Ten-Minute Time-outs *235* / Valuing Our Values *236*
The Ledge of Authenticity *237* / Exercising Our Options *244*
Creativity Center *245* / Choose a Spirit Mentor *247*
Spirit Mentors *247* / Check-in *248*

The Ninth Transformation: Part Two / *250*
WEEK TWELVE ▪ RESTING IN AUTHENTICITY / *252*
Tools: Trusting Trust *253* / Mining Our Mystery *256*
Building a House *257* / Succeeding at Success *259*
Playing at Play *262* / Every Picture Tells a Story *263*
Gratitude *263* / Check-in *264*

Epilogue / *265*
Suggested Reading / *266*
Acknowledgments / *268*
How to Reach Us / *269*
Index / *271*

INTRODUCTION

■

IDEAS AS MONEY, MONEY AS IDEAS

INTELLECTUAL CAPITAL — ideas as money, money as ideas — is today the real currency of the business world. This capital is more than technical knowledge or bits and bytes of data. It is a wide range of social, emotional, intuitive, and interpersonal skills that together comprise the creative spirit. It is our goal to bring those skills to fruition, integrate them, and reawaken that spirit.

THE DRAGON'S GATE

THIS BOOK IS called *The Artist's Way at Work: Riding the Dragon* because the creative spirit, like the dragon, is a thrilling, joyous, chaotic, and powerful force that deserves and demands respect. The act of creation, whether it's a new idea, a new business, or an old business revitalized, can feel like both a high-altitude ride and a free fall. Learning to engage and channel this creative force is the key to remaining vital and enthusiastic in our professional *and* our personal lives.

The business of America is business.

—CALVIN COOLIDGE

In the ancient Chinese tradition of Taoism, the Tao (the Way) is the most elemental force in the universe, considered beyond description or explanation. It is the life-force itself, our animating breath, found in the always changing yet eternal and immutable laws of nature. It is in the spirit of this great mystery that we have chosen Chen Rong's famous thirteenth-century painting of the *Nine Dragons* as the organizing metaphor of this work. The dragon's nine transformations in the painting have for centuries been interpreted as a symbolic representation of the enlightenment of Taoism's founder, Lao-tzu. They serve as an emblem of the emo-

tional, mental, and spiritual journey that is *The Artist's Way at Work*.

As in all journeys, there will be advances and setbacks; there will be times of soaring and times of retreat, times of rest and times of teaching, times of learning and times to let new knowledge settle into silent wisdom.

For each of the nine dragons of the scroll, we have assigned a specific set of teachings and tasks aligned with the focus of each of the twelve weeks of *The Artist's Way at Work* program. We ask that you keep an open mind and let the dragon serve as a metaphor for your own journey. You'll find no dogma here, no articles of faith, only a window for your imagination.

We present these images, metaphors, and ideas as guideposts along a course we have carefully mapped. They are the means to an end, the tools of a potential transformation, a way to make meaning of the changing and growing self—a self embedded in a social world.

FROM "I" TO "WE"

WE LIVE IN a fractured culture. We have learned to think of ourselves as separate from others, as "us" and "them." Because our world is compartmentalized, so are we. We speak of our "work world" and our "real life" as though they were two separate things. Often we long for more meaning in our work and in our lives, but we do not see how the two can be integrated to deepen our satisfaction.

It is the aim of this book to give you a more satisfying, fully creative life in which you feel a sense of wholeness, not fragmentation; a sense of camaraderie, not competition. This book will make you more creative not only in your business life, but in your life as a whole. One result of this creative emergence will be a heightened sense of authenticity. Many of you will feel that you are becoming more your "real" self—a self that perhaps too often feels muffled, discounted, and discredited in the work world as we know it.

While this book is grounded in state-of-the-art ideas on creativity, leadership, innovation, and organizational behavior, and will be in that sense quite modern, it may also seem in some ways simple and timeless, as you reconnect to your own values, history, and integrity, often using techniques that are thousands of years old.

The best thing about the future is that it only comes one day at a time.

—ABRAHAM LINCOLN

We cannot really separate our lives into a home part and a work part.

—EDWARD SHAPIRO AND WESLEY CARR

As you use the tools in the chapters that follow and choose the elements you will emphasize in your life and work, you may begin to have the sense that your very modern life is nonetheless hand-crafted and personal, even sacred. This sense of sacredness will begin to expand and shape your world into a new lived reality and, we hope, a kind of collective enlightenment.

CALMING THE SKEPTICS

FOR TWENTY YEARS we have worked with our own creativity and with the creativity of those we have taught. Together the book *The Artist's Way* and Artist's Way workshops have helped more than a million people find their creative voice. Those million people taught us what we know. *The Artist's Way at Work* translates Artist's Way tools directly to the business world. This is not a book of creative theory; it is a book of field-tested practice.

In teaching *The Artist's Way* over the past two decades, we have heard many of our students tell us how the tools from the book helped them in their business lives. Time and again we've heard how our techniques unexpectedly helped students clarify and reach their business goals. It became apparent that many of the people we taught carried unrealized hopes, sorrows, or frustrations about their business lives, as well as their creative ones, and somehow we had articulated a way to help them in both.

Following our students' lead, we began to experiment with what worked and, as news of our work spread, to teach more and more businesspeople. Slowly we evolved a set of special tools to help people in their work world. Those tools are what you now hold in your hands. They have been refined for some time, in a number of diverse settings.

This work is the merger of three histories: Julia's in the art world, where as a playwright, essayist, screenwriter, filmmaker, and poet, she wrote, developed, and taught the initial program that became the country's most successful course on creativity, the Artist's Way; Mark's decade of experience as Julia's teaching partner and collaborator in that work, as a Harvard-trained educator and member of the Dialogue Project at MIT, and as a former new-products inventor and entrepreneur who has built products for Fortune 500 clients in Asia and who was a member of the free enterprise tran-

> Discovery follows discovery; each both raising and answering questions; each ending a long search, and each providing the new instruments for a new search.
>
> —J. ROBERT OPPENHEIMER

> Businessmen go down with their businesses because they like the old way so well they cannot bring themselves to change.
>
> —HENRY FORD

sition team in the former Soviet Union; and Catherine, a senior-level executive in the financial services industry and business consultant, and innovator, who taught in the graduate business schools of George Washington University, Georgetown University, and American University in Washington, D.C., and served as a strategist and new-products specialist for major corporations for more than twenty years before the Artist's Way process changed the way she approached business and initiated her into a string of successful new entrepreneurial ventures.

We decided to collaborate because each of us brings a unique and an important vantage (as well as dedication and individual motivation) to this work from our diverse worlds: the artistic, the educational, the entrepreneurial, and the corporate.

Experience is the name everyone gives to their mistakes.

—OSCAR WILDE

RIDING THE DRAGON

FOR OUR PURPOSES, the dragon embodies the power, beauty, and mystery of your own inner forces that shape and interact with your world. There is an opportunity inherent in every failure, a chance to turn negative experiences into positive lessons, to learn—in effect, to *ride the dragon*, instead of being devoured by it.

Companies of all sizes have gone through a series of changes in recent years, changes so unexpected that they have left thousands of people and businesses in a state of fearful paralysis. From the mom-and-pop stores on Main Street to the huge multinationals, the shift to a global marketplace, the flight of capital to cheaper overseas labor, the emphasis on short-term gains over long-term strategies, and the loss of traditional work roles all have required difficult changes. Many firms have hunkered down, turned inward, and focused on restructuring, layoffs, risk avoidance, and cost control.

While these actions can be effective in the short term, they ignore the impact that innovation can have on the underlying infrastructure of an industry. A company needs to be adaptive, flexible, and focused on new-product and service delivery in order to achieve success. In order to stay competitive in the next decade, individuals within corporations and those who are self-employed must be willing to be adaptive and embrace change.

As you use these tools, we can promise you that your creativity will expand and deepen. As you focus on yourself as your greatest

business ally, you will find that your heightened sense of competence and authenticity makes you a better team player and a more collegial colleague.

We asked hundreds of businesspeople to tell us the things that concerned them. We received a wealth of heartfelt questions such as:

- "How do I stay creative in a hostile and competitive environment?"
- "How do I align my personal and business goals?"
- "How can I remain creative despite criticism?"
- "How can I clarify and apply my strengths to my work?"
- "How can I overcome the depression I feel at my job?"
- "How can I handle an impossible workload?"

If you always do what you always did—you'll always get what you always got.

—UNKNOWN

While there is no magic way to achieve instant fulfillment in life, there is a path toward it. At its root *The Artist's Way at Work* is a workable program of personal excellence, combining constant forward-looking vision with daily achievement. It allows us to "Live in the paradox"—meaning that we strive to be happy and content today, while keeping an eye on a plan for tomorrow. This is not a quick-fix book or a get-rich scheme. It is a guided encounter with your own ingenuity.

Many of you may have picked up this book because of a precipitating event: a business failure that made you determined to do better, a business success that you want to protect and maintain, or the recommendation of a friend who may have worked with these tools through contact with the Artist's Way books or one of our seminars.

Do not be intimidated by the notion that you are going to be working on your creativity. That is only part of what you'll do. You will find the process more exciting than daunting, more supportive than demanding, more joyful than arduous. Working together, we will dismantle the cultural mythology that tells us that only a few of us are truly creative or truly gifted and that creativity itself is a volatile and dangerous process.

Creativity is not dangerous, not volatile, not limited to a select few. It is a universal, not an elitist, gift. Creativity is safe. Creativity can be stabilizing. Creativity belongs, as a birthright, to all of us.

You may be thinking that creativity is for "crazy artists" or that

Nobody goes to work to do a bad job.

—EDWARD DEMING

it is too scary or wild for the business world, but that's only because we've been *told* that it's scary. Creativity is essentially an energy flow that must be grounded. This book will teach you to ground your creative energy, to access and experience your creative flow as vital rather than volatile. Whether you regard creativity as an intellectual power or a spiritual electricity, you will discover that it is a power that can be generated and controlled.

Consider for a moment this idea of creativity as spiritual electricity. If one person in a workplace increases his or her creative voltage, the extra light helps everyone to see more clearly, with greater vision, the work at hand. If one person shows that authenticity is comfortable and user-friendly and serves the group as a whole, others will be drawn to increase their authenticity as well.

In other words, when creativity is safely grounded, it is catching. We have seen a creative contagion move through a workplace where one individual becomes creatively healthy and this health cascades through his environment, first to one trusted colleague, and then another, inspiring an ever-widening circle.

An individual cannot be truly authentic in an organization that stifles innovation, and an organization cannot be innovative unless the people involved are allowed to be authentic and creative. If a corporation is essentially a creative ecosystem, you have within you the power to increase not only your own potential but the potential of the entire company.

DOING, NOT THINKING

INTELLECTUALISM IS A primary block for many creative people. (If being "smart" were the answer, most of us would have it by now.) Sometimes knowledge impedes change: We *know* more but *do* less. Expect your intellectual skepticism to be your adversary and your constant companion on this journey. This is an experiential book. It should not be merely read—it must be worked for best results.

This book, with its emphasis on "just do it," may enrage your Intellectual Tyrant, who is used to running the show, or your Internal Rebel, who will want to discount this process because of an unconscious fear that it might work. (We are often a lot more afraid that something might work than that it won't.)

It's okay to be skeptical. We invite it. We ask only that you

It is not these well-fed long-haired men that I fear, but the pale and the hungry-looking.

—JULIUS CAESAR

Work keeps us from three great evils, boredom, vice and poverty.

—VOLTAIRE

withhold judgment long enough to work these processes for a short time and then judge what we are talking about for yourself.

This book is based on four ideas:

1. We are all creative.
2. Increased creativity is a teachable, trackable process.
3. All of us can become more creative than we already are, and this will make us happier, healthier, more productive, and more authentic in everything we do.
4. The business environment will increasingly reward those people who are able to be creative.

The only completely consistent people are the dead.

—ALDOUS HUXLEY

Over the next twelve weeks you will contact an expanded sense of intuition, confidence, and satisfaction. You will do exercises and tasks that are specifically designed to guide you slowly and safely to a heightened awareness of and appreciation for your particular gifts and challenges.

People, not bricks and mortar, make up companies. A company is not an it; it is an *us*. By increasing your innate powers of ingenuity, intuition, and candor, this book will help you become a catalyst for positive change in your life and in your workplace.

It will revolutionize the way you live and the company you keep.

Tool: Entering the Gate

THE FIRST TOOL of creative emergence is simple and pragmatic: housecleaning. Take a blank sheet of paper. List your fears, your angers, and your hopes regarding the work you are about to do with this book.

For our purposes, no fear is too silly, no anger too petty, no hope too preposterous. All parts of you are welcome here. You may feel frightened or grandiose. Your anger may feel volatile, or perhaps you simply feel numb or indifferent. Whatever you are feeling, fearing, or hoping, get it on the page (or pages). Date the page, and place it in a sealed, dated envelope to be reread at the book's end.

No pessimist ever discovered the secrets of the stars, or sailed to an uncharted land, or opened a new heaven to the human spirit.

—HELEN KELLER

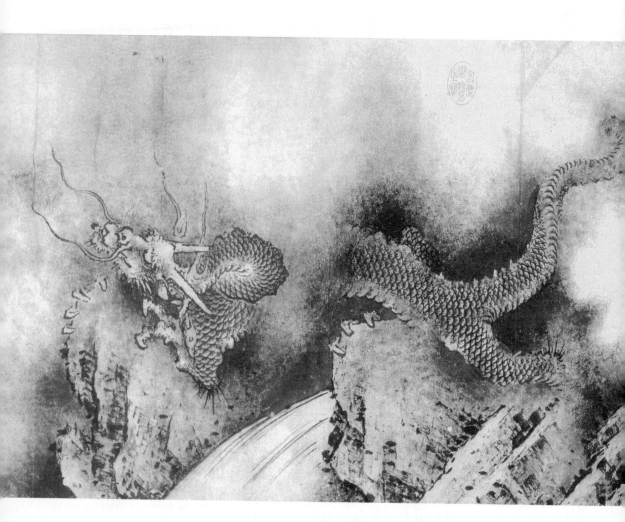

THE FIRST TRANSFORMATION: PART ONE
EMERGENCE

THE DRAGON RISES from the mists and rolling fog of *not knowing*, aware that the journey has begun. It is time for the authentic self to emerge from confusion, seek its education, claim its heritage. This powerfully creative self has been obscured in the mists of life—its frustrations, its demands, its expectations.

During this first week—indeed, throughout the coming weeks—remember that there are no right or wrong answers, no ways to do this work perfectly.

> I ALWAYS KNEW THAT ONE DAY
> I WOULD TAKE THIS ROAD BUT
> YESTERDAY
> I DID NOT KNOW TODAY
> WOULD BE THE DAY.
> —NAGARJUNA

WEEK ONE

■

EMERGENCE

■

IN THE BEGINNING

THIS WEEK WE begin working in the swirling mists of our history.

For this reason, our initial bedrock tools concern communication of the self to the self. We call these tools the Radio Kit. They allow us both to determine and to broadcast our creative and emotional bearings. They are simple, workable, and mandatory.

(If you have already worked with the Artist's Way, then some of the first few tools will be familiar to you. However, we will be using them in new and unexpected ways that we think you will find illuminating and exciting. As the weeks progress, you will discover many new concepts and exercises that will expand your use of these classic tools and will reward you for your faith in this work. For now, the drill as you know it.)

Our primary tool—the morning pages—is three pages of daily longhand morning writing. You will be using this tool first to contact your inner self and later to discover your patterns in groups.

We all suffer ambivalence about our simultaneous desires to be a part of, and apart from, groups, and many of our new tools are designed to explore this ambivalence. We have found that morning pages show us both our connectedness and our individuality.

As you will soon discover, the inner self has a variety of voices. In doing morning pages, you will experience some of them. You will also learn to discern which voices of this "self" are best heeded and which best disputed. You will discover many positive forces that might have become silenced over the years, including one we call the Inner Mentor.

This Inner Mentor, which some of us characterize as an older sage, is not unlike the eldest dragon of Chen Rong's painting or *Star Wars'* Obi-Wan Kenobi in our popular mythology. Knowledge of this and similar voices will eventually evolve into a guidance system you can depend on. But first you will meet a host of other voices, the voices most of us think of as "myself."

RESIST RESISTANCE

EVEN THINKING OF doing morning pages has probably already triggered resistance in some of you.

"When will I have the time?"

"I can't write."

"This sounds like mumbo jumbo to me."

Realize that in just thinking about doing morning pages, you have already heard one of your inner voices. If you listen carefully, below the resistance you will probably hear the whisper of "hope," barely audible above the din of your other "rational" voices, that might say, "What if this works? Wouldn't it be exciting?"

See what we mean?

Morning pages will acquaint you with yourself in a new way. If all this sounds a little too "weird" to you, perhaps nebulous or ungrounded, let us assure you that it is not our "theory" that morning pages attune you to your inner voices and forge a workable intuitive link that alters lives; it is our considerable teaching experience.

Creativity expert Howard Gardner has noted three practices common to many "Big C" creatives:

1. Some type of daily reflection
2. The ability to leverage their strengths
3. A way to reframe failures

Morning pages and other techniques in this book help you do all the above.

> A talent is formed in stillness, a character in the world's torrent.
>
> —JOHANN WOLFGANG VON GOETHE

WHAT ARE MORNING PAGES, EXACTLY?

WHAT EXACTLY ARE morning pages? How and why do you do them? The "what" is three pages of longhand writing first thing in the morning. The "why" is a little bit more complicated than that.

First of all, let us say that although you will contact a great deal of inner wisdom through the practice of morning pages, not much of what you actually write in the morning pages will, or

> Creativity can never be explained by appeal to reason alone. Like the birth of a child, creativity compels us not to explanation but to wonder and awe.
>
> —GEORGE VAILLANT

should, strike you as wisdom. Far from it. Morning pages are about anything and everything that comes into your mind as you write. In this way they are very different from standard "journaling" in which you set a topic and try to say something meaningful, or write in response to a specific agenda.

In the MPs, anything goes. This means they will be scattered, often trivial, frequently negative, petty, self-doubting, angry, and seemingly pointless. They are not.

All that mental debris is the clutter that comes between us and our creative potential. We often call the pages brain drain because they are designed to siphon off poisonous attitudes, the "pond scum of the mind." Like the first dragon, we do morning pages to rise from "The Mist of Not Knowing."

You can expect morning pages to contain everything: the flotsam and jetsam of your relationships; your concerns about your aging parents' health; your anger at the guy who took credit for your work in yesterday's meeting. Put it all down. Report in the pages anything you think or feel about your life, and write it as fast as you can. Some days the pages may be joyous: your hopes for your children's happiness; your pride in a job well done. Other days sadness will sweep through the pages as you discount your life as one long futile endeavor.

In the morning pages (sometimes the mourning pages) you are free to feel and be exactly as you are in the moment. The pages are completely accepting. To put it in psychological jargon, they are meant to be a safe place.

Do not tame your pages. Extreme emotions, judgments, and reactions all are part of what the pages help clarify and ground. On the days when life feels like a battleground, think of your pages as a field report. And as in a debriefing, put in every nagging thing that occurs to you.

Be petty. Be picky. Be silly, be joyous, be crude—whatever. Don't look for deep thought or deep meanings. Simply record what occurs to you and keep your hand moving across the page until you have filled three pages longhand. Do not analyze them or yourself. Just write. Write fast.

One starts an action simply because one must do something.

—T. S. ELIOT

We do not walk on our legs, but on our Will.

—SUFI PROVERB

RULES OF THE ROAD

SOME GUIDELINES:

1. The pages are written on three pages, one side each of eight-and-a-half-by-eleven-inch paper. (Small notebooks crimp our thoughts, and legal size is daunting.)

2. The pages are never to be shown to anyone else. They are your private place to dream, to fantasize, to complain, to exult. Keep them private.

3. They are not to be reread or mulled over. Write them, and move on. (Do save them. For now.)

4. It is three pages a day. If you write five today, it is still three tomorrow. If you write one today, it is still three tomorrow. No racing ahead or catching up. (Hint: If you hit the wall at a page and a half, use the rest for prayer, wishes and dreams, or disputing your critics or other negative voices.)

5. It is okay if they are half to-do lists.

> Thou shalt ever joy at eventide if thou spend the day fruitfully.
>
> —THOMAS À KEMPIS

■ *Tool: Morning Pages*

SET YOUR CLOCK early, perhaps forty-five minutes to an hour. You are about to begin morning pages, the pivotal, nonnegotiable tool of creative emergence. Today. And every day for the rest of this book—and, we hope, far longer—you will write three pages of stream of consciousness.

There is no wrong way to do pages. Simply do them longhand and keep your hand moving across the page. Write down anything that comes to mind. Continue for three pages, and then *stop*. Repeat this exercise daily. Notice that morning pages may take time, but they will also give you time by prioritizing your day. For most of us the actual time it takes to write pages gradually decreases as we become more and more fluid.

According to Carl Jung, "Wholeness is possible only via the coexistence of opposites. In order to know the light, we must experience the dark." In order to move toward our creativity, we must experience our resistance to that creativity. Morning pages will give you that chance.

A WARNING

EVEN TALKING ABOUT doing morning pages, you may experience yourself vacillating between two poles of your personality—the Tyrant and the Rebel, whom we mentioned before. The Tyrant is a perfectionistic bully who says:

"You'll never do this every day."

"You will never do this well."

"This won't work for you."

"You never stick to anything."

The Tyrant is an all-or-nothing character. This extremism is not in your best interests. Even doing a small percentage of what we ask will be extremely helpful.

The other voice to watch out for during this time is the Rebel, the "I don't care what they say" voice. This voice wants to cross his or her arms and say:

"Who are these people, anyway?"

"I am doing fine just as I am."

A master of camouflaged self-destruction, the Rebel may try to keep you from even beginning to work with this material. You may already have heard this internal voice, cynical and wary, like a petulant teenager, balking as you read. The Rebel is often guarding something—a jealousy, an insecurity, a long-held resentment, or something she should *do*—and is unconsciously afraid that the morning pages will bring this fact to consciousness. Watch for your Rebel to act up when your explorations get too close for comfort.

Remember these characters are at play when you are tempted not to *start* morning pages because you might not do them perfectly or when you are tempted to *quit* the process because your skeptic is saying, "If you can't do something *right*, don't do it at all."

It is not necessary to silence, avoid, or even be distressed about the Tyrant or the Rebel—or any of your other voices. We all have them to one degree or another. Just be aware when they are speaking. It might feel foolish, but you can engage in a little inner dialogue. Tell them they will become cherished allies once they learn to lighten up, listen, and play a little more.

There are voices which we hear in solitude, but they grow faint and inaudible as we enter into the world.

—RALPH WALDO
EMERSON

WHY BY HAND

"MY TYRANT AND Rebel won't stop me, but longhand will," students often complain, not realizing it is their Rebel speaking. "Do the pages really have to be done longhand?"

Yes, longhand. Years of experience have taught us that the morning pages are best done by hand. Computers may be faster, and certainly they are okay to use if you must, but computers tempt us to edit, to shape our feelings into "real" writing. Morning pages are intended to show us our unedited thoughts and feelings; they are supposed to be loose, messy, disorganized, disjointed, and flighty. It is out of this deliberate chaos—a positive form of *not knowing*—that order will spontaneously be born.

Do not "order" your pages. Instead allow them to order you. Handwritten morning pages yield a handmade life. They clarify our thoughts, our feelings, and our days—first in the day we're in, when we can take small, concrete actions, and, secondly, in our lives, as our true goals and aspirations gradually emerge from the storm and heat of our busy days. Morning pages clear the mists that surround the dragon.

The heights by great men reached and kept / Were not attained by sudden flight / But they, while their companions slept, / Were toiling upward in the night.

—HENRY WADSWORTH LONGFELLOW

WHY THREE PAGES

THE THREE-PAGE quota is carefully chosen. We have found that writing less than that keeps your burners on low heat. More than that turns the fire up too high and may send you into a level of introspection that makes it difficult to return to normal functioning for the day. Cook it all at a low simmer, and try to write three pages, not less and not more. If you miss a day, don't try to catch up. If you are a go-getter, don't try to race ahead. The three-pages-a-day quota is tried and true. Work within it.

WHY IN THE MORNING

"YES, MORNING PAGES should be done in the morning," Julia jokes, "or we would have called them evening pages."

"But my only private time is in the evening! Can't I write them then?"

"No." Two reasons.

First, morning pages done in the evening can only review the day you've already had. Because one of the primary functions of morning pages is to consciously and unconsciously lay the track for the day ahead, evening pages are from that point of view useless.

Second, morning pages are not journaling. In traditional journal writing, topics are set and explored. Morning pages are purposely more free-form than that. The waking mind slips around rapidly from subject to subject. Morning pages tend to do the same — except we have a word trail, a kind of cognitive tracer that lingers in the subconscious mind long after we have finished the conscious writing, the ideas and problems of our lives being then sent to "cook" in the unconscious while we go about our daily routine.

"I don't know why, but if I mention it in the pages, I tend to deal with it in the day."

"My pages are just to-do lists, but I tend to get a lot more done."

"Something will occur to me, and I will simply act on it, often with amazing results."

Some of you will resist the idea of an early reveille, no matter how beneficial:

"But I'll have to get up even earlier, and I already get up too early to suit me."

"Sleep when you're dead," Mark jokes.

"I teach only grown-ups," chides Julia.

"Write them on your lover's back," our joke goes.

"Create the time. The payoff is well worth the extra effort," says Catherine.

Get it?

To do morning pages, you need to get up early. If you already do, you're used to it. If you don't, the adjustment will quickly feel normal. (We have a longtime student who jokes that by the time he gets up in the morning his Critic is already awake and has smoked a cigarette and had a cup of coffee.)

Morning pages usually take from twenty to forty-five minutes at first. And everyone gets faster as he or she goes. We think the faster the better.

As you become accustomed to moving your hand freely across the page, your writing time will speed up. You will also notice a curious phenomenon: As you take the extra time in the morning,

A problem well-defined is half-solved.

—JOHN DEWEY

Whatever the reasons, we do not pursue emotional development with the same intensity with which we pursue physical and intellectual development. This is all the more unfortunate because full emotional development offers the greatest degree of leverage in attaining our full potential.

—BILL O'BRIEN

you will find yourself winning more and more frequent windows of personal time in the rest of the day. In other words, morning pages both take time and make time. They do so by prioritizing and ordering our days according to our authentic needs and agendas, needs and agendas that are often lying just outside our awareness.

PAST, PRESENT, FUTURE

WHILE WRITING MORNING pages, focusing on the necessities of life in the here and now, you may encounter a swell of memories that gradually rise to the surface, asking to be claimed. Morning pages help you claim, reframe, and integrate your past.

"I hadn't really thought about the past in years," Jeannette told us, "but as soon as I began my morning pages, I remembered a time when I had major aspirations. I was a young woman, fresh from college, moving into the big city, full of energy, living in an apartment up the block from an Italian bakery. I would have a cappuccino there and plan my career. My ambitions seem to have mixed forever with the aroma of coffee and freshly baked bread. My morning pages connected me to that time, to that young woman and the bright autumn days of riding my bike to my first job, and to the sense of hope I had then and suddenly felt again."

Often when we talk about this process, we speak of people undergoing a creative emergence. What emerges—first in fleeting glimpses (sometimes amid tears, sometimes in a roar of awakening)—are parts of a more authentic self, often lost or buried over the long haul of life.

Because the morning pages work simultaneously in the past, the present, and the future, many people find them a viable form of meditation. (This is what the academically inclined call a reflective technology.) No matter what you call them, MPs create an internal "holding environment"—what we call a sacred space—where your true thoughts, feelings, insights, and inspirations can safely emerge.

(If you are a longtime adherent to the Artist's Way and have done morning pages for more than a year, you might want to augment the pages for a time with meditation, exercise, or music practice—anything that will form a ritual and jog you out of your normal routine—though this is not necessary. If you have a practice of

> Artistic growth is, more than it is anything else, a refining of the sense of truthfulness. The stupid believe that to be truthful is easy; only the artist, the great artist, knows how difficult it is.
>
> —WILLA CATHER

meditation or other form of reflection, you might want to integrate MPs into your routine. If you have trouble with the pages, do them however haphazardly you can, and concentrate on the other exercises in the book. No one does this perfectly.)

"Writing morning pages made me mad," Daniel told us. "I guess I was already mad—I felt trapped in my job—but I hadn't felt angry, just depressed. The pages gave me a place to let off some steam. When I did, I could see a lot more clearly. I proposed some new directions at work and my ideas were accepted. All that steam was actually blocking my vision of what to do!"

Tool: Creative Colleague

TRAVELING CAN BE more fun with a friend along. Find a trusted friend to work this process with, or at least to support you with weekly check-ins. Though this process is effective when worked by oneself, it can be even more fun when experienced with others. A friend or friends from work, school, or the old neighborhood is fine. Since this work will free up an enormous amount of energy, it is good to keep it quiet at first, until you have several members of a team with whom to discuss it. Doing it as a group outside the office, or as a secret clique within it, can make the process more fun and more effective, and not arouse the organizational defenses that naturally rise up against change.

THE INNER FORTRESS

DANIEL NEEDED A safe place to admit he was angry, feel the grief underneath it, and use it as fuel for action. Think of your morning pages as a sort of inner fortress, a place where your often-conflicted emotions and perceptions can duel and play out. Morning pages allow us to engage with our life *and* view it with greater detachment, a trick called building an observer self.

Morning pages reveal that although we are embedded in a social world, we simultaneously occupy an individual world and hold a unique perspective.

"I think of it as calling an inner meeting," Lorraine says. "I go to my morning pages with a problem, and I ask my differing inner voices to speak about how they feel. Often I find that different parts

It requires a better type of mind to seek out and to support or to create the new than to follow the worn paths of accepting success. . . .

—JOHN D. ROCKEFELLER

Know thyself.

—INSCRIPTION AT DELPHI

of me feel many different ways. One part is furious at my boss. Another part sees his perspective. A third part comes up with a way to please both him and me. I'm collectively a lot wiser than I knew."

■ Tool: Secret Selves

ALL OF US contain multiple inner voices. You may have a Censor, an Inner Explorer, perhaps an Inner Romantic, a Wonderer, a Pragmatist, a Bully, an Intellectual, maybe even a rock-and-roll Drummer. Take a blank sheet of paper, number from one to five, and list, name, and describe your secret inner selves. For example:

1. Nigel, my critic. He has an upper-crust British accent, and he looks down on the rest of me. Nothing is ever good enough for Nigel.
2. Dutiful Dan. He is a drone who works overtime without extra pay. He's more than a team player. He's a chump who lets himself be used.
3. Quick Nick. He's a scheming entrepreneur. He wants to get rich quick by any way possible. He looks for corners to cut and people to know.
4. Vain Vanessa. She's the office snob, very invested in being in vogue and in control.
5. Anxious Andrew. He's a worrier. He overthinks everything and frets about the rest. He's so afraid of losing his job he doesn't think clearly about how to do it.

In naming your secret selves, try to maintain some humor and affection for the cast you carry within you. Each of these multiple *yous* has a role and a value.

SPIRITUAL CHIROPRACTIC

WHEN A BODY is out of alignment, it cannot move effectively. A visit to the chiropractor, a few simple adjustments, and freedom of motion is restored. Spiritual chiropractic works much the same way.

What do we mean by that?

We each have a mental/emotional/spiritual body that is just as real as our physical body. We respond to the cues and urgings of

> He who knows others is wise. He who knows himself is enlightened.
>
> —LAO-TZU

> When we exercise our imagination, we interact more critically with our environment. Life is genuinely interactive, consisting of two-way traffic between us and our varied contexts.
>
> —EDWARD SHAPIRO AND WESLEY CARR

this unacknowledged body all the time. When we ignore its cues, we go out of alignment. We are, as psychologists say, "not in touch with our feelings." Over time feelings we don't acknowledge can become very uncomfortable.

"Just being in the same room with Paul, the new copywriter, gave me a stomachache," recalls Beverly. "I tried to ignore it, but it wouldn't go away. Something about him just made me physically uneasy. My body didn't trust him—and rightly so. It turned out that he leaked our campaign to a rival agency he was freelancing for."

When we are out of sync with ourselves, we suffer a loss of effectiveness. Just as a few simple spinal adjustments can create a far greater range of motion for a physical limb and can return our body to its proper powers, so too a few simple adjustments can create greater freedom and integration for the various selves that make up our "I." Adjustments such as:

Lacking a place to own and process her feelings about Paul, Beverly became uneasy and off-balance, blaming herself for being too suspicious. Instead of listening to her internal cues and clues, she discounted them. In doing so, she muffled herself and her natural resourcefulness. She might have discussed her fears with a trusted friend outside work, then with a trusted coworker; she might have talked directly to Paul after writing about her feelings; or she could have discussed it with her boss. Instead, by ignoring her intuition, she opened the door for Paul's creative robbery to occur.

The morning pages give us a container large and free-form enough to hold our multiple opinions, ideas, and conflicting voices.

For instance, have you noticed yourself "traveling" anywhere while you have been reading this? In any given moment we may be cued into recalling our past or plotting our future—watching our Inner Movie. Taking the time to view it each morning in the pages makes us less likely to be distracted from the tasks at hand during the workday, more able to express ourselves in honest emotions from the present.

Once we begin to understand the power of our minds to travel across time and space, to "join" others or to separate, we have come a long way toward self-awareness. At all times, in all situations, we have one big "I" present, but also multiple smaller "I"s present.

"I've got one inner self who is a sunny optimist," says Claire.

Once turn to practice, error and truth will no longer consort together.

—Thomas Carlyle

First ponder, then dare.

—Helmuth von Moltke

"She's always coming up with sweet plans and ideas, but another part of me is a real wet blanket, and she's always shooting the happy ideas down. Once the pages revealed these selves to me, I could watch them both, and I was able to choose which of them got to 'win' at any given time."

Many of us, like Claire, carry negative doubting voices. Let's look at two common ones:

Some of us rely too much on our "rational" selves, while others of us rely too much on our wishful, "fantastic" selves. Those who are overinclined toward the rational may experience voices that remark:

"What will they think?"

"Maybe I'm crazy."

"Who am I to suggest this?"

Morning pages help the rationalist to hear self-doubt as exactly that and not as the voice of reason.

Those of us who are overinclined toward the grandiose or the fantastic often experience many great ideas without the willful follow-through necessary to see them to fruition.

"I could start a new airline."

"I could run the whole damn company."

The daily feedback of morning pages grounds the person lost in fantasy in the reality of the moment, showing what needs to be done step by step to sort out and implement those ideas that are actually practicable. Conversely, the pages can inspire the rationalist who needs to allow his imagination to soar to achieve more than he dared.

In either case the ritual of morning pages helps build the will to succeed that proves effective in attaining goals and dreams, by allowing us to hear our Rationalist, our Critic, our Observer, our Rebel, our Dreamer, our Tyrant, and others as a sort of miniature chorus, a forum where all parts of ourselves are welcome, all heard. In this new fuller consciousness our negative voices become simply that: negative voices. Once we are aware of them, we are free to choose, learning to act on our more positive inner promptings.

Over a surprisingly short period of time an integrated, more transcendent "I" emerges, one who is able to take in the "advice" of our inner chorus and act in the best interests of them all.

> The curious paradox is that when I accept myself just as I am, then I can change.
>
> —CARL ROGERS

> The eye sees a great many things, but the average brain records very few of them.
>
> —THOMAS ALVA EDISON

Carlos, a corporate executive, began doing morning pages convinced that he was in a dead-end job that he would need to leave. Within a month his pages had acquainted him with his cast of inner characters, some of them self-sabotaging, those voices that squelched his confidence and silenced his ideas at meetings, short-circuiting his chances for advancement.

The larger the island of knowledge, the greater the shoreline of wonder.

—RALPH SOCKMAN

"I saw that some parts of myself actually loved my job and had lots of ideas about how to do better, while another part of me just took out a machine gun and mowed those good ideas down. I began, in the pages at least, to protect those positive notions. When my machine-gun critic came out, I started to say, 'Back off.'"

Within two months, as his positive inner promptings became stronger and clearer, Carlos found himself feeling less threatened in meetings, more free to offer his ideas. By having a safe place to dream and be himself, he gained the confidence to venture into enemy territory.

Often, finding ourselves in a psychologically safe place where judgment is suspended helps us become better able to take risks in public. The morning pages in effect grant us a sanctuary from within which we can build a more resourceful will.

■ *Tool: Listening to the Chorus*

REFER TO YOUR list of secret selves. Ask each of those secret selves to volunteer an insight or opinion regarding your current work environment. They might run something like this:

Nigel: "This company's run out of steam. My boss is a jerk, and if I had any brains, I'd get out of here."

Even one person can have a sense of dialogue within himself, if the spirit of the dialogue is present. The picture or image that this derivation suggests is of a stream of meaning flowing among and through us and between us.

—DAVID BOHM

Dutiful Dan: "My workweek includes twenty free hours of overtime, and I resent it. Maybe I should log my hours and put in a formal request for overtime pay."

Quick Nick: "There's a window of opportunity that we're close to missing because the design team is taking too long."

This tool increases your peripheral vision for troubles and opportunities. You may wish to use it once a week. Do not be surprised if your secret selves begin to argue, discuss, and relate to one another!

THE INNER MENTOR

THE POWER OF daily reflection improves our listening capacity so that we become more aware, first about ourselves and then about others. Morning pages become in time more an Inner Mentor, listening with increasingly sage ears, granting us the wisdom we need to persevere day by day. For instance, before a difficult meeting, we might dash off a spontaneous page and "hear" ourself think:

"He's saying one thing but meaning another."

"He's acting aggressively, but I think he's feeling scared."

Acting on these intuitive leads, we begin to respond to others in new ways, often more effectively, disarming a hostile client by calm reassurance, listening to the subtext as well as to the text, seeing below the surface.

Over time we learn to hear with an inner ear what some might call the still small voice, and what others might call a hunch, a gut feeling, or intuition.

No matter what you call your inner mentoring faculties, you will gradually come to trust them. Think of your morning pages as a sort of predawn rendezvous where the many parts of yourself that constitute your Inner Mentor can confer on the plans for the day.

If your morning pages turn into glorified to-do lists, that's okay. Morning pages evolve and alter over time. For Julia, they are the source of what she calls her marching orders. Creative projects may appear as tiny seedlings; a new direction may emerge as a repeated urge to act. For Mark, they combine to-do lists with a sudden impulse to call so-and-so or with a new solution for a problem. For Catherine, they help her see nonlinear connections between business opportunities.

Morning pages put interesting insights front and center. Watch for what Carl Jung called synchronicity:

"I seem to be in the right place at the right time more often."

"Maybe I'm just noticing my opportunities more clearly."

"I think I'm getting luckier."

"I'm more in the flow."

"I'm working on a project, and suddenly I notice support coming from all quarters."

Mark often calls this phenomenon the yellow Jeep syndrome.

An invasion of armies can be resisted, but not an idea whose time has come!

—VICTOR HUGO

You buy a yellow Jeep, and suddenly you notice yellow Jeeps everywhere. Those Jeep owners didn't just move to your neighborhood. They were there all along; you just didn't notice them.

Synchronicity, serendipity, selective perception, the unconscious becoming conscious, coincidence, or luck—call it what you will, it will become familiar to you in time. (We do not expect you to take our word for this, and certainly the experience is not the same for all of us. We ask you to work with the pages and see if this phenomenon happens for you.)

No snowflake ever falls in the wrong place.

*—*ZEN SAYING

▓ *Tool: Inner Mentor*

THIS TOOL ENCOURAGES a supportive and nurturing form of inner dialogue. Students often report feeling surprised and comforted by this exercise. We ask you to try it with an open mind.

Set aside forty-five minutes. You will need quiet, privacy, writing paper, and a pen. Settle in, get comfortable, and "ask" your older and wiser Inner Mentor to write you a personal letter. Many of our students imagine their mentors to be far older and far wiser than their normal selves. The Inner Mentor is tough but benevolent, long-sighted, and kind. Allow your Inner Mentor to write for about thirty minutes. You may encounter wise counsel, rueful humor, shrewd political advice. After half an hour, stop writing. Reread your mentor's letter. If any point puzzles you, ask your mentor to clarify and write out the answer which you "hear."

ALL FOR ONE AND ONE FOR ALL

THE MORNING PAGES usually include musings not only about ourselves but also about who we are in our social worlds. This dual perspective can help you become simultaneously more personally authentic *and* better able to interact socially—social individuation.

As teachers we have watched many introverted individuals become, over time, more at ease and more candid in their work environment. On the other hand, our more extroverted clients become more reflective, more able to accept the input of others, more empathetic with their own and others' feelings and thoughts.

Then join hand in hand, brave Americans all!

By uniting we stand, by dividing we fall.

*—*JOHN DICKINSON

James, the vice-chairman of a billion-dollar multinational, tended to dominate his creative team, steamrollering others with his

quick wit, his endless energy and the unceasing flow of his ideas. James, a friendly man despite his overwhelming personality, suffered a deep sense of isolation as his ebullience stifled others and caused resentment.

Working with his morning pages in secret even from his wife, James found himself examining and appreciating the input from others he had often rushed past. "Maybe I should slow down, let others carry the ball more," he wrote.

When he eventually tried passing the ball, his creative team-mates welcomed the change. James, at first tentative in his overtures, soon found their ideas exciting and synergistic to his own. Instead of losing power, which had been his fear, he gained power. He became less controlling and rarely needed to retreat to his isolationist stance. Instead he involved his team more spontaneously, with fewer of his self-imposed agendas. Everyone participated more actively on a moment-to-moment basis. The creative level of his entire team rose as its members felt safe, respected, and heard.

This rebalancing of an individual's personal style within a team context occurs through regular contact with the safe psychological space of the morning pages. James discovered that they helped him extricate himself from counterproductive behaviors and nonreciprocal relationships—they made him more "socially" individual.

Without a form of daily reflection, our moments of awakening can be lost or dismissed. The repetitiveness of the pages grounds insight and spawns initiative. Within the safety of the pages, both James and Carlos discovered and faced their anxieties, and instead of rationalizing their behaviors or indulging in self-blame, they honed the will to take action.

In this way the morning pages also work on a group or corporate level to create new and healthier creative exchanges. Change begins at the individual level but immediately affects the company as a whole. When a number of individuals are working with morning pages, the creative synergy can be very exciting. Inspiration and enthusiasm are contagious.

> I left the woods for the same reason I went there. Perhaps it seemed to me that I had several more lives to live, and could not spare any more time for that one....
>
> —HENRY DAVID THOREAU

> Do I have the personal qualities it takes to succeed? This is the most important question of all.
>
> —PETER LYNCH

A BODY OF KNOWLEDGE

OFTEN, IN SEEKING to be creative, we look only to our intellectual responses, not to our emotional and physical ones. The folk wisdom

of the centuries often includes the acknowledgment of the body's role in recognizing emotion:

"He was a pain in the neck."

"She was brokenhearted."

"He gave me a real stomachache."

Morning pages, written by hand, reacquaint us with our bodily cues to our emotional reality:

"I feel tired."

"I feel stressed."

"My head hurts."

"I am so excited I can't sit still."

"Walter makes me nervous, and I don't know why . . ."

When we tune into our emotional as well as our intellectual selves, we begin to "surface" a great deal of previously unconscious data. When we allow ourselves to acknowledge all our "knowings," we often know more and know it sooner than other people. Situations far less frequently catch us by surprise. Our senses are engaged in a new way: We "see" these situations. We get "in touch" with our responses. "Now I *hear* my emotional beeper go on," is how Annie phrases it. "My pages will often bring up a problem when it is still only a potential problem. I have learned to rely on these hunches and call, for example, to check with production on a certain project. When I call, I often learn there is some good reason that I did. As my still small voice becomes louder, I listen more."

Returning to our analogy of the Radio Kit, morning pages allow us to determine our creative and emotional bearings and broadcast them. "Here is what I see, feel, think," they say. "This is where I'd like to go."

In this way morning pages give us both self-knowledge and motivation. We see the obstacles in our path, but we also see beyond them.

Our friend Sharon Fritz, an experienced river guide, says that in white-water rafting, a beginner will often focus on the rocks, attempting to get around them but not knowing how, often ending up swimming, wet, and scared. An experienced rafter, by contrast, will ignore the rocks, looking instead for the flow line of the water moving far ahead. By following that flow, focusing on it, as the water moves in an endless stream around the rocks, the experienced rafter successfully navigates the dangers.

Facts which at first seem improbable will, even on scant explanation, drop the cloak which has hidden them and stand forth in naked and simple beauty.

—GALILEO

Our lives are like islands in the sea, or like trees in the forest, which commingle their roots in the darkness underground.

—WILLIAM JAMES

Morning pages teach you to see your own forward-moving flow. You become alert to the rocks in your personal river, but remember to avoid them by focusing on where you want to go. And the farther upstream in your day you do your pages, the better you will flow downstream.

THE SACRED CIRCLE

KEEP YOUR PAGES private. This is *your* writing. Furthermore, we advocate that you practice writing without rereading your pages for at least a month, perhaps more. Yesterday's pages dealt with yesterday. Let it go. Let today's pages deal with today. Then let it go.

For a while Mark practiced what he called Zen pages. He wrote his pages, then tore them up and threw them away, so he couldn't reread them. Looking back on that period now, he laughs. "I realized the pages were bringing up issues I didn't want to look at. For example, I was dating a woman who wasn't very interested in me, and I didn't want to face that fact. No wonder I didn't want to read about it."

So. Write your pages. Save your pages. Know that later you may reread them, but only you—and only later.

THE WONDERER

VERY QUICKLY MORNING pages will acquaint you with another inner voice we call the Wonderer. You will recognize the Wonderer because he, yes, "wonders." He has daring and uses imagination in positive, quirky, and intriguing ways:

"I wonder what's down that road."

"I wonder if I could go to Tahiti on vacation."

"I wonder if there isn't a better way to position that product."

The Wonderer does not accept stock wisdom. The Wonderer does not consider the odds. The Wonderer considers the possibilities.

"I wonder what would happen if," the Wonderer says.

In future weeks you will get to know and trust your Wonderer as an important guide to creative breakthrough.

Always frame conflict as a clash of ideas, not persons.

—ROBERT KEGAN

Fundamentally, we work to create, and only incidentally do we work to eat.

—WILLIS HARMAN AND JOHN HORMANN

THE BOTTOM LINE

IT IS BETTER to do morning pages sometimes than not at all. It is better to write some pages on the commuter train or at lunch than to go without writing; better to catch four out of seven days than to let weeks go by because you cannot do them perfectly. Even scattered and ragged, rushed, late, or incomplete, morning pages will help you. Three pages of morning pages daily will help you most of all.

CHECK-IN: WEEK ONE

1. How are you doing with your morning pages? Is this tool comfortable for you? Challenging? Informative? Describe your reaction to writing pages.
2. List three shifts or insights that you have experienced this week. Do you feel steadier? More hopeful? Even more stuck? Has work with your Secret Selves or your Inner Mentor given you a broader perspective? Describe your sense of progress to date: Which tools have felt effective to you? Have morning pages clarified your priorities or better ordered your day?

■ *Tool: Creativity Contract*

I, _____, understand that I am undertaking an intensive guided encounter with my own creativity. I commit myself to the twelve-week duration of the course. I commit to weekly reading, daily morning pages, a weekly time-out, and the fulfillment of each week's tasks.

I further understand that this course will raise issues and emotions for me to deal with. I commit myself to excellent self-care—adequate sleep, diet, exercise, and comfort—for the duration of the course.

(signature)

(date)

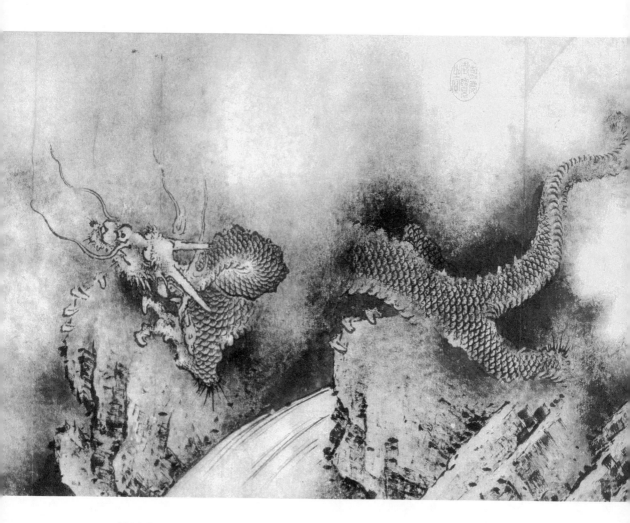

THE FIRST TRANSFORMATION: PART TWO
THE ROAR OF AWAKENING

THERE ONCE WAS a dragon that was lost at birth by its parents and raised among farm animals. It grew up to eat grass and walk the fields like other tame beasts.

One day an older dragon flew over the fields, breathing fire and scattering all the animals in the barnyard. The young dragon on the ground was fascinated and frozen in its tracks. The older dragon, spying its young cousin, swooped down, grabbed the younger one in its huge jaws, and flew far up into the sky.

When they were so far up the houses looked like toys, the older dragon dropped the younger one from his mouth, causing him to fall screaming toward the ground. Then, just before the younger dragon would have been killed, the older dragon swooped down, caught him in his mouth, and returned him to the sky, where he promptly dropped him again.

This horrible fall happened several times before the young dragon, frightened and angry, finally spread his own wings and with a roar of fire, sailed high into the sky— becoming—for the first time in his life—his real self.

This young dragon's first realization of his true nature was what similar stories from the east call "the roar of awakening."

THE

ROAR

OF

AWAKENING

SOLITUDE: TAKING TIME-OUTS

AS THE DRAGON rises from the mist of not knowing into the clearer sky of self-knowledge, its vantage point broadens. This week's challenges expand our ability to receive information, inspiration, and guidance both from external sources and from the various voices within us.

Let's go back to the image of that Radio Kit. With the morning pages you are broadcasting. Now you must learn to receive, to re-plenish, to restore, to relax. That's a lot of r's, and the second non-negotiable tool does involve what seems like r and r. Historically we have called this tool an artist's date. You may wish to consider it your recharging time and call it a time-out.

It has long been a source of fascination in our teaching lives that students will readily undertake the "work" of the morning pages, but they will stall and avoid undertaking the "play" of a time-out. Somehow "work" appeals to our cultural ethic, while "play" feels as if we're shirking on the job. Yet we all talk about "the play of ideas" without realizing that this is a statement of how ideas are born. So, yes, we ask you once a week to go play—by yourself.

This is a time-out. All bets are off. For one to two hours, at some point in your busy week, you take the time and the energy to do something festive and fun. *By yourself.* You go to a museum on your lunch hour. You stop by the Rand McNally map store on your way back home. Solo, you catch a movie, see a play, explore an engineering exhibition. What you do is up to you.

Time-outs are intended to fill the well. Creative work draws on an inner reservoir that we must consciously restore and replenish. Think of yourself as an ecosystem, perhaps a trout run. If you over-fish your stream, you need to restock it. If you put images and energy out, you need to put images and energy back in. This is not goofing off; it is tuning in to your own creative needs.

Watch the great professional coaches from Tony La Russa in baseball to Rick Pitino in basketball. Watch how the players are

shuffled in and out, given time to rest. Look at the rhythm of their seasons, how they allow for months of downtime. We see Michael Jordan on the golf course. We spot Dennis Rodman in a movie. Above all, we catch the drift: Work hard, play hard. Most of us have forgotten the play part.

"How am I going to find time to play? And by myself!" you might be asking.

Again, this is an example of exactly how out of balance our society—and perhaps your life—may be. We can always find time for one more hour of work. But play? "I run an entire company," we've had executives say with a snort.

"Then make an executive decision to give yourself an hour or two a week for a planned break." No, the gym does not count— unless you haven't been in one in a year. The truth is, all of us can make an executive decision to take an hour a week, but we must make the decision. So why should we?

Creativity experts from Alex Osborn to Rollo May extol time for incubation—the on/off pulse of creativity: Think hard, really concentrate on the work at hand, then *relax*. Let the ideas cook for a while outside your consciousness.

As Osborn wrote in 1942, "Relax. Forget it. Listen to music, go to the theater or go to church." Regardless of where you take your time-out each week, when you do, insights and solutions will often present themselves.

"Why is it," an apocryphal Einstein story has him saying, "that I get my best ideas stepping into the shower?"

Steven Spielberg claims that his best ideas come to him while he's driving. Kierkegaard swore by a long daily walk. No matter what form your time-out takes, take it you must.

Let's go back to the Radio Kit. Imagine you are stranded mid-ocean, sending out a call for help. That's what you're doing when you write your morning pages. On your time-out you're switching the dial to "receive." That's when you hear the ideas coming to your rescue.

Without time-out, you're stranded, stuck in the problem and cut off from the powers of the unconscious to relay the solution.

Nature builds downtime into every process, from the cheetah resting after a kill to the downhill chemical reactions of photosynthesis. It must know something about rhythm by now.

When you cease to dream, you cease to live.

—MALCOLM FORBES

Sometimes you win, sometimes you lose, sometimes you get rained out.

—SATCHEL PAIGE

Did we mention that time-outs are supposed to be fun? That's why a lot of us avoid them. Dennis was a busy and important man; just ask his press agent. He ran a tight ship and put in long hours, longer than most of his crew. When we first broached the idea of a time-out it struck him as frivolous and counterproductive. He was too busy working to let himself play—and he'd better not catch any of his team slacking off either.

Dennis reluctantly agreed to do his morning pages. He noticed a shift in himself because of them and, after a month's trial, declared them "useful—in fact, great."

"So try the other tool," we urged him. "The tools work fifty percent better together."

Dennis stalled. The pages were changing things fast enough; why, he'd started doodling again, a passion he'd had as a younger man. He loved cartoons and "cartooning."

"So visit an animation studio," we urged.

Dennis, feeling guilty and foolish at his frivolity, had his assistant make an appointment for him to visit an animator's studio. He learned about vector and raster graphics, and soon he bought a real-time video gadget for his computer and started making his own storyboards.

"Well," he reported sheepishly, "I did it. I am learning to input video and use it in my homemade ad campaigns. And now I've developed this obsession for architectural drawings. I've told my staff I was sick of brown-nose memos from our ad agency. I want to be in on the process step by step. For fun, not to be critical. In working more closely with them, I have a lot more energy for what we are doing. I find myself fired up again."

It is one of the paradoxes of creative emergence that by taking ourselves more lightly, we take ourselves and our work more seriously. The time when we recharge is often a time when what is preconscious will surface. Many things we have often felt or thought but have not allowed ourselves to know will come to us as sudden clarity, insights or breakthroughs. It is as though we suddenly take our nose off the grindstone and see what has been on the periphery. As our view becomes more panoramic, we see things from a wider, higher perspective. Time-outs literally put you in touch with more of yourself. All of that newly liberated preconscious information becomes a new and available energy source for your work.

Creativity requires the harnessing of feelings as well as thinking.

—GEORGE VAILLANT

I don't want to take myself seriously, but I want others to.

—NINA TSAO

Many of our students report an actual physical shift in their sense of well-being as the result of time-outs. Optimism blossoms, and with it a wealth of new notions and ideas. As Abraham Maslow phrased it, "The generation of really new ideas lies in the depths of human nature." Time-outs put us in touch with these depths and with the ideas that dwell there. Again, it is a paradox: By adding levity, we attain gravity.

"Why do the damn time-outs have to be done alone?" we are sometimes asked. "I have a hard time explaining that to my significant other, if you know what I mean. And I don't see enough of the kids as it is."

Time-outs are not "done alone." They are done by yourself, with several levels of your own consciousness. This is not mere semantic quibbling. As businesspeople we often lack the solitude that is a prerequisite to the inner autonomy necessary to think creatively. The free flow of ideas is blocked by ringing phones, meetings, people walking by or stopping in. Even lunch is often business.

Time-outs spent following your own interests train you to keep a through line on your own train of thought. By encountering ourselves more deeply and authentically, we also encounter others more fully. In other words, creative solitude leads to creative community.

"So these time-outs are about getting happy, right?"

Yes and no. Time-outs are about getting real.

In our busy lives, driven by deadlines, rushed and alienated from our friends and family, we often become unconsciously sad as we sink slowly out of contact with our own lives. The weight of our unfelt feelings—sad, happy, frustrated—can weigh us down and "gray" us out.

The elected solitude of time-outs places us squarely back in ourselves. As repressed sorrow emerges, we integrate it, feeling it and shifting it through reflection. Often, when we stop long enough to notice it, we feel it rapidly transform into gratitude and contentment and happiness for all we do have.

We do not, however, place a special emphasis on "happiness" as a result of any of our work. Happiness is only one color on our emotional palette; call it sunny yellow. There are many other colors to the authentic self. The tools you are using help *all* those colors to emerge. Life is a vibrant paint box of experiences. We want to be present for them all.

> In solitude we give passionate attention to our lives, to our memories, to the details around us.
>
> —VIRGINIA WOOLF

> Your work is to discover your work and then with all your heart to give yourself to it.
>
> —BUDDHA

"When I began working with time-outs," remarks Anton, a real estate broker who runs a fifty-person office, "I had two marriages behind me and two colors, black and red: depression and determination.

"As I spent more time in creative solitude, I began to add some grays, paler shades of red, even pink, as I became more forgiving of myself and others. I even began to regain my sense of humor. Colleagues in the office remarked that work with me was becoming fun again."

What was Anton doing that created such a shift? He was reconnecting through time-outs to what some have called the "natural child," an open, vulnerable, and curious inner self that you might prefer to think of as an Inner Explorer. This adventurous and youthful part of you is a wellspring of creative ideas.

Note here that we are talking about a childlike, not a childish, aspect of the self. The Inner Explorer retains a sense of wonder, awe, even grace. Listen again to Anton.

"One night I was taking a time-out along Chicago's Michigan Avenue. I was looking into shop windows. The avenue was deserted; the shops were closed. But as I walked, I felt, for the first time in years, that everything was going to be all right. I guess I experienced what many people call a moment of grace, but I know that since that time a solid yellow of joy has joined my paint box, as you guys call it."

Time-outs take some of us to visit museums, churches, and synagogues. Others explore art galleries, antique stores, gem and rock stores, computer stores, planetariums, aquariums, clock stores, and fabric shops. Where you go matters less than that you go. Flea markets, piano stores, nature, graveyards, great old film revivals, cultural centers—any of these might interest your Inner Explorer and broaden your inner horizon line.

There is a final point to be made about time-outs: they train you to take risks in the direction of your authentic interests. Each week, as you plan and commit and execute a time-out, you are actively discovering or reawakening your ability to take risks, to function in solitude, to set goals and meet them while keeping an attitude of optimism.

Personal solitude or optimism may not seem connected logically to your work life, and so you may balk at this assignment. Yet

No one is laughable who laughs at himself.

—SENECA

Time is nature's way of preventing everything from happening at once.

—GRAFFITI

if you try it for yourself, you will clearly see how time-outs benefit your work life as you allow your creative inspiration to enter, as the poet and potter M. C. Richards phrases it, "through the window of irrelevance." In other words, you invite and accept the element of surprise.

As surprise enters your life, spontaneity increases. As spontaneity increases, so does the sense of play. Because creativity is really more accurately thought of as intellectual play than work, learning to play is pivotal. Time-outs teach us to play, and playing helps prevent burnout.

> Be happy. It's one way of being wise.
>
> —COLETTE

■ *Tool: Time-out*

SO BEGIN. ONCE a week for at least one hour, take yourself—the part of yourself you think of as your Inner Explorer—on some small festive adventure. Surely there's some place or activity you've always wondered about. Your time-out is your chance to go there or to try your hand at something new, to explore your wonder. As Linus Pauling remarked, "There are few things in life more enjoyable than satisfying one's curiosity."

Think mystery, not mastery. Time-outs are about awakening our sense of wonder. They are *not* about self-improvement.

BUILDING THE INNER FORTRESS

"BEGIN EASY, END easy," advises the sage. And so we will begin easy. That is to say, we will begin now to uncover the bedrock influences of our childhood and culture that make it difficult for many of us to enter our full creativity.

It is a paradox for many people that in order to feel safe to take risks in our adult world, safety being a prerequisite for creativity, we must return to our childhood world. But isn't joining the business world about leaving the world of childhood behind?

Yes and no.

Many of us spend long business days in which we bemoan the childish behaviors of our peers: the boss as bossy as a schoolyard bully, the colleague as introverted and shy as the classroom geek, the self-aggrandizing partner puffing himself up—like the class show-off—to look bigger than he is.

> I like the silent church before the service begins, better than any preaching.
>
> —RALPH WALDO EMERSON

If we look at it squarely, much of what we deal with in our adult world still smacks of grammar school. Very often our own inner responses also retain the flavor of our childhoods. Incidents at the office that we "shouldn't let get to us" still do.

And why?

You don't get to choose how you're going to die. Or when. You can only decide how you're going to live. Now.

—JOAN BAEZ

Because very often business situations are reenactments of working models of relationships that we learned as children, reopening old wounds left over from the dynamics of our family lives or educational experiences. Without realizing it, we may be repeating unproductive patterns that have been with us since childhood.

All too often, the conference room and the childhood room bear an alarming resemblance to each other. The same roles we learned in our families are acted out in our business lives all the time. The smaller the work group, the more likely its members are to fall into familial patterns or roles, each role having both a positive side and a shadow side, as in the "Hero/Dictator," the "Jester/Clown," the "Mirror/Scapegoat."

In order to go forward and claim authenticity as adults, we must go back and inventory what we are carrying with us from our past. It is therefore a first task of creative emergence to revisit our childhood selves and to explore with our adult detachment the exact nature of the programming we received. This effort will free energy that has long been locked in our habitual, ingrained perceptions.

■ *Tool: The Dialogue*

CREATIVE EMERGENCE REQUIRES honesty. Honesty requires that we not suppress parts of ourselves we consider unacceptable. This tool involves allowing two disparate poles of your personality to have their say.

Set aside fifteen minutes. Take a blank sheet of paper, and draw a vertical line down the middle. Label the left column "My Pessimist." This column belongs to your skeptical self. Label your right column "My Optimist." This column belongs to your hopeful, sunny Pollyanna self. Under your left column, list all the negativity and doubt you feel about your work with this process of creative emergence. Really let it rip. Now, in the right-hand column, list all your hopes and positive expectations:

My Pessimist	My Optimist
This is silly.	Try it, I'll bet it is fun.
This won't work.	It is interesting.

Both your optimist and your pessimist need to be heard. Taking in both poles of your thinking leads to transcendence.

> Freedom is what you do with what's been done to you.
>
> —JEAN-PAUL SARTRE

THE SHADOW OF THE PAST

SOME OF US remember childhood as a sunny halcyon time when we were free, happy, encouraged, and safe. Most of us remember childhoods with more turbulence and ambiguity than that. For many of us, childhood was the time when our dreams were sometimes encouraged, sometimes molded to other people's agendas.

Elizabeth remembers being a fourteen-year-old girl with a love of animals. "I think I want to be an animal doctor," she told her parents at the dinner table one night. Silence fell. Worried glances were exchanged. Finally her mother cleared her throat and spoke.

"Honey," her mother said. "You can be anything you want."

"Your mother's right," her father picked up. "Yep, you are one smart cookie all right."

"But you want to be able to have a man love you and raise a family together," Elizabeth's mother continued.

Elizabeth remembers that this conversation left her enraged, discouraged, and stinging with shame. As teachers, we have heard variations on this conversation thousands of times. It is a double bind that catches many women off guard: be successful, but not "too" successful.

> First and last, what is demanded of genius is love of truth.
>
> —JOHANN WOLFGANG VON GOETHE

Michael wanted to become a teacher. Michael's father, a salesman, was horrified. He didn't have a college education, and he made a good living. Everybody knew teachers didn't make money. "You need to find a way to put bacon on the table. Besides, isn't teaching sort of a feminine thing to do?"

Michael remembers this conversation with a deep sense of shame. He experienced it as a personal attack on his masculinity: "Real men don't teach school." Michael's father ascribed the aesthetics, as many do, to the realm of the feminine.

As Maslow writes on creativity in men: "If he's been brought

up in a tough environment, 'feminine' means practically everything that's creative: imagination, fantasy, color, poetry, music, tenderness."

In contrast, women become professionals but experience deep conflict about being as "large" as they truly are.

Confusing sex role expectations deflect many people from following their authentic interests. Who wants to be creative, passionate, and connected if one's sexual identity is at stake? Not most men — or most women, either. Is it any wonder that many talented young people lose their hopes of authentic living? They learned to place a ceiling on their dreams, aspirations, and ambitions, their power thwarted.

Backing off from careers they wanted, they settle into more conventional roles, often using their creative gifts in ways that parallel or support their original dreams, like assisting people who have their dream jobs. They may derive satisfaction from this use of their skills, but they may hunger for more. Often, feeling the pinch of "responsibility," they may lose energy for anything better and hide themselves in pastimes that make no contribution to their development, like watching television, barhopping, shopping, or other passive "wastetimes." As for their dreams, "It's not to be," they tell themselves.

Instead of bringing their full powers to bear in their chosen careers, they are like engines with their governors set low: They cannot go full throttle. Their internalized lack of self-worth, left over from unexamined childhood enculturation, often causes these "thwarted" selves to have an approach/avoidance behavior toward success.

They think of bright ideas and then dampen their own enthusiasm: They forget to put their thoughts down in a memo, miss the application deadline for grad school, refuse to speak up in meetings, suppress their "too large" personalities to keep from "upsetting" their parents. Only their parents aren't there — or are they?

Often a thwarted self will cling to a sort of middle ground anonymity in the workplace, suffering a lingering shyness, exhibiting a manipulative posture, or maintaining a victim position — a legacy of controlling parental tapes, early heartbreaks or betrayals.

Often very smart and frustrated, thwarted selves come up with good ideas and are expert at second-guessing the programs being

I think self-awareness is probably the most important thing towards being a champion.

—BILLIE JEAN KING

Loyalty to petrified opinion never yet broke a chain or freed a human soul.

—MARK TWAIN

implemented, but they lack the courage or temperament (or train-
ing) to put themselves effectively center stage even when they be-
lieve it is in the best interest of the corporation to do so.

"It won't look right," they tell themselves. Or "It's not smart to
go too overboard."

Parents like Elizabeth's or Michael's usually do not dampen
their children's dreams out of malice but out of our accepted folk
wisdom. In our culture real creativity is believed to belong to an
elite few. A stellar career is considered a risky endeavor, one that
comes with a price, or worse, is the province of people who are not
as moral as the rest of us.

It follows that being seen as too smart or too ambitious is a risk
that many people are afraid to run for fear of being branded a
"geek," an "outsider," or "ruthless."

In our cultural mythology, success is perceived as a devouring
obsession that gobbles families, relationships, and normal life. "Real
pros"—read: those who are more successful than we—are perceived
as selfish, neurotic, arrogant, driven, even undesirable characters.
They don't enjoy normal family lives. Fulfilling your ambitions and
meeting your family obligations are often not regarded as compatible
pursuits.

I can either have a family or be truly successful, women are
taught to believe. I can either have time with my family or fulfill
my economic promise to them, men are taught to believe. Under-
lying this either/or thinking is our deep cultural belief that "success"
has to be born into, sacrificed for, or stolen.

"I may be broke and depressed, but at least I'm sane," the
thwarted self declares, plugging along in his lackluster job, one he
hates.

This course is not about making either/or decisions ("I'll quit
my job, divorce my wife and kids, and go to med school"). This
course is not about abandoning our family by working eighty hours
a week for a few extra perks. This course is about integrating our
creative energies into our daily living—at the office and at home—
to further our careers and our lives.

The first step is to realize that our society defines creativity and
success too narrowly. While we may acknowledge "genius" in busi-
ness greats, we seldom acknowledge the creative accomplishments
we achieve in our own business lives. We fall victim to the my-

A man who is always ready to
believe what is told him will
never do well, especially a busi-
nessman.

—PETRONIUS

To put something in the world
that was not there before, you
have to be able to see that
which others before you have
overlooked. Both creativity and
play involve appreciating para-
dox and the unexpected.

—GEORGE VAILLANT

thology that successful creativity is some mysterious faculty which a lucky few can freely access, thereby winning colorful, lucrative "careers," while the rest of us "less creative" types must settle for mere "jobs."

A job is something that is done for someone else for the sake of a paycheck. A career or calling is something that emerges from our own drive to express ourselves, serve the world in a useful and enjoyable fashion, and be paid in the process. Very often the difference between a job and a career is one of perception, not changing position.

As you re-examine your familial and cultural mythology about using your creative gifts, you may find yourself feeling more internally free, though your external reality may remain much the same.

A career is a job that has gone on too long.

—CARTOON CAPTION
BY JEFF MCNELLY

■ *Tool: Archaeology, Round One*

FILL IN THE blanks below as quickly as possible.

1. My father thought I was _____.
2. My mother thought I was _____.
3. In my early education I learned _____.
4. In my early jobs I was considered _____.
5. In my later education I _____.
6. Three of my creative monsters were:
 a.
 b.
 c.
7. Three of my creative champions were:
 a.
 b.
 c.
8. The lives I most yearned for as a youngster were _____
 _____.
9. The lives I gave up on by the age of twenty-one were
 _____.
10. If I'd had a "perfect" childhood, I'd have grown up to
 _____.

WORD WOUNDS

WHEN WE TEACH, we often joke, "There is a reason they are called nuclear families." For many children the home is the place where they first suffered creative meltdown rather than found creative support.

"You're such a daydreamer," Ted was told. The word was made to feel like an insult.

Ted's father and mother feared that Ted's daydreaming would be his undoing.

"Keep staring out the window like that and you will never make a living," they told him.

Ted did not tell them that when he was staring out the window, he was thinking of math problems that he loved.

"Get a job," was what they said when he talked about his love of mathematics. "Earn a living and settle down."

A dutiful son, Ted did as his parents asked. He was preparing for a corporate job after graduation from a good college when, without telling anyone, he began his creative emergence. He started a small company designing software for computers. His father called him a moron. But Ted remained undaunted. By being able to play at work, Ted, "the daydreamer," made his dream job his day job. His math daydreams became business challenges to be mastered and a lucrative career as well.

Often the very words used as insults and slurs within the family or classroom point the way to creative talents that are the unused batteries needed to fuel a more successful corporate life.

"Sophy always has to be the leader," ran the joke in Sophy's family.

"Sophy refuses to be a follower" was how her grammar school teacher criticized her on the "social skills" side of her report card.

Boiled down to its essence, the message Sophy received was: "Pipe down. Clam up. Your personality is too big. Your bright ideas make everybody else feel dull."

Sophy, a wellspring of fun ideas as a child, felt embarrassed by this criticism. Becoming self-conscious in her teenage years, she began to hold her tongue. By the time we encountered her in her thirties, reticence had become an unconscious and unpleasant habit. Sophy stifled herself both on the job and off. In her creative emergence, Sophy began to "pipe up," not down — to everyone's benefit.

You don't succeed for very long by kicking people around. You've got to know how to talk to them, plain and simple.

—LEE IACOCCA

Sophy's teacher and mother were "creative monsters." Don't get us wrong; we don't mean to say that in a blaming way. We do not believe in victimhood. Though Sophy's parents meant well, their critical style of parenting had shamed Sophy into suppressing her natural leadership abilities.

Most people can easily remember and cite the creative monsters they have encountered. With a little digging, they can often cite creative champions as well. (Often the same people can appear on both lists.) Typically, creative monsters turn us aside from a gift we are enjoying.

Don had loved to draw until a grammar school art teacher "corrected" his fanciful drawings. "Real houses don't look like that," she said. "I can't draw," he told himself, discouraging his dream of attending architecture school.

As a child Arthur mediated his parents' fighting. As an adult he was always the one who fixed problems for everyone else, seldom remembering to take care of himself. Not surprisingly, in his work life, Arthur has difficulty asking for anything on his own behalf, from time off to raises.

In the following exercise you are asked to look back at your family and your childhood education. What attitudes did you encounter regarding your temperament? Your personality? Your creativity? Were you discouraged or encouraged in general? What patterns of behavior are the same now as they were then?

> He who shall teach the child to doubt / The rotting grave shall ne'er get out.
>
> —WILLIAM BLAKE

■ *Tool: Archaeology, Round Two*

1. What I would have needed as a child was _____.
2. The thing that makes me most sad about my life is _____.
3. The things I wish were different about my childhood are

 _____.
4. If only I had _____
 and _____
 and _____.
5. If only they had _____
6. I feel _____ about _____.
7. My strengths as a child were _____.
8. My family's strengths are _____.

9. The one thing I am most grateful for about my childhood
 is _____.

10. Does this work make you sad or happy? Why? _____.

EXTREMES

OUR CULTURE TENDS toward extremes when describing creativity.
Most of us, much to our detriment, have soaked up stereotypes of
creative people:

Negative	Positive
Crazy	Brilliant
Broke	Genius
Drunk	Special
Irresponsible	Visionary
Selfish	Inspired
Tormented	Disciplined
Flaky	Unique
Unhappy	Guided
Loners	Leaders

Extreme language, either positive or negative, can steer us away
from our creativity. If you believe that a creative person is "crazy,
broke, drunk, irresponsible, selfish, tormented, flaky, and an un-
happy loner," you may not want to rush right out and be creative.
If, on the other hand, you place creatives on a pedestal and believe
them to be "brilliant, genius, inspired, disciplined, unique, guided
leaders," you may, by virtue of your own definition, exclude yourself
from the category.

Neither extreme is true. Moving into our strengths is a matter
of moving out of our extreme perceptions. It is a matter of saying:
All of us have unique skills. We form for ourselves a new mythology
of the creative life, one grounded in realism. Our experience tells
us that successful creatives can be:

Realistic	User-friendly
Responsible	Interactive
Solvent	Sane
Cheerful	Optimistic

Man is made by his belief. As he
believes, so he is.

—BHAGAVAD GITA

Toughness . . . is not dependent
on being crude or cruel. You
can be feminine and tough. I
love my femininity—as much as
I rely on my toughness. What
others call tough, I call
persistent.

—ESTÉE LAUDER

Don worked for many years as the head of a small construction business installing wallpaper and fabrics. He was a classic version of a thwarted self. As a boy he dreamed of being a designer or an architect, but the closest he could come to design was installing the work that other designers and architects created. Don's work was high-quality, and he took pride in it, but he still wanted to have a drafting table of his own and to have command of his drawing abilities. He yearned to be the man with the plan, "but I'm just not the creative type."

In Don's mind, successful architects and designers were either brilliant geniuses or flaky, irresponsible creative types, which Don could not afford to be. He had a nice home, two children to feed, and a wife to support. The last thing he needed, he thought, would be to study architecture and "go off the deep end."

Still, his dream of designing would not go away. (The bad news and the good news are that creative dreams seldom do go away.) At his wife's urging, "You need something to make you less miserable!" Don started morning pages and did the exercises you now hold in your hands.

Now, two years later, Don is about to finish a degree in design and has become a fair draftsman. The architects on the job sites, whom he used to resent, are now more like comrades, since he is beginning to understand their work better and feel less inferior to them. We often see this happen as we learn a new skill: People we used to resent suddenly become more than one-dimensional. It is also true that we often give them undue power when they have a skill we covet.

Far from going off the deep end, as Don feared, he is actually finding himself happier and more balanced. Far from leaching energy from his work life, his new enthusiasms have been spilling into it, giving him fresh ideas in his field. And, adds Don's wife, "He's a whole lot easier to live with."

No one can make you feel inferior without your consent.

—ELEANOR ROOSEVELT

One gets large impressions in boyhood, sometimes, which he has to fight against all his life.

—MARK TWAIN

▣ Tool: The Us and Them List

FILL IN THESE blanks as rapidly as you can.

1. Creatives are _____.
2. Creatives are _____.

3. Creatives are _____.
4. Creatives are _____.
5. Creatives are _____.
6. Success is _____.
7. Success is _____.
8. Success is _____.
9. Success is _____.
10. Success is _____.

> The battle of Waterloo was won on the playing fields of Eton.
>
> —ARTHUR WELLESLEY,
> DUKE OF WELLINGTON

Your answers should reveal some of your personal mythology about creativity. Be alert for extreme thinking. Notice, too, that if you start off with negatives, after a few words your list may shift to positive. If you start off positive, a few words down you may find your hidden negatives. The point of this exercise is to help flush your unconscious thinking and attitudes into the open.

IMAGINARY LIVES

MANY OF US shoulder heavy responsibilities, but we seldom realize that in order to enjoy the "play of ideas" that leads to creative solutions at work, we must be willing to play the childhood game of make-believe. Very important positive payoff of revisiting our childhood is that we can reawaken and bring skills long forgotten into our adult world.

Much of corporate brainstorming is really just an adult version of make-believe. Instead of saying, "Let's pretend," or "Let's make believe," in the adult version of the game, we say, "What if?" As in:

"What if we downsized that division?"

"What if we launched an interactive website?"

"What if we made a sports bar size of that soap?"

Now we ask you to go back to your childhood version of make-believe. We want you to name five Imaginary Lives, lives it would be fun or exciting to have.

Let's look at Mark's list from the first time he did the exercise. His list included "teacher, preacher, doctor, actor, ambassador, and writer." When Mark made that list, he was pursuing a master's degree in advertising. While he enjoyed the brainy aspect of advertising, he had closed off all hope of any of his other dream lives.

It is now ten years since Mark made that list. The list, initially

scrawled on a napkin, then tacked to his bulletin board, began to focus him on his personal dreams. Guided by the input of his list, Mark altered his degree to adult education with a specialty in human development and psychology. He wrote two movie scripts, took acting and improv classes, and acted in a national commercial. He taught the Artist's Way in schools, companies, churches, and hospitals. He wrote three nonfiction books and traveled to the former Soviet Union as a member of the free-enterprise transition team. In short, his real life took on many of the flavors of his Imaginary Lives.

We find this phenomenon often happens with our students. We think of the Imaginary Lives exercise as a sort of time capsule. While people may not become what they have listed, what they have listed becomes a more active part of them. People have often disowned their dreams but easily reclaim the imaginary selves they have listed once they allow themselves to bring them into conscious awareness.

Karen's list of Imaginary Lives began with "cowgirl" and "adventurer." At the time, she was living in Manhattan in a "no pets" apartment working at a desk job in the fashion industry. Ten years later, Karen has moved out west. She owns her own horse, and her desk job is for a major sportswear company, a product line she feels passionate about.

> Surviving means being born over and over.
>
> —ERICA JONG

■ *Tool: Imaginary Lives*

NOW IT'S YOUR turn. If you had five other lives, what would you really enjoy being? Astronaut? Okay. Or maybe torch singer, scuba diver, brain surgeon, psychic, president, songwriter, architect, pilot, portrait artist. . . . (Do not try to be sensible here!) The point of these lives is for you to have a good time in them, a better time than you might be having in your life as it's currently constituted.

IMAGINARY LIVES
1.
2.
3.
4.
5.

PRACTICING THE PRESENT

AS WE HAVE noted, creativity requires safety, a secure inner fortress. In order to have one, you must disarm the snipers, traitors, and enemies that may have infiltrated your psyche.

If you have been writing morning pages, you are acquainted with the character you may think of as your inner Censor, Critic, or Sniper. He or she is the one who always voices your second thoughts (and your third and fourth).

"I feel better about stuff on my creative team," you write.

"It probably won't last," your Sniper pipes up.

How do you get rid of this Sniper? For that matter, do you want to get rid of him, or could he be valuable to you if only you could make him less trigger-happy?

We think the Sniper, or inner Critic, is both valuable and overrated. We are used to accepting his nay-saying as "sensible" and as the "voice of reason." Sometimes it is, but very often it is simply doubt and low self-worth that throw you off stride and keep you from making changes.

The negative inner voice is a learned voice. It may sometimes say things that by now you have probably traced back to a creative monster: to a critical parent, teacher, or boss; to a nasty lover; to a jealous sibling or friend.

The good news is that if the negative voice is a learned voice, a positive inner voice can also be learned. We learn to dispute the negative voices by learning to be still and silent in the moment. The first step is to build a silent inner self that notices the negative voices as they speak.

> One does not become enlightened by imagining figures of light, but by making the darkness conscious.
>
> —CARL JUNG

■ Tool: Affirmations and Blurts

THERE IS A process for disarming our Sniper. We call it affirmations and blurts. An affirmation is a positive statement, the kind your inner Critic objects to. When it does, it says something nasty—that nasty something is a blurt.

"I, Mike, am a brilliant and prolific businessman," the affirmation might run. "Bullshit," goes the blurt.

Now, create your own affirmation, using your own name and

> Words hang like wash on the line, blowing in the winds of the mind.
>
> —RAMESHWAR DAS

creative goal. Write it down ten times in a row. Listen for the negative blurts that pop up each time. Write those blurts down too.

1. I, Mike, am a brilliant and prolific inventor. ("Yeah, what about that product for BK?")
2. I, Mike, am a brilliant and prolific businessman. ("Then why aren't you rich?")

You get the idea. Note your blurts carefully. They hold the keys to your inner freedom in their nasty little claws. Try it now with work-related affirmations.

1. I, Mary, am a good group leader. ("Nobody likes you.")
2. I, Mary, am a good group leader. ("Your ideas are stale.")
3. I, Mary, am a good group leader. ("You're too timid.")

Notice that the blurts can be turned around in a positive fashion that grants some absolution:

1. I, Mary, am a good group leader. My team likes me.
2. I, Mary, am a good group leader. My ideas are fresh and interesting.
3. I, Mary, am a good group leader. I am decisive and clear.

These transformed blurts become customized affirmations. They are positive and personal, and they directly address the lines of attack used by your inner Enemies. Most of what stands between us and our creativity is not a negative outer environment but a negative inner environment.

Your inner Enemy aims straight at your personal jugular. And he fights dirty. Your weight, your hair, your clothes, your sexuality, your personality—all are fair game. Affirmations reveal your weak flanks by flushing out blurts. Customized affirmations, used repeatedly, both in writing and aloud, while you're driving or exercising, for example, go a long way toward creating a safe inner fortress.

You may call it personalized positive thinking, or cognitive restructuring, learned optimism, or even declarative prayer. What you call it doesn't matter. You don't even need to believe in this tech-

nique in order to use it. Instead, experiment with open-mindedness. Try working with this tool and watching for positive change.

◼ Tool: *Customized Affirmations*

WORK WITH YOUR customized affirmations right after morning pages, in a spare moment at the office, or on the commuter train or at night before you go to bed. Search out and respond to your private blurts with specific arguments on your behalf. You might use the list of affirmations below, selecting the ones that activate the most negative voices in your head, then customize a secular or spiritual affirmation to dispute that voice. Give them a good argument on your behalf:

1. My creativity profits me and others.
2. My creativity is clear and expansive.
3. I trust and use my creative impulses.
4. My creativity is safe and exciting.
5. As I trust my creativity, it becomes stronger.
6. My creativity flourishes.
7. My creativity brings joy to me and my world.
8. There is a divine plan of goodness for me and my work.
9. As I create and listen, I am led.
10. I am willing to create.
11. I am willing to use my creative talents.
12. Through using a few simple tools, my creativity flourishes.
13. I am allowed to nurture my creativity.
14. My creativity leads me to friendship and service.
15. I am a conduit for the universe to create good things.
16. My creativity is God-given.
17. Using my creativity is a gift back to God.
18. I allow creativity to flow through me.
19. I welcome a flow of creative ideas.
20. I act on my creative impulses with faith and clarity.

Choose five customized affirmations — write each of them five times. What did your negative voices have to say about them? Give those voices a good argument.

ALBATROSS VERSUS LIFE SUPPORT

WHEN WE HAVE lived a life cut off from our creative impulses—perhaps told that we should be sensibly sane, or do or be less than fully who we are—we become cut off from our core strengths and passions that give life continuity, interest, and meaning. Our work becomes precisely that—*work*. It becomes an albatross, dragging us down. In losing touch with our inner life, we also lose touch with our life's work.

The very idea of a life's work can be intimidating to people. We may be reluctant to explore our own creative passions or consider bringing them into the business world, fearing we'll be perceived as a threat and possibly be ostracized or even fired.

In reality our employers may honor and welcome our creative participation. Often we hesitate to offer a creative solution or propose a new idea, afraid that if it fails, we will look foolish.

Many of us believe that to be fully creative, we would have to leave our lives as we know them: quit the job, move to another state, divorce our spouses. We convince ourselves that "this job is blocking my real opportunities," "if only I lived in California," "my wife will never understand or support me if I try to build a company from the ground up." So we harbor resentments about these aspects of our lives, wishing they would just go away so we can do what we really want to do.

This blame game undermines our ability to work creatively. It takes us out of the moment and away from what is directly in front of us. It can be disastrous to our attitude. Instead of facing, with enthusiasm and confidence, the blank page of a new proposal, the research for a new product launch, or the day's meeting agenda, we obsess about what we could really do if only we were "free." This escapist thought process is an example of what happens when we are not willing to deal with the discomfort of the moment.

Notice anything that takes you away from the action you desire. Pay attention to what you do during a stressful time in your day. Do you head to the refrigerator or to the kitchen cabinets, "grazing" for something to eat even though you are not hungry? Do you pick up the phone and call your lover to see if he or she really loves you? Do you order a double martini at lunch? Obsess about the company you would start if you had the backing? The book you would write

You don't have guarantees in this world. You've got to take chances.

—MURIEL SIEBERT

if you had the time? The traveling you would do if you had the money? Creative blocks are anything that we use to lessen our anxieties, our ability to stay in the "empty bowl." These behaviors keep us from effectively using our energies.

Notice when your thoughts wander. What was happening just before they went? Often our thoughts wander when we are faced with an emotion we're avoiding, with an anxiety-producing stimulus, with the state of emptiness, the discomfort of the creative vacuum. Be aware of your thoughts as they hunt for someplace to focus instead of on the task at hand. To be able to create, we must be willing to learn how to quiet our minds, feel our emotions, and stay in the vacuum so the ideas can well up from our deepest place of knowing.

In both our teaching and work experience, we have found that it is far more difficult to succeed at something when you do not enjoy it. Overcoming the job-as-albatross syndrome is essential for clearing the way to learning to love and appreciate the work we do.

If you were to talk to someone you perceive as having the ideal job—say, a surgeon, a lawyer, an actor, a writer, or a chairman of a huge corporation—chances are excellent that that person would tell you that there are many aspects of his work that he does not enjoy but that they are necessary steps to get to the part he does enjoy. If you consider your job unfulfilling and are frustrated by it, but it pays you well enough to support yourself or your family, rather than resent that job, you can learn a renewed gratitude for it.

When people change their attitudes, they change their perceptions, and as their perceptions change, they continue to change their attitudes. This spiral can go either way, toward the positive or the negative, but even just realizing that is what is happening can stop the spiral long enough to send it toward the positive. When this happens, both the quality and quantity of your work will improve.

"Myth #1" of creativity is "I cannot do it in my present situation." This perception keeps many of us permanently powerless and unhappy. Once we come to view our job—whatever that job is— as an albatross, a terrible fate we must endure, a burden we must carry, we have become asleep. It is the BELIEF, the *myth*, that is the albatross, not the job itself. The realization that it is their *mind* that keeps them stuck, not their job, is often a profound realization for people.

> In the middle of difficulty lies opportunity.
>
> —ALBERT EINSTEIN

> What sort of God would it be, who only pushed from without?
>
> —JOHANN WOLFGANG VON GOETHE

Knowing there is more to life than our work is essential to doing our job well and to holding a positive attitude about ourselves and our profession. (Our resentments corrode our optimism, and optimism is essential to success.)

Fritz Perls says that "the more deeply grounded we are in our *actual* reality, the more possibility exists for *actual* change." In other words, acceptance of the present must precede action.

John is a well-trained mechanical engineer working in a large construction firm. He liked his job and his colleagues, but as the years went by, he began to feel "stale" as the challenges became more and more routine. He longed for work that would satisfy him more, but family responsibilities tethered him to his management paycheck while his resentment grew. Eventually John's work and his relationship with his family suffered as his resentment began to affect both him and those close to him.

For John, the job had become an albatross. His negative attitude became his private albatross, weighing down his sense of vitality and keeping him from his creative dreams and from his best work.

Over time John became caught in the negative spiral. He resented his job, so he did less than usual; he began to sleep in; his mind wandered at work. His productivity dropped, so on the weekends he was soon carrying work home, where he was restless and discontented. His wife, Jody, noticed he was not sleeping very well and always wanted to be out of the house. He just didn't seem happy anymore. He wasn't.

John came close to losing a job he used to love. When John began doing morning pages and time-outs, his sense of possibility returned, and he found time to tinker with some bicycle parts. He soon discovered that he could build gears as well as anyone and began selling custom-made bicycles in his hometown, working with his wife and kids to make it a family event. The money he made fueled his hobby, and the satisfaction he received from his creative work made John happier both at work and at home. As his excitement rose, so did his productivity. Remember the old saying about how to get something done: "Give it to the busiest person you know." John's attitude became one of "can do" instead of "what's the use?" The fruit of his awakening was a profound realization: *He was the only person who had control over his life and how he was going to feel about it*. He could choose, wisely or otherwise.

To stay with the battle and feel, and not to run from what must be borne.

—LESTON HAVENS

Though I have all faith, so that I could remove mountains, and have not charity, I am nothing.

—I CORINTHIANS 13:2

■ *Tool: Dumping the Albatross*

THE FOLLOWING LISTS and exercises can help you come to a new appreciation of your job:

1. List ten reasons why your job is important to you.
2. Imagine for one day that you are a Zen monk, and make every move part of your practice. In other words, pay attention to every detail of your day. What did you learn?
3. List ten things you like about the people who work with you. Who are your favorites? Why? Who are your least favorites? Why? How would your work experience be different if you liked each other? What would you change? What would they?
4. List positive things about your current position that you can use in future positions—for example, contacts, ability to run computer software programs, experience in communication. How can you improve those things that are most important?
5. Consider creating a new position in your company. See a need in your organization, department, division, and create a position to address it. What would this new job entail? What would you like about it?

> In order to burn out, a person needs to have been on fire at one time.
>
> —AYALA PINES

BEYOND THE ALBATROSS

AS OUR CONSCIOUSNESS evolves from the position of victim, where we are being reactive, to the powerful position of taking charge of our destiny, we begin to gain a larger sense of who we are and what we can accomplish.

Armed with the energy of our awakening and inspired by renewed activities and interests, we can begin to experience our jobs as places of liveliness and productivity. This certainly happened for John. As bosses, friends, and family felt his shift toward optimism, they began to reward him accordingly. This in turn inspired him to be even more effective. Optimism becomes a self-propelling upward spiral. This is not Pollyanna thinking; John's acts of self-nurturance worked counterintuitively to help make him more productive and present with colleagues and family. Once John changed his "alba-

> Sloth, like rust, consumes faster than labor wears, while the used key is always bright.
>
> —BENJAMIN FRANKLIN

tross" job to a life-support job, he found himself owning a better life to support.

Like John, Elizabeth and Michael, whom we met earlier in this chapter, had become trapped in the albatross problem. Elizabeth was unhappily working in a low-level position at a medical supply house. Michael, discouraged from becoming a teacher, was selling industrial supplies for his father's company. Both were caught in living adult lives overshadowed by childhood conditioning.

Working with the tools of creative reclamation, Elizabeth and Michael began to give themselves permission to reclaim their creative powers. Elizabeth recalled her childhood discouragement about her interest in animals. Michael recalled his discouragement about teaching. Both of them saw that in their current lives they were retriggering feelings of embarrassment whenever they thought of putting themselves forward. With the initial work of morning pages and time-outs, and using the exercises of the awakening, they both began to reframe their "lost" lives as something they could "find."

"Just because my parents felt I could never be married *and* be a career woman doesn't mean I have to buy into it anymore," Elizabeth told herself as she prepared to finish the college degree she had dropped in the third year.

"Just because I was afraid of Dad thinking I wasn't macho enough when I was fifteen doesn't mean that I have to feel that way now that I am grown," Michael said as he enrolled in a public speaking course and began to coach a local intramural team, an outlet for his "teacher."

Once Elizabeth and Michael had successfully located and deactivated their childhood creative monsters, they began to feel safer to experiment in their adult lives.

Elizabeth, hearing of a shorthanded animal hospital, began to volunteer there. She was horrified when she learned that twenty million unwanted animals are put to sleep each year, and helping stop that reality has become a passionate cause for her. Her college work proceeds as she gets the time.

Michael, more confident in his ability as an assistant coach after two seasons, has enrolled in exercise physiology and sports nutrition classes at a local community college so he can further help his team. Michael has a life that is much more his own now, and

Go to your bosom: / Knock there, and ask your heart what it doth know.

—WILLIAM SHAKESPEARE,
MEASURE FOR MEASURE

Do all the good you can / By all the means you can / In all the ways you can / In all the places you can / At all the times you can / To all the people you can / As long as ever you can.

—JOHN WESLEY

his coaching communication skills aid his job in sales. He has stopped thinking of himself as being stuck in a dead-end loser job and is now an inspired salesman with an interesting life.

■ *Tool: Walking Your Wisdom*

GET OFF THE subway one stop early. Head out the door at lunch. It doesn't matter when or how you manage it. Take a twenty-minute walk; allow yourself to receive the information your body has stored to share with you. Do you feel anxious? Optimistic? Frustrated? Does an alternative solution to a vexing problem suggest itself?

Very often the exercise of writing morning pages moves our students to physical exercise. A twenty-minute walk serves as a moving meditation. Ideas are both initiated and integrated. A daily walk opens the doorway to alpha ideas, ideas that seem to come from a higher and more innovative source than our normal flow of thought.

So walk. Walk at least once a week for twenty minutes. Walk twenty minutes daily if possible. Like morning pages, walking is a reflective technology. Use it.

> All men should strive to learn before they die what they are running from, and to, and why.
>
> —JAMES THURBER

CHECK-IN: WEEK TWO

1. How are you doing with your morning pages? Do you feel the fog lifting? Are you gaining a sense of clarity? What are your feelings about pages this week?
2. What did you do for your time-out? What shifts, if any, did you notice?
3. Are you walking?

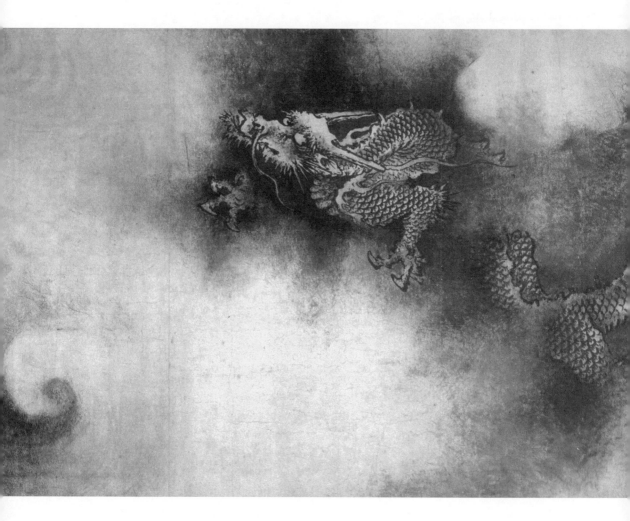

THE SECOND TRANSFORMATION
SOARING

THE DRAGON, NOW awakened, soars on the high winds of emotion: exhilaration, sadness, anger, frivolity. These winds are the dragon's energy freed from tight control as it learns to relinquish the need for predictability and certainty.

During this phase of your creative emergence, you may feel lighthearted, light-headed, even lighter than usual on your feet. This feeling—of soaring above the clouds—is the wonder and power of the second dragon.

Sometimes at this point people who have felt blocked for a long time are tempted to make impulsive decisions. Relax and take a deep breath. No need to change everything at once. Be prudent instead. Your flight has just begun. For now, your job is to let fancy take flight, to understand as deeply as possible that you will find wings to hold you up, to ride and navigate emotional currents, to feel the thrill of your own power returning.

SOARING

SETTING BOUNDARIES: SECURING THE INNER FORTRESS

WE OFTEN TALK about creative emergence as being similar to watching a photo develop. The image at the start is a blurred something that lacks edges and definition. As it develops, as the chemicals of the photographic bath do their work, the image comes into clarity.

The tools of this week are the tools of focus. They require a commitment to reality, and they signal an end to denial.

You will survey your current surroundings, focusing on your perceptions regarding your environment and your colleagues, with an eye to your own best interests.

This is both good news and bad news. Often, as we "come to" and look around us, we realize that we are surrounded by people who expect us to function as their creative batteries. As our own identities become clear to us, we begin to know and speak our minds. As we do, these people may find us suddenly selfish. And we are — in the very best sense. This can be threatening to others and to ourselves. Remember that treating yourself like a precious object will make you strong.

You will need your determination this week because you may be faced with the temptation to knuckle under and go back to being the person who served others' agendas. "Better safe than sorry," you might catch yourself thinking. You have undertaken this creative reclamation on the hunch that your life can be more fulfilled. It can.

In order to practice self-expression, you must first have a self to express. Your cynicism may be giving way to curiosity as you find yourself and your inner world more and more apparent. You are in the process of creating a better-realized definition of *you*.

In the Chen Rong paintings the dragon at first blends with the roiling clouds. Before we can reclaim our powers, we, too, have to see in what ways our environments are draining and confusing us. During this week you may feel yourself emerging from a fog of

denial. As you do, you may see for the first time the shape of your own creative wings.

■ Tool: Secrets

LIST THREE SECRETS that you wish to protect from the scrutiny of others. Your secrets may be feelings, plans, suspicions, fears, insights, hopes, or behaviors. Now list three more.

> The man with a new idea is a crank, until the idea succeeds.
>
> —MARK TWAIN

FIGURE GROUND REVERSAL

THERE ARE FAMOUS creativity exercises with which many of you are familiar. They feature either a face/vase reversal of a dark central image on a white background or a picture that can be interpreted as one kind of face or another, depending on how you view the image. This week we open our perceptions enough to see both sides of our own reality, simultaneously learning to see the face and the vase of our experience, to be what is known in anthropological circles as a participant observer, or what we call "going sane." At first going sane can feel just like going crazy.

Before you began working with morning pages and time-outs, you had a version of your world that seemed clear and fixed: it is what it is. I may not like it; but that's how it is.

As we reflect on it, write about it, and think about it, that world description often changes. We become clearer and clearer on how it seems to us, but this clarity is often phrased, "I may be nuts, but it seems to me . . ."

You are not "nuts." What you are seeing is what's been there all the time, but with an official voice-over that told you otherwise. Once you start to tune in to yourself and tune out the official version of reality, you begin to think more independently and reach your own conclusions. This freedom makes you invaluable as you begin to come at problems from a personal, independent, nongeneric perspective.

> Men can starve from a lack of self-realization as much as they can from a lack of bread.
>
> —RICHARD WRIGHT

This process is like watching the television picture without the sound. It works like this.

The voice-over: "You will be getting a raise." The real picture? It hasn't happened yet.

The voice-over: "I really appreciate all your help on my proj-

ect." The real picture? None of that help was ever mentioned publicly.

The voice-over: "You'll be training Patty and Bruce to assist you." The real picture? You're being phased out by two cheaper young people.

The voice-over: "The workload should be lightening at the end of the quarter." The real picture? This is the same speech you've heard four quarters in a row. Your actual workload is growing, and your income isn't.

As you begin to see the dissonance between what is said or described and what is actually done, you begin to be able to assess clearly your prospects for advancement. You may become both clearheaded and a little alienated: "If I can see this, why can't everybody else?" (In order to see, you must be looking.)

As you record your insights, hunches, and intuitions, you become more and more attuned to the currents and subcurrents of the workplace. You become like a seismograph: you feel the tremors and are less often caught by surprise.

Feeling the tremors, sensing trends and upheavals earlier than others is something that takes getting used to. Trusting ourselves and our own creative perceptions is new behavior for many of us and we may feel fearful as we become more independent. Early in a creative emergence this fear, which manifests as self-doubt, can tempt us into self-sabotage.

"If this were a good idea, it would have been done already."

"I am sure that someone has already thought of this."

"I can't be right," we say.

Our rule of thumb is this: Assume that you are right and keep watching, keep listening, and keep recording. Your pages will test your perceptions and allow you to trace accurately the development of events. They are like a trail of bread crumbs into the forest. They both mark your train of thought and allow you to retrace it. This new sense of inner selfhood may at first feel disorienting.

Remember: Going sane feels just like going crazy—except that you're not nuts.

Nothing astonishes a man so much as common sense and plain dealing.

—RALPH WALDO
EMERSON

. . . in the small matters trust the mind, in the large ones the heart. . . .

—SIGMUND FREUD

■ *Tool: Watching the Rapids*

SET ASIDE THIRTY minutes at home and finish the following statements. Write quickly.

If it weren't so crazy, I'd say _____.

If it weren't so crazy, I'd say _____.

(Repeat five times.)

Now, set aside fifteen minutes to write as rapidly as possible. Describe the currents you feel moving through your office, rational or not. What are the rocks? What is the through line?

> The next message you need is always right where you are.
>
> —RAM DAS

SUPPORT

"IF I CAN'T see it, touch it, feel, it, taste it, or smell it, I don't believe it exists," David told us defiantly when we suggested that one of the fruits of a creative emergence was the recognition of invisible variables working in our favor.

"A benevolent universe? That's a fairy tale," David scoffed. "What about war, famine, global warming?"

"What about them?" we responded. "Do you really think the universe does those things without a not-so-helping hand from all of us?"

"Well . . ."

One of the most interesting phenomena of creative emergence is the fact that so many of our students report that as they become clear and plan and execute actions in their own behalf, all sorts of "coincidences" seem to arise to help them along in their chosen direction.

> I firmly believe that mankind was once wiser about spiritual things than we are today. What we now only believe, they knew.
>
> —HENRY FORD

As we noted earlier, Mark calls this the yellow Jeep syndrome.

Catherine says it helps her identify new business opportunities, based on "educated intuition."

Julia simply calls it synchronicity.

No matter what you call it, it is time to start being alert for it. Without warning, it can be quite disconcerting.

Aaron was a few weeks into his creative emergence when he determined that what his midwestern company really needed was more senior-level expertise in foreign markets. Two days later, in New York on business, he was having breakfast in the restaurant

at his hotel. The man at the next table shared the financial section of the *New York Times* with him; the little coffee shop had sold out.

"We got to talking, and his field was exactly what I felt we'd been lacking. I liked him. We traded business cards. After I got home, we talked on the phone at some depth several times. I was able to write up a very specific memo and back it up with his expertise as well as my own. My boss ended up contacting him and taking him on as a freelance consultant."

We do not ask you to "believe" in a participatory universe. Instead we ask you to experiment and decide for yourself. There are three steps to experimenting with synchronicity:

1. *ASK*: Become clear in your own mind about precisely the problem, goal, or task for which you would wish to have support.
2. *LOOK*: Be alert for support coming to you from any and all sources regarding your goal.
3. *RECEIVE*: Accept the support that comes to you, and do not turn it aside no matter how unlikely its source appears to your logical mind.

Remember David, who was determined not to believe in any form of nonlogical help? During his time in the process he found himself coming up with the repeated hunch that there was a much cheaper way for his company to print its lengthy biannual reports. Taking it upon himself to do a little legwork, he phoned half a dozen companies to ask for bids on the job—only to find that the bids he received were comparable to or even higher than the price they currently were being charged. Still, his stubborn (and irrational) feeling that there was a cheaper way persisted.

One night after a particularly grueling workday David stopped off at his gym to see if he could sweat out some of his day's wear and tear. In the weight training room, jammed with the postwork crowd, he ran into Greg, a former employee of the company where David worked.

"What are you up to?" David asked.

"I work at this new printing company," Greg replied.

There is no such thing as chance; and that which seems to us blind accident actually stems from the deepest source of all.

—FRIEDRICH VON
SCHILLER

By the time they had finished spotting each other on weights, they had "spotted" an opportunity to work together.

"I won't say the experience made me a believer," David says of synchronicity, "but it definitely rendered me more openminded."

■ *Tool: Wish List*

THIS IS A surprisingly potent tool. We ask that you use it often. Number a piece of paper from one to twenty and complete the phrase "I wish . . ." Open the door to your authentic desires in realms ranging from work to personal fulfillment.

RECLAIMING OUR POTENTIAL FOR LEADERSHIP

> The society which scorns excellence in plumbing because plumbing is a humble activity, and tolerates shoddiness in philosophy because philosophy is an exalted activity, will have neither good plumbing nor good philosophy. Neither its pipes nor its theories will hold water.
>
> —JOHN W. GARDNER

BUSINESS IS FOR many of us a personal paradox, a matter of both leadership and teamwork, of personal responsibility and corporate anonymity.

Leadership is the act of saying: "I think we should go this way. I think we should try this." For many of us the act of asserting ourselves this way is fraught with internal trauma. In some of our early family conditioning, self-assertion was tantamount to self-annihilation, as early acts of healthy autonomy were met with the phrase "Who do you think you are?"

Claire came from a family that placed a high premium on modesty. In Claire's large family no one sibling was expected or allowed to outshine the others.

"Claire, pipe down, Claire. Let somebody else get a word in. Claire . . ."

Is it any wonder that Claire, a natural leader, grew to be conflicted about her own talents and temperament?

"I have these great ideas, but every time I put them out, I feel ashamed," Claire told us. We urged Claire to look at her family rules about self-assertion. She discovered that like many of the people she worked with, she held many self-limiting beliefs about leadership that hampered her in her career.

We have found such beliefs to be both common and damaging to personal and corporate health. Here are some common negative beliefs about leadership:

<u>Leadership is:</u>

Dangerous	(Everyone will hate me.)
Self-serving	(Leaders are out to get theirs.)
Self-centered	(Leaders are full of them-selves.)
Self-important	(Leaders are conceited.)
Selfish	(Leaders just want attention.)
Elitist	(Leaders think they're special.)
Egotistical	(Leaders step on toes.)

No man ever listened himself out of a job.

—CALVIN COOLIDGE

With any of these beliefs in place about leadership, the mere thought of self-assertion can trigger an attack of shame. Shame is a two-edged sword, asking:

1. Who do you think you are?
2. Who do they think you are?

At its authentic core, leadership is about service, but negative conditioning tells us the precise opposite: Leadership is about ego. Certainly the shadow side of leadership is egotistical. The warrior becomes the bully when he is thinking only of self-aggrandizement. The priest becomes the antipriest when he is thinking of being served instead of serving others. But because leadership requires initiative, the assumption that all leaders are ego-driven and therefore somehow untrustworthy causes us as a culture to discourage the young from becoming leaders.

Great leaders almost always exude self-confidence. They are never petty. They are never buck-passers. They pick themselves up after defeat.

—DAVID OGILVY

"I'm not sure I know the right thing to do."

"I don't want to seem too opinionated."

"I don't want to seem bossy."

"I don't want to seem self-serving."

Whenever we are concerned with the question of how an action will "seem," we have moved away from our core. The issue is not how our actions *appear* but what our actions *intend*. True leadership intends the good of all concerned. It is based on principle, not personality. True leadership is not always popular, but it is always productive. True leadership makes decisions based on how something looks in the long range, for the highest good of the most concerned, not on how something may appear in the moment or how controversial it is.

"Whenever I wanted to make a statement in a meeting, this little voice would go off in my head, 'Gary, who do you think you are? What makes you think you're such a hotshot?'" Gary told us.

"I realized it was my big brother the Bully's voice. He was always cutting me down to size, always competing with me at the dinner table, at sports, in school. He was so much a part of me I carried him into the boardroom."

As we've said before, the conference room, the schoolroom, and the family dining room may have all too much in common until we identify and neutralize any negative working models we carry.

■ *Tool: Leadership Quiz*

COMPLETE THE FOLLOWING statements as rapidly as possible. (Speed will help you bypass your Censor.)

1. My father thought leaders were _____.
2. My mother thought leaders were _____.
3. In my family, leadership was considered _____.
4. In grammar school, I learned leadership was _____.
5. In high school, leadership seemed _____.
6. In college, leadership was _____.
7. In extracurricular areas, I considered leadership _____.
8. Leadership in sports was _____.
9. As a rule leaders are _____.
10. The problem with leadership is _____.
11. The reason I don't lead more is _____.
12. The reason I want to lead more is _____.
13. My fear about leadership is _____.
14. My hope about leadership is _____.
15. My plan about being a leader is _____.

> Integrity is honesty carried through the fibres of the being and the whole mind, into thought as well as action so that the person is complete in honesty. That kind of integrity I put above all else as an essential of leadership.
>
> —PEARL S. BUCK

COLOR

BLAME IT ON the assembly-line mentality of many of our corporate work spaces, where we are expected to do one thing over and over. At work many of us mimic the cogs in a machine. We become well-oiled automatons, functioning smoothly in near anonymity until our days have a dronelike quality.

Often it feels as though we were expected to be worker bees in service of the corporate queen. Such narrow-minded focus, while superficially laudable, actually leaves many of us with a sense of inner emptiness and drains our endeavors of spontaneity and passion. Like the old Peggy Lee song, we catch ourselves asking, "Is that all there is?"

There is much more to life than going through the motions, drawing a paycheck, and paying our bills. To find that "more," however, we must be willing to wake up, come to, come out of the anesthetic of mindless work, and remind ourselves that our work life must also "work" for us. We have to bring our fire to it, or both of us may die.

"My life was lackluster. I knew it but lacked the will and resources to change it," Jerry, an accountant for one of the big six, told us. "I crunched numbers by day, in a place that felt like a tomb, and I ate cookies at night to calm my fears of being dead."

As Jerry began his work with morning pages, he found himself "coming to." He noticed his office space: gray and lifeless. He noticed his wardrobe: gray and lifeless. He noticed the car he drove: also gray.

"My life was like an old black-and-white TV. There was lots of static, lots of blur, and no real way to change the channel."

When he started the course, Jerry was diligent, as always, and did the morning pages faithfully. But even after six weeks he was without the joy we usually observe in students.

When questioned, Jerry admitted that he had not been doing time-outs. We encouraged him to do so, explaining that it was very possible that they would lift his spirits. At first he could think of nothing that interested him. Then, seemingly out of the blue, he remembered an interest in oriental rugs. He began exploring rug stores.

"The feel of the stores fascinated me. There was a romance, a timelessness. I felt the spirit of the caravan moving across eternal dunes. I began to ask questions, to study up."

One day, at a secondhand rug store, Jerry found a small, rare, perfect rug. He ran the numbers—something he could do better than anyone—and realized that the rug was priced far below its value. He bought it and took it to the office.

> It is not necessarily those lands which are the most fertile or most favored in climate that seem to me the happiest, but those in which a long struggle of adaptation between man and his environment has brought out the best qualities of both.
>
> —T. S. ELIOT

> If there was a simple formula for success and it was easy to follow, everybody would be doing it.
>
> —EDWARD C. JOHNSON III

"That first rug transformed my office and my life. It gave me something to talk about with clients, and I suddenly understood in a visceral way what my job really was. I was supposed to help clients turn their money into beauty, things they dreamed of. I suddenly had new respect for my job and new respect from my clients. I learned to listen to the beauty in the numbers. Money saved was beautiful in a very tangible way. Subtly I shifted my thinking from accounting to financial planning, something that was far more creative. I help clients manifest their dreams.

"The rug became a symbol for our entire office that made all of us feel more elegant, more important somehow. We weren't just number crunchers."

Not surprisingly, that first rug led to other rugs and to "investment" rugs. "A good rug is as good as blue-chip bonds," Jerry says. "I've made more money and more friends and had more fun trading rugs than I'd have imagined possible."

Perhaps it was their intricate, subtle beauty. Perhaps it was their precision, their deep and glorious colors. Whatever the specific catalyst, rugs fired an engine in Jerry's imagination. His new passion and energy served as a catalyst for the entire department. Once he allowed himself to explore this passion, to study and invest in it, Jerry found himself following his intuitive impulses more frequently in all areas of his life.

Often one of the first signals of a successful creative emergence is the impulse to introduce some touch of personal beauty or color into the workplace. For Jerry it was that first, magical rug. For Barbara it was a beautiful ginger jar; for Arthur, a serene bonsai that brought to his office an air of wisdom and grace.

Sometimes clothing signals an inner change. "I realized that I was dressing like a man—square, boxy, dress-for-success suits," says Deborah. "Yes, I needed to be businesslike and appropriate, but there was no office rule against being feminine and appealing." A 4-H seamstress in her youth, Deborah signed up for a dressmaking class on impulse.

"I realized in my reflections that I missed sewing. I saw the ad and signed up on a whim. What a brilliant move! I made three beautiful wool suits with soft foulard blouses. Far from taking me out of my business head, they added something to it."

Living well is the best revenge.

—GEORGE HERBERT

Ever since there have been men, man has given himself over to too little joy. That alone, my brothers, is our original sin. I should believe only in a God who understood how to dance.

—HENRI MATISSE

For many executives, the reemergence of a hobby is a signal of health. Far from leaching power and creativity from our work lives, hobbies actually feed the creative flow.

Robert began his creative emergence in his mid-forties. A mid-level executive who enjoyed solid success, he nonetheless hungered for more creativity. Two months into his morning pages, he noticed himself writing longingly about cars. As a teenager he had loved tinkering. He had refurbished and restored a dozen cars before giving up his grease-monkey gear as being beneath the dignity of his corporate self.

"I realized I missed puttering. Then I realized I didn't need to act like an executive; I *was* an executive. Then I saw a vintage MG roadster that needed love. I picked it up for almost nothing and set to work. At first I felt guilty. Then I noticed there was something about crawling around with a grease pan that set my wheels turning. I can't tell you how many tricky personnel problems got cleaned up as I cleaned a dirty carburetor."

Creative emergence is not a linear process. The sun setting in the west lights the mountain's flank to the east. Taking time to play brings a sense of play into work. Creativity is tidal. We must both deepen and become more shallow in order to deepen again. Time-outs—deliberate frivolity—bring to our work life renewed passion, vigor, and inspiration. Like Jerry's magic carpets or like our dragon on the wing, they allow us to soar first in imagination and then in reality.

▨ Tool: Explore a Sacred Space

THIS TOOL IS intended to awaken a sense of the numinous. It can be done by believers or nonbelievers. Take yourself for fifteen minutes to an hour into a sacred space as you define it. It may be a cathedral, a library, a museum, a synagogue, a beach lookout. Sit quietly, and allow yourself to absorb a sense of the transcendent.

STEPPING INTO THE OPEN

MOST OF US are secret dreamers. Most of us, in our hearts, yearn for lives that are sweeter and more succulent, juicier and more

There is the risk you cannot afford to take, and there is the risk you cannot afford not to take.

—PETER DRUCKER

tender than the lives we have. It is one of the unspoken rules of the business world that we keep our dreams secret.

Despite these vulnerable feelings—or because of them—most of us present armored and partial selves in our business dealings. We are crisp, efficient, and semipresent. We tell ourselves that our lack of candor is proper etiquette, that the business world is not the place for our "entire selves." In short, we are tenderhearted on the inside and skeptical on the outside. While we long for greater connection at work, we do not risk the self-disclosure necessary to achieve it.

It is not our intention to tell you that you should be more revealing. At this point, however, part of making a successful creative emergence is to examine which parts of ourselves we do not access in our business lives and to question whether or not more of our authentic personalities and talents could be brought to the table. In other words, we need to redefine what is and is not appropriately self-revealing.

Karen was an executive in a large publishing firm. There were many jokes, quiet ones, about the company's being as gray as a pinstripe and just as narrow in its views. The domineering CEO set the tone, and that tone was uptight and conservative.

Karen began to explore in her morning pages the fact that she often felt her humor was repressed in her business dealings. "This is hard," she wrote. "I feel like half of me waits in the car in the parking lot all day while the rest of me gets on the train and goes into the city to work. Then, at night, I get off the train, into the car, meet back up with myself, and ask how my lousy day went."

A few days after Karen recorded this insight, she found herself in a meeting where new book jackets were being reviewed.

"What do you think of the jacket?" she was asked about a particularly drab and uninspired selection.

"I think it's dull as dirt," she replied. Shock rippled through the room. Someone, Karen, had actually spoken her mind.

"Actually she's right," Tom, a colleague, chimed in. Evidently candor was catching.

"Actually the whole fall catalog looks pretty blah," Ellen, another colleague, piped up.

"Maybe we need some new blood. Our designers are pretty old hat," Karen said aloud what she'd been thinking for months.

> You can't depend on your eyes when your imagination is out of focus.
>
> —MARK TWAIN

> Even God lends a hand to honest boldness.
>
> —MENANDER

"That's for certain," Tom backed her up.

"Do I gather we have a consensus here?" Karen's boss finally managed to say, the faintest hint of a smile breaking his normally bleak facade.

"Looks that way," said Ellen.

"Yep." Tom again.

"I'd say so," Karen all but crowed.

The room, Karen remembers, was electric with energy. For the first time you could feel the "team" in the term "teamwork."

"When I got on the train that night," Karen recalls, "I was excited to meet myself and report in. I loved having more of me at work, and I think it was catching!"

In our determination to shoehorn ourselves into "fitting in" in the corporate environment, many of us lop off larger limbs of our creative trees than necessary. We prune ourselves in the name of being prudent, and we prune ourselves back too far. One of the first fruits of work with the morning pages is a new candor in the workplace. Often we surprise ourselves by our newly outspoken selves. What is even more surprising is the way that others accept and enjoy our previously hidden selves.

"As a rule I'd practiced 'zip the lip,'" reports Scott. "A few weeks into morning pages I found myself saying far more of what I thought. To my surprise, everybody seemed to like the change. People opened up more to me in response. I'd have to say I think good communication is a contagious skill. When I became more open, so did the people I worked with."

Cecilia, a generally conservative senior editor at a major publishing house, once got up and sang at a sales conference. "I was terrified," she told us later, "but I went with my gut and brought the house down."

Morning pages help us become intimate and comfortable with ourselves. When we know how we really think and feel, self-disclosure seems natural rather than threatening.

One of the paradoxes of working with morning pages is that while we are rendered more revealing, we are also rendered more discreet. More comfortable with our own interior terrain, we do not suffer sudden volcanic explosions of unexpected and unexplored emotions. We know when something is ticking within us and can

To my mind, the manager is distinguished by his willingness to take risks.

—LEO B. MOORE

express (or choose not to express) our feelings and thoughts with far greater security. Listen to Steve's shift:

"I had an office nickname—the MVP, Most Volatile Person. I used to fume, steam, and occasionally mouth off," Steve recalled, describing his pre-pages persona. "People weren't comfortable with me because I wasn't comfortable with myself. Once I began to know my mind and speak it, I lost my office reputation for being smart yet temperamental. People began to seek me out for work on their projects. I went from Most Volatile Person to Most Valuable Player."

As we become more self-accepting, we are actually rendered more acceptable to the outside world. Our sense of balance and perspective improves, allowing us more space for humor and fun. As we become more fully human to ourselves, we become more fully human—and humane—to others. Our skeptical shells crack a little. Our more vulnerable dreams become visible. Once hatched in the world, they are on their way to being fulfilled.

> In giving advice seek to help, not to please, your friend.
>
> —SOLON

■ *Tool: Secretly, I'd Like to . . .*

THIS TOOL ACQUAINTS us with the more mischievous and often more repressed aspects of the self. Number a sheet of paper from one to twenty and list twenty actions—from naughty to nice—that you'd *secretly* like to take.

PAYING ATTENTION

ONE OF THE most intriguing paradoxes of this work is that affecting our lives on a grander scale often begins with the smallest changes.

We often talk of bringing "vision" to our work, but we seldom realize that the act of seeing, of really looking, is an integral part of how vision is born. Moving through our busy days, we are often blind to our surroundings. We seldom take the time and attention necessary to focus on the details.

One of the great misconceptions about creativity is that it is a vague and nebulous process. The truth is precisely the opposite. Creativity is born in detail, in precise, focused attention. When we seek to bring greater "vision" to bear on what we do, we must begin by using our physical vision. For those who have eyes to

see, the world is a constant catalyst and companion on our creative endeavors.

Carol worked in the Chicago Loop. Every day she rode the el train with her nose buried in a newspaper. As part of her creative emergence, she consciously set her paper aside and began regarding the fellow travelers on her commute as a sort of portable portrait gallery. "I was struck by the incredible diversity: the old and weary, the young and hopeful, the multiplicity of races."

Triggered by her new consciousness of the city's multiplicity, Carol methodically began, on her time-outs, to explore the city's ethnic neighborhoods. She went not just to Japantown and Chinatown, but to Cuban, African-American, Puerto Rican, Polish, Vietnamese, Thai, and Indian neighborhoods. Not only her culinary but her emotional palette expanded. She began to dress more colorfully and, she found, to think more colorfully.

"It was as if in really learning to look at the world I moved through, I began to act with greater clarity, to see shortcuts and possibilities that I had missed before. I began to feel connected to a larger world. I found myself freer to make suggestions in my smaller world," Carol told us.

Very often a shift to a larger perspective can come from the smallest of changes in our routines. Roger, an efficient man, had long ago found the quickest and most direct commute for him to drive to work from his home in the suburbs. We suggested he become a little less efficient and explore routes that took him slightly out of his way. Roger resisted, then tried it.

"I found myself driving through neighborhoods, seeing swaths of the city I'd never known. I found what I thought of as a great hidden world, a wonderful neighborhood tucked away within the city but with all of the things I enjoyed in my more distant suburb. Do I need to tell you I moved there? Now I am close to work and close to all the city's cultural richness that I had missed."

Happy to be back in a world filled with rich extracurricular possibilities, Roger volunteered to organize field trips for those at work who shared his interests. Both he and his corporation enjoyed the fruits of his creative emergence.

As Jerry's "magic carpet" story revealed earlier, creative emergence is not a linear process. Roger had no notion that he would be moving back into the city, In fact, he would have bet against it.

In democracies, nothing is more great or more brilliant than commerce: it attracts the attention of the public, and fills the imagination of the multitude; all energetic passions are directed toward it.

—ALEXIS DE TOCQUEVILLE

Carol, who would have called herself timid, would not have foreseen that visiting ethnic neighborhoods would lead her to proposing an employee photo exhibition centered on the diversity of the neighborhoods from which the corporation drew its employees.

"We put it up in the cafeteria. We all got a little peek at everyone's 'real' life. It turned out to be a great bonding experience. Now we're planning a photo show on families."

In raising their personal morale, both Carol and Roger brought to their work lives a higher level of involvement and creativity. This is what we mean by the term "creative contagion."

Creative contagion is born in the act of individual attention that leads to the act of connection. Creative contagion disproves the myth that creativity is an act of isolation. When we speak of someone's having "vision," it is usually because he or she has seen and devised a way to connect in very human ways.

> Every executive has to recognize sooner or later that he himself cannot do everything that needs to be done.
>
> —ALFRED P. SLOAN, JR.

■ *Tool: Watch the Picture Without the Sound*

BUY A DISPOSABLE camera. Photograph your workday. Document the people and places of your work world, quietly. Use your camera to notice what pleases you, displeases you, and engages your attention.

This tool is intended to help give you objectivity. What about this world would you like to change? What about it can you change?

FILLING THE FORM

WHEN MANY OF us think of changing our lives for the better, we think in terms of sweeping changes: a new job, a new city, even a new country. We imagine that change, in order to be real, needs to be sizable—and therefore intimidating. Intimidated by the emotional price tag of the huge change we envision, we back off from changing at all. Our fear keeps us cornered in lives we have outgrown. We are like large dogs in kennels too small for our expansive natures. We become irritable, snappish, despondent. We gnaw at our surroundings, miserable in our lives and miserly toward our needs. Change, we tell ourselves, is just too threatening.

Large change is threatening, we tell our students, but small change is doable and durable. We believe in making small, lasting

changes in the lives we have right now. We call this process filling the form.

Filling the form is realistic. It starts by looking carefully and specifically at the life you now inhabit and making small, concrete changes. Sometimes the changes are actions; sometimes they are acquisitions:

- A few new pairs of socks
- A new wallet
- A CD holder
- Cleaning the hall closet
- Polishing shoes
- Getting a hall table
- Stripping and refinishing bookcases
- New sheets
- A real briefcase
- A travel clock

For Jessica, the simple purchase of a tiny $9.99 travel clock translated into a large inner shift: "I travel all the time for my work. I often have early-morning meetings. BC—before clock—I always worried about whether my hotel wake-up call would really come. This meant a shallow, nervous, and restless night's sleep. Now I set my little clock, use the wake-up call as a backup, and go deeply to sleep, knowing I'll be awakened on time for my meetings. I feel like that clock is a personal valet. I've even named it."

For Sandy, refinishing the painted-over oak bookcases he found in a garage sale gave him a sense of solidity and hope.

"I hate tacky, plastic, modern furniture," Sandy says. "I love antiques. I love beauty and a sense of history. My new 'old' bookcases give me a reading area that feels like a real library. Every morning I do my morning pages near them. At night I settle in to read. It took only two four-hour sessions to refinish the shelves, but the pleasure and sense of security they give me are immense."

When we fill the form we live in, we lead a cherished life. Our growth occurs organically, from the inside out. By learning to care for ourselves in small, concrete ways, we gain a sense of security: "Somebody cares—I do—and that somebody—me—is powerful enough to improve my life in many ways."

For Roger, filling the form took the shape of action, not acquisition. "I wanted to go on a two-week retreat to get my head together," he says. "The company said it simply could not spare me, so I decided to build 'retreat' into my day. I set three ten-minute reading breaks and a twenty-minute walk at lunch. I kept a meditation book in my desk drawer, brought a Walkman with a relaxation tape for my walk, and found I could sneak a lot of nurturing spirituality into my very busy business life. I stopped yearning for time I didn't have and began using time I did have."

Filling the form requires us to pay gentle attention to our wishes and needs. We may not be able to make the large changes that we yearn for, but we certainly can make small changes that bring us a sense of comfort and optimism. Paradoxically, over time the many small changes of filling the form add up to a life as greatly altered as we originally dreamed.

True life is lived when tiny changes occur.

—LEO TOLSTOY

■ *Tool: Filling the Form*

LIST THREE SMALL changes you can make in each of the following areas:

1. Your work space
2. Your car (or mode of transportation)
3. Your kitchen
4. Your wardrobe
5. Your reading list or entertainment plans
6. Your living room
7. Your bedroom
8. Your exercise habits
9. Your eating habits
10. Your spiritual/intellectual maintenance

CHECK-IN: WEEK THREE

1. How are the morning pages going? What kind of problems have you encountered? Have you been tempted to change your style of dress, hairstyle, or decor in your office? Do you feel generally more opinionated or open?
2. What about time-outs? If you have been doing time-outs, what benefits have you discovered? If you have not been doing them, how have you explained not doing them to yourself? Is there any pattern of similarity here with the ways you have explained other similar situations to yourself or to those in authority?
3. Do you remember that this is supposed to be fun?

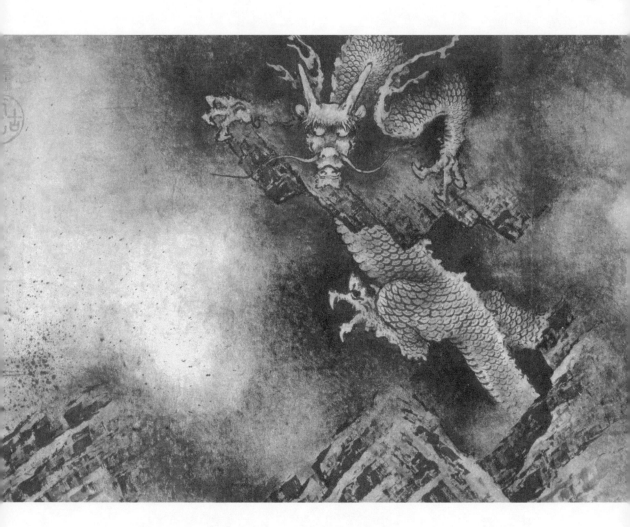

THE THIRD TRANSFORMATION: PART ONE
THE ABYSS

IN THE THIRD transformation the dragon suddenly finds itself plunged into a dark chasm. In a desperate attempt to stop its plummeting, it claws at the edges of the abyss. Where only moments ago it had been soaring on waves of newly liberated energy, now it finds itself in a sudden and terrifying free fall. Both the danger and the desperation are real.

It is here in the terrifying darkness of our vulnerability that we discover who we really are. It is here, struggling in the abyss, that we learn to find meaning in our suffering and emerge radically changed, with new knowledge about ourselves and the world.

REALITY CHECK

IT IS A principle of our work that all of us are creative. And all of us, to some degree, experience our creativity as blocked.

Much of what passes for depression is actually blocked creativity. For this reason, we often say that the initial phases of creative emergence require a period of mourning. We will examine that period now.

Many of you will have picked up this book as a way to recover from being fired, phased out, or burnt out. Any of these events can throw our world into a downward spiral of disorienting emotions and uncertain future, and all of them require a time of mourning—honoring the loss.

Since these events can cause a deep loss of self they overwhelm our defenses. Long-hidden insecurities surface and bring us face-to-face with our own mortality, or render us so apathetic that we lose the will to fight back or go on. Often the abyss shows itself in explosive volatility—an unrecognized symptom of depression, particularly in men. If you have this book in your hands, it is a good sign that you are willing to consider returning to the fray. Good.

It is also possible to slip slowly into the abyss after a protracted time of intense work, a personal crisis such as divorce, or health problems. It might even go unnoticed at first, but may appear as a loss of focus, skepticism, jaded thinking, cynicism, or self-doubt.

THE EMOTIONS

BY THIS POINT you have probably experienced sudden flashes of intense power: powerful joy, sorrow, anger, grief—a kaleidoscope of colors and perceptions. You may feel volatile, joyous, precarious, or a swirling tornado of all three. As formerly blocked creative energy begins to move through us, our emotional weather frequently becomes turbulent. Do not worry, this will pass.

It is important that you pass through this phase, because it reconnects you to many parts of yourself that have been shunted aside. It is also important that you learn to defuse anger so that it does not destroy your relationships. This potential for destruction is why we deal with the volatile emotions early in the course.

We often refer to the third and fourth weeks as emotion weeks. The dragon is thrashing its tail and gnashing its teeth; we must be careful when riding this dragon that anger or grief does not throw us off.

It is also not mandatory that you be feeling any particular emotion at this time or any time. People deal with things in different ways and at different times. We simply address the emotions early on because they are the factors that are most likely to bounce you out of the process. Fear of these emotions is why many people hesitate to start the process at all.

One of the first ways that our creative power returns to us is as anger. We are angry at the way other people have treated us and angry at the ways we have treated ourselves. This anger is good — as long as it is used constructively.

"But isn't anger negative? Besides, I don't need more anger in my life. I'm mad enough as it is," you may be thinking.

Anger as fuel is not negative. Used as a road map to our real feelings and properly channeled, anger is profoundly useful. Anger, resentment, or frustration is the invisible ink that marks our emotional boundaries. As we uncover more self-respect, we demand better treatment and realize that we are angry at ourselves for the way we have allowed ourselves to be treated.

As you continue your creative reclamation, you will find bits of yourself that were lost. As the mosaic of your new self begins to take shape, you may find yourself facing many memories of times when you gave away too much of yourself to other people and their agendas: when you had your colleagues over for dinner all the time, and they never reciprocated; when you worked all through the holiday while your partner went skiing; when you stayed docile while your colleague ranted and raved at you; when you delivered and picked up your boss's dry cleaning even though it wasn't in the job description; when the boss gave bigger bonuses to your subordinates than to you and refused to offer an explanation. The surfacing and

> I was angry with my friend / I told my wrath, my wrath did end / I was angry with my foe / I told it not, my wrath did grow.
>
> —WILLIAM BLAKE

> No cross, no crown.
>
> —WILLIAM PENN

clearing of these memories will restimulate some of those feelings. Resentment means "refeeling." We refeel these things so we can remove them from our emotional landscapes.

As you become aware of pain, often masked in anger, you may find yourself working like a cartographer, redrawing your emotional map: Where do you overextend yourself when answering the needs of others? When have you been hurt but not acknowledged it? You may even find yourself speaking up and out when these boundaries are breached.

"It's not okay that you're late constantly."

"It was really thoughtless of you to borrow that book of mine for your project and return it all beat up."

"I don't want work calls at home unless it's a real emergency."

"I don't have half an hour every day to listen to you go on about the same old thing. Either fix it or stop talking to me about it."

"You know I don't mind working overtime, but I do expect to be paid for it. I've left you a memo detailing my extra hours."

"Your work reflects my standards. I want every letter proofread before it leaves this office."

Yes, the tone of some of this sounds like anger, and though its source is a healthier sense of boundaries and a long-overdue reclaiming of misplaced power, there are ways to reclaim your boundaries that do not put your job or your relationships unduly at risk.

In the work world and in our personal lives we must express anger calmly and articulately. According to Edward Shapiro and Wesley Carr, authors of *Lost in Familiar Places*, "profound emotions, both conscious and unconscious, are often experienced in the workplace."

By working to understand and contain our anger (or other emotion) we help to create a safe work environment in which creativity becomes possible and profitable. The key to doing this begins with *knowing* what you feel, *reflecting* on it (the opposite of reflection is blame), and then *finding a way to express it* that is effective.

■ Tool: Admitting Our Emotions

WE ASK YOU to set up a safe environment before you begin this tool. First of all, assure yourself privacy. Secondly, choose a piece of safety

The cobra will bite you whether you call it cobra or Mr. Cobra.

—INDIAN PROVERB

It requires moral courage to grieve; it requires religious courage to rejoice.

—SØREN KIERKEGAARD

music—a piece of music so soothing and reassuring that you experience a sense of well-being when you listen to it. (For some of us, this is Mozart; for others, Brahms or the Boss.) You may even wish to light a candle. Ground yourself thoroughly and number a blank sheet of paper from one to ten. Complete the following statement ten times:

If I let myself admit it, I feel _____.
If I let myself admit it, I feel _____.

RELEASING ANGER

DOING A QUICK page of writing—a reflective exercise we call getting current—can help you vent your feelings in a way that releases anger *and* yields insight. Quickly write whatever comes to mind about the person or incident that is troubling you *before* you blow up, send an E-mail you can't change, or quit your job in a huff. Writing fast, then reading and rewriting something *you will not send* can help avert disaster. Deep breathing also helps, and some of us may need to get physical. Many of you will experience emotions as an extra voltage in your bodies. We strongly recommend that you "play" them out. Play some pickup basketball, or toss a football with some pals. Alone at home, turn on your favorite music and dance it off, or work out in the gym until you drop. Anything that races your heart and chases emotion from your body in healthy ways will do.

Particularly in our culture, women are not allowed to have anger, while men are allowed to have *only* it. Subsequently women stuff anger, men stuff tears. Both positions block creative energy.

Jana worked in a large corporation where her job was to organize and distill the reports of the line workers and present their results cohesively to her boss. For years she had tolerated late reports even though it meant that her own writing and thinking were always done on deadline, costing her ease, clarity, and much sleep.

"I want your reports two weeks before quarter's end," she announced one day, to her own dismay and theirs. "If you're late, your work will be excluded from my reporting, and I'll tell my boss why."

At first Jana thought she would be perceived as a "bastard." To her surprise, the opposite happened.

"I'm really glad you're so clear."

The orientation of the creative is not a perpetual state of euphoria, however. Creators experience frustration, pain, sadness, depression, hopelessness, and fatigue, as well as hope, joy, ecstasy, fun, and exaltation.

—ROBERT FRITZ

"It feels good to get this off my desk earlier."

"Thanks for pushing me. I can really drag my ass sometimes."

When it is used constructively to address a problem, anger is a powerful housecleaning tool. It is also an uncomfortable place to get stuck. Sometimes we see the problem clearly, but we can't bring ourselves to stand up to people and speak the truth about it. Sometimes that takes time. When expressed properly, anger is a wonderful fuel, a catalyst for forward motion.

In our cultural mythology, anger is perceived as "irrational." In a creative emergence the more uncomfortable truth emerges: Our anger is rational; what is irrational is trying to avoid our anger and the remedial action that it demands. This is a week when the question to ask yourself is: "In what new direction is my anger pointing me?"

I am willing to be angry and to act on my anger is a useful sign to post in your environment this week.

"Lead, follow, or get out of my way," you may catch yourself thinking. This is good. You're not stuck anymore.

Tool: Anger as Map

SO, FIVE THINGS to remember: Anger is uncomfortable; it is useful; it announces our boundaries and can goad us in the direction of our dreams; if unchanneled, it is a highly destructive force; if channeled for change, it is a booster rocket.

List three situations that anger you. Why are you angry? Write about each one. What positive action can you use your anger to accomplish?

For example, "I'm angry that this office is so disorganized." Action: Organize it.

"I'm angry that Jerry takes credit for my work." Action: Write a memo detailing your contribution.

"I'm angry that Elizabeth bends my ear about how bad she has it." Action: Set a ten-minute limit on phone calls with her.

Tool: Metabolism

VERY OFTEN WE come to the Abyss out of a sense of loss or change. List five losses or changes you may not yet have metabolized:

1.
2.
3.
4.
5.

■ *Tool: Footholds for Optimism*

IN SEEKING TO emerge from the Abyss, we must find Footholds for Optimism. List five persons or situations about which you entertain positive feelings:

1.
2.
3.
4.
5.

Man who man would be / Must rule the empire of himself.

—PERCY BYSSHE SHELLEY

CRITICISM

IN A PERFECT world we would be our own best critics and our own constructive bosses, surveying our work performance, analyzing its strengths and weaknesses, gently shaping it toward the good. But the world is not perfect. Critics abound. Some of them are good critics; some of them are bad. Our work lives are scrutinized, sometimes fairly and sometimes not. Criticism is a fact of the corporate environment. Dealing with criticism constructively is a matter of our growth and development.

Most of us hear accurate criticism with openness. Even if the criticism is pointed, we experience it as a healing scalpel, not a lance. When criticism is accurate, it relieves us because it supports our desire to do well. The fact is that most people *want* to do a great job.

Unfair criticism is indirect, unprincipled, and ambiguous; personal, negative, and derogatory. Any criticism that attacks us as people rather than addresses us as potentially competent is toxic criticism.

Toxic criticism creates toxic work environments—negative, backbiting, and backsliding—where honesty becomes harder and

Only the boss can set a tone that lets people feel comfortable enough to say these magic words "I don't know."

—LEE IACOCCA

harder to come by. Expecting that confronting problems will only bring us pain and debasement, we defend rather than listen, lie rather than explore, deny rather than experience the situation. Eventually, our anger at ourselves for being inauthentic festers until we strike out in defiance or succumb to burnout. This dynamic can happen at any level in a company. Defiance creates resistance, and resistance to criticism creates stalemates. Stalemates create stagnation, which creates depression, which breeds despair. A despairing work environment is truly abysmal: counterproductive, anticreative, and all too common.

You will always find some Eski-
mos ready to instruct the Con-
golese on how to cope with
heat waves.

—STANISLAW LEC

▉ Tool: Countering Our Critics

WE ALL ENCOUNTER criticism, some of it fair, some of it unfair. List three pieces of painful criticism you have received:

1.
2.
3.

Begin by asking what you might call your Child Self to respond to each one. (Your child's response may be simple: "I hate you. Go away. You hurt me.")

Next, turn to the part of yourself known as your Adult Self. Ask this aspect of your personality to respond responsibly to the criticism proffered.

Third, seek the counsel now of your Inner Mentor, the oldest and wisest part of your "selves." (This part weighs the input of both you and your antagonist.) What counsel does your Inner Mentor offer? Is there room or need for change? What was your contribution to the criticism?

He who learns must suffer. And
even in our sleep, pain that can-
not forget falls drop by drop
upon the heart, and in our own
despair, against our will, comes
wisdom to us by the awful grace
of God.

—AESCHYLUS

▉ Tool: True Confessions

SET ASIDE ONE half hour of truly private time. Cue up some safety music, perhaps light a candle, or do some deep breathing—whatever makes the room feel like a ritual space. Your life's work is sacred although we seldom acknowledge it as such.

Imagine yourself in a medieval abbey, where you are meeting

the abbot, a man whose long experience in spiritual and psychological problems has allowed him to guide many. There is nothing he has not heard. Nothing is too petty or horrific to shock him. He listens with calm, focused, and loving attention.

Now take pen in hand, and set on the page all the elements that you find threatening or embarrassing in your work environment. Admit what you long to say and do if only you dared. Here is where you may encounter toxic care, the desire to overprotect others from our own emotional truths. Remember, the abbot has heard "everything." Allow yourself to put "everything" on the page (or pages).

This exercise is a call to clarity and a subliminal call to action.

> Always do right. That will gratify some people and astonish the rest.
>
> —MARK TWAIN

REBUILDING THE INNER WALL

FADS COME AND go in our pop culture. Many fads have their bases in valid concepts that then become trivialized or overused. In recent years it has been modish—and then outmoded—to talk of the "inner child." We are going to talk about that child.

Although we may wish it were different, one part of us that creates *is* characterized by the childlike traits of openness, vulnerability, and wonder.

We want to establish a working partnership between our natural childlike self and what we jokingly call our Inner Adult. As a creative person you must learn to hold the tension of a dialectic (or dialogue) between these poles of your personality.

It is the job of your Adult to ensure the safety of your creative child.

We encapsulate this place of the innermost "I" with the Inner Wall, a boundary that defines and protects our sense of self, our integrity, our confidence, and our values.

Sometimes in a working situation this Inner Wall can be breached. It can happen in a variety of ways, but the results are always painful. A supervisor suddenly yells at you in public; a co-worker betrays your confidence; a project you have worked hard on is scuttled; a promotion you expected goes to someone else; a vicious critic attacks your work.

While many of these situations might be considered the cost of doing business, a breach of our Inner Wall often takes quite a toll. It manifests itself in a loss of confidence or in feelings of anger

or shame; it can even cause a physical reaction, such as headache, stomach pain, or tears.

Larry works in a division of a multinational company, responsible for creating new product and business opportunities. The problem, according to Larry, is that the division is run by a senior VP, Mitchell, who is autocratic and ego-oriented. He often delights in humiliating his staff in front of others to show how powerful he is, proving that he in effect "owns" everyone who works for him.

Misery acquaints a man with strange bedfellows.

—WILLIAM SHAKESPEARE,
 THE TEMPEST

"This particular incident involved a colleague of mine, Tom, a dedicated, serious Boy Scout type, who was presenting at our monthly review with Mitchell. There were twenty-five people in the room, all senior and experienced executives themselves.

"As Tom began his presentation, Mitchell attacked him for not completing another project on time. Tom became flustered and tried to defend himself, which only caused Mitchell to attack more viciously. The outrageous part of this was that it wasn't even Tom's project Mitchell was addressing; everyone in the room knew it belonged to Lee, who was sitting right next to Mitchell. But nobody, including Lee, spoke up.

"We all were confused and appalled by what was happening. We had been advised by another senior VP never to speak up and defend ourselves or others because it made Mitchell even more vicious and irrational. The sole goal of these monthly reviews was to get in and out of the meeting as quickly as possible.

"Tom nearly broke down under the attack. I was so angry and outraged at Mitchell and at myself for not speaking up I walked to the men's room and threw up."

What Larry experienced was a breach of his Inner Wall. He had sat quietly while a colleague was being crucified when what he really wanted to do was stand up to Mitchell. He resolved never again to allow a colleague or himself to be undermined like that, and he began to look for ways to shore up his defenses, his Inner Wall, from attacks by Mitchell.

Fire is the test of gold; adversity, of strong men.

 —SENECA

"What I did, after I made my resolution, was to perceive Mitchell as mentally ill (as he may have been) and relate to him in a rational and detached manner. When he would attack me at the reviews, I would keep going, and in a very self-confident manner I

would say, 'Mitchell, I know you think differently about this, but I am sure you want your staff to hear all the alternatives,' or, 'Yes, Mitchell, I can see you might think that way, but . . .' "

Larry relates his triumph. "I upset his tactics because he couldn't get to me. He couldn't breach my Inner Wall. Over time he quit attacking me, and I think he secretly respected me."

There are several lessons to be learned from Larry's experience:

- Having your Inner Wall breached is extremely painful and disorienting.
- Healing or mending your breach is not only possible but empowering.
- Once you understand what is happening, the person who has breached your Wall in the past will no longer have power over you.

> That which does not kill me
> makes me stronger.
>
> —FRIEDRICH NIETZSCHE

■ Tool: *Define Your Inner Wall*

1. List ten things you believe are your core values, such as being honest in business dealings or supporting colleagues in accomplishing their goals.
2. Describe a situation in the past when you think your Inner Wall was breached. How did you feel? What did you do? How did others feel about the situation? About your role in it? Were you able to mend the breach? Now write how you can mend the breach. What specific actions could you have taken then and now? How can you resolve the old hurt? What can you do when a similar situation occurs? Run your answers to these questions by a trusted colleague.
3. Finally, forgive yourself for past incidents and write: I, [name], resolve that never again will I ⎯⎯⎯⎯⎯⎯⎯⎯ ⎯⎯⎯⎯⎯⎯⎯⎯⎯⎯⎯⎯⎯⎯⎯⎯⎯⎯⎯⎯⎯⎯⎯⎯ .

 In the future I will use one of the following coping mechanisms: ⎯⎯⎯⎯⎯⎯⎯⎯⎯⎯⎯⎯⎯⎯⎯⎯⎯⎯⎯⎯ ⎯⎯⎯⎯⎯⎯⎯⎯⎯⎯⎯⎯⎯⎯⎯⎯⎯⎯⎯⎯⎯⎯ .

 I forgive myself as of today [date] ⎯⎯⎯⎯⎯⎯⎯⎯⎯⎯ for allowing my Inner Wall to be breached in the past.

> There is only one journey: going
> inside yourself.
>
> —RAINER MARIA RILKE

"But, aren't you being a little dramatic with this Inner Wall stuff?"

Yes and no. We are adults, but the creative self is young and vulnerable, a gifted child in a grown-up body. It is this gifted child whom we must protect in hostile work environments. Over the years we have devised a number of effective strategies for dealing with toxic criticism in general.

1. Hear the criticism all the way out. Don't interrupt or defend, just listen.
2. Weigh the criticism for a time. Sift it against your inner sense of truth, allowing some hours or days to pass.
3. Take time and space to feel your feelings. Let them rise up and subside.
4. Write out the criticism.
5. Write out your criticism of the criticism.
6. Share both pieces of writing with a trusted colleague.
7. Absorb your colleague's response. Do not defend or argue. Sift the feedback against your inner sense of truth.
8. If you decide to defend or argue, put your thoughts in writing.
9. Make an action plan. List concrete behavioral changes you can and are willing to make.
10. Carry out your action plan.

WORKAHOLISM

MOST BLOCKED CREATIVES do not work. They *overwork*. Believing that more is better, they work so long and so hard that they work ineffectively. As we have said, each of us is a creative ecosystem, a trout pond filled with creative ideas. If we overwork, we overfish the pond. We cast our lines in vain. Our ideas and resources are depleted.

Our society encourages overwork. As a culture we often lose the balance between work and pleasure, work and leisure. As a society we are bent on achievement and material success. We become addicted to work for work's sake, productive or not. In other words, we can become workaholic.

Only recently recognized as a "process" addiction, workaholism is often supported in our society. Our media are full of glossy, glam-

Every one has time if he likes. Business runs after nobody; people cling to it of their own free will and think that to be busy is a proof of happiness.

—SENECA

orous images of high-powered, hard-driven, high-profile executives who work hard, work late, and love it.

We say, "I'm on deadline," or "I'm working," and expect that to explain our absences from intimate personal relationships, responsibilities, and commitments. Very often we are working not to get things done but to avoid ourselves, our spouses, our feelings.

As we mentioned earlier, as teachers it is far easier to get people to do the work of morning pages than the fun of time-outs. For most blocked creatives, fun is scary; the very idea of play can make a workaholic nervous.

> We all procrastinate at one time or another. The most unfortunate procrastination of all is to put off being happy.
>
> —MAUREEN MUELLER

Dean, a high-level television producer, took a beautiful woman out on a first date. They attended a concert, then went to dinner.

"I haven't been to a concert for fun in years," Dean told the woman. "And I don't think I have time or energy to get involved right now."

The woman, he remembers, looked at him in astonishment.

"That's when I realized all my work was a ruse. I was terrified by fun, terrified by intimacy."

We often like to tell ourselves that if only we had more time, then we'd have fun, but most of us fill new free time with new work. Ask yourself how much time you allot each week for just pure, unadulterated fun.

When people are blocked creatively, they avoid fun. Why? Because fun leads straight to creativity. Fun leads to healthy anarchy, to festive rebellion, to sensing our own strength and power. Feeling our own power is often frightening.

When we talk to our corporate students about workaholism, the atmosphere gets volatile and defensive.

"I may have a little problem with overwork, but I'm not a workaholic," they often say.

"We don't mean it pejoratively," we try to assure them.

■ *Tool: Workaholism Quiz*

JUST FOR DATA, try answering these questions:

1. I work outside office hours: seldom, often, always, never?
2. I cancel dates with loved ones to do more work: seldom, often, always, never?

Perpetual devotion to what a
man calls his business is only to
be sustained by perpetual ne-
glect of many other things.

—ROBERT LOUIS
STEVENSON

3. I postpone outings until the deadline is over: seldom, often, always, never?

4. I take work home on weekends: seldom, often, always, never?

5. I take work with me on vacations: seldom, often, always, never?

6. I take vacations: seldom, often, always, never?

7. My intimates complain I always work: seldom, often, always, never?

8. I try to do two things at once: seldom, often, always, never?

9. I allow myself free time between projects: seldom, often, always, never?

10. I allow myself to achieve closure on tasks: seldom, often, always, never?

11. I procrastinate in finishing up the last loose ends: seldom, often, always, never?

12. I set out to do one job and start on three more at the same time: seldom, often, always, never?

13. I work in the evenings during family time: seldom, often, always, never?

14. I allow calls to interrupt—and lengthen—my workday: seldom, often, always, never?

15. I prioritize my day to include an hour of creative work/play: seldom, often, always, never?

16. I place my creative dreams before my work: seldom, often, always, never?

17. I fall in with others' plans and fill my time with their agendas: seldom, often, always, never?

18. I allow myself downtime to do *nothing*: seldom, often, always, never?

19. I use the word "deadline" to describe and rationalize my workload: seldom, often, always, never?

20. Going somewhere, even to dinner, with a notebook or my work numbers is something I do: seldom, often, always, never?

The sun will set without thine
assistance.

—TALMUD

Workaholism is a block, *not* a building block. There is a huge difference between enthusiastic work toward a cherished goal and the treadmill, driven quality of workaholism.

The trick is to learn to differentiate between work and *overwork*. A helpful tool is to keep a daily checklist of time spent working and playing. Even one hour weekly of creative play can go a long way toward fending off the feelings of hopelessness and workaholic desperation that keep our dreams out of reach.

Remember, an alcoholic gets sober by not drinking. A workaholic gets sober by not *over*working.

▢ *Tool: Bottom Line*

IT IS HELPFUL for many of us to set a bottom line clearly defining the behaviors around work that we see as self-abusive. A bottom line might contain limits such as these:

> The cost of a thing is the amount of what I call life which is required to be exchanged for it, immediately or in the long run.
>
> —HENRY DAVID
> THOREAU

- No business calls after 8:00 P.M.
- No going into the office on weekends
- No taking work out to dinner
- No taking projects on vacation
- No more than one hour of work at home nightly

Remember that workaholics may surround themselves with other workaholics. Your new behavior may be threatening to your friends. Remind yourself that you are changing the quality of your work for the better.

▢ *Tool: Signposts*

POST A SIGN that tells you:

> Quantity does not equal quality.
> Overwork is not working.
> Workaholism is a block, not a building block.

It is our experience that the first several weeks of sane work can actually feel very unsettling, even crazy. We suggest that you deliberately schedule both a time-out and an appealing creative project for after-hours. You may need, for a while, to work at not working.

THE FALSE SELF

THE BUSINESS WORLD can be a very exciting, stimulating, and re-
warding environment. It can also be an intimidating place where
others compete with us for money, status, and power and where our
decisions can make the difference between success and failure both
for ourselves and for our companies. Stress is pervasive, and security
is in short supply.

In such a competitive arena as this, many of us feel like
frauds—that we're not nearly as competent as we may appear.
What's more, we convince ourselves that we have to be more and
more vigilant not to be found out.

For one afflicted with the fraud complex, every encounter is
permeated by fear, by a deep dread of being exposed as incompetent.
This fear requires the manipulation of others' perceptions at all
times. It also turns satisfaction in one's accomplishments into its pale
counterfeit: relief. Success becomes merely another temporary re-
prieve from failure, from the impending doom that haunts the
"fraud."

For example, one remarkable woman we interviewed, whom
we'll call Rebecca, manages a workforce of seven thousand employ-
ees and a seven-hundred-million-dollar budget for a successful in-
formation systems company, serving as the head of its technology
and operations division. Growing up in an immigrant Italian family
in New York, she was a bright and conscientious child who excelled
in school and graduated from college with honors. She advanced in
her career by virtue of her energy, resourcefulness, and intelligence.
Rebecca doesn't believe this, however. She often thinks she's a fraud.

When we asked her why, she told us that she hadn't gone to
Harvard, her family was poor, she didn't know everything she
thought she should about emerging technologies, and she had just
been lucky so far.

Rebecca was unable to see that it was precisely because of the
talents and resources of her authentic self that she had been able to
meet the several challenges of her life and become the extraordinary
success she is. Instead she habitually measured herself against others
and found herself wanting.

We explained to her the "velocity formula" first explained to
us by our friend Robert Horton. The velocity formula states that for

Chase after money and security
and your heart will never un-
clench. Care about people's ap-
proval and you will be their
prisoner.

—TAO TE CHING

The courage we desire and
prize is not the courage to die
decently, but to live manfully.

—THOMAS CARLYLE

any achievement in human endeavor we must calculate the amount of struggle one was confronted with in order to assess the achievement accurately.

For example, if you were born into the royal family and became the king, you have a much lower velocity than, say, Abraham Lincoln, who was born poor and unknown but still managed to become president of the United States. Lincoln had "velocity."

While it generally isn't a good idea to continually compare oneself with others, in this instance we asked Rebecca to do just that. This time, however, instead of restricting her comparison to salary, titles, responsibilities, and popularity, we asked her to look carefully at the people with whom she was comparing herself: at their backgrounds, challenges, abilities, successes, mistakes, and limitations, and at the external and political realities affecting their lives. Doing this helped her gain perspective on her own accomplishments, because she saw her velocity was quite high.

Many of us occasionally experience a "Fraudian slip"—a pang of insecurity, the temptation to tell a white lie, the urge to cover up for error, the reluctance to say "I don't know." The goal is progress, not perfection, and what we want is to become fully aware, in every moment, of just the possibility of doing better.

> All men are frauds. The only difference between them is that some admit it. I myself deny it.
>
> —H. L. MENCKEN

■ Tool: The "Fraudian Slip"

HERE ARE A number of exercises meant to help you regain perspective and understand the particular ways that the fraud complex robs you of authenticity and affects your work.

1. List five reasons why you feel like a fraud.
2. For each reason, write the viewpoint that counters it. For example, "I feel like a fraud because I don't know everything about Internet technology, yet I am chairing a committee at work about it. What if they ask me . . ." A list of viewpoints countering this feeling might look like this:

 a. I know a lot more than most people.
 b. I'm comparing myself with the handful of people who are engineers and have worked in the industry since its inception.

 c. I am very good at communicating with people about com-
 puter technology.

 d. I know who to ask about what I don't know.

Write your responses in the same way to each issue you think
makes you a fraud.

CHECK-IN: WEEK FOUR

1. What are your current feelings regarding the use of morning pages? Do you feel yourself becoming more authentic? More in touch with your true feelings and opinions?
2. Are you using any other reflective technologies? Meditation? Yoga? Tai Chi? Are you remembering to walk?
3. Are you maintaining your time-outs? The work of this course is deep and may feel volatile. Time-outs are necessary for balance.
4. Are you beginning to be more lovingly candid with people in general? With coworkers? With family?

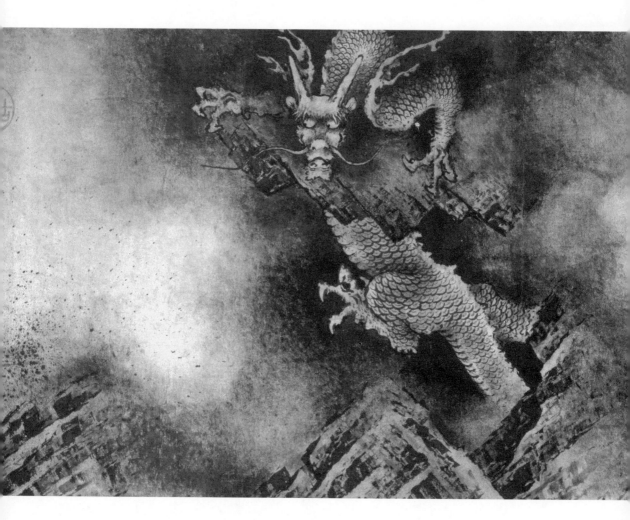

THE THIRD TRANSFORMATION: PART TWO
SURVIVING THE ABYSS

FEW OF US willingly undergo change. It almost always takes a transformational crisis to make us question ourselves and reassess our priorities. Most often it is hardship or heartbreak that provides us with the do-or-die moment and offers us the opportunity for profound change. Yes, life's dangers are real, but so are the dragon's wings:—its passion and its courage. It will come through this crisis tempered, strengthened, and wiser.

The lesson here is that all things change. So can we. Once the dragon has a moment to regroup, to halt its descent, it can prepare for flight again.

SURVIVING THE ABYSS

THE REALITY OF MONEY

THIS SECTION OF our teaching always causes headaches, neck aches, and pensive stares as people come face-to-face with some of their deepest fears: homelessness, poverty, hunger, the IRS, retirement, and so on. Let us assure you that a few simple concepts can radically transform your experience with money *and* your savings account. Do not let your defensive responses to these tools bounce you out of the course.

Anyone who says that "money doesn't matter" has never had to live without it. "I earn a lot, but I never have enough," we are often told when we teach. Next to lack of time, lack of money is the most commonly cited block to creativity. Yet lack of money is seldom the real issue. What is more often at issue is the use of our money. Very often we have more than enough money, but we do not allocate its spending in ways that are self-nurturing.

Seeking to understand our students' volatile feelings about money, Julia and Mark devoted several years to analyzing the relationships of money to creativity and personal freedom and came up with startling results.

As a society we are trained to believe that more is always better. Our advertising teaches men that if they just get enough money to buy the right car, they'll end up with the right girl—the Picture Woman. Our women's magazines and our home shopping channels teach us that if a woman just spends enough on herself, she will attract the right man, the man who will spend even more—the Money Man. Reduced to such cartoon names, this cultural conditioning seems laughable, easy to cast aside, but it is not. It exists in many cultures of the world.

In our culture the idea that monetary worth equals self-worth equals happiness is marrow-deep. Money is expected to give an emotional hit of "I'm okay. I'm great." When money doesn't deliver that hit or when it delivers it very briefly, we are trained to look immediately for more.

For many people, we discovered, "enough" is never enough because their relationship to money is essentially addictive. Just as an alcoholic can never get enough to drink, a money addict can never get enough to spend. A money addict always wants *more* and, like any other addict, runs through the "stash" at hand while obsessing on how to get more.

Instead of looking for more, let's stop for a minute and look at some possible spending styles caused by and relating to money as an addictive substance. Let's accept for the moment the notion that our society is "money drunk" and see how that plays out in our use and abuse of money.

First of all, what do we mean by the phrase "money drunk"? We mean that money can be a very powerful drug and that money is mood-changing and addictive for *some* people. Because of this, their behavior around spending is erratic and baffling, much like alcoholic behavior—which strikes 10 percent of our population.

However baffling their money problems, just as recovering alcoholics can get and stay sober, it is possible for people hampered by money problems to become "money sober."

The first step to financial solvency is awareness of the problem. So as a service to those who may need it, here is a list of ways in which money-drunk behavior may manifest itself. We've divided the behavior into thumbnail descriptions of the most common types. See if the descriptions fit the company you work for as well:

The Binge Spender. Like the periodic alcoholic, the Binge Spender goes on sudden and spectacular spending sprees. He spends wildly and comes to later with a "hangover" of remorse and self-recrimination. After each binge Binge Spenders say, "Never again."

The Maintenance Money Drunk. This type of spender is more difficult to spot. Like the maintenance drinker, this spender medicates feelings by constant "moderate" spending. He spends just enough on a lot of little things to prevent having enough money for the real thing. Where does my money go? he wonders.

The Big Deal Chaser. This spender chronically overspends against the big deal that's going to come in and make him who he really is, a somebody. "This one will be it," the Big Deal Chaser says, chasing a magic number: the amount of money that will make everybody show respect. (Magic numbers always go up.)

Keep thy shop, and thy shop will keep thee.

—ENGLISH PROVERB

To flee vice is the beginning of virtue; and to have got rid of folly is the beginning of wisdom.

—HORACE

The Cash Codependent. This spender hooks up with a flamboyant compulsive spender or Big Deal Chaser and foots the bills for the other's irresponsibility. "This is the last time I'm bailing you out," the Cash Codependent says.

The Poverty Addict. This spender is addicted to *not* having money. If money comes in, it is chased away as fast as possible. Poverty Addicts overwork, underbill, and even lose paychecks.

These sketches are exactly that: mere sketches of a whole web of behavior you may intuitively recognize as your own. Recognizing that many of their students grapple with these issues, Mark and Julia wrote *The Money Drunk,* a book of financial tools to help you to examine your relationship to money grounded in these concepts. For now we would like to present a few simple tools that lay the groundwork of what we have dubbed Financial Sobriety. The first tool is Personal Accounting.

Tool: Personal Accounting

REVIEW THE THUMBNAIL sketches just presented. Do any of them strike a personal chord? Why? Write for five minutes concerning your feelings of unmanageability related to money. In what ways do you feel volatile or vulnerable?

Tool: Emotional Solvency

FOR MANY OF us, money is the most personal and painful of topics. Take fifteen minutes to pamper yourself in a personal way. You may need a workout, a walk, a hot shower, a bubble bath, some yoga stretches, a few minutes of inspirational reading, a quick phone call to your most comforting friend.

COUNTING

"I DON'T KNOW where my money goes," many of us say, seldom realizing how literally we mean it. While many of us make handsome salaries, we often believe we do not have sufficient money to spend on some of the things we would really like. We go to the

Let money work for you, and you have the most devoted servant in the world. . . . It works night and day, and in wet or dry weather.

—P. T. BARNUM

Many evil men are rich, and good men poor, but we shall not exchange with them our excellence for riches.

—SOLON

cash machine: we withdraw "enough" for the weekend, only to find, halfway through, that it is not enough, not half enough.

Counting our money in and money out—every penny of it— is a swift and simple route to financial clarity. The point of this tool is not to judge our financial behaviors but simply to observe them. Counting teaches us to value our money and to value ourselves.

■ Tool: Counting

WE SUGGEST BUYING a pocket-size spiral notebook, and begin by recording the cost of that:

Little spiral notebook: 89¢ or $0.89.

From there, go on to write down all expenditures for the following week:

Coffee and sandwich	$6.65
Tip	$1.25
Taxi	$4.25
Tip	$0.75
Magazines	$5.85

. . . and so on.

As we've noted, counting is an observation tool. It makes us aware of our cash flow and allows us to see our choices. After even a few days of counting, we may see different ways to funnel our money that would be more soul-satisfying. Food is an area where we often misspend and where even a slight shift can feel luxurious and healthy.

"I was spending one hundred and twenty-five dollars a week on diner food," Allison recalls. "I was always grabbing a quick burger and fries on the run. My counting showed me I was spending good money on bad food. I began getting really good deli sandwiches and fruit juice and spending half an hour having lunch in the park near the office."

Be meticulous. For one week count everything. Observe, don't

The beauty of the soul shines out when a man bears with composure one heavy mischance after another, not because he does not feel them, but because he is a man of high and heroic temper.

—ARISTOTLE

Nine out of ten of the rich men of our country today, started out in life as poor boys, with determined wills, industry, perseverance, economy, and good habits.

—P. T. BARNUM

judge, your expenditures. Ask yourself, "Am I spending along the lines of my true values or am I frittering away my money?"

"Theater tickets are too expensive," we say, until our counting shows us our cappuccino habit runs us ten dollars a day. A week of regular coffee, and we've got a box seat. Pack a lunch twice a week, and take a class in ballroom dancing or get a massage.

Counting makes us shrewd. We begin *automatically* to spend more precisely. You may want to continue counting for a full month.

LUXURY

OFTEN WE WORK "too hard" for too little *personal* reward. Giving ourselves a small taste of luxury can go a long way toward giving us a sense of reward.

For Jacob, a corporate lawyer, a very small something gave him a sense of luxury. He bought a refillable leather notebook with blank pages. Small enough to fit in his briefcase, it doubled as a sketchpad/ diary. He used it for random insights, quick doodles, the odd sketch grabbed when he was alone, at lunch, or waiting for a meeting to convene. "That little book gave me a sense of me — me before, during, and after my business life. It was a handsome book, I loved the feel of it, but I loved even more the feeling it gave me that my life and thoughts were personal and important."

Money does not equal wealth. Attention focused on our authentic, creative selves, however sparingly, is what makes our lives feel rich. We notice what we are creating. We cherish ourselves in the act of creation.

William, a tough and bitter corporate warrior, began carrying disposable pocket cameras in his briefcase. At a business dinner or after a successful meeting he would take a shot or two. Printing the film, he would order duplicates. One set went on to a corkboard in his office. The other set was sent as thoughtful mementos to his colleagues. "The snaps took very little time and very little money, but they added up to my feeling that my life counted for something," he said.

As his creative emergence progressed, so did William's interest in photography. While he continued his disposable camera habit — "the casualness appealed to people" — he also invested in a good

That one can do without it makes the small luxury into a psychological necessity.

—PETER DRUCKER

There are two fools in every market: one asks too little, one asks too much.

—RUSSIAN PROVERB

35mm camera with which he played on business trips and weekends at home. For William the cost of a roll of film often meant the difference between a workweek that felt flat out pressured and a workweek with the luxury of personal time built in.

"It wasn't much time, the flash of a snapshot, but it made me feel that what I saw mattered," William said. "My life began to feel more interesting and adventurous."

For Alice, using nice note cards to write business thank-yous gave her a sense of luxury. For Carl, it was a good Waterman pen. Matthew bought a Walkman and stowed it in his office desk drawer. He'd plug in private music when doing his architectural sketches.

"I think luxury is having a sense of personal continuity, of personal passion, in the midst of a busy public life," Julia postulates.

Personalizing one's work space with desk accoutrements that reflect one's unique self can offer comfort, individuality, and continuity. Scent can give a potent sense of luxury. A scented Rigaud candle burning discreetly on an office bookshelf, a jar of potpourri deskside, a drawer with a few sticks of incense to burn along with the midnight oil when working overtime—all these can go a long way toward promoting a sense of well-being. A box of fine chocolates or freshly cut flowers may be just the right touch. Even a few judicious wardrobe purchases can greatly enhance one's sense of luxury, which in turn adds to self-esteem: cashmere scarves, silk ties, or artfully designed cuff links.

"My life had lost its sense of the personal," Al, a music business executive, complained. "It was all rush, all show, and no time for me at all. Morning pages were my first privacy in years. I gradually realized that I missed good reading. I stopped just hitting the hotel and turning on pay-per-view. Instead I joined a book club and began taking quality reading with me on the road. It's made all the difference. Sometimes I can't wait for the end of the booze and schmooze to get back to my book."

At its root, luxury is about personal care. We must care enough to notice what small things make us feel pampered; then we must act on our own behalf.

When men are employed, they are best contented; for on the days they worked they were good-natured and cheerful, and, with the consciousness of having done a good day's work, they spent the evening jollily; but on our idle days they were mutinous and quarrelsome.

—BENJAMIN FRANKLIN

■ *Tool: Luxury*

PLEASE LIST TEN things that cost less than twenty dollars and make you feel luxurious. For example:

1. Fresh raspberries
2. Trip to a health club
3. A new classical CD
4. Homemade soup
5. A shoeshine
6. A manicure (yes, for men)
7. A sheet of attractive stamps
8. A new pen
9. A bunch of flowers for the office
10. A new coffee mug

Intentional acts of deliberate self-nurturing alter our experiences of life, increase our sense of possibility.

ABUNDANCE

ABUNDANCE HAS MORE to do with the balance in our lives than with our checking accounts. If we are overdrawn emotionally, focusing too much on others and too little on ourselves, we are going to experience a sense of lack. This emptiness is triggered by many lacks, not just financial. Not enough sleep, not enough time with a spouse or lover, lack of exercise — any or all of these can undermine our sense of abundance.

Positive inflow in many areas of our lives can translate into an abundant sense of well-being. A twenty-minute walk, a fifteen-minute meditation break, a half-hour coffee break with a friend — all these add up to a sense of more abundant living.

■ *Tool: Lapping Up Luxury*

BE GENTLE AND kind to yourself in specific ways this week. Take good care of yourself: time for a good haircut, a manicure, fresh groceries, nice-smelling bath salts, rewarding music, some exercise,

a concert, theater, or sporting event, or a steam bath. Spoil yourself with one small treat a day. Remember it is not how much we spend on ourselves that creates abundance, but how we care for ourselves. We are in charge of loving ourselves, and in fact, we are the only ones who can do it.

■ Tool: Nasty Rules

MANY OF US are habitually self-punishing. We talk to ourselves in punishing ways. We forbid ourselves even legitimate pleasures.

This is a two-part test. Take a blank sheet of paper and draw a vertical line down the middle. Label your left column "Nasty Talk." List five mean, self-abusive things you habitually say to yourself. Then, briefly, refute them.

Label the right column "Nasty Rules." List five things you love to do but do not allow yourself to do. What purpose are these rules serving? This week choose one and do it.

FUNDING YOUR DREAMS

CREATIVE EMERGENCE IS at once a vital and a valuable process. Dreams, long buried beneath the weight of everyday life, the years— even decades—of heavy responsibility, of deferred gratification, be- gin to stir and rise like our dragon from mists.

The very word "dream" is a two-edged sword. On the one hand, we have the American Dream of money, property, and prestige, which may have fueled years of work and overwork. On the other hand, we have our private dreams, dreams of accomplishment that may not be tightly tethered to success as others know it.

Often delayed, deferred, or even deleted from our lives, our private dreams, our "soul" children, deserve our acknowledgment and action.

One of the greatest impediments to realizing our dreams, per- sonally and professionally, is how we approach money. Having too much can be as detrimental in some ways as having too little.

What we want to discuss here, however, is how you fund your dreams, not your everyday existence. To do that, you need to know what those dreams are, both large and small, and understand the

> I have no money, no resources, no hopes. I am the happiest man alive.
>
> —HENRY MILLER

> I don't like work—no man does— but I like what is in work: the chance to find yourself.
>
> —JOSEPH CONRAD

cost trade-offs. You will have to be creative in how you pursue them and realistic about how much you are willing to divest from everyday existence in order to realize them. View every dollar you save not as a sacrifice but as a step closer to your dreams.

Marjorie once dated a man with whom she had endless arguments about saving because of their different philosophies toward money. He believed in saving for saving's sake (you ought to . . . rainy day . . .). It made saving seem a chore, a penalty, a puritanical reminder to enjoy neither life nor luxury. He was unable to enjoy dinners out, vacations, or the purchase of a piece of art because of the admonition to save. Marjorie came from the opposite perspective: to spend what you needed to enjoy life, to experience luxury, to satisfy needs. Marjorie rebelled against the puritan ethic — at one point almost to the point of financial ruin.

On the positive side Marjorie had risked her savings to fund her graduate education, but her degrees later enabled her to increase her earning power. She also changed careers and companies when she saw the opportunity to earn more. She loved antiques and had an instinct for finding and buying quality pieces at good prices. The antiques were aesthetically appealing to her, served a useful purpose, and increased in value enough for her to sell or trade them for better pieces.

Marjorie spent most of what she earned and had put aside little for retirement. She had also made some unwise investments.

When Marjorie started to write her morning pages, she began to see she had been funding her dreams to some extent but that she had not been doing so very wisely because she was not fully conscious of what her dreams were. Writing her morning pages helped her focus more on those things she most wanted: a loving relationship, security in retirement, a lifestyle of travel and of collecting antiques and art, a house in the west where she could entertain friends and family, the freedom to shift careers eventually to writing, and the ability to give back to the world whatever would emerge from those endeavors.

By articulating her dreams, Marjorie was able to focus her savings and investments more specifically and allow herself little luxuries along the way.

Essentially, learning to fund your dreams is a four-step process. You can fund your dreams by:

It is good to have an end to journey towards; but it is the journey that matters, in the end.

—URSULA K. LE GUIN

All the arts we practice are apprenticeship. The big art is our life.

—M. C. RICHARDS

1. Articulating them
2. Saving and investing toward them
3. Cutting costs to fund savings
4. Contributing time where you can't contribute money

Our dreams are our most important motivators in life. They are far more powerful than fear or longing. When we articulate them, we make them real; when we take small steps toward them, they become more attainable. When we fund them, we make them happen.

▓ Tool: The Dream Account

THE DREAM ACCOUNT allows us to imagine and reflect on our authentic dreams and wants. Far from infantile fantasy, the Dream Account is in fact a step toward maturation.

This account differs from your regular savings account. It is a separate bank account funded, however modestly, on a continual basis. We suggest earmarking a dollar a day to begin. Many of our students up the ante to one hundred, even one thousand dollars per month—payable on the first, just like a mortgage. You are after all building the house of your dreams.

Note: One of our students financed a trip to South Africa after only six months' work with this tool. Another financed a graduate degree.

THE CREATOR GOD

OUR SOCIETY IS peculiar. "In God We Trust" is emblazoned on our currency, but we as a culture more often put our faith in the dollar itself.

"I just want enough money to feel secure," we say, as if feeling secure were strictly a fiscal, not spiritual, matter.

"If I had a million bucks, then I'd go back to school," we state, as if a fat enough bank account would give us faith in our academic abilities.

"If I get a little ahead, then I'll slow down and think about the direction I'm headed," we announce, as if having enough money in the bank would somehow help give us our moral bearings.

> The new meaning of soul is creativity and mysticism. These will become the foundation of the new psychological type and with him or her will come the new civilization.
>
> —OTTO RANK

With enough money, we don't need a God. Money is supposed to fix it, "it" being us with all our undermining feelings of loneliness, low self-worth, and guilt.

For some of us, thinking of God as a form of spiritual electricity is a useful jumping-off point. We see how being connected to this power, tapping into it, could actually help us with our lives.

As long as we have God in one camp and success in another, many of us will feel profoundly conflicted: angry when we're broke and guilty when we're well-to-do. Some kind of spiritual life, no matter how secular, can be a tremendous boon to the entrepreneurial spirit.

Mike says, "My idea of spirituality is to combine prayer *and* hard work. I pray to catch the bus—and then run like hell to the bus stop. 'Faith without works is dead.' " We couldn't agree more.

"I think of God as an electrical current," says Arthur, a CEO. "I set a direction or goal, and the current helps me get there."

"I don't call God God anymore," says Judith. "I use the term 'Source.' I can comfortably believe in a universal source of energy that likes to expand and expands through me."

"I refer to David Bohm's book *Wholeness and the Implicate Order*," says Matt, a scientist. "It relates a notion of the universe as an ever-unfolding entity, sort of God through the lens of a quantum physicist. I trust science, so Bohm's work gave me permission to be open-minded."

The Implicate Order refers to the force embedded in everything that causes it to expand naturally, just as the oak already exists within the acorn. "The force that through the green fuse drives the flower," as Dylan Thomas put it. "This is what I think happens when I visualize the results of a new idea or product. I see the intricate, unfolding order of the universe as my description of what the unknowable God is," says Matt.

Why do we insist on talking about God in a section devoted to money? Because our unexplained and unacknowledged ideas about God often sabotage our success, and psychology alone is unable to address all the ways that humans must make meaning in our world.

As we each delve deeper into the human drama or psyche, we must wrestle with the ultimate questions. Finding a personal meaning for life's struggle is imperative for wisdom. We do not need to find the answer, only to seek it, to be successful.

Many times we have watched people work hard, even martyr themselves to achieve success, only to sabotage it as soon as it's in their hands or to wreck their families getting it because they were driven by fear, not faith.

Over and over, when closely examined, self-sabotage stems from guilt. Either the person believes he is not good enough to deserve success or he believes success is not good. God doesn't approve of it, and he had better get rid of it as fast as possible. Beliefs like these, lurking in our unconscious minds, are directly tied to how we have been taught to conceptualize God, something most of us haven't reexamined since we accepted or rejected our childhood programming.

God speaks as softly as he can, and as loudly as he has to.

—RAFI ZABOR

"I was raised to believe in a God who didn't like luxury," says Clark. "God likes sackcloth and ashes, not executive suites, cell phones, and private saunas."

If God, as you understand God, doesn't like business, you need to find another way to understand him. You need to conceptualize a power that supports rather than undermines your endeavors.

For many people, God the creator of nature is a good starting point. God the creator clearly loved expansion and new ideas. There isn't one type of pink flower; there are hundreds, perhaps thousands of various pink blooms. Snowflakes are another example of creative abundance. Something—or somebody—surely loved creating. Wouldn't this force be friendly toward us, its brainchildren?

Whether you conceive of your helping force as anthropomorphic, as a quantum energy, or even as a collection of energies, whether you conceive of it as external or internal, it is our experience that once we open our minds to the possibility of an unnameable benevolent force working in the universe, we become connected to others in a new way.

"My open-mindedness seems to throw a switch. I began to experience hunches, insights, and what I would have to call God Shots—benevolence, highly unlikely experiences that supported me and my goals," reports Gerald, a high-ranking communications executive.

"I'm a pragmatist," says Terry. "The God idea works because it focuses me, gives my life meaning, so I use it."

Whether you think of God as the God idea, as energy or as something more conventional, experiment with the notion of how

much more secure you might feel — even about your money — if you made this God idea your safety net instead of trying to get your security from your paycheck.

▧ Tool: Explore Your Feelings About God

THIS TOOL EXPLORES our spiritual conditioning, as well as points us toward the more positive and pragmatic spirituality that is possible. Take a blank sheet of paper and draw a vertical line down the center. Label the left-hand column "Old Ideas About God." Label the right-hand column "New Ideas About God." (Some ideas may fit in both lists.)

In the left-hand column, list the traits and associations you have with the God of your childhood. Was that God authoritarian? Male? Distant? Fragmented? Loving? Helpful? Supportive? List any and all traits you remember.

Now move to the right-hand column. Imagine an all-powerful, benevolent force, available to encourage your dreams. What traits would that power have?

Some of your responses may surprise you. Humor and forgiveness are often high on students' lists. Do words like "compassionate," "positive," "user-friendly," "accessible," "dependable," "kind," "innovative," "empowering," or "bold" show up on such a list?

▧ Tool: Going to Take a Miracle

ASSUME FOR A moment that you have the full support of the positive power you have just described. What changes would you make in your life if spiritual support were truly available?

Take a blank sheet of paper. Label the left-hand column "Fear." Label the right-hand column "Faith." In the left-hand column, list situations and behaviors in which you are stuck because of fear. (Students have recorded negatives as diverse as drinking problems, temper tantrums, overweight, violence toward spouses or coworkers, sleeping with subordinates, money problems.)

In the right-hand column, list the shift you desire to accomplish if you had the spiritual help. (Shifts have included answers to all the above and more.)

THE WONDERER WONDERS

AS THE NAME suggests, the Wonderer retains a capacity for wonder, even awe. The Wonderer likes mystery, is open-minded, and even, though maybe not a believer, is at least curious about spiritual ideas.

"Maybe there is a God—or something," the Wonderer says. For our purposes, the "or something" is enough.

In effecting a creative emergence, we are refusing to accept our limits as we have known them, and our Wonderer is often the one who remains open-minded during our times of skepticism. Now might be a good time to contact him. "Perhaps there is more to life than this," he wonders. "What would that mean for me?"

If we believe we are operating solely on our own devices, we set limits for ourselves that are far too low. If we don't believe in a helpful force—call it God, the universe, the Tao, what have you— then *everything* is up to us.

If we believe in a stingy God, then we may get some help, but not much. Or the help will come with a price. We may in fact decide just how much help God can give us. We may look at a new venture and decide it's too much for us rather than give it a try.

Even a modest belief in spiritual possibility creates a level of healthy autonomy. This is why the Wonderer thrives on faith. When a business catastrophe rears its head, the Wonderer responds with curiosity, not panic.

"I wonder what the lesson is here."

"I wonder how we deal with this."

"I wonder where I might be happier working, if it comes to that."

"I wonder if this might not have a silver lining," the Wonderer thinks, facing a business obstacle. The Wonderer, in short, guides us toward conscious, learned optimism.

If we have a belief that goes something along the lines of "Somebody up there likes me," we may be more inclined to take positive, calculated risk, believing that it all will work out, and it most likely will.

It is one of the paradoxes of the business world that business stars are great believers. Titans dare. Titans take risks. Titans expand. They are great *Wonderers*. Business greats talk of listening to their

> Men are never so likely to settle a question rightly as when they discuss it freely.
>
> —LORD MACAULAY

guts, "following my hunches." Their eye must learn to see both the vision and the reality, to hold the delicate tension between the two.

For many of us in the middle ranks of business, however, believing is often thought of as dangerous, maniacal, ungrounded. It is our opinion that we could all do with a dollop of believing, a good-size serving of wondering.

"I wonder if there's another supplier just as good."

"I wonder if we shouldn't give that new producer a try."

"I wonder if the market exists for an economy size."

"I wonder if my employees know how important they are."

The Wonderer can be a fragile voice in some environments, rarely wishing to risk exposure. But risk we must.

The Wonderer is important because with even a modest belief in a benevolent universe, risks become more possible. When we begin to entertain the notion that we might all be interconnected and that our demand might cause the universe to create a supply, we begin to wonder about a whole new set of interesting things.

Tool: Wondering

FOR SOME OF US, our Wonderers have been asleep a long time. It might take a little practice to rev them back up. Exactly why is the sky blue? Remember?

1. Find something to wonder about. Write it down.
2. Wonder about it for a few days. What are some possibilities for why it is the way it is?
3. Try to talk about it with a friend. Force yourself to risk it.

"Love God's kids and help them get what they want," was how a very rich real estate broker described the marriage between her spiritual beliefs and her business life. Moving in her business world with an attitude of service and an expectation of universal guidance, she prospered.

We all know the adage "Where there's a will, there's a way," but we often take it as a praise of willpower, rather than a statement of faith.

"We all pretty much get what we believe we'll get," Jonathon

If you wish to make an apple pie from scratch, you must first create the universe.

—CARL SAGAN

It is easier to fight for one's principles than to live up to them.

—ALFRED ADLER

states flatly. "I've been in business a long time. Those who expect to win tend to win. Things tend to work out in their favor."

So, is this the Pollyanna chapter? We don't think so. We think we are squarely at the point of opening the mind through experimentation. Call it the behavioral chapter: If I act as if I believed in benevolent helping forces, what small risks would I then feel free to take?

CHECK-IN: WEEK FIVE

1. Are you consistent with your work with morning pages? Have you tried other reflective techniques? Do you resist your own resistance? Do you find yourself writing more freely in all areas of life?
2. The tools of this chapter were volatile and demanding at a deep internal level. Are you able to commit to continued counting as an aid to financial clarity?
3. You are opening a door to reflective spiritual consciousness. Have you noticed an increase in benevolent synchronicity? (It is okay if you have not.)
4. Look back at your luxuries list. Pick three luxuries and indulge in them this week.

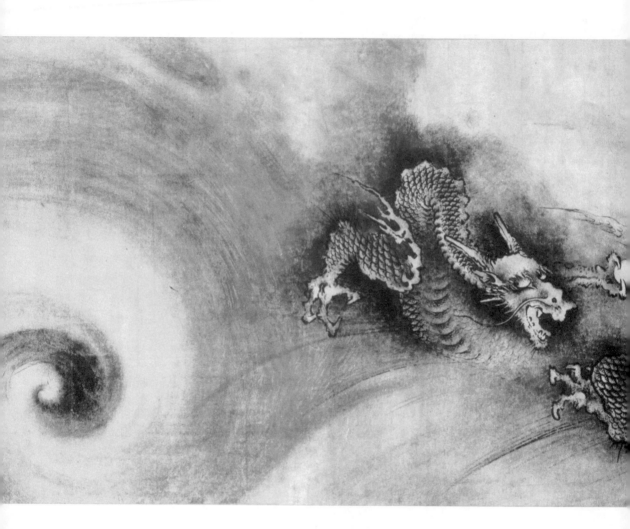

THE FOURTH TRANSFORMATION
THE PEARL OF WISDOM

IN ITS FOURTH transformation the dragon appears exuberant, openly proud, exhilarated by the deep satisfaction and joy of one who has come through a trial and emerged victorious, holding the pearl of wisdom.

This depiction of the dragon speaks to us of success. The sense of accomplishment, the gratifying feeling that our labors have borne fruit, is as much a part of our spiritual birthright as sadness and struggle. We're counseled, by this dragon, to celebrate our accomplishments.

At the same time, the scroll contains another five dragons after this one, to remind us that even the perfect moment, when you grasp the pearl as your prize, cannot last. As one who has been through the trials of the Abyss understands, it is the nature of life that all things arise and change and perish. Nothing on this earth lasts forever. Moreover, the artist seems to be telling us that this realization, the pearl of wisdom, is not merely a trophy but a tool. Perhaps the most important reason to savor a victory lies in our ability in the future to draw strength and optimism from the memory of its sweetness.

RHYTHMIC INTELLIGENCE

OFTEN WE THINK creativity is all about action and speaking up, all about being assertive and putting ourselves forward. More accurately, creativity is about receptivity and listening. When we listen to ourselves, to our inner flow of ideas and insights, we "hear" our cues. We respond accurately and effectively to our business circumstances.

"I can't hear myself think," we sometimes say. Morning pages and time-outs train us in the art of listening. Corporate creativity lies not only in listening to ourselves but also in listening to others. Business is a dance in which we must both lead and follow. This week will aim at focusing you on the rhythms of the dance. We will focus on the common blocks of perfectionism, risk avoidance, and jealousy. As we work to dismantle them, we will clarify your personal dreams and goals.

BODY ENGLISH

LIVING ON FAST-forward, we experience our life as a whirl of people, events, meetings, and madness. We live on deadline, under pressure. Our lives crackle with the energy of modern life.

"He's really a live wire," we say of high-level Type A personalities.

"She's wired," we say of the tense executive who whirls into a meeting.

In order to deal with high-voltage energy, we need to learn and practice grounding techniques. We can ground ourselves with various forms of meditation, martial arts, morning pages and time-outs, and any ritual or exercise we undertake daily, as well as any combination of the above.

Remember, we are like Radio Kits. We receive and transmit energy. When we experience ourselves as blocked, it is often be-

cause our channels are jammed. Our bodies are stuffed with unprocessed messages:

- "She shocked me."
- "Sue gave me a beating."
- "He threw me out of his office."
- "I'm going to wring his neck."
- "I'm running behind."

There can be no acting or doing of any kind, till it be recognized that there is a thing to be done; the thing once recognized, doing in a thousand shapes becomes possible.

—THOMAS CARLYLE

Creative emergence requires that we listen to these cues. We listen by doing morning pages, but we can also listen by walking, running, bicycling, using a StairMaster, a treadmill, or a Nordic Track. We use the phrase "I need to exercise my judgment," without realizing that this phrase is a directive for mental clarity.

"At your suggestion, I began getting off the bus a stop early and walking a few extra blocks to the office each morning," Terry told us. "I was amazed at how hunches and strategies would come to me in those few minutes."

"I started doing twenty minutes of yoga by video," Candace told us. "I swear those stretches stretched my mind as well. I came up with all sorts of ideas and seemed to let go of a lot of resentments and simmering tensions, too."

Ken, a highly paid salesman who logs one hundred thousand air miles yearly, undertook walking twenty minutes daily. "I told myself I didn't have the time to do it, but then I thought, 'Damn it, I will make time.' I began doing that. I'd get into a hotel room, unpack, and walk before getting on the phones. I can't tell you my resistance, but I can tell you the results: I felt less like a caged animal. I actually began to see the cities I was working in, and I began to be able to hear myself think, 'Life ain't so bad after all.'"

For many people the act of moving out of their heads into their bodies and into the world seems to put them squarely into the flow of ideas. Many report an increase in synchronicity.

"I swear, it's like people stage conversations for me," Carl claims. "I'll catch a snippet of conversation and think, 'That's it.' Or else I'll see a sign of some sort, a headline, a notice, posted in a store window and—click—a stratagem will lock into place."

We shape clay into a pot, but it is emptiness inside that holds whatever we want.

—TAO TE CHING

▪ Tool: Body English

WHEN BODY ENGLISH speaks, we need to listen to it. We find our body intelligence to be a reliable, frequently prescient source of wisdom.

This tool requires fifteen minutes of solitude behind a closed door. Take off your shoes, loosen your belt, lie flat on your back, and close your eyes. Beginning at your feet, clench, hold, and then release the muscles. Work sequentially up the legs from toes to the top of the head. As you do so, hold the question "What do I need to realize about my current situation?" Insights, ideas, strategies, and emotions will swim to consciousness as your body volunteers its information.

▪ Tool: At the Wheel of a New Machine

TAKE ONE CLASS in one of the movement therapies you have never tried, such as the Alexander Technique, the Feldenkrais Method, yoga, or dance. This is not so much a commitment as an experiment. Listen to what your body says. How do you carry yourself? Like a champion? Like a humble warrior? Like a priest?

SOLITUDE

HUMANS ARE SOCIAL creatures. We lead lives embedded in the needs, expectations, and aspirations of others. Creative emergence requires a subtle refocusing of our inner attention. While still being user-friendly to family, friends, and coworkers, we must learn a sense of heightened responsibility to ourselves. This inner quietude creates a space where we can recapture the pearl of our innate wisdom.

For many executives, flights are valued times of solitude, mulling on the page in their morning pages journal or playing the game of "I wonder." They invite their Wonderer to step forward: "I wonder what would happen if I . . ."

Some of our students take a cue from Julia and formally pose questions to themselves. Taking pen in hand or computer on lap, they ask the page their quandaries.

Even in the most sophisticated person, it is the primitive eye that watches the film.

—JACK NICHOLSON

The more faithfully you listen to the voice within you, the better you will hear what is sounding outside. And only she who listens can speak.

—DAG HAMMARSKJÖLD

Q. "What should I do about what Tony did in the meeting yesterday?"

Then they listen for an answer and write down what they "hear" when they listen quietly.

A. "Let it go. People are on to his showboating."

Such inner listening can rapidly become a "grooved" habit. Over time many of us come to rely on it, learning the identity of the voices that answer: your Critic, your Rebel, your Wonderer, your Cheerleader, and so on.

The act of taking pen in hand—or hands to keys—creates instant privacy. A wing chair in a crowded hotel lobby becomes a refuge from the omnipresent hurly-burly when the time is used to "drop down the well." What most of us seek—and find—through inner listening is a sense of continuity, grace, safety, and guidance that gives our business life new and welcome underpinnings of security. This grounding allows us to stay balanced even in unbalanced situations or hard times.

"I don't think of myself as a religious person," Malcolm told us, "but I am aware that my taking time for brief reflection, several times daily, is a long-honored technique from many spiritual traditions."

Buddhists call it practicing mindfulness. Theologian Emmet Fox called it practicing the presence. No matter what you call it, taking a moment several times a day to tune in and listen to your inner source is, indeed, a spiritual tradition that yields us insightful detachment. Such detachment is invaluable for rendering us clearheaded in our business lives.

If inner listening smacks too much of piety to you, try thinking of it in sports terms. You are calling "time" while you marshal your wits and resources before returning to the fray.

Inner listening puts us in control of life, rather than having life control us. The habit of checking in with ourselves before we act grants us the chance to respond to events rather than react to them. We create for ourselves the opportunity to take the action of nonaction, often a powerful position from which to deal.

"Before learning to listen, I was always reacting," says Clarence. "I felt I had to act in response to every stress, every so-called emergency. When I began checking in with myself, I found that many

> The real voyage of discovery consists not in seeking new landscapes, but in having new eyes.
>
> —MARCEL PROUST

business 'emergencies' were just empty dramas. I began to concentrate my energies on getting the job done rather than play into the hysteria or the politics. When I kept coming back to reflection as my baseline—by dashing off a page of writing—I found the truest path out of the emergencies and a more balanced view of the politics. I sensed a lot of people were relieved to put their eye back on the ball and off each other."

The inner calm experienced from knowing where we stand and how we feel often manifests as an outer calm that translates into expanded trust on the part of our colleagues. They begin to seek out *our* pearls of wisdom.

"People began to talk to me more, to lay out their problems once they knew I could keep my own counsel and not overreact," Mel reported.

"I hadn't set out to become wise, just sane," Marion told us. "But my sanity kept being perceived as wisdom. There was simply a greater vision, a sense of the overview that came to me when I began regularly checking in."

Morning pages are the first check-in of the day, but you can call time anytime. A few minutes grabbed midday, a quick dash to the page before an important meeting or call, for some of us a few quick notes at night to review a particularly knotty problem—these stolen moments in the midst of business brouhaha create a sense of structure and self-determination.

"At first I felt self-indulgent," David told us, "but then I thought about the fifty-minute hour psychotherapists adhere to. If I were a psychiatrist, I would give myself ten minutes of each hour to regain my sanity. Why not a businessman?"

Viewed as a way of maintaining professionalism, the habit of pausing to check in becomes not self-indulgence but enlightened self-care.

"I've learned to hear myself think," is how James phrases it. "I've learned that I think with my body as well as my mind—with my neck muscles, tension in my shoulders, an uneasy feeling in my stomach. Listening in a whole body way, I find myself a lot more accurate. Sometimes my teammates call me the psychic because I seem to pick up the direction a client is moving in. It's a learned skill I got from the inner listening."

It is a paradox of communication that the more you risk sharing

Creative thinking may mean simply the realization that there's no particular virtue in doing things the way they always have been done.

—RUDOLF FLESCH

It is interesting that visionary and mystical inspirations are behind many of the world's greatest inventions and scientific breakthroughs; even those of such giants of the mind as Albert Einstein and Nikola Tesla.

—DAVID TAME

personal data in a communication, the more trust will be built in the group.

We've spoken before of creative contagion. It is our experience that practicing the skill of inner listening often results in our colleagues' becoming more attentive and attuned to listening to us. When two or more members of a creative group begin the art of really listening, the group as a whole often rises in its level of cooperation and acuity, taking flight—as when a flock of birds responds as a body to a stimulus or cue.

> Just remain in the center, watching. And then forget that you are there.
>
> —LAO-TZU

When a creative team learns to soar as a unit, teamwork becomes a matter of cooperation and coordination, not competition.

"It may sound macho," says Chris, "but I think of my creative team like a bomb squad. We've each got a job, and when we work together, we're safe and effective."

As Chris's analogy points out, in order to be an effective team player, each of us must be clearly focused, autonomous, *and* cooperative. The ability to stay both separate and connected is the gift of practiced inner listening.

■ Tool: A Letter to the Self

TAKE YOURSELF TO a coffee shop or diner, and handwrite yourself a letter of encouragement. Include in this letter the progress you have made to date. List at least five positive changes, however small, you have made since beginning the course. Sign this letter, date it, and mail it to your home. (Small, playful rituals are an important part of regaining our optimism.)

THE ABCS

AT ITS HEART creativity is about play. We play with ideas. As Carl Jung said, creativity is the imagination at play with the things it loves. In order to recapture a sense of play, many of us must consciously journey backward through years of "adult" behaviors. We must return to a sense of safety, hope, and optimism that we may not have felt since we were very young—if at all. It is our experience that optimism can be regained, relearned, and even learned.

"So," you ask, "how do I learn to be optimistic?" Well, you have already been learning it. The morning pages move us toward

optimism in several ways: first, by serving as a psychological holding environment, a place to free-associate, grieve, and celebrate; second, by becoming a ritual of reflection; third, by giving us a place to examine many aspects of an experience so that we can reframe our failures into lessons learned and thereby approach our next challenge from an emotionally neutral or positive stance.

> You've got to find the force in-side you.
>
> —JOSEPH CAMPBELL

Now, to our ability to reflect, we can add the conscious building of appropriate risk taking. Time-outs have been training us to be okay alone, to think for ourselves, and to feel our emotions. This heightened ability to reflect on our experience and extricate ourselves from others' agendas for us helps us to build toward autonomy—a necessary component for optimism.

With the foundation carefully set, we move toward an active engagement with our internal voices. By now, you should have identified several voices of your personal committee in your head. Many of these voices play distinct roles in our individual psyches and can be trained to be more cooperative and effective.

YOUR OTHER VOICES

ACCORDING TO DAVID N. Berg and Kenwyn K. Smith, authors of *Paradoxes of Group Life*, as their groundbreaking book is titled, "group members remain unconsciously stuck in adversarial positions—often reinforcing the very condition they wish to change." We get stuck in adversarial stances when our Critic is working overtime. When our Critic dominates us, we become "conservers." We pull back. We stop risking. We comply rather than stick our necks out. We withdraw or procrastinate rather than confront a problem.

The Observer self can shift us from our "conserver" stance to one of "expander" by taking the Critic's shouts and grumbles as valuable signposts for action. We spot problems and suggest solutions. We sense resistance and address reluctance. We anticipate the reactions of other conservers and respond to their concerns. In this way, the Observer self offers a path to learned optimism—paradoxically, by heeding the Critic.

When we are in our expander mode, change doesn't throw us. We welcome it as a chance to move forward in power. We reach fearlessly for the pearl.

The theory is simple enough: If you have a negative filter on

the way you perceive the world, you will be a conserver. You will tend to take *no* risks at all, or you will expect to fail when you do take them. This is why Peter Senge says that success goes to the successful. In sports, politics, and business, the optimist or expander tends to win the majority of the time. Here's the next step, toward a better outlook.

You have already recognized the Critic's voice. Now we want to teach you how to train it and your other voices to cooperate with your highest aspirations. Your Observer self, who listens to all the voices, can be trained to dispute the critical voices with the truth and slowly move you out of stuckness. You began this movement using affirmations and blurts, and now we'll add two components to them: the ABCs of cognitive restructuring developed by Albert Ellis and Martin E. P. Seligman's principles of learned optimism.

For years we did an exercise called Self-talk to change our inner voices. Now, we have adapted Martin Seligman's ABCDEs to modify that tool for the better. The ABCDEs stand for Adversity, Belief, Consequence, Disputation, and Energizer. Here's an example of how it works:

Years ago, while he was working in Los Angeles, Mark used to say to himself, "I could never afford to live here," or "I could never buy a house here."

His *Adversity* was that he didn't own a home and he was struggling with his finances. The *Belief*—that he would never make enough money to own his own home in Los Angeles—had the *Consequence* of allowing him to stay in denial about his misuse of cash and about his general vagueness about where his money went. In this approach to learned optimism, the *Disputation* would have us first argue with our Critic in concrete terms.

For example, Mark might say to his Critic, "Wait a minute, I make fifty-five thousand dollars a year and if I manage it well, I can save ten percent of my money so fifty-five hundred dollars a year will add up, and in five to ten years I will own a home."

The next step, the *Energizer*—what we always called "taking the jump," taking action toward the dream—is a small step on our own behalf defined by the Disputation, like setting up a savings account, buying financial software, or going to an open house or two to get a better idea of what kind of house we like and what is available.

... he allowed himself to be swayed by his conviction that human beings are not born once and for all on the day their mothers give birth to them, but that life obliges them over and over again to give birth to themselves.

—GABRIEL GARCÍA MÁRQUEZ

By following these ABCDEs we can effectively change our negative self-talk from discounting and disempowerment to optimistic stances and specific actions that change our current reality and point us toward our desired future.

In Mark's case, his Critic had served a very useful purpose in that it identified the fear that was keeping him from moving in the direction he wanted to go. To use the Critic effectively as a catalyst for action, you must just change your attitude, but then that new attitude *must* lead to actions, however small, in the direction of the goal. *Intention* is not enough.

The rise in awareness and expectation engendered by practicing ABCDEs will often cause a bit of anxiety as the energy bound up in fear gets released. This anxiety is a natural fuel for change. Use it to take the action.

■ Tool: Positive/Negative Poles

TAKE A BLANK sheet of paper. Think of a problem in your life. Draw a vertical line beneath it. Label the left column, "My Pessimist." Label the right column, "My Optimist." Turn to your difficulty. What does your pessimist tell you? What does your optimist say? You are now ready to apply the ABCDEs to the situation.

List the Adversity, the Belief, the Consequence of the belief, and the Disputation from your optimistic column, and lastly choose an Energizer—what you may call the next right thing—a small positive action in your behalf. Remember large change begins with small steps.

Use this tool to propel you out the door and into some action, however small, toward the goal—i.e., "I could never get into graduate school." Send for brochures.

"I could never get a better job without a financial background." Take a class.

MEDIA DEPRIVATION

BUSINESS IS A wordy affair. Missives fly. Ideas fly with them—some of the time. All too often words are more like airborne debris than actual units of information. In many corporate environments we suffer from information pollution: Too much is said and written

Skepticism, as I said, is not intellectual only; it is moral also; a chronic atrophy and disease of the whole soul.

—THOMAS CARLYLE

Out of clutter, find simplicity.

—ALBERT EINSTEIN

about too little. We are inundated with information about events we can do little about and barraged as well with the basic messages of our consumer culture at every turn. We have become accustomed to ingesting massive dosages of low-grade information, like junk food. As workers we are often so busy taking in massive amounts of written material—other people's thinking—that we lack the time and clarity to do our own thinking. To cast it in technological terms, we lack the disk space necessary to download our own opinions. To cast it in "dragon" terms, we are too busy grasping at straws to grasp the pearl.

What the superior man seeks is in himself. What the mean man seeks is in others.

—CONFUCIUS

Few techniques function as a stronger jump start to original thinking than a week of media deprivation. We originally taught this as Reading Deprivation, but with the explosion in electronic media, we had to expand this exercise to include all media stimulation, except for music without lyrics for workouts.

So for the next week, turn off the TV. Turn off the talk radio. *Do not go online.* Turn off the tapes and CDs in the car. *And above all—don't read!*

That's right. Don't read. Don't watch television or use the VCR. Don't listen to radio or news of any kind. Also, just as important, *do not surf the Internet* or check E-mail, or have anything to do with electronic mail of any kind—E-mail has become an addiction of ever-widening proportion. Yes, you can write us a nasty letter if you want. We are used to it.

Many of our students get angry about this tool. They lash out: "I have to read. My job depends on it." "I always read before bedtime. How the hell am I going to get to sleep?" Or "I get a hundred E-mails a day. What am I going to do with them?" they ask. We say, have your assistant read them for the important ones, or send everyone an E-mail postcard asking that they contact you by phone, or wait a week, to which our angry student replies, "Don't you know who I am?"

The very people who resist media deprivation most strongly are often those who report that they got the most out of it. For many of them it is a profound experience. Try it. You'll see. (What if we told you it would improve your sex life?)

"I couldn't believe how clear my thinking became. I began to see all sorts of new solutions, shortcuts, and areas where I had options."

"I read myself to sleep as a rule. Instead I began writing myself to sleep, a habit I've kept up with ever since."

"My gratitude level zoomed way up. I really noticed other people, the work they did and the lives they led. I began to appreciate my own."

Media deprivation casts us into an inner silence. As we empty our minds of numbing chatter, we find a deeper stream of ideas, insights, and recognitions. We encounter our authentic urgings, hear with greater clarity the true voice of our dreams.

But as is the case with all habits, any attempt to threaten our source of supply makes us angry. And our cultural addiction to the media has become deeply embedded, pervasive, and very hard to escape.

"I thought you guys were out of your minds," snaps Danny, a marketing exec. "I liked my junk-food reading; I liked my talk radio. I checked my E-mail eight times a day. I really hated the idea of giving any of it up. It felt like punishment to me."

"And?"

"And I loved the results. I found myself talking *to* my wife, instead of *at* her. I hadn't noticed how much the media invade my space. Hell, I suddenly realized I was watching ads at the movies. I had plenty of things to do besides television, but for a while I just twiddled my thumbs in anger. Then I realized how much I just sat around on my butt, watching someone else do interesting things."

Media deprivation often causes tension at first, but later it creates inner calm. It allows us to hear the flow of our thoughts like subtle music. Like a temporary fast, media deprivation cleanses the mental system. It can be essential for anyone attempting to return to school. Mark says: "Particularly if you want to finish any school-related goals, put your television in the closet. Before you know it, school will be done. And you might just decide to leave the damn thing there."

After a week of media deprivation, many people return to reading or the entertainment media with an increased appetite for finer fare.

"Suddenly I wanted to read for pleasure, to read novels again, a habit I had all but given up."

"I let myself subscribe to some really fine magazines."

"I joined the Book-of-the-Month Club."

Do you have the patience to wait till the mud settles and the water is clear? Can you remain unmoving till the right action arises by itself?

—*TAO TE CHING*

As people grow up, they cease to play and they seem to give up the yield of pleasure which they gain from playing.

—SIGMUND FREUD

"I started going to the health club again."

"I found out that three-fourths of my E-mail is junk mail—now I have my assistant screen it."

Like couples in counseling who are asked to give up sex for a month and work on their intimacy, media deprivation is a short-term mental abstinence that pays off with long-term results.

"The minute I stopped reading, I started writing. A big report I'd been stalled on suddenly became exactly what I wanted to do."

Media deprivation is old-fashioned. It throws many of us on our own resources in a healthy and healing way. Paperwork gets taken out and accomplished. Broken friendships get mended, too, as there is suddenly time and space for phone calls, letters, coffee dates. It puts us in touch.

"I painted my bookshelves and bureau—a project I'd put off for two years."

"I reorganized my office. Now it is much more efficient."

"I went through my Rolodex and sent all my old clients a card, just of appreciation."

"I wrote my sister, my brother, and my college roommate."

Media deprivation is actually a lesson in self-nurturance. We turn to different, higher sources of inflow: hobbies long abandoned, projects postponed, music revisited. All these streams of nurturance refill the inner well. Very rapidly that well-filled well spills over into our corporate lives.

"I not only reorganized my files, but set up a new flow system for my department," reports Marion of her week on media deprivation.

"I did a week of media deprivation, and it changed my cultural palette," claims Jeremy. "I stopped listening to NPR, and now I practice to a voice tape on the way into work. Now I speak in a clearer voice at work."

Expect turbulent emotions at the outset of media deprivation. Think of those emotions as a rolling river. The static in your mind, like sediment in that racing river, will settle and clear as the week goes on.

"I began to feel really connected to myself," reports Debbie. "That feeling of connecting was so powerful that I now do one day a week of media deprivation just to keep myself tuned in."

Whether you think of it as tuning in or toning up, media deprivation offers a very potent form of spiritual chiropractic.

> Newspapers are unable, seemingly, to discriminate between a bicycle accident and the collapse of civilization.
>
> —GEORGE BERNARD SHAW

"I felt really on the beam," says Ted. "I resisted media deprivation the way some people resist falling in love. Once I got over my fear, I was glad that I did it."

▪ *Tool: Media Deprivation*

THIS IS A radical, potent, and challenging tool. We ask you for one week to *abstain* from reading as well as from television, accessing your E-mail or the Internet, from movies, and talk radio. You may find this tool threatening, angering, even overwhelming. Stick to it. The rewards are enormous.

"I thought of it as fasting," one student told us. "I felt like I was detoxing from junk culture, not to mention from other people's ideas and agendas. I began to hear myself think."

DETECTIVE WORK

DURING MEDIA DEPRIVATION, suppressed feelings and thoughts often emerge, chief among them shards of memory. Most especially, forbidden longings surge to the surface.

As children, many of us packed lunch boxes with sandwiches and thermoses, kissed our mothers, and breathed good-bye to our invisible friends because we were headed off to school, a place where imaginary playmates were not welcome.

As adults, many of us prepare for our workday by packing away the parts of ourselves we have deemed inadmissible to our office world. Our love of music or of fine fabrics, our gift for carpentry or cooking—these parts of ourselves are set aside as we don the mantle of "worker" and take on a less colorful identity.

Very often we submerge these parts of ourselves so deeply that we feel cut off from ourselves. It can take a little detective work to raise and reintegrate the parts of ourselves left behind.

▪ *Tool: Reconnecting the Dots: Detective Work*

THE FOLLOWING STATEMENTS are intended to catalyze self-connection.

1. When I was a child, my favorite toy was _____.
2. When I was a child, my favorite friend was _____.
3. When I was a child, my favorite pet was _____.
4. In grammar school my favorite subject was _____.
5. In geography my favorite place was _____.
6. After school my favorite game was _____.
7. At recess my favorite game was _____.
8. When I was a child, my favorite book was _____.
9. When I was a teenager, my favorite music was _____.
10. When I was a teenager, my favorite car was _____.
11. When I was a teenager, my best friend was _____.
12. When I was a teenager, my passion was _____.
13. As a teenager I loved _____.
14. When I was a teenager, my favorite teacher was _____.
15. As a teenager I read _____.
16. As a teenager I hated _____.
17. When I was a teenager, my first love was _____.
18. When I was a teenager, my favorite sport was _____.
19. When I was a teenager, my favorite food was _____.
20. When I was a teenager, alcohol, drugs, and sex _____.

> Here I am, fifty-eight, and I still don't know what I'm going to be when I grow up.
>
> —PETER DRUCKER

BURIED TREASURE

"AS A GIRL I was a maniac about music," Kathy recalled. "I'd snuffed out that part of me when I got divorced. Music reminded me of him, so I went without it. Going without it got to be a habit, a dull, joyless habit. My detective work woke up my inner musician. I began listening to tapes in my car.

"Next, I bought a Walkman and took classical music to play at the office when I worked after hours. Finally, six months in, I brought a tiny boom box to the office and cued up classical and environmental sound tracks in my office. To my surprise, no one minded or reprimanded me. In fact," Kathy jokes, "my boss took to dropping by for five-minute breathers. 'It's so relaxing in here,' he said. In his case, music tamed the savage breast."

Like Kathy, many of us found that forgotten skills and passions could enrich, not inhibit, our work lives. Those who love photography might bring framed photos to the office walls. Those who

love needlepoint might bring pillows to the office couch, a sampler to the office wall. Richard, who loved to draw, decorated his office with delicate charcoal sketches that always drew comment—and a measure of new respect for his "artistic discernment." Andy, an avid rock climber, stocked his cubicle with Sierra Club calendars, framed photos of natural wonders, and a watercooler of "real" water. Catherine has her Washington, D.C., office decorated with antique Mission furniture and old Navajo rugs to remind her of Santa Fe.

Rather than alienate coworkers, these personal touches often endear our students to their colleagues because they are more accurate representations of who they are.

"Once I became more self-disclosing in a positive way, I found those I worked with more open with me in return. I began to forge actual friendships which brought richness and warmth. My office life and my real life didn't seem so separate anymore."

> Music has charms to soothe a savage breast,
> To soften rocks, or bend a knotted oak.
>
> —WILLIAM CONGREVE

Tool: Beyond Price

FOR THIS TOOL, you will need a stack of magazines, a file folder, and scissors. Leafing through the magazines, select and clip the images that speak to you of well-being.

They may be images of filial or romantic love. They may be images from nature or images of human daring and imagination. Select twenty or more images that connect you to an inner sense of wellness. File the images, and take this file to your office. In times of stress or when you seek inspiration, turn to the file for a sense of transcendence.

Tool: Meeting the Inner Rebel

HOW DID YOU "break" your media deprivation? Did you just discount it from the start, letting your Rebel keep you from even trying it? Did you go a few days, partly committed, then stop with a binge of reading or TV watching? Did you make small deals with yourself all along, granting yourself permission to cheat a little bit—say, one TV show a night or just reading a *little* bit?

What does this experience tell you about how you have dealt with authority in other areas of your life? Can you see any patterns that might be affecting your work currently?

CHECK-IN: WEEK SIX

1. Make a list of any pearls of wisdom you have gleaned in your life. What were the most important ones? Why?
2. How are morning pages and time-outs going? Anything different in them during the week of media deprivation? Did your sleep patterns or exercise patterns change? Was the tone of the pages different? Did you do anything differently this week that seems important to note? Did you have more fun? Were you tempted to act up? Did you?

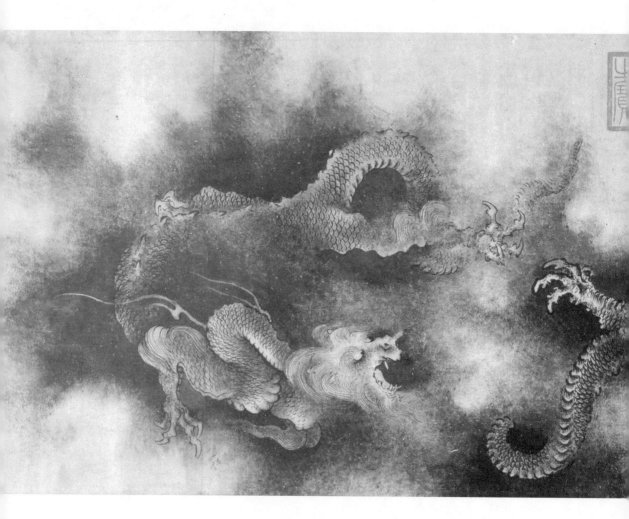

THE FIFTH TRANSFORMATION
LEARNING (AND TEACHING)

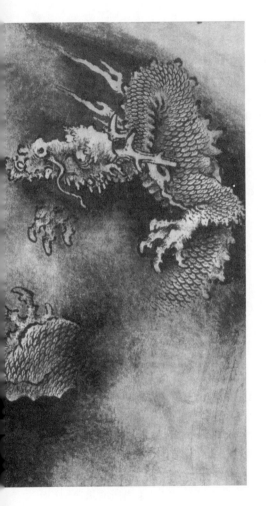

THE TWO DRAGONS pictured here, one appearing older, one younger, represent the inseparable twin processes of teaching and learning. The reciprocity between these two principles at times becomes so ferocious that the dragons here seem almost to be engaged in combat. The fierce interplay of these dragons demonstrates the paradox that to be whole we must play a part in the lives of others. This is the vital dance that the human world depends upon.

WEEK SEVEN

LEARNING
(AND
TEACHING)

LIFELONG LEARNING

THIS WEEK WE turn our attention to prioritizing our lives. Many of our students think that this part of the course pertains to efficiency: how to work faster, get more done, and get to the bottom of their in box in record time. We say that efficiency is nice but clarity is better. What do we mean by that?

When we are clear in our life purpose, our priorities fall into line. Tasks quickly assume a hierarchy of importance, from essential to silly. (You may still have to do the silly ones, but you'll do them with an eye on the larger picture and with the knowledge that small irritants cannot derail you.)

So this is a week of learning, of tapping your deepest desires, talents, and goals. The learning extends, too, to your expression of yourself in your day-to-day work life. We will explore how, in tiny increments, to reshape gently the life you actually have into something closer to the life you actually want. We will examine your losses, wounds, and worries and see what small steps might be taken to mend them. In short, we will practice the skill of survival.

Additionally we will do some personal archaeology. We are, after all, taught how to value ourselves, and by reexamining some of that teaching, we can learn new and more constructive ways to express our value to others. Creativity is like breathing. We must rhythmically expand and contract. We must learn when to add to our creativity "training" program and when to go more lightly. Creative living, as we noted in the last chapter, is a matter of listening, but it is also a matter of acting on that listening, working with life as it currently exists.

AGE AND TIME

FOR THOSE COMMITTED to a creative life, age is a matter of perception. "I'm too old to change" is an intellectual defense many of us use to avoid the vulnerability caused by change. Change makes

us nervous. It makes us feel insecure. In fact, it's resisting change that makes us miserable, not change itself. Electing to change—choosing change as a deliberate, considered course of action—makes us feel powerful and alive.

"I'd think about revamping the department, but I just don't have the time or energy," we say—ignoring the time and energy drain caused by our resisting change.

"I'd think about changing jobs—but I'm just too old for the market," we say—avoiding the legwork needed to see if we might not find a happier niche.

"I'm sure it would help if I were computer-literate, but I think I'm a little old to be learning new tricks," we say, guaranteeing our own obsolescence.

Age is a physical reality that is greatly influenced by our psychological choices.

"You're only as old as you think you are" may be a cliché, but it holds a large kernel of truth. Even in the area of IQ and sexuality, the research proves the adage "Use it or lose it."

For many of us, our ideas of what is age-appropriate were shaped by watching our parents' generation, a generation far less vital, less health-conscious, and even less aerobicized than our own. In our parents' time, fifty was the beginning of old age. In our time, fifty is not even the middle of middle age. Our life expectancy is longer and our lifestyle more active. Our career expectancy is also often longer: Many of us make creative transitions into second and even third careers as our interests and enthusiasms expand and alter.

As creative people we like to pretend that a year is a very long time. If we take a proactive creative trajectory, however, a year is a small investment that may alter the course of many years to come. At the very heart of the age-avoidance block is a denial of process, a denial of ourselves as ongoing, evolving creatures. When we focus on ourselves as works in progress, we regain a sense of adventure and fulfillment. We embrace change as integral to our continual process of unfolding.

Creativity happens in the moment. In any given moment we are ageless and timeless.

Doris was a sixty-year-old restaurateur, a veteran of thirty years in her field. She yearned for a more portable career, one in which she was not tethered to the same site day after day. Her restaurant

> Till the first friend dies, we think ecstasy impersonal, but then discover that he was the cup from which we drank it, itself as yet unknown.
>
> —J. KRISHNAMURTI

> It is better to wear out than to rust out.
>
> —RICHARD CUMBERLAND

was the center of her life, yet she longed to travel. The world came through her doors, but she longed to move out of those doors into the world. "I had simply had enough. I needed a change, wanted a change, and was willing to change myself to get it."

As a part of her creative emergence she began the exploration of outside creative interests. She studied computers. She studied word processing. Doris now works as the personal assistant to a globe-trotting mystery writer. Using her newly learned skills, Doris travels with her employer.

"If I hadn't been willing to be a beginner at computers and word processing, I would never have qualified for the job I now so enjoy," says Doris. "I wasn't too old. I was just old enough."

■ Tool: Being a Beginner

MANY OF US curtail our own growth and expansion by unconscious ageism. Number a sheet of paper from one to ten. List ten hobbies, skills, or interests you would pursue if you weren't too old. Choose one, and do a time-out related to it. Begin to be a beginner.

JEALOUSY

MACHIAVELLI WAS NOT the first or the last to notice envy in the workplace. All of us experience it. Sometimes it comes at us from others as an underhanded remark or as a conspicuous absence of support for what we know to be a superb idea. These are uncomfortable experiences, although they are not so uncomfortable as when our own "green-eyed monster" rears its head, resenting, judging, and coveting.

"I love my friend Harry, but when he got promoted, it almost killed me," says Ted.

"I thought I was mature until we hired a new copywriter and I resented her getting all the attention in meetings," Jenny told us.

"I was doing just fine until my wife got a raise and was suddenly earning more than I did," Patrick confessed. "Suddenly I was biting her head off for every little thing."

At its root, jealousy is grounded in fear: fear that we won't get what we want; fear that someone can take what we've already got;

It's never too late to be what you might have been.

—GEORGE ERNST

The cult of success can become a source of instability for an open society, because it can undermine our sense of right and wrong.

—GEORGE SOROS

fear we are not good enough. Jealousy is a pang, a shooting pain, a dull, throbbing fog. Jealousy comes between us and our generosity, between us and our faith in the world. Jealousy is grounded in scarcity thinking: He's getting what I want, and there's not enough to go around. Jealousy, in short, is painful.

It is also useful.

In Julia's musical *Avalon*, she made light of envy, reminding us that it points us toward what we really want:

> Envy means you're merely mortal.
> It's a portal we pass through.
> All the people that we envy
> Do what we would like to do.

This brings us to the Jealousy Map.

Poverty is not the absence of goods, but rather the over-abundance of desire.

—PLATO

■ *Tool: The Jealousy Map*

IN A CREATIVE emergence jealousy can be useful. It clarifies our dreams and points us in the direction we would most like to go. It also, paradoxically, starts us toward camaraderie with the object of our envy. Watch.

Down the left-hand side of a sheet of paper, number from one to twenty. Then list twenty people you are jealous of. For anything. Petty or grand, it doesn't matter. Now, to the right of the names, make two new columns. Label the first column "*Why?*" Label the other column "*Action Antidote.*" Next to each name list why you are jealous of that person, and then next to that name a small action that would move you toward what you envy about that person.

Name	Why?	Action Antidote
Maria	Speaks Spanish	Take a class
Bill	Knows economics	Go to a lecture
Janice	Great writer	Write three letters a week

Now the most important part. What patterns in the list become apparent? Do the issues relate to character? Experience? Comportment in the world? Education? Finances? The more distinct the pat-

tern, the more effective the map can be. Consider this problem for a while: What are the links (if any) between the jealousies I have.

Pick one small action from your list, and do it.

EARLY PATTERNING

Skill and confidence are an un-
conquered army.

—GEORGE HERBERT

MANY OF US harbor creative dreams or yearning in areas that we have declared off limits for ourselves. We would love to play the piano, but "I'm not musical." We long to start our own business . . . someday. We resent not being paid for our performance, but we do not approach the boss about it. We have an idea for a great product, but we tell ourselves, "I'm sure it has already been done."

This has to stop.

Our dreams contain the seeds of our identity. The "reasons" are the result of our negative conditioning. When given room to grow, our dreams can form the foundation for undreamed-of achievement. The following exercise is aimed at making conscious some of the negative conditioning we received regarding our dreams and aspirations.

■ *Tool: Creativity Quiz*

FINISH THE FOLLOWING statements very rapidly:

The first step . . . shall be to lose
the way.

—GALWAY KINNELL

1. When I was a kid, my dad thought my creativity was ___. That made me feel _____.
2. I remember one time when he _____.
3. I felt very _____ and _____ about that. I never forgot it.
4. When I was a kid, my mother taught me that my day-dreaming was _____.
5. I remember she'd tell me to snap out of it, reminding me _____
6. The person I remember who believed in me was ___.
7. I remember one time when _____.
8. I felt _____ and _____ about that. I never forgot it.
9. The thing that ruined my chance to be successful was _____.

10. The negative lesson I got from that, which wasn't logical but I still believe, is that I can't _____ and be an artist.
11. When I was little, I learned that _____ and _____ were big sins that I particularly had to watch out for.
12. I grew up thinking tycoons were _____ people.
13. The teacher who shipwrecked my confidence was _____.
14. I was told _____.
15. I believed this teacher because _____.
16. The mentor who gave me a good role model was _____.
17. When people say I have talent, I think, _____.
18. The thing is, I am suspicious that _____.
19. I just can't believe that _____.
20. If I believe I am really talented, then I am mad as hell at _____ and _____ and _____ and_____.
21. The things I have learned that make me stronger are _____ and _____ and _____ and _____.
22. The behaviors that I use that make me most proud are _____ and _____ and _____.
23. The skills I have for which I am most grateful are _____ and _____ and _____ and _____.
24. The most important recent change in my attitude is _____.
25. I am most excited about _____.

THE INTELLIGENCE BLOCK

WE SELDOM LOOK at it squarely: Our institutions—academic and corporate—train us to think, but they rarely train us to think creatively. Instead, from childhood on we are trained in the art of *critical* thinking. We are taught to take something apart, not how to put something together. This is deconstructive rather than constructive thinking.

In our popular media the emphasis remains on deconstruction. We read "reviews" that emphasize faultfinding: What is wrong with a film, book, or television show? We seldom read any serious think-

ing about what is right with our creative media and how we can encourage more of that.

Most of us encountered the demon of deconstructionism in our own schooling. We turned in fine papers, only to have them graded in terms of their negative, not their positive, qualities. We were told "Review the use of the semicolon," instead of "This paragraph displays some wonderful original thinking."

Our teachers, often with the best intentions, primarily teach us what is wrong with our thinking, not what is right with it. Grammatical errors, spelling errors, mistakes in logic—these are singled out for our attention. Our positive work—good ideas and creative solutions—is often ignored. We learn from this to focus not on original thinking but on not making mistakes. In other words, we are behaviorally conditioned to be cautious and logical. We are trained to censor ourselves. Out of our multiple ways of knowing and perceiving, we are trained to focus on one modality. We are like a rainbow with only a single hue.

In order to become more fully creative, we must dismantle what we like to call the Intelligence Block. This is the voice within us that hears any nonlinear, nonlogical thinking as "dumb" or "not grounded." Instead of shoehorning all our intelligence into a narrow chute, we need to open the gate a little.

"This may *sound* dumb," we might try saying, "but it occurs to me that . . ."

"It doesn't make logical sense, but it strikes me that . . ."

"I know it isn't logical, but I wonder what would happen if . . ."

Any of these statements nudge open the gate a little and give us room to expand our creativity. If you think of the rainbow as being bands not only of color but also of frequency, you can see that what you are doing is shifting the dial, taking in other ways of thinking.

In order to create freely, we must experience a sense of safety. Safety is what our censor gives us in a backhanded way. Our Censor is like a crossing guard who tries to march our thoughts in orderly rows "for our own good."

When we ask our Censor to stand aside, we are inviting a little more chaos into our thinking, a little more jumble and malleability. The morning pages teach us to think with "I wonder" and "Maybe if."

I have heard him [William Harvey] say, that after his book on the circulation of the blood came out, that he fell mightily in his practice, and that 'twas believed by the vulgar that he was crack-brained; and all the physicians were against his opinion.

—JOHN AUBREY

The most important skill is the capacity to learn from individual experiences, our own and others.

—EDWARD SHAPIRO AND WESLEY CARR

Giving the Censor time off is a learned skill. We practice it daily with morning pages. We develop a sort of shunting system: We hear the Censor, but we steer its concerns to a side track while we write on without it.

This shunting is a transferrable behavior. We practice it first in the privacy of morning pages and next in the arena of action and conversation. We learn to say to our Censor, "I hear your reservations, but I am going to try . . ."

And then we try:

- Putting our thoughts on paper in memos
- Speaking up at meetings and throwing in our two cents
- Listening to colleagues and responding with what we honestly think
- Roughing out proposals for how to revamp the floundering department

Using these tools, we move out of our linear, logic-based thinking and into something more freewheeling, associative, and illuminating. Once we learn to think of our Censor-based critical thinking as only one form of our intelligence, we are free to tap into others, often the neglected stepchildren of the psyche.

Morning pages are not a "waste" of time; even the censor is not a "waste" of time. When we take *time* to practice hearing all our voices, then they can snap to attention in the *moment* we need them. *That* time is effectively used.

Our voices—and the morning pages—help us become more *present*. Morning pages help us to perform well in the time we have when we must, like practicing tennis for the match or an instrument before a performance.

■ *Tool: Feel, Think, Wish*

THE FOLLOWING EXPERIMENT allows you to experience changing frequencies from one band or color of intelligence to others. Think of the following questions as keys to the different forms of thinking available to you. Use them on a problem you are currently concerned with. (These questions are designed as sequential steps. Applying them in order to any given problem allows us to explore solutions from many different vantage points.)

> To the question whether I am a pessimist or an optimist, I answer that my knowledge is pessimistic, but my willing and hoping are optimistic.
>
> —ALBERT SCHWEITZER

> There never was a great character who did not sometimes smash the routine regulations and make new ones for himself.
>
> —ANDREW CARNEGIE

1. What do I *think* I should do?

 This question opens the well-used door to the logic brain.

2. What do I *feel* I should do?

 This question opens the door to intuition, to body knowledge.

3. What do I *wish* I would do?

 This question opens the door to constructive intelligence.

4. What would I do if it weren't impossible?

 This question locates and expands perceived limits and possibilities.

5. What action plan can I make that encompasses all these possibilities?

GETTING CURRENT

THIS WEEK YOU have been deepening your self-understanding with the goal of expressing yourself more authentically and creatively at work. Of course, actually doing so can be quite another matter. When we're in our work setting—perhaps enthused by an idea we love but unsure how to pitch it to skeptical colleagues; perhaps feeling intimidated by a boss or caught in a political squabble; perhaps trying to ride out a crisis or a deadline—we can be thrown by the currents swirling around us. Rather than be caught in the current, we recommend "getting current."

Kenwyn Smith and David Berg say that "a group works best when members know each other's strengths and weaknesses, abilities and disabilities, and when the group's tasks and ambitions are well matched to the limitations of its members."

Lee uses getting current whenever he has a complex meeting ahead of him, whether business or social. He jots down all his thoughts and feelings, just to get started and help center himself.

Here, on the page, he is able to say the difficult things that, left unexpressed, might send him into his meeting with his emotions running too high or low or his thinking too murky for him to articulate his position clearly.

By getting current, Lee gains an important moment of reflection that makes him aware of his own preconscious content at that moment. He is then able to say difficult things in an unthreatening

manner that increases the likelihood that he will be heard and understood, and he is better able to hear and understand what others are saying without the distortion of his own biases or filters.

■ *Tool: Getting Current*

TAKE A BLANK sheet of paper. Draw a vertical line. Label your left-hand column "Unsayable." Label your right-hand column "Sayable." Reviewing your current circumstance, fill in each of the columns.

This tool has a dual effect. It allows us to become conscious and comfortable with our own unconscious material. It also allows us consciously, slowly, and discreetly to move pertinent "unsayable" feelings and insights into the realm of the "sayable."

Now, as organizational guru and Harvard educator Chris Argyris might have you do it, imagine a conversation with a superior or colleague over a specific issue of contention. In the right-hand column write both your responses back and forth. This is how you imagine the actual conversation to go. Now in the left-hand column, as you look back over the conversation, what would be your *unsaid* responses? What do you think would be your colleagues' *unsaid* responses?

In the left-hand column is the key to better understanding and effective communication. We often assume answers from others that are different from those we do receive.

SHOW OFF AND SUFFER

ALTHOUGH OUR CULTURAL mythology would tell us otherwise, creativity is about comfort. When we are creatively alive and awake, we are comfortable in our own skins, in our own sizes. Yes, we have aspirations, but we also have the realistic hope and expectation of fulfilling our aspirations. Many of us find the process of creative emergence to be a process of dismantling our dysfunctional defenses that have long served us and learning more authentic ways to serve ourselves and others.

We all have done things to appear more formidable than we are, things we have done out of insecurity, things we later regretted. Our friend Mary Russell coined the phrase "show off and suffer" to

> Cowards die many times before their deaths; the valiant never taste of death but once.
>
> —WILLIAM SHAKESPEARE,
> *JULIUS CAESAR*

describe this behavior. "Every time I show off in some way," she tells us, "I suffer." Many animals, perceiving a threat, bluster defensively by spreading their feathers, making their fur stand on end, rearing up, and roaring their self-importance to cover their fear. Think of the blowfish afraid to be eaten, the cobra spreading its collar to enhance its threat, the peacock trying to win the mating game by opening its fan.

Consider Bob, who became a kind of human peacock, spreading his fan in a vain attempt to impress. A stockbroker with a prestigious firm, Bob was on his way up. To realize his next goal, becoming a floor trader, he had to appear before the licensing board, a potentially harrowing experience.

Preparing all the necessary documentation for this meeting, Bob began to feel increasing insecurity about how his financial situation might appear to the panel. He had gone bankrupt some years before, and though he had worked hard to pay back his debts, he still owed money. Nervous about how his financial statements would look, he decided to revise his documentation to include his new wife's income as well. Telling himself that he would now appear to be a shrewd money manager, a comeback kid, Bob felt sure the panel would find him worthy of its approval. After all, he was at least being candid about his remaining debt. He looked over his materials one last time, decided he had portrayed himself in a sufficiently flattering light, and went off to the licensing hearing. Confident his colorful tail feathers were in working order, even if several of them were borrowed, he began his peacock strut.

The meeting started well enough. The members of the panel asked relatively undemanding questions while shuffling the pages he'd given them. There were one or two silences that made Bob nervous. To counter that sinking feeling, he decided to spread his peacock's fan. He told the panel of a recent media project he'd proposed that was under consideration by CBS. He let drop that he'd been recruited by a high-powered firm in New York. He had an idea about this, an idea about that. It was all calculated to demonstrate that he was worth betting on.

The panel listened attentively, nodding at all the appropriate moments. Then it rejected his application.

Bob was crushed. The peacock had become a feather duster.

Through pride we are ever deceiving ourselves. But deep down below the surface of the average conscience a still, small voice says to us, "Something is out of tune."

—CARL JUNG

The most fundamental assumption of the underground managerial world is that truth is a good idea when it is not embarrassing or threatening—the very conditions under which truth is especially needed.

—CHRIS ARGYRIS

His longed-for promotion was now out of reach; in fact, it now seemed unlikely it would ever happen.

A few days later Bob called one member of the panel and asked him to discuss the reasons for his rejection. The man agreed to meet with him and told Bob, gently but firmly, that the board had concluded that with an income as large as his, he should have been able to pay off more of his debt. "Frankly," the man said, "you also seem to have an awful lot of irons in the fire. We all wondered how you could devote the necessary attention to being a dependable trader."

Research suggests that people with some kind of daily meditative practice, some well-developed means for observing their own thoughts and feelings about a situation, are less likely to lie and even less likely to lie to themselves about lying (as Bob did, rationalizing his falsification of his financial reality).

What if Bob had developed the habit of checking in with himself frequently? What if he had done a page of "getting current" before the hearing? What if he'd made acting with integrity his goal and acknowledged that beyond that, he was unable to influence the outcome of the meeting? This kind of self-appraisal yields an authenticity that wise people acknowledge regardless of the humble truth it might require. Bob's grandiosity had forced him to suffer.

Imagination and self-reflection are two primary conditions for our psychological development.

—EDWARD SHAPIRO AND
WESLEY CARR

■ *Tool: The Hidden Résumé*

MANY OF US find ourselves tempted to show off out of a variety of feelings. This tool brings renewed security and esteem. Set aside one hour of private time. Taking pen in hand, list at least ten circumstances in which you have done work for which you have never been credited either officially or by your own self. For example, Karen functioned as a ghostwriter on her husband's doctoral thesis; Ralph redesigned his division's sales strategy; Caroline revamped her company's newsletter. By acknowledging and crediting our authentic, disregarded accomplishments, we are helped to avoid the need to show off and suffer.

THE GRANDIOSITY OF THE WOUNDED

BY THIS POINT in our process, you may feel a diminution of fear and an increased sense of optimism. Your work with morning pages, time-outs, and other tools will have brought you to a plateau of new possibility. With increased objectivity and candor you may find yourself able to review and revise business behaviors that no longer serve you.

Many of us suffer from the grandiosity of the wounded. Bob, the peacock, certainly did. This is the false bravado and arrogance that we sometimes carry as the result of hurtful experiences in the past, whether in our careers, our educations, or even our childhoods. We have all made claims that we couldn't back up in an effort to have others like us, to cover up an error, or to shield a weak link in our armor. When an adult displays this grandiosity, it is often misinterpreted as arrogance or indifference, although it is really meant to shield a childlike vulnerability. The problem is that protecting that childlike part keeps it childlike.

The grandiosity of the wounded often keeps a person jumping from one opportunity to another. Defended and defensive, such a person fails to see what is being offered or decides that he or she is too talented, smart, or powerful to put up with even the most minor slights or vexations. This arrogance can lead even very smart men and women to "look a gift horse in the mouth," costing them opportunity after opportunity.

For example, Bruce was an arbitrage clerk on the trading floor of a large midwestern exchange, buying and selling Treasury bonds for a midsize brokerage house. Watching the money that the traders made was what had inspired Bruce to enter the business in the first place, and by now he had worked in several clerical positions. His company saw that he was a talented, dependable young man and agreed to pay his tuition to college. But Bruce wanted to be on a faster track to the fulfillment of his grandiose dreams. College would take years. Soon the lure of big money led him into work for a less-than-reputable trader, a once-respected powerhouse who had been broken by dint of his own greed. Bruce fell for the first of the grandiosity traps: thinking that risking one's integrity for big money is worth it. He was building a mansion of glass.

Despite initial reservations, Bruce left the trading floor for the

Nobody realizes that some people expend tremendous energy merely to be normal.

—ALBERT CAMUS

We have been taught to believe that negative equals realistic and positive equals unrealistic.

—SUSAN JEFFERS

sales office of this former icon. Bruce made very good money, but because of his boss's unsavory practices, regulating agencies eventually shut the office down. Bruce was out of a job and the promise of an education, and he narrowly escaped with his license to trade intact.

Still convinced he could make money as fast as anyone else, and hoping for the big lucky break that so many of the grandiose wounded count on, Bruce decided to start his own business. He borrowed money from everyone he knew and even sold his car to fund his first small office.

We might say here that you have to admire his guts. Bruce not only didn't let a near-fatal career decision defeat him but decided to show the world that he was no loser!

On the other hand, you might notice that once again he had suffered a wound, and that instead of trying to learn what the experience could teach him about himself, he responded with the grandiosity of the wounded.

We would be the last ones to argue against the entrepreneurial spirit, but every year one million Americans go bankrupt. Many of them were convinced they could start a new company in a business they had never even worked in.

Bruce had little experience in the business he was entering. He had never managed a business; he had done clerical work and sales. Bruce did better, however, than most new entrepreneurs who squander money on frivolous expenditures instead of starting small and letting the growth of the business dictate the size of the office and the expense accounts. Still, he found himself undercapitalized, and like most entrepreneurs, he went looking for an infusion of investment capital to stay afloat.

This is where Bruce fell prey to the second grandiosity trap: the "I want my own business" trap. A well-known and well-respected trader who had made millions met with Bruce to talk with him about plans for his company. The trader told him, "Bruce, I don't want to fund your company, but I will invest in you personally, and you can come to work for me. I will pay you very well and allow you to share in the profits, and you will learn from me everything you need to know to be very successful in this business." Bruce thought about the offer but eventually turned it down, telling himself that he wanted his own name on the door, even if it was a small

> The most exhausting thing in my life is being insincere.
>
> —ANNE MORROW LINDBERGH

> Experience is the toughest teacher because she gives the test first, and then the lesson.
>
> —UNKNOWN

company. Within a few months, however, the doors of Bruce's company had closed for good, and he left the field entirely, embittered and feeling wounded once again.

The lure of owning our own businesses can blind us to opportunities staring us right in the face. Had Bruce been willing to look at his work as a service to his customers instead of as a service to his ego, he could have secured for them the help of one of the most successful traders in the world, helping himself immeasurably in the process. Bruce would have acquired a hands-on education second to none, and he might finally have healed that old wound of insufficiency he kept reopening.

The third trap of grandiosity is the myth of self-sufficiency: the "I'm a self-made man" syndrome. This syndrome can engender a spiral of isolation that can leave us broken and undone no matter how much money we may accumulate.

Richard was a self-proclaimed self-made man. He began a small business selling auto parts in a big midwestern town. Over a twenty-year career he opened store after store and built the chain into a highly successful operation. When he started out, he worked all the time, often putting in eighty hours a week or more. "After all," he said, "it's my name on the door."

True enough, and it was his vision and drive that built his dream into a major business that paid him a million dollars a year. However, like many entrepreneurs who build lucrative businesses, Richard was so driven by his image of himself as a self-made man that he found it impossible to delegate work. This "old dragon" needed to learn a new trick: the art of teaching others and of letting himself be taught by them. Never able to face the idea that he could be replaced, he dismissed the efforts of his subordinates to prove themselves and help him run the business. Manager after manager came and went as Richard found something lacking in each one of them. Richard worked harder and harder, feeling more and more alone. He was in a spiral into painful isolation. This spiral starts, particularly for men, with the honorable intention of providing for their families. We often seek to prove our worth by working hard and "bringing home the bacon." The problem is that the skills that normally propel us to the top of the business world are not the ones required for intimate conversation at home.

Truth is completely spontaneous. Lies have to be taught.

—R. Buckminster Fuller

Love truth, but pardon error.

—Voltaire

People who are successful in the business world often feel like fish out of water when they're home. This difficulty with intimacy can propel them into spending more time in the work world, where they feel more successful.

Soon this spiral creates a strange equation: "The more I succeed, the more I am away from my family, and the more I am away from my family, the more successful I am."

For Richard, this spiral had progressed to the point where despite making a million dollars a year for many years, he had been unable to delegate work to trusted lieutenants. Not only did he not have any trusted lieutenants, but he had less and less talent to rely on, since the word on the street was that working for him was a dead end. At the end of Richard's spiral, his wife was divorcing him, and his children had grown up without really knowing their father. In what seemed to him like the blink of an eye, Richard went from being a brash young man on the way up to being a wealthy, miserable divorced man having to relearn how to be intimate with loved ones.

Without the humility of seeing himself as a worker among workers, who indeed was supported in many ways by many people, he held on too tightly to his illusion of self-sufficiency: being a self-made man. Some wound in his past resulted in his fear of intimacy, but rather than explore what he might learn from a courageous exploration of that fear, Richard escaped into a kind of medicinal grandiosity, the all-too-common delusion that only he could be trusted to run the show. His fear and his grandiosity were two sides of the same coin. His unexamined woundedness kept him isolated from those he loved and from able men and women who would have gladly helped him shoulder his burdens so that he could have had a fuller life—and a longer one.

For many senior executives today, it is a fact of life that their days are scheduled in fifteen-minute increments from 7:00 A.M. until 6:00 P.M. But our time at work isn't some other kind of time; it is the time our lives are made of, and leading life this way can only result in burnout and confusion.

Taking the time to notice yourself in Richard's story may help you to pull out of that spiral into a more manageable lifestyle that will allow you to live long enough to enjoy the fruits of your labor. Finding the time for morning pages and time-outs helped Richard

Everything that deceives may be said to enchant.

—PLATO

What is the first business of one who practices philosophy? To get rid of self-conceit. For it is impossible for anyone to begin to learn that which he thinks he already knows.

—EPICTETUS

finally back away from his eighty-hour weeks just long enough to begin to feel the pulse of his own life again. It is never too late to learn to be intimate or to repair some of the damage of the grandiosity of the self-made man. Then those around us can share not only in the credit for helping us become successful but also in the *whole* life of the man they have been missing.

What Richard needed was to learn to trust his subordinates, to trust that they were able and competent businesspeople who as a team could keep the office running. He then could devote time to other things, like for the first time ever spending a day fishing with his son.

Grandiosity can be overcome by learning to be secure in what really matters and by not depending on getting our names in the trade journals or on the business pages to prove our value. Real ambition is different from trying to prove oneself worthy to compensate for an earlier wound. Success is sweet only for those who have not lost the ability to taste it.

The grandiosity of the wounded prevents the kinds of relationships necessary to grow and learn. It makes creative exchange impossible. Without the dynamism of teaching and learning, the creative spark dies and life becomes empty and sad.

Tool: Becoming Right-Sized

VERY OFTEN IN our work lives we reach junctions at which are must choose between grandiosity and humility, between being an oversize hero and being a worker among workers. In our desire to succeed we often indulge in grandiose behaviors that isolate us from our peers.

Number a blank sheet of paper from one to five. List five problems or situations, personal or professional, in which you could ask for help, support, or guidance. Who would you ask?

THE ART OF UNDERSTANDING WHAT IS REALLY BEING SAID

NOW LET'S TAKE the process of attunement one step further. David Bohm, the quantum physicist, tells us that we are active participants

> I believe in an open society because it allows us to develop our potential better than a social system that claims to be a possession of ultimate truth.
>
> —GEORGE SOROS

in a reactive energy field, that as we think and move, the universe moves with us, in what he calls participatory thought.

In our business lives, our quickened creative intelligence can stimulate a quickened creative response—a creative contagion. As we give others our active attention, we catalyze their creativity as well as our own. Our work together both deepens and accelerates.

When creative executives listen in business, they keep four questions in mind:

> Forgive your enemies. It will drive them crazy.
>
> —ANONYMOUS

- What is the agenda of the person speaking?
- What is actually being said?
- What are the implications of what's being said to those hearing it?
- How can the outcome be influenced, if necessary?

To listen well requires a great deal of focus, energy, and attention to detail. It also requires you to listen to emotions, not just to facts, and to understand the players—speaker and audience—intended and otherwise.

Many of today's business experiences, with consortiums and alliances as the preferred structures, provide a wealth of examples demonstrating how necessary it is to listen in the context of the four questions because often these organizations are made up of competitors and partners, executives from diverse industries and backgrounds, with multiple agendas involved.

Understanding these agendas means having a good personal and professional knowledge of the people involved. This includes what an individual's company wants as well as his own personal agenda—maybe to find a new position or get his ego massaged. By doing some research, talking to others, and getting to know people one-on-one, you will be more attuned to where others are coming from on any given issue.

Accurate, personal knowledge helps you in at least two ways: to frame issues from their individual perspectives and to be able to understand where their "hot buttons" are, whether good or bad. Often the best crash course is to create a social setting in which you can use humor and informality to better understand one another's agendas.

Listening to the facts is fairly easy. It requires you to listen to words and their meanings carefully and to use techniques like re-stating the point or asking questions in order to clarify and be sure that what you're hearing is what's being said. Catherine recommends taking notes at all meetings (even the so-called unimportant ones, just to strengthen the habit) in order to capture your own thoughts at the time and to remind yourself of points that need clarification.

> While listening may be the most undervalued of all the communication skills, good people managers are likely to listen more than they speak. Perhaps that's why God gave us two ears and only one mouth.
>
> —MARY KAY ASH

Along with listening to the facts, however, you can be thinking about their implications; notes help point to those issues that will have the greatest impact and will need to be revisited. Sometimes the implications of a statement or decision have to do with people who are not in the room and who may later get a slanted version of what's been said. Remember that facts can be, and often are, easily distorted by others' agendas. No meeting is private as long as two people or more are together. People naturally think of things in terms of implications to them—their jobs, their salaries, their work-loads—and they pass that on to others.

Influencing the outcome is where your listening skills pay off. If you've listened to the facts and taken into consideration the agendas on the table and the implications you've discerned, you can begin to orchestrate the group's understanding by making those observations part of the discussion. Once issues are in the open, people tend to want to resolve them in ways that forward their agendas, and they are generally at that point more willing to consider others' viewpoints.

▓ Tool: Taking Note

CHRIS ARGYRIS SPEAKS of "right- and left-hand columns" of thought in which the right-hand column represents what is spoken—the public speech that is part of our formal business interactions—and the left-hand column represents the unspoken material that we think but do not say. This unspoken material is often important material for the group because in this left-hand column reside the assumptions, prejudices, resentments, hopes, and preferences that for one reason or another, often out of fear of threat or embarrassment, we keep to ourselves. Material from this left-hand column forms the stuff of many an informal hallway or watercooler conversation. Often

we bring home this hidden discourse to our spouses, but share little of its emotional or intellectual content in meetings because it seems too risky.

This tool is to be practiced in the trenches. At your next business meeting, take a blank sheet of paper, and draw a vertical line. Label your left-hand column "Unsaid." Label your right-hand column "Said." Reading the meeting for body English as well as the spoken word, record your impressions. (No need to share your observations.)

Trust requires risk, but it yields more trust. More trust yields more honest communication, and more honest communication yields more effective and creative solutions to questions.

> Reminding one another of the dream that each of us aspires to may be enough for us to set each other free.
>
> —ANTOINE DE SAINT-EXUPÉRY

THE ECOLOGY OF RELATIONSHIPS

IT IS A central paradox of creative emergence that our growing inner autonomy renders us user-friendly to our creative colleagues. Less influenced and threatened by others' agendas and expectations, we are paradoxically more capable of true cooperation.

We work within a layered network of interconnecting relationships, a kind of ecosystem in which many disparate interests are held in a dynamic balance. Just as a myriad rain forest is home to creatures, each of which plays an integral part in the whole, so a business is comprised of a wide variety of people who bring their own understandings, skills, problems, insights, needs, and energies to bear on the company's mission. Each person also has a specific role in the creation and maintenance of the company culture. Most of us understand this intuitively. We profess to honor diversity, tolerance, and harmony. Why, then, does it seem that the quality of life in America's companies is in decline?

One reason lies in the fact that we seldom take the time to teach anymore. We dismiss those who do not meet our expectations, those who do not conform to our—or the company's—ways of doing things. We forget the power of melding behaviors, finding it easier to write people off. Unfortunately this way of approaching workplace relationships breeds a contagious fear and negativity that undermine everyone's best efforts. Soon we find ourselves written off in turn, and the downward spiral of fear, doubt, and insecurity continues and accelerates.

> Business, after all, is nothing more than a bunch of human relationships. It's one guy comparing notes with another.
>
> —LEE IACOCCA

How much more rewarding it would be to see our company as a dynamic and beautiful rain forest, complex beyond our limited understanding, not only a collection of living creatures but itself a living entity?

The creative ecology in companies is often noticeable only by its absence. When people are not nourished and treated as important, the whole ecology begins to tend toward extinction. The world of work becomes devoid of spirit, dreary, and stale. No one is comfortable enough to operate instinctually, spontaneously, creatively.

What is the "goal" of the rain forest? What would be its mission statement? Well, it might go something like this: "Rain Forest, Inc., is a publicly entrusted corporation dedicated to preserving the many relationships that nurture creative exchange and generate business."

Too many American businesses fail to preserve the many relationships that nurture creative exchange. All too often a narrow focus on personal aggrandizement destabilizes and erodes the entire ecology of the company. This erosion soon spreads into other areas of the culture as people cease to feel like a team. Work becomes what you must do to pay the mortgage, send the kids to college, pay your life insurance premium. Those who find no joy in their work come to expect none and unconsciously teach their children to expect the same. The quality of American life is threatened by this spreading epidemic of disillusion and indifference as surely as the natural environment is threatened by the ravaging of our rain forests.

How do we reverse this process? How do we promote a healthy workplace ecology in which complex balances are restored and creativity is encouraged?

The secret lies in the contagious quality of creative energy. The good news about a complex interdependent web of relationships is that a change can begin almost anywhere in the ecosystem and vibrate up and down the system. It matters less where you are in the company hierarchy than that you understand that along with your own creative emergence comes the potential to revitalize those around you. Creativity calls forth others' creative energy. Call it creative contagion. Call it inspiration. Call it your personal reforestation program.

Organizations learn only through individuals who learn.

—PETER SENGE

If you make believe that ten guys in pin-striped suits are back in a kindergarten class playing with building blocks, you'll get a rough picture of what life in a corporation is like.

—LEE IACOCCA

▪ Tool: Nurturing Nutrients

THIS TOOL ASKS you to be proactive on your company's behalf. All of us carry within us the healing power to alchemize our work environments positively. This week we ask you to practice two key behaviors that encourage a sense of safety and creativity: encouragement and witness.

Once a day every day this week deliberately extend to a colleague positive encouragement and reinforcing witness. For example: "Gayle, I loved your idea in this morning's meeting." Or "Ted, I really sympathized with your frustration about production." Such collegiality nurtures effective teamwork.

LIVING IN THE PRESENT

CREATIVITY IS FLUID and adaptive. It welcomes change, initiates change, and survives change. It is evolutionary and revolutionary. It must be to survive.

As any veteran of the corporate world will tell you, the bottom line is survival. This is not to say that the business world is a hostile place, but it is an environment in which we must be alert and self-guided. This week's tools were designed to help you unlearn old patterns of interaction and learn new skills for more self-attuned survival.

As we've noted, it can be useful to think of business as a forest environment. It is comprised of flora and fauna, some of which are known and familiar. Moving through that forest are creatures that can be dangerous to us if we do not learn to identify them and respond with appropriate action. Also in that forest are aids and helpers that may come to us in unexpected forms. These too we must learn to identify and utilize.

The corporate forest, like any forest, has seasons of growth, seasons of abundance, seasons of decay and scarcity, and seasons of gestation. Careful observation teaches us that change itself is the only thing that can be counted upon to continue. Knowing this, we are able to inhabit uncertainty by applying the paradox of certainty: This too will pass.

"You may think of my morning pages as a flora and fauna report," says Julia. "You record life in your part of the forest and

> For most people, experience in a business organization constitutes a major dimension of their lives. For them the exploration of values and beliefs in that setting is crucial and far from abstract. Profound emotions, both conscious and (as we shall also argue) unconscious, are involved.
>
> —EDWARD SHAPIRO AND WESLEY CARR

look for where you need to react or respond. I think of it as an anthropology field report."

"I see it like a game plan," says Mark. "I try to observe my team and theirs accurately and devise appropriate strategies."

"For me it's a kind of miniature strategic plan," says Catherine. "I evaluate my environment and look for where we can be most effective."

No matter how you state it, the habit of accurately surveying your environment is indispensable to business creativity. Noting the possible dangers and probable windfalls is also indispensable. So is knowing what kinds of creatures you are dealing with. Sometimes it is useful to use the analogy of the natural world to understand our hugely technological one better. The element of play allows us to name accurately circumstances that our rational mind is still busy being aloof about. The metaphor helps us think outside the narrower parameters of our usual cognitive habits.

In the phrase of Howard Gardner, we have "multiple intelligence." Others refer to four realms of experience: physical, emotional, mental, and spiritual. The following game is designed to help you look at your work environment using the full complement of your intelligences.

■ Tool: The Forest Environment

ANSWER THE FOLLOWING questions as rapidly as you can:

1. Describe your business environment. What kind of forest is it? A jungle? A maple forest? Western? Eastern? High altitude or low?
2. Name the dangerous situations in your forest. Any possible flash floods? Mud slides? Places where you must be alert for snakes? Rock slides? Mountain lions?
3. Name the dangerous predators in your forest. Give them animal identities. Any bullying grizzly bears? Cunning sidewinders? Wily foxes? Deadly scorpions? Which are you?
4. Name and describe the beautiful elements of your forest. Any waterfalls, meadows, bushes heavy with berries?
5. Name the friendly plants and animals in your forest.

Life is not a problem to be solved, but a mystery to be lived.

—THOMAS MERTON

Cooperation is as much a part of the system as competition, and the slogan "survival of the fittest" distorts this fact.

—GEORGE SOROS

Working on this seemingly whimsical exercise, Carl discovered he had many feelings and intuitions about his corporate environment that he had never fully metabolized.

"Mine was a western forest. The office bully was my grizzly; he even usually struck when hungry, before lunch! We had a flash flood situation in an understaffed division that was on the brink of sudden expansion. I called one colleague, Laura, my aloe vera plant. Her presence soothed all of us, and she always knew how to take the sting out of someone's burning criticisms. My rattlesnakes came out just as snakes do—in late afternoon, at the day's end meetings where everyone was tired and less defended. Two of them became very clear to me as dangerous personalities as soon as I asked the question."

Jean's work environment, a children's book publishing company, was a New England fall forest. "I saw that we had many beautiful elements: the meadow of production, the clear stream of books, the bright birds of our fine writers and illustrators. I saw that I loved this forest but that some of my colleagues were like jealous squirrels, greedy and competitive with one another, grabbing for ideas and hoarding credit instead of sharing. I saw that I was the doe that needed to learn when it was safe to go into the meadow and when I should stay secluded. I saw my boss as a great aging stag trying to defend his territory and threatened by too much change. I saw some of my colleagues as young bucks wanting glory before they were really able to lead."

Andy's forest was a dangerous battlefield. He experienced stunning clarity as the result of this exercise: "Snipers were everywhere. So were land mines. I never felt safe. My boss frequently put his men at risk. Colleagues were devious and couldn't be trusted not to ambush one another. This exercise made me realize I really wanted to change jobs. It was the spur I needed to start looking. When I did, I asked myself of each company, 'What kind of forest is this?'"

We cannot live only for ourselves. A thousand fibers connect us with our fellow men; and among those fibers, as sympathetic threads, our actions run as causes, and they come back to us as effects.

—HERMAN MELVILLE

CHECK-IN: WEEK SEVEN

1. If you have gotten this far, your morning pages are by now trusted allies. What positive changes are they suggesting?

2. Consistency with time-outs is pivotal. At this point we suggest you renew your commitment to them. A sense of adventure is important to this work. Scan this week's newspaper for one-"time"-only opportunities.

3. Are you practicing a truly open mind? What benevolent or useful synchronicity did you notice this week?

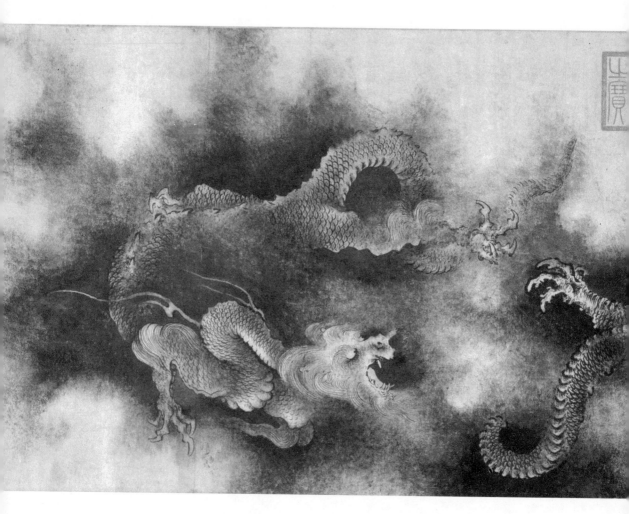

THE SIXTH TRANSFORMATION
TEACHING (AND LEARNING)

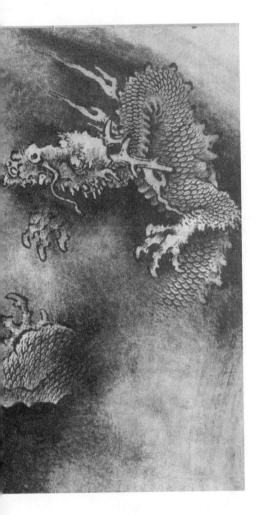

SPIRITUAL MASTERS HAVE warned for centuries that wisdom cannot be contained. If you try to hold its powerful energy inside, it will destroy you. When we give freely of what we have learned, we teach by example, and the creative exchange that results fills us again and again with new understanding.

It has been said that you cannot give what you do not have, but it is also true that you cannot keep what you have without giving it away. Together, teaching and learning are the soul of creativity. Our creative vitality arises from our generosity as teachers coupled with our humility as learners. The two cannot be separated; they are the very heartbeat of the creative self.

TEACHING (AND LEARNING)

THE INFORMATION AGE

THESE DAYS THE new medium of exchange between people—as much as money, goods, services—is information. Useful information is more valuable than gold. The sharing of this information is a complex shuttle back and forth between the twin processes of teaching and learning.

When we get caught in attitudes or behaviors that cut us off from our best work or from useful exchange with others, the profitable flow of information is distorted or stopped completely. We suffer and the organization suffers with us. We can learn to avoid the traps that impede clear and satisfying interaction. When we set a better example, others have an opportunity to improve as well. The organization's power is lifted up, enhanced, intensified. And so is ours.

This week we will explore some of the impediments, both personal and organizational, to the free exchange of ideas, to the creative interplay of teaching and learning, to the progress of your journey. The most important information of the future will be how to function creatively in a group.

THE ROLES WE PLAY

IN YOUR WORK with the tools to date, you have performed a considerable amount of what we call spiritual chiropractic. Your own position and perspective are far clearer than when you began, both on the page and in the moment. You are far more able to articulate your truth.

Without bravado, without posturing, without grandiosity or defiance you are becoming more able to state the facts as you see them, bearing in mind the validity of other perspectives. This capacity for grounded self-disclosure is the gift of speaking truth to power. Rooted in your inner power, you are able to render unto Caesar that which is Caesar's, and unto God that which is God's.

From the balanced point of integrity, business dialogue becomes creative and noncoercive.

Sometimes it is necessary to speak your truth not only to subordinates, but also to colleagues and superiors, generally a harder task. In some companies, the hierarchy is so rigid that communication flowing downward is usually negative, while upward communication is almost always skewed to the positive. Needless to say, it's hard to get an accurate view of how things are going in such a company. The fact is that many people are afraid to share their truth with those above them, especially when it can be read as bad news. As the *Titanic's* first mate was heard to report, "It's nothing, Captain. Just a little bump. I've got everything under control." It requires courage to find one's own voice in a group, to speak with personal authority in the presence of institutional authority.

In hierarchical structures, individuals' reluctance to speak up is more often the result of hidden organizational dynamics than of personal inadequacy or apathy. Psychoanalyst Wilfred Bion (and others from the Tavistock Clinic in London and the A. K. Rice Institute here in D.C.) gave us a way to describe and understand group dynamics that can help us understand the difficulty people have in speaking truth to those in power.

Bion's most important concept is that a group has unconscious emotions and motivations just as an individual does, and that people all have certain propensities, or valences, as the result of their backgrounds that make them especially suited to fill certain roles within the group.

Often people are sucked into certain roles on behalf of the group. For instance, others may feel but deny what the cynic, for example, expresses. When the roles people play are seen as a group phenomenon, then we can stop the scapegoating—or hero worship—that gets in the way of working as a team.

For instance, certain people may carry the group's needs for heroic action, cynicism, risk taking, caution, humor, and so on. Just understanding this simple idea can go a long way toward relieving the tensions that can arise between colleagues and undermine their work together—relieving coworkers of our resentment or superhuman demands—once we realize they may be unconsciously filling roles or carrying emotions the group has assigned to them.

Maybe it isn't just Charlie who is cynical, or who is relentlessly

> There are two kinds of adventurers: those who go truly hoping to find adventure, and those who go secretly hoping they won't.
>
> —WILLIAM LEAST HEAT MOON

> If a man can write a better book, preach a better sermon, or make a better mousetrap than his neighbor, though he builds his house in the woods the world will make a beaten path to his door.
>
> —RALPH WALDO EMERSON

optimistic, or who always insists on "getting down to brass tacks." Maybe Charlie is playing an important role for the group, based on his own valence for skepticism, optimism, or practicality. Perhaps in this same way other members of the group are mirroring the group's hopes, fears, and anxieties.

The person who has been sucked into a role by the group is often assigned the least palatable emotions, letting everyone else in the group off the hook.

George, for example, who owns a hundred-plus-person high-tech company, has an employee, Howard, who is always negative. In meeting after meeting, the group made fun of Howard, using derogatory language the moment he walked out of the conference room. George, a world expert in his high-tech field, was puzzled: Nothing seemed to please Howard, and George was fast approaching the point of firing him for what he perceived as his negative "drag" on the group. On the other hand, George had to admit that Howard's remarks were sometimes prescient, pointing to problems that only later came fully into view.

Using Bion's model, we can say that Howard has a positive valence for being the negative voice of the group and may be expressing the skepticism that the others in the group are unwilling to express.

As George deepened his understanding of group dynamics and individual valences, he saw that if he fired Howard, not only would he lose someone whose sobering voice had at times proved important, but once Howard was gone someone else would inevitably be sucked into the role Howard was filling for the group.

George understood, upon reflection, that his company had evolved into a kind of ecosystem in which each member of the group played an important and often unconscious role. It was as if each person had an unwritten or unofficial job description.

As George became familiar with this concept and thought about all this, he no longer saw his employees' negative thoughts as a personal attack on the company, but as the voicing of important undercurrents. Howard, for one, had been offering George information he could use by voicing the worries and fears of the group. This allowed George to help his company become a place of candor, where even those thoughts that might be considered threatening or embarrassing could be expressed.

Everyone thinks of changing the world, but no one thinks of changing himself.

—LEO TOLSTOY

I can't understand why people are frightened of new ideas. I'm frightened of the old ones.

—JOHN CAGE

With this new perspective, George was able not only to understand the dynamics that had earlier threatened to polarize or block the group from effective action but also to help the group members "own" and express their deeper feelings, and his company has a stronger sense of cohesion as a result.

Now, when Howard is being especially negative, George can intervene by asking the other members of the team if they have thoughts similar to Howard's about the issue. This helps remove Howard from the role of critic as the other members of the team take back their own projected fears that Howard had been voicing for them.

If we begin to view groups as more than just a grab bag of individual opinions, then we can begin to ask important questions about the group as a whole, such as: Who is empowered to speak on the group's behalf? Who is chosen by the group to "face off" with other members over certain issues? Who is silent? Who is belligerent? How do I function in the group?

David Kantor, a family systems therapist from Cambridge, Massachusetts, says you can do four things in a group: Lead, Follow, Oppose, or Bystand. It seems that any of these roles can derive from a positive and proactive stance or a negative and reactive stance. For instance, the Bystander can be standing by proactively — waiting to see how best to help — or reactively — opposing in a passive manner, waiting to be covertly oppositional around the watercooler in the informal groups that form outside the offices of power. This model, too, can be useful in helping us decode the complexities of relationships between colleagues.

> Everybody gets so much information all day long that they lose their common sense.
>
> —GERTRUDE STEIN

▮ Tool: Roles

LEARNING TO VIEW our relationships in terms of roles and role-playing allows us a more detached and even playful sense of self that paradoxically results in greater feelings of safety and autonomy.

Take a blank sheet of paper. Write down the words "Lead, Follow, Oppose, Bystand" across the top. Under each heading, list the names of those in your group who habitually fill these roles. Where do you fit in?

Now list the words "Optimist, Pessimist, Realist, Visionary." Place the people in your team under the appropriate heading.

Which roles do you tend to play? How does this affect your choice to oppose, follow, lead, or bystand?

IDENTITY AND BAGGAGE

In all chaos there is a cosmos; in all disorder a secret order.

—CARL JUNG

ANOTHER OF THE most important concepts in the field of group communication is Chris Argyris's notion of the ladder of inference. It explains much of the miscommunication that happens between group members.

The basic premise is that the ladder has four rungs. These rungs hold our emotional and intellectual baggage. On the bottom rung is the actual observable, often personal data that contribute to a person's identity. The next rung is the cultural filters through which we all see the world. The third rung is the attributions and assumptions we make based on our own experience. And at the top of the ladder are all the generalities and unconscious assumptions that we attribute to others based on the first three rungs of the ladder.

If we can help ourselves and others in our group to climb down the ladder of inference, we create a powerful opportunity to build a new foundation of trust, understanding, and clear communication. We immeasurably enhance our ability to *judge current reality* and enhance the creative contribution of each member.

Mark always relates an experience he had working with a multicultural team: "Our team consisted of Diana, an Asian-American businesswoman; Sharita, an Indian-Fijian woman journalist; Kate, a British-born social activist; Schmuel, a male Israeli doctor and army commander; Alison, a white woman journalist who had grown up in rural Appalachia; and myself, a now-middle-class Irish-American also born in rural Appalachia.

"This group illustrated for me how a small piece of communication can be interpreted six different ways by six different people. When Julia and I are writing together, we often use the term 'laying track,' as in building a railroad, to refer to the habit of writing each day to move the project forward. The phrase reminds us that if you are trying to build a railroad, you have to lay several miles of track each and every day.

"I kept using the term 'to lay track,' meaning, I thought, just to

begin at the beginning and write our proposal 'one piece of iron at a time.'

"After several unsuccessful attempts to start, we attempted as a group to uncover our resistances. It was a revelation. What I had believed to be an innocent phrase, 'laying track,' brought up six very different images and feelings. For Diana, it conjured memories of her Chinese-American ancestors working under severe conditions to build American railways; for Sharita, it inspired similar painful memories of Indian laborers building railroads for the British; for Schmuel, the idea of trains was too close to the horrors of the Holocaust. Alison was reminded of our antiquated social policies that leave some people 'on the train' and many people behind.

"For Kate, railroads were representative of the one good thing she felt her country's imperial power had offered its colonies: infrastructure. At least when the British left, she reasoned, there were railroads on which to ship goods. As for me, born in West Virginia, railroads have always symbolized the coal mines and the great struggle of man against machine mythologized by the legend of John Henry."

The reason we bring up this issue of ethnic and social diversity is not to claim to have any answers, but to ask us all to be alert for the right questions. How might my various ethnic, social, and gender affiliations affect my judgments? How might others view me because of theirs? How might I be misinterpreting the group phenomenon because of my own biases, assumptions, and attitudes? How do my various group affiliations—for example, for Mark, white, male, graduate-educated, forty years old, and so forth—influence the way I hold or share power, speak or stay quiet, assume leadership or follow? What does this mean for the way I receive information from someone whom I perceive as being unlike myself?

> If the need for emotional connectedness is not satisfied, collective human endeavor is impossible.
>
> —EDWARD SHAPIRO AND WESLEY CARR

▧ Tool: Biosketches

THIS TOOL REQUIRES a set of manila folders and a set of three-by-five cards.

On the first card, list the identifying groups to which you *know* a colleague belongs—for example: white, male, Protestant, well-educated, recovering alcoholic, tennis player, family man, community volunteer, heterosexual.

On a second card, list your observations about your colleague's character—for example: kind, reserved in meetings, self-sacrificing to the point of obsequiousness, knee-jerk liberal, optimist.

On a third card, list the areas of friction you encounter with this colleague—for example, differing views toward corporate spending, differing values related to change, different conversational styles (he always interrupts, you stop trying to talk) resulting in impatience.

On the final card, list what you value about this colleague. Do this exercise on each key player in your business life. (Keep these private, and be open for new information.)

ROLE REVERSAL

MOST OF US do not work alone. We are individuals functioning within a large group. We are like a piece of a mobile that has a delicate balance. If we learn to think of the workplace as this mobile, it is easy to see that each of us has a certain "weight," a certain position or role, and a certain relationship to the other parts of the whole.

When we try to change a role that is rigid or ill-fitting for us, we jostle the entire mobile, which tends to want the roles and positions to remain the same. This is why we advocate finding a colleague or two with whom to work this program—they will support your change, and give you a place for reality checks and practice.

Many groups tend to create roles similar to those found in a dysfunctional family. When this happens, the workplace can become toxic and our roles can obscure the truth and exploit rather than empower us.

As we noted in earlier chapters, many of us unconsciously carry unexamined patterns of expectation and behavior from childhood into our adult worlds. We act and react from our early programming. We bring to our work families the dynamics—positive and negative—of our families of origin. Once we become aware of these roles, we can change them. Our first task is to notice in what ways we act toward others when times are good and *re*-act toward others when times are stressful.

Each of us plays different roles at work at different times, and within different group contexts, our roles may change. The hallmark trait of someone filling a role positively is an attitude of *service*; the

Knowing others is intelligence; knowing yourself is true wisdom. Mastering others is strength; mastering yourself is true power.

—*TAO TE CHING*

To believe your own thought, to believe that what is true for you in your private heart is true for all men—that is genius.

—RALPH WALDO EMERSON

hallmark trait of someone filling a role negatively is an attitude that is only *self*-serving. Each role behavior is on a continuum from the positive (light) side to the negative (shadow) side. Viewing roles as potentially either "light" or "shadow" gives us both an understanding of the roles being played *and* a method to help people move toward healthier roles. Listed below are a few of the roles we often play out—the light side listed first, the shadow second:

The Hero / The Dictator: The Hero is the office save-the-day specialist. This character never misses a deadline. He does his work well, is able to share credit, and often may be anonymous. His general demeanor is cheerful. The Dictator is long-suffering and needs to be larger than life. His desperate, driven attitude infects the whole team and his need to control disempowers the group. The trap is that both of the roles are good at pulling difficult projects out of the fire—one with joy, the other with rage.

The Jester / The Clown: The Jester is the class cut-up. Like the jesters of the King's court in days of yore, the Jester is able to say things no one else can say, and diffuses tension with humor. The Jester becomes the Clown when he uses his humor to cover up his weaknesses, his mistakes, or the team's failure to act responsibly. The trap is that too much humor can take the group off task.

The Mirror / The Scapegoat: This character carries the role of outcast. The Mirror shows everyone else who they are—including the truths we would rather not see. When the Mirror is operating from a service perspective, he is tactful but candid and keeps the team grounded in reality. It takes real courage to tell the truth because being the Mirror is often a thankless job. If the Mirror is not conscious of his role, he will become the Scapegoat who gets blamed, often wrongly, when something doesn't work out. If the Mirror isn't self-reflective enough, he may bring some of the blame on his or her own head by acting out rebellions that others are feeling. Unable to contain the anxiety of the group, he may retreat to such dysfunctional behaviors as dishonesty, drinking, or other self-destructive habits. The trap is that finding a Scapegoat is a convenient way to keep from facing the group's failings.

The Quiet One / The Victim: The Quiet One often keeps a very low profile, observing what is happening in groups yet remaining alert. In this way she acts like a ground wire for the creativity of others, helping to hold the creative terrain by her very presence.

Leadership is the quality that transforms good intentions into positive action; it turns a group of individuals into a team.

—T. BOONE PICKENS

Your health is bound to be affected if, day after day, you say the opposite of what you feel, if you grovel before what you dislike and rejoice at what brings you nothing but misfortune. Our nervous system isn't just a fiction; it's a part of our physical body, and our soul exists in space, and is inside us, like the teeth in our mouth. It can't be forever violated with impunity.

—BORIS PASTERNAK

If she lacks self-confidence, however, the Quiet One can regress to a Victim position, in which she may become privately very opinionated and angry, feeling that no one "sees" or listens to her, creating an uncomfortable atmosphere in the group. The trap is that the Quiet One can become a repository for the group's failings, as they blame him for not speaking up, thereby making him a Scapegoat; or the Victim can covertly sabotage the group task by running the dialogue in circles.

The Warrior / The Bully: The Warrior is also a peacemaker of sorts as she sets herself high standards of performance, using her own standard as an inspiration for her team. She is at her best when she communicates her standards through her own efforts, and works to protect members rather then threaten them. If she becomes so driven that she becomes self-serving, she becomes a Bully—threatening the team and creating a chaotic, hostile atmosphere that causes team members to work just to stay out of her way. The trap is that either way can be used to stop truthful disclosure: we might admire the Warrior too much to tell him the truth, and be too scared to tell the Bully.

The Leader / The Charmer: The Leader is charismatic, often holding the overview and the vision for the group. When she works in an attitude of service, she is encouraging yet truthful and holds the team to the task. When a Leader becomes self-serving, she becomes a Charmer caught in her own aggrandizement at the expense of the team—and liable to bend and distort reality to keep everybody pleased with her. The trap is that too much Leader worship diminishes the value of the team, and the Charmer can be caught literally with his pants down, as the group displaces sexual energy his way.

The Caretaker / The Controller: The Caretaker is the harmonizer and plays Florence Nightingale to the team. As long as he remembers to nurture himself as well as others he will be an important and supportive healer for the emotional needs of the team. The danger for a Caretaker is that he will fall into the self-serving trap that requires other people to fall apart so he can feel together. The Caretaker then becomes a passive Controller, not just nursing but compensating for others' failing or weakness. The trap is that too much caretaking no longer supports team growth and controlling stifles the team energy.

"I grew up in a chaotic family," Carl told us. "I learned there

to try to run an even ship amid crisis. At the office I took on the same role. As a kid I'd denied my own terror and just functioned. If Mom and Dad were crazy drunk, I packed the little kids' lunches. I got them dressed and off to school. At work, when my rage-aholic boss would go off, I'd snap into autopilot and function, function, function as if everything were normal. Being the Scapegoat gave me a bleeding ulcer. Now I know how to stand up for myself and the team. I can mirror back what needs to change."

Karen, who learned as a child to crack jokes to break family tension, found herself doing the same thing in meetings—and was not being taken seriously as a result. "I was always the funny one, but I took my work very seriously. When I kept getting passed over for raises, I had to ask why. I discovered I was perceived as 'not caring.' This was far from the truth.

"In my efforts to relieve my own tension, I had taken the group off task and was resented for it. I realized that the tension—mine and the group's—was sometimes important and didn't need to be dispelled. Now that morning pages have helped me express my fears and my successes, I feel more confident. I can choose the places to add humor and the team appreciates rather than resents me—and we stay on task."

Both Carl and Karen had to learn to recognize and dismantle their roles in order to function in healthier ways at work. For Carl, this meant *not* always volunteering to save the day. If the boss raged, Carl no longer went straight to overtime to compensate. For Karen, change meant "zip the lip." She bit her lip to keep from wisecracking in tense situations. Gradually she was perceived as taking office difficulties to heart. Her humor, while still apparent, was no longer an automatic defensive reaction. As her level of self-control rose, so eventually did her paycheck.

Ralph, the Scapegoat of his office and the frequent butt of the Bully's jokes, worked with morning pages and found himself being very clear about when he was unfairly blamed. He began saying so—quietly but firmly. His continued calm and clarity in pointing out when he was being devalued led gradually to his colleagues' reevaluation of him. He was no longer a familiar dumping ground for office shame or discomfort. And the rest of the office had to look at parts of themselves they had disowned.

First, we must see which role is ours, light and shadow sides

It is easier to appear worthy of positions that we have not got, than of those that we have.

—La Rochefoucauld

alike. (This admission can be hard on the ego.) Second, we must accept that yes, truly, that is our most common role. (This is where the temptation to slip into denial arises.) Third, we must draft for ourselves a "bottom line" to facilitate change. (This puts us into action.)

Learning is not attained by chance; it must be sought for with ardor and attended to with diligence.

—ABIGAIL ADAMS

A chronic Caretaker might devise a bottom line that goes: "I will no longer use my creative time and energy to be the office wailing wall. I will no longer try to ease everyone's uncomfortable feelings. I will let people solve and resolve their own problems."

"I am certain that I have needs, goals, and options of my own," a Caretaker might affirm. "I will focus on those."

A Hero's bottom line might read: "I will no longer automatically take on overtime to rescue the unreasonable demands of others. I will step back and allow others to be responsible as well." The Dictator might say, "I will no longer drive myself or my team just to make myself look good."

For the Jester, a bottom line might say, "I will no longer use my humor in ways that boomerang on my self-esteem. I will hold my tongue and allow people to work through their tensions and difficulties."

As these examples show, the key to all positive change is self-knowledge leading to self-containment, leading to a vision of how it should be. An honest inventory of our own behaviors is one of the benefits of daily reflection.

As we become conscious of our own roles, we become conscious of our abilities to improve them. We move from being *re*-actors to being actors on our own behalf. We set a constructive example by our actions.

The Victim resolves, "I must take responsibility, quit blaming others, and speak up," and begins in small ways to do that. The Bully realizes that abusive behaviors lead to resentment from others that becomes a vicious circle for him, and leads to covert sabotage of the project, so he begins to curb his tongue.

As we begin to dismantle behaviors that lock us into counter-productive patterns, we find ourselves experiencing what spiritual traditions call grace: that is, we experience an unexpected inner power that helps us to say and do what we need. Often we also experience the sudden appearance of outer synchronicities that reinforce our positive change.

Carol, a Quiet One, mustered the courage to say to the office Bully, "You cannot speak to me that way or I will write a memo detailing your comments to our boss." When the Bully spewed more venom, Carol went home, drafted the memo, and delivered it the next day. When her boss called her in for an appointment, she expected to be dressed down. "I'm so glad you put your comments in writing," her boss said instead. "This is the second complaint I've had but the first concrete description. I'll look into this." Her truthfulness and action forced the Bully to learn an important lesson for the future and Carol even received an apology. We do each other a great favor when we hold each other to our highest expectations — it helps us grow as people.

Changing a toxic office dynamic requires the courage to change our part in it. We often think of this as a sort of dance in which if one partner changes the steps, the other partner must adjust. It does not happen easily, but over time small changes reap big rewards.

> Anger is extremely contagious, perhaps especially when indirect and semi-secret.
>
> —LESTON HAVENS

▇ Tool: Family Functions

THIS TOOL OFFERS another lens for examining the dynamics of your group. It is our experience that you will intimately know which characteristic yields you the most reliable information. List the roles across the top of your paper: Hero/Dictator, Jester/Clown, Mirror/Scapegoat, Quiet One/Victim, Warrior/Bully, Leader/Charmer, Caretaker/Controller. Add however many you need, or invent your own.

Assign to each of your coworkers his or her accustomed role. Which role do you habitually play? Does it change? Would you like to change? List three behaviors you could exhibit or not exhibit to alter your role.

CORROSIVE COLLEAGUES

AS WE'VE NOTED, every organization is an ecosystem: some large, some small. Within a large ecosystem are a number of smaller ecosystems: your workplace, your community, your network of friends. As you alter your creative pH, you directly impact on the ecosystems of your life. When you change your patterns, other peo-

ple, like the denizens of a shared pond, react to your changing patterns with both interest and alarm. "What does your behavior mean to me?" they ask. Though your change is self-elected, it creates a ripple effect that other people may experience as upsetting the balance in their lives.

> Over time defenses often mature and allow the "mentally ill" to evolve into the mentally well.
>
> —GEORGE VAILLANT

People thought they had you pegged, but now you are acting different. You're not predictable anymore. Friends, spouses, and colleagues may feel frightened. They may try to leverage you back into the *you* you used to be, the one they felt comfortable with. They may unconsciously act as saboteurs toward your new plans.

Before beginning his creative emergence, Dave often worked overtime to pick up the slack left by Andrew, his friend, a hard-drinking bon vivant. Dave was the workhorse; Andrew was the star. Dave did the grunt work; Andrew got the credit. Dave executed the work which the clients all loved; Andrew schmoozed the clients and took more than his fair share of credit.

Is it any wonder that when at the direction of his morning pages Dave began pouring energy into himself, into projects of his own devising, and into building his own more personal client relationships, Andrew became at first frightened and then hostile? Dave was changing, "speaking his truth to power," becoming more candid and effective. His colleagues regarded him with new respect, sought out his previously unspoken and unsolicited opinions.

"You used to be such a great guy," Andrew started in. "I hardly know you anymore. You're so selfish these days."

Dave detailed this feedback in his morning pages. At first he was baffled, but gradually it became clear to Dave that Andrew wanted him to be "good old Dave," a person Dave wasn't willing to be anymore. Gently but firmly, Dave withdrew from being Andrew's "good buddy" and took a new position as Andrew's colleague.

As we begin to reclaim our power and priorities, there will be some around us, like Andrew, who will find our new candor so unsettling that they will seek to poison us with their criticism or doubts—they are corrosive colleagues.

You know the type. They undercut your emerging ideas, interests, or self-confidence. They offer only negative feedback instead of being a believing mirror. Seeing them in the group dynamics perspective as people who may be unconsciously carrying your split-off

ambivalence about your change can help you relate to them until this dynamic tension can be reintegrated. But first you have to have a *self* into which to bring back those feelings.

Anne Marie saw herself as pigeonholed in a job with an invisible glass ceiling. As she began her creative emergence, she decided to do something about it. She saw that advancements were being divvied up along sexual lines; the men were being seen as more computer-savvy while her own computer skills were regarded as merely clerical.

Unwilling to accept a dead end as the answer to her career aspirations, Anne Marie signed up for after-hours computer tutoring and became adroit at working on state-of-the-art systems. This excited her and gave her the sense, which proved correct, that the glass ceiling was about to lift. Her best friend and office mate Karen acted as if the ceiling were caving in instead.

"Don't you think you're turning into a drudge?" Karen chastised her. "It seems you're turning into a slave."

Anne Marie was startled by Karen's criticism. They had been such good friends! But their friendship had been founded on their mutual frustration. Now that Anne Marie was taking action, Karen's negativity began to feel toxic. After noting several times in her morning pages that Karen seemed more and more hostile, Anne Marie reluctantly concluded that she was faced with a corrosive colleague who had best be avoided until Anne Marie was strong enough to confront her own skepticism that Karen might have been carrying for her.

We often tell our students, "The things we often hate most in others is something we have disowned in ourselves that we are not yet strong enough to face."

Consider the soft-shelled crab that lives comfortably within its shell until it grows larger and the shell starts to pinch. If the crab remains in the too-small shell, it will die. So, in order to survive and grow, the crab must break out of its safe small shell to grow a larger one. The crab must be vigilant of predators as it changes sizes, especially while it is between shells. A creative emergence is a delicate passage; you are growing stronger but must be vigilant as you move from one size to another.

Like a crab without a shell, you may feel vulnerable. Therefore, you must carefully survey those around you with an eye to who is

> Morality is not properly the doctrine of how we may make ourselves happy, but how we may make ourselves worthy of happiness.
>
> —IMMANUEL KANT

> There is nothing stable in the world; uproar's your only music.
>
> —KEATS

safe and who is not. Those around you who are blocked themselves may unconsciously short-circuit your creative emergence while you are in a vulnerable stage. Realize, however, that they may be doing you a favor, carrying skepticism or fear that you cannot afford to have right now—no need to hate them. Therefore:

Avoid people who call you selfish.
Avoid people who make you feel guilty.
Avoid people who ask, "Are you okay?" in "that" tone.
Avoid people who are sarcastic and skeptical.

As emerging creatives, we are vulnerable to guilt tripping. We may be accustomed to giving our power away to others and their agendas. We allow people too easily to "should" on us. When people try to leverage you back into "the nice guy you used to be," recognize that you are being manipulated and hang tough. People, including you, will get used to your new autonomy and come to like it. Remember the endless cycle of teaching and learning: You are learning a new way to be and teaching by example.

▪ Tool: Containment

THE FIRST RULE of magic is containment. This means we need to protect our fledgling efforts and ideas from particularly corrosive colleagues. Name them: What ideas do you have to protect? What aspects of your attempts to change should you keep private? From whom?

(If it is a coworker or superior, it is best to process your emotions in your morning pages and not grant your fears free rein. Just be aware of how the interactions between the two of you usually run. Noticing is all you have to do at first.)

What are your patterns when embarrassed or threatened? Do you clam up? Rage? Withdraw? Lose focus? Lie? How *do* you react when people are negative toward your ideas or views? How *might* you react that would be better?

Watch your own behavior for clues to how you can begin to disengage from any dance of inauthenticity you are engaged in. Sometimes it is as easy as taking a few breaths and not responding

The man who has never had to stand squarely on his own feet is never in a position to march ahead.

—J. OGDEN ARMOUR

in your old patterns, such as slinking away, blowing up, making rude side comments, or undermining the project as an act of revenge.

■ Tool: The Power Dance

SET ASIDE FIFTEEN minutes for quiet time. Dress comfortably in athletic or dance wear. Cue up a powerful and propulsive piece of music, such as Gabrielle Roth's CD *Bones*, or vintage Rolling Stones, Motown, or your rock and roll of choice.

Call to mind a situation in which you felt frustrated, disempowered, or discontented. Now run, exercise, or dance yourself into a hard sweat. Watch how your attitude changes after the endorphins begin to run. (For some of us, it will take forty-five minutes or more to release emotions.) What new insights welled up from your body? Did you feel the power of your body?

> The reward of a thing well done is to have done it.
>
> —RALPH WALDO EMERSON

THE PRINCE

BECAUSE IT IS difficult to quantify in direct monetary terms, business creativity may erroneously be discounted as nebulous or ephemeral or elusive.

Creativity is alert, attentive, and even assertive. Nowhere is that more evident than in our increasingly canny response to difficult and hostile factors in our corporate environment. What once baffled us as overwhelming and demoralizing we now see as a problem set to be admired and then approached with effective tools.

In business, we encounter a variety of personalities, and the Machiavellian character appears all too often. In fact, many business executives read *The Prince* to learn how to outsmart and outmaneuver their competition and their colleagues. These people are motivated primarily by power and influence and often exercise this controlling strategy on their subordinates in order to gain advantage.

Much of this game playing and maneuvering in corporations occur at the very top, leaving the next tier of senior management frustrated and prone in turn to abusing their power.

This behavior is consistently destructive to the organization and utterly debilitating to its employees—at the top or otherwise. This fear-based structure is the antithesis of how organizations need to

function in the next century, when team-structured business and constructive alliances will be critical to making it in the new millennium.

The more we assess this phenomenon, the more clearly we can see that trouble in the workplace is less a result of personal vendettas than a direct outgrowth of frustration, mistrust, and fear of embarrassment caused by vying for power at the expense of real integrity. Following is an example of how debilitating Machiavellian maneuvers can be and how their effects can be mitigated.

Peter is an assistant to the chairperson of a large brokerage house on Wall Street. Under the chair's directive to research new computer trading techniques to make the company more competitive and technologically savvy, Peter decided to call a meeting of top-level executives and staff.

"I sent out an E-mail message explaining the topic and asking for best dates and agenda. I included a message to Frank, who was in charge of our international division. Having been with the company for twenty years, he has been a key strategist in the past. Frank was also feeling much pressure from the chairman to come up with creative and more competitive strategies, but Frank's background was very old-world and conservative, so he was probably feeling some frustration at not having delivered anything.

"After I sent out the E-mail, I got responses from everyone, and there was a lot of enthusiasm about the meeting. I wasn't prepared for the E-mail we each received from Frank. In it he castigated me for even calling the meeting, said he had no interest in exploring this area, that it was a waste of time and he couldn't believe the 'rest of the staff didn't have better things to do.' It was shocking.

"Not only did he shoot down the meeting, but he totally undermined my position, which had always been perceived within the company as solid and respectable. Furthermore, Frank said, there was only one strategist in the organization when it came to international matters, and that was he, that no one else should even be consulted.

"After that I tried calling another meeting, this time excluding Frank, but the morale had been so debilitated and the creative energy and enthusiasm for the project so drained that some people refused even to attend the meeting."

It is possible that Frank was acting out his frustration at being

For this relief much thanks; 'tis bitter cold, and I am sick at heart.

—WILLIAM SHAKESPEARE,
HAMLET

pushed by the chairman to be more innovative, but not knowing what to do. His fear worked against him. Whenever we lose our human perspective, we are open to the syndrome of becoming a "Prince."

In self-created isolation from our peers, we come to view them as subjects, rather than equals. This then increases the feelings of isolation and paranoia and fuels the fears of revolution. Frank was primed to pull his Prince act. He reacted defensively, and Peter just happened to be in his way.

When the Prince syndrome is at work, the costs to an organization can be great. Discounting others' contributions, claiming to be the "only strategist," for example, helps create a fear-based organization that discourages the honest exchange of creativity and energy. It makes people risk-averse at a time when innovation is needed in order to be competitive. In this environment, people lose their incentive to cooperate and morale suffers, leading the company down the trust/mistrust spiral.

When we met Peter, he was feeling angry and frustrated in his situation. Not only was he experiencing a loss of personal power and worth, but he thought the entire corporation was suffering by not exploring these new technologies, which had already proved effective.

First, Peter and his colleagues didn't blame or attack one another, a common scenario, but met to try to understand *Frank's* motivations and what he might be expressing for them as a group. Peter did not take Frank's actions personally because doing so would embroil him in a negative power play.

From a business viewpoint, the facts were on Peter's side. He was exploring areas that had proved successful for their competition, so while Frank had fears, Peter had information.

Peter discussed with Frank his own fears about the new strategies and allowed Frank (on an unconscious level perhaps) to discover the positive aspects of Peter's argument and feel included, almost as if Frank had come up with the strategy himself and were directing the team. (Peter's team knew perfectly well that Peter had invented the strategy.)

By viewing Frank's action as driven by the unconscious projection of Peter's own disowned fears, Peter was able to take back effectively the part of the fear that was his and achieve Frank's buy-in

> What if we smashed the mirrors and saw our true face?
>
> —ELSA GIDLOW

to the new work. Like the dragon who teaches (and learns), Peter transferred some of his own creative energy to Frank and empowered himself in the process.

What is important here is that if you cannot change the reality, *reexamine your view of it.* "Reframing" reality then becomes an act of creativity itself. Over time, organizations learn where the real credit and power belong. As a team player, you can create power through effective use of the group dynamics.

Peter worked quietly with others on strategy with which he believed Frank would be comfortable. He enlisted the aid of another senior executive to work with Frank and position the plan as a product of Frank's *team,* of which Peter was the leader. Peter got results by formulating a well-thought-out, coordinated strategy and not going "out" too early with new ideas.

This is another key point: Keep your ideas safe in a supportive environment. Know who the Princes are, and plan your approaches accordingly. Bring your idea out for inspection only when it has been "contained" long enough to have evolved to the point of viability.

Here are several suggestions for dealing with the Machiavellian elements in your organization:

- Allow new ideas to incubate in a supportive and trusted inner circle until the idea has a life of its own.
- Try to enlist the Prince's participation and get his (or her) cooperation early, before meetings become too public.
- Don't chase the Big Deal. We often become convinced that this one new project is going to make our career, make us famous, get us noticed. This Big Deal orientation can make us secretive and shallow, often inspiring paranoia. When we realign our focus to view each project as part of our ongoing body of work, it takes the pressure off the deal we are working on and makes us more likely to enlist help and share credit. This helps your career *and* the organization in the long term.
- Be realistic. Accept people for who they are. It is human nature that some people like us, some don't. Have the courage to discuss someone's feelings and motivations—the more

To laugh often and much; to win the respect of intelligent people and the affection of children; to earn the appreciation of honest criticism and endure the betrayal of false friends; to appreciate beauty and find the best in others; to leave the world a bit better whether by a healthy child, a garden patch, a redeemed social condition; to know even one life has breathed easier because you have lived—this is to have succeeded.

—RALPH WALDO
EMERSON

we discover our shared essential humanness, the more effective we are as a team.

- Learn which people you have problems with: Identify their likes, dislikes, and limitations. Then plan your actions according to what you know, keeping your goals in mind.
- Look for the humanity in your Prince by trying to understand his or her pressures, issues, perspective. Through compassion you can often understand and/or forgive Princely behavior and at the very least learn how to work around it.

■ Tool: Unmasking Machiavelli

MACHIAVELLIAN COLLEAGUES ARE a fact of life. Yet they are not only rejecting of others but self-rejecting as well. Seeing their destructive behaviors as fear-based can create compassion in lieu of outsize terror. If we see that the bully is afraid, he is a less frightening bully.

Exercises for discovering the "Princes" in your past:

1. Describe a situation in which you think ego, maneuvering, and power plays went on in your organization. Who was the Prince? How did it affect you?
2. Draw a circle. Put those people from work who are your supporters and friends inside the circle. Put all the people who have behaved like the Machiavellian Prince on the outside.

■ Tool: Practicing the Present

BY NOW IT should be clear that creative emergence requires a commitment to a body of sustained work. This work is meant to help you build a body of work over time. Are you still harboring "I'll show them" scenarios of sudden and spectacular success?

Take a blank sheet of paper, number from one to fifty, and list fifty people, places, and things for which you are grateful in your current life. This will aid you to Practice the Present.

> The soft overcomes the hard. The slow overcomes the fast. Let your workings remain a mystery. Just show people the results.
>
> —TAO TE CHING

> Listen. Make a way for yourself inside yourself. Stop looking in that other way of looking.
>
> —RUMI

WHEN MENTORS BECOME MONSTERS

MYTHOLOGY AROUND CREATIVITY has been known to make it sound perilously close to fantasy. Our experience has shown us that far from flights of fancy that avoid reality, a true creative emergence involves the erosion of denial, the facing of difficult facts, and the forging of proactive solutions. All of us need (and need to be) mentors. But the intricate relationship between mentor and mentee is often fraught with a certain peril.

Amanda was executive editor of a successful trade publication in the field of health care technology. She was responsible for staying abreast of the latest innovations, finding capable writers to communicate advances in cutting-edge technologies to generalists in health care, and overseeing not only the editorial staff but the marketing and production departments as well.

Amanda had been handpicked by her new boss, Tim, because of her broad knowledge of where health care technology had been and where it was going and because she was widely respected throughout the industry. She was also useful to him because Tim's background was in publishing general-interest magazines, and Amanda had a wealth of useful contacts throughout the health care industry.

Amanda viewed Tim as an important mentor because he was smart and had an excellent reputation. He was also a member of the publisher's senior executive team and controlled significant resources. It was a mutually beneficial relationship.

For more than two years Amanda and Tim worked well together. Amanda provided Tim with expertise, contacts, industry knowledge, political savvy, and, above all, loyalty. Tim included Amanda in his inner circle of advisers, counting on her as a sounding board for ideas. He supported her vision of the magazine and gave her and her team free rein.

One issue of the magazine required Amanda to take an editorial position concerning a controversial leading technology. Her comments became of interest to the media. At first, Tim was enthusiastic and supportive because her knowledge and obvious expertise reflected well not only on the magazine but on its publisher as well. Amanda felt alarm, however, when the two of them were supposed

Act only on that maxim whereby you can at the same time will that it should become a universal law.

—IMMANUEL KANT

to be photographed for a major business daily and Tim scheduled the photo shoot for a time when Amanda would be out of town on business. When Tim's picture ran with the story, Amanda, who was savvy about political issues, chose not to make an issue of it. Nevertheless, she was hurt and thought it extremely inconsiderate of Tim. She took it as a sign to avoid press interviews and hand them off to Tim or others. She did so.

Amanda was beginning to feel she had done something terribly wrong or offensive to Tim, but she had no idea what it might be. She continued working with him, as committed and loyal as ever but feeling a sense of sadness and strain in a job that until that point had been thoroughly enjoyable and challenging.

Tim soon found himself under increasing attack from a rival, Joe, who was envious of his power and wanted his job. Joe began to attack Amanda and her projects as a way to discredit Tim. Joe's attacks on Amanda resulted from Tim's purposeful deflection of criticism away from himself and toward her. Feeling the pressure of Joe's hostile competition, Tim used Amanda as a scapegoat.

Unfortunately Amanda was unaware of this dynamic for a long while. She blamed herself for failing her mentor in some way and tried to talk to him. Although he denied it, she knew in her heart that something was wrong.

Amanda's fall from grace was brutal. Suddenly she was not included in the inner circle. Meetings she called were canceled. She was snubbed and shunned. Her every idea was subjected to hostile criticism, and the resources that had made her earlier successes possible disappeared.

At one point Tim sided publicly with Joe in criticizing Amanda for doing something Tim had explicitly instructed her to do. She was crushed, defeated, crazy. What was going on?

The ultimate betrayal came when Tim canceled a symposium Amanda had organized, denying he had ever approved it when in fact he had championed the idea. Publicity had already gone out. Speakers had been engaged. Reservations were already being made.

The betrayal took place on a Friday. Amanda held herself together until after the meeting, but as soon as she got in her car, she broke into deep sobs, mourning the loss of a relationship and hurt by Tim's betrayal. She was the sacrificial lamb. Her support and

> You must do the thing you think you cannot do.
>
> —ELEANOR ROOSEVELT

loyalty meant nothing. She was heartsick, angry, sad, ashamed, and full of self-doubt. Her mentor had indeed become a monster.

In her morning pages Amanda began to reframe the event so she could move forward. She retraced the facts, reviewed her perceptions, and objectively let go of blame. What she kept from the experience were the lessons it offered:

> A good problem will gather you up at your tender, growing edge and change who you are.
>
> —ROBERT KEGAN

- Mentors can become monsters when you get powerful enough that you threaten their sense of superiority. Pay close attention so you can discern the shift.
- Sacrificial lambs are symptoms of situations not entirely under mentors' control.
- Betrayal is not always intentional and may simply be a shift that occurs in response to unknown situations.
- The end of a mentor/mentee dynamic sometimes includes tensions similar to those apparent when a teenager must leave home—control by the parent, rebellion by the child; anger and heartbreak as the old world comes to a close. Both roles often cover a special love and respect temporarily lost in the fray.

Amanda, by the way, has moved on to become the editorial director of a publishing group that has launched its own journal in the field of health care technology.

■ *Tool: Mentor Magic*

CREATIVITY FLOWS MOST freely in an emotional healthy atmosphere. If we are centered solely on our own dreams and desires, we often feel thwarted and unfulfilled. For this reason we have found helping others one of the most powerful tools for helping ourselves. Rather than focus on the lacks and limitations of our mentors, let us focus on how we can best mentor another.

Choose a younger or newer colleague with whom you feel a sense of affinity. Ask that colleague to lunch or coffee. Remind yourself you are there to function as a friend and sounding board. This means you are as valuable for your listening as for anything insightful you may say. We think of mentoring as a behavioral equiv-

alent of tithing. It reinforces the bonds of community and the balm of gratitude.

(NOTE: A good hint for mentoring is to refrain from telling someone specifically what to do, rather tell them a story of a decision you have made in similar situations, and what the consequences were. This grants them the dignity of the choice and the protection of your experience.)

> Hold faithfulness and sincerity as first principles.
>
> —CONFUCIUS

CRAZYMAKERS

WHILE MANY OF the blocks to creativity are internal, one of the largest and most common blocks is not. This external block is a destructive alliance that many creative people make with the type of personality we call a crazymaker. What is a crazymaker? The name tells all.

A crazymaker is someone who makes you crazy by constantly stirring up storms. Crazymakers are frequently charismatic, charming, and likable people, but for the creatives around them, they can be poison. Long on problems, short on solutions, crazymakers drain your creative energy. They always have a reason why something can't be done: "It's too late"; "It's not my job"; "They said we couldn't"; "Let me finish this first"; "I forgot."

Crazymakers make you feel dramatic. You veer between wanting to kill them and wanting to kill yourself. There's no right way to deal with a crazymaker because the situation keeps changing. Crazymakers thrive on drama, and melodrama requires a sense of impending doom. Everything is an emergency, a deadline, a matter of life and death, or something they will get to eventually: Read "never." "Normal" doesn't enter the picture. ("Normal" doesn't serve their need for power.)

Any person or group can serve as a power source for a crazymaker, and nearly any situation can be cast as melodrama to support the crazymaker's plot lines:

> Learn to see in another's calamity the ills which you should avoid.
>
> —PUBLILIUS SYRUS

- The same snowstorm happens to everybody, but it's somehow much worse for the crazymaker, who can't get the job done.
- The crazymaker needed to borrow money last month and the month before that and the month before that.

• The crazymaker is always asking for help, and before you know it, you are doing the whole thing.

It's easy to see what an effective creative block crazymakers can be. They give us someone to blame rather than finish the project. They become convenient scapegoats, as in "Who has time to be creative when there's always a drama to be calmed, a situational bomb to be defused, a big, chaotic something that creates a smoke screen around reality?"

No doubt about it, for the creative who wants to stay blocked, linking forces with a crazymaker is an ideal way to do it. There are two kinds of crazymaker energy: Either the crazymaker is so slow you feel as if you are in quicksand, or he is so frenetic that the room seems like a swirling wind. See if any of these sound familiar.

Crazymakers break deals and destroy schedules. Their "emergencies" always take precedence. "Sorry I missed the conference call, my wife's car had a flat!"

Crazymakers expect special treatment. They suffer a wide and colorful variety of ailments that require your care whenever you have an important deadline or anything that deflects your attention from their demands. "Could we postpone our breakfast meeting? I didn't sleep last night. I've been having these nightmares."

Crazymakers discount your reality. Your pressing agendas—however real—are never as real, as important, as critical as a crazymaker's drama of the moment. "The client needs layouts, ASAP, so could you drop what you are doing to help me out?" The crazymaker thinks he's having a heart attack. "It's probably something perfectly normal, maybe a stitch from working out too hard—who knows?—but—"

Crazymakers triangulate those they deal with, always relaying what "so-and-so" said about us. They are expert at gossip, at feeding paranoia, at driving wedges between working colleagues. "I hear from a little bird there's trouble in your creative group," the crazymaker announces, refusing to make any helpful disclosures.

Crazymakers are expert blamers. Everything is always their problem, but nothing is ever their fault: "The damn printer was running behind"; "The damn secretary was late to work"; "The damn deadline wasn't reasonable to begin with."

Crazymakers hate schedules—except their own. It doesn't

No person is your enemy, no person is your friend, every person is your teacher.

—FLORENCE SCOVEL SHINN

matter that everybody has known about the deadline for weeks. It could not have come at a worse time: "my mother-in-law is visiting"; "deferred taxes are due"; "I have to fix the leaky faucet, it's driving me crazy."

Crazymakers hate order. Papers blanket the office. Phones ring off the hook. There's an avalanche of inflow and a minimum of outflow. Underneath all the busyness not much business is getting done.

Crazymakers deny that they are crazymakers.

If crazymakers are so awful, what are we doing hanging out with them? We all have to work with crazymakers sometimes. (We can all be crazymakers sometimes.)

What we're doing is avoiding ourselves, our creativity, our own self-actualizing possibility. Life with a crazymaker may be frustrating, but it's also convenient: Who has time to be creative when you're right in the middle of a nuclear meltdown?

The craziest thing about a crazymaker is that we are crazy enough to get involved with one. If the thumbnail sketches above sound familiar, admit that you've found a clever way to sell yourself short.

Now, stop doing it. Ask yourself just what creative agenda your crazymaker is helping you avoid. Remember, even if the crazymaker is your boss, recognizing the behavior for what it is can help you set more exact boundaries once you know what they should be.

"Yes, I can lend you money this time, but this is the last time."

"Yes, I will get this report done by working late, but I need to know about delays like this in advance from now on, so I can plan my time."

"Yes, I will help you with the report this time, but this is not my area of expertise or my responsibility, so next time you are on your own."

By carefully phrasing your yes, not only can you help out "this time," but you can also use this time to set a boundary. The crazymakers will be much more reluctant to impose their agendas on you when they have had not only your help but the honesty of boundary setting. You will feel better, though setting the boundaries might be difficult at first.

According to David Berg and Kenwyn Smith, a group often spends more time destroying the perceived task than working toward

> The drowning man is not troubled by rain.
>
> —PERSIAN PROVERB

its fulfillment. Unmasking and understanding the crazymaker dynamic allows the group to move again toward task completion.

▪ *Tool: Going Sane*

FOR MANY OF us, unmasking our crazymakers brings a shock of recognition. "I really have sabotaged my time and energy through those people." Be gentle with yourself as you arrive at this realization. You may want to plan a walk, a movie, or a time-out for immediately after using this tool.

Answer the following questions:

1. Do you have a crazymaker? Yes or no?
2. Who?
3. What in his or her behavior makes you feel crazy?
4. What payoff is hidden in your involvement?
5. What boundary can you set?
6. What unconscious group dynamic could the crazymaker be expressing?
7. When might you be the crazymaker? For whom? How might you stop doing it?

MANAGING UP

IN CREATIVE EMERGENCE this week we have not only contacted a stronger sense of our personal identity, but we have developed as well a stronger and more accurate sense of those around us. Paradoxically, as we accept the truth that we are each our own boss, piloting our ship through each day's seas, we also see how to serve as a better first mate to our superiors.

The truth in most organizations is that we help manage those above us. We have a responsibility not only to do our job well, but also to do it in a way that anticipates our boss's needs. Learning to manage up to our bosses, seeing what they need, and getting it done, can help make us truly valued employees, not only more efficient but happier in our work.

Some people are unable to manage up to their superiors because they are unused to managing themselves. They remain mired

in a restrictive, literal job description as a way of minimizing risks. They keep to a rigid routine to maintain a feeling of safety because they do not know how to prioritize, always doing only what is in front of them, or they are unable to see the bigger picture necessary to participate fully as a team member. You know them; "I only work here" is their motto.

Some people of course are the opposite: good at anticipating the needs of others, particularly their superiors, yet unable to give their own work and goals the same priority and attention. They serve as batteries and leave their own work undone.

You might ask yourself: "Which type am I?"

Once we realize that it is our job to help those above us reach their goals, then managing ourselves and those below us in the hierarchy is easier because we can concentrate on the end result. By focusing on our bosses' visions, discovering the larger picture, we won't get sidetracked by details or skirmishes.

If it is not clear what your boss's vision is, it is important and acceptable to ask. It might even help clarify your boss's own thinking. If he or she wants to build a bridge out of steel, there is no need to buy wood. If he or she wants to raise the roof, digging a basement isn't going to help.

So manage up, and our job gets easier. It's a subtle skill that requires practice. But what it requires most of all is that we know what our boss ultimately wants to accomplish, so that we can best help them do *it* and not our version of it.

If we think of ourselves as managing up, we will be more likely to speak the truth to our superiors. We can be more candid (since it is imperative that our bosses know what is really happening). Of course, this places the responsibility for the achievement of the real company goals on our own shoulders as well as theirs.

While managing up might seem at first like a heavy load to carry, the truth is that taking this responsibility will begin to shift our attitude. From a posture of reaction in which our bosses have to manage us, checking up on us, and supervising in ways we often find objectionable, to a shift to a posture of action and autonomy in which we not only have our self-respect but gain the power to contribute. As we make ourselves players, carve out a position on the team, we find ourselves enjoying the game more.

> Boss your boss just as soon as you can; try it on early. There is nothing he will like so well if he is the right kind of boss.
>
> —ANDREW CARNEGIE

> All work is as seed sown; it grows and spreads and sows itself anew.
>
> —THOMAS CARLYLE

■ *Tool: "Dear Boss"*

THIS IS A letter that won't be sent, although many of its insights may later be acted upon. Taking pen in hand, describe the vision you feel your boss holds for himself or herself and for the company or division for which you work.

Next, expand on this writing by detailing your vision of your boss's role and the potential expanded role you can play in fulfilling this vision. Ask yourself not "How can I succeed?" but rather, "How can I best serve?"

A deepened commitment to service frequently translates into heightened success.

TRUST/FEAR SPIRAL

SUSTAINED CREATIVITY REQUIRES that we locate and maintain our emotional bearings. Because we lead lives—particularly business lives—in which our well-being is impacted by our dealings with others, it is pivotal that we learn tools that allow us to keep our feet during the pitch and heave of a corporate squall.

As we have said before, our creative self is characterized by a youthful vulnerability. This means that feelings of distrust and fear can easily be triggered and spiral out of control without "adult" intervention. We carry within us both the creative child and the discerning, protective adult—and we do need both.

True creative exchanges, vital to success, depend on trust. Although there are certainly untrustworthy people to be found in the workplace, most violations of trust are the erosion of faith between well-intentioned people. This is the trust/fear spiral. It takes our adult to understand and dismantle it. Here's how it works.

For many years Louise's company worked with a small contractor whose job was to provide ten new products for launch each year. Louise, new in her position, got off on the wrong foot with her contractor, who had missed a deadline. Worse, he seemed cavalier about responding to her complaint and defensive about the whole situation, so Louise moved him down a notch on her trust spiral. This was the beginning of a scenario that we see all the time: The first steps down the trust spiral culminate eventually in the end of the relationship. The defensive attitude of the contractor, Tom,

If a house be divided against itself, that house cannot stand.

—MARK 3:25

It is a painful thing / To look at your own trouble and know / That you yourself and no one else has made it.

—SOPHOCLES

made Louise feel he was arrogant. Without discussion of the matter, Louise changed the terms of their contract from ten products to a reduced number to be decided on a case-by-case basis.

This in turn caused Tom to move Louise down his trust spiral and prompted him to approach Louise's divisional heads behind her back for support and to put pressure on her to renew their ten-product contract. It is easy to see where this is going: Louise felt betrayed by this power play and outsourced a new product development to a lower-priced European concern.

In this case there were two distinct truths: Louise's and the contractor's. Louise's truth was her justifiable irritation at not being respected and at being treated cavalierly; Tom's truth was that his was a small shop and Louise's changing the contract had thrown him into panic mode, causing him to take the desperate measure of going directly to the divisional heads, a grandiose and counterproductive move.

Louise, to her credit, was able to see that if the downward trust spiral were to continue, it would play out something like this: She would continue to outsource work in response to feeling distrustful; Tom, faced with declining revenues, would have to forgo hiring the new manager he was about to engage, and perhaps he would be forced to cut staff, resulting in even greater delays and more missed deadlines. Louise would be left to deal with these delays as well as with a host of untried suppliers who afforded her no economy of scale.

Foreseeing the damage of continuing down the trust spiral, Louise was sufficiently horrified to schedule a meeting with Tom to try to stop the accelerating downward spin. Reframing Tom's actions in terms of his desperation to make his payroll allowed Louise to see that his truth, the *other* truth, was as real as hers. They were able to have several productive meetings that led to a creative new contract that guaranteed his payroll while also allowing her some flexibility to experiment with new suppliers. Slowly, from this new perspective, Louise, Tom, and Louise's division heads began to move back up the trust spiral toward mutually beneficial relations.

> The two most important words I ever wrote were on that first Wal-Mart sign: "Satisfaction Guaranteed!" They are still there.
>
> —SAM WALTON

■ *Tool: Stopping the Spiral*

DO YOU HAVE a negative spiral happening? How did it happen? List the events, step by step, where you can start a healing advance upward. When the intervention point is decided, write out what your ideal conversation would be. What will you say? What will your counterpart say? What are the qualities you need from him or her? What do you think he or she needs from you? Schedule a mock discussion with a colleague and ask him or her to play the other side. Now reverse roles with your colleague and you speak from the point of view of your counterpart. Any new insights?

(If the discussion to come is feared to be volatile, set it in a neutral public place — and perhaps have a colleague or your superior attend. The fear of these meetings is usually felt on both sides, causing delays and rescheduling. The vast majority of the time, confronting a trust/mistrust spiral lightens our emotional load, comforts both parties, and allows everybody to get back to work with renewed vigor.)

FREEING THE ENERGY

AS THE ESSAYS and tools of this week have shown, we are seldom aware of the profound effect that unresolved negative emotions have on us. All of us possess far more powerful energies and potentials than we realize. Dampened by years of self-distrust, displaced by years of corporate codependency in which we have channeled our creative energies into managing others' perceptions of us, those energies awaken with startling power and poignancy. We are like avalanche survivors, coming to with tingling limbs as we rejoice in our survival, throwing off the numbing weight of others' agendas.

Coming to, we may feel uncomfortable with the situations we have so long accommodated. We burn with resentment and a yearning for change. But we cannot learn new ways of being — or teach them to others — without first accepting the feelings that drive dysfunctions.

We often fool ourselves by trying to process intellectually what cannot be intellectualized. The fact is that minor resentments tend to accumulate, layer by layer, until everyone is weighed down by the heavy energy of negativity. The slights may

'Tis skill, not strength, that governs the ship.

—THOMAS FULLER

seem small, none of them especially difficult to handle in the scheme of things, until the next thing we know we're ready to fire someone, dump friends, or quit our jobs in a huff. It is astonishing how frequently this happens.

These days, we tell ourselves, we all are trying our damnedest just to stay afloat. Who has time to talk out every little annoyance? At the same time we resent the guy down the hall for something he said last summer! That's a lot of negative energy to be carrying around.

Consider Dick, a divisional director of a large manufacturing company. Several salespeople, all of whom are making six-figure incomes, report directly to him. One of these salespeople, Pat, had come to be an embarrassment to the company. Pat's behavior in client meetings had become especially disagreeable. He talked on and on, meandering far from the subject at hand. He seemed incapable of listening to anyone else, including important clients. Dick, his boss, and even Pat's colleagues had come to find his boorishness intolerable.

Dick's immediate problem with Pat was merely the tip of the iceberg. The prior year, senior management had not given Pat a year-end bonus, and in retaliation Pat had announced to Dick, his immediate supervisor, that he wasn't going to "bust his hump for a company that didn't even give him a bonus at the holidays."

Dick never responded to the comment directly, but it gave him serious concern over Pat's attitude. This single incident turned the trust/fear spiral in the negative direction and began to color Dick's other judgments of Pat. Pat, sensing but not comprehending what was happening, became clouded by an increasing sense of insecurity, bordering on paranoia, that led to his becoming more and more outspoken and grandiose in meetings in a counterproductive attempt to curry favor.

In his daily meditations Dick was able to tell himself quite a bit about this situation. First, he stumbled upon the forgotten link to Pat's insecurity and grandiose behavior over not getting a bonus. Further, Dick saw how Fritz, the company's ace salesperson, had become even more his favorite by contrast and how he had lavished praise on him, although Fritz seemed on closer inspection to have actually slacked off a bit.

Dick decided to try to talk with Pat. In fact, in order to make

> Reflective thinking requires a mental "place" to stand apart from, or outside of, a durably created idea, thought, fact or description.
>
> —ROBERT KEGAN

> Where there is great love, there are always miracles.
>
> —WILLA CATHER

the conversation safe for Pat, Dick began by telling Pat that he had recommended that the company renew his contract but that there was some work for Pat to do in order to work well with him. Pat expressed some appreciation for the contract but went on to say that he felt Dick played favorites and never acknowledged his hard work, while lavishing praises on Fritz. Dick agreed with him, and it was a revelation as he realized that last year's buried resentment against Pat had caused him to stop praising him fairly.

The conversation, extremely difficult at first, gradually became easier. Long-held emotions were expressed. Words long unsaid were spoken, included a remembrance of their early fondness for each other and high hopes about working together. Because Dick had witnessed his own feelings in his reflections, he was able to speak his truth and to listen to Pat's, in a way that felt useful to both of them. He had managed to intervene in the trust/fear spiral and to turn it once again in a positive direction.

Dick says he "felt as if an anvil had been lifted" from his shoulders, and that he had become a better manager, more capable now of a level of understanding and problem-solving that had earlier eluded him—and Pat has since become a much more productive member of the team.

One of the many rewards of a creative emergence is the ability to intuit the deeper emotional currents in ourselves and others that affect the daily flow of information and activity. We become self-aware and centered, secure enough to risk embarrassment with our colleagues and others. Working more authentically without the need to cover or protect inspires others to risk more loving candor in their own creative emergence, and a profound and powerful positive energy cascades through our workplace. In embracing the twin processes of teaching and learning we increase the group's capacity for wisdom.

Tool: Releasing Resentments

THIS IS A tool of release and renewal. It is a tool of spiritual housecleaning. Undertaken regularly, it keeps us current with ourselves and with our colleagues.

Take a blank sheet of paper, and writing rapidly, list any resentments, grudges, issues, or sensitivities you are currently harbor-

> It matters not how small or large the job you now have; if you have trained no one to do it as well, you're not available; you've made your promotion difficult if not impossible.
>
> —MALCOLM S. FORBES

> Before you seek revenge you should first dig two graves.
>
> —CHINESE PROVERB

ing about your work life. Also list any fears. Do this by making three columns: The first column is whom you resent, the second column is why you resent them, and the third column is *your* part in the situation.

What patterns do you see that occur again and again? What can you do differently in the future? Does anyone deserve an apology? What about a simple conversation? Can you feel the energy release as the truth gets expressed? Much blocked creative energy can be found through simple conversation.

CHECK-IN: WEEK EIGHT

1. Who are you? What are your group affiliations: Start with the sentence "I am . . . :" and write for ten minutes.
2. How were morning pages this week? Did you notice any shifts in perspective as you interacted with others?
3. Take a time-out to a new neighborhood or restaurant. Can you spot the people you identify with or who turn you off? Are you discovering anything about yourself?
4. Have you noticed any changes in your experience of group interactions? Write about them. Anything different about how you interact with the group? Have you had a chance to speak truth to power? Manage your superiors? Free the energy of a resentment or turn the trust/mistrust spiral?
5. How is your self-care? Are you taking time to do a time-out or to walk or exercise?
6. Let the ideas from this chapter settle for a while. Noticing the group in a new way is enough for now.

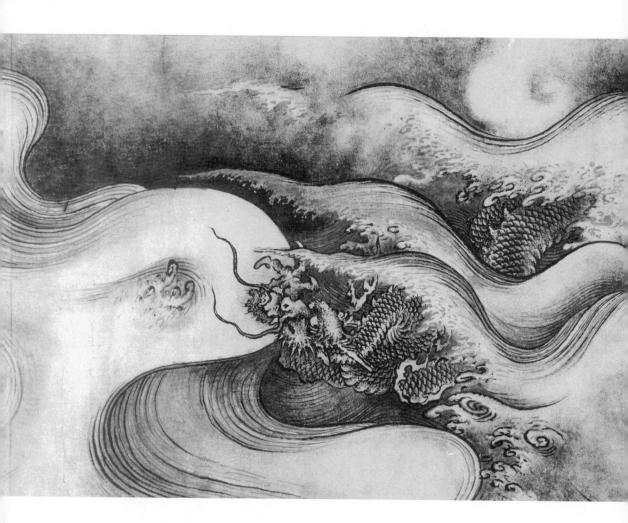

THE SEVENTH TRANSFORMATION
OWNING OUR AMBITION

THE SCROLL'S SEVENTH dragon battles the waves of fortune and the tides of nature. Confident and courageous, it struggles against the world's resistance in a determined effort to move in the direction of its dreams. What had seemed impossible, even unthinkable, before the awakening at the dragon's gate, is now clearly seen. Gathering its strength, the dragon fully grasps its creative mission and advances upon its goal.

FOCUSING OUR POWER

"THE MASS OF men," wrote Henry David Thoreau, "lead lives of quiet desperation." Few people allow themselves to pursue their dreams fully. Some are fearful of losing what they've gained thus far and will not venture beyond the bounds of their current, reasonably comfortable situation. Some lack the necessary confidence in their own abilities. Some shrink from the threat of others' misunderstanding and ridicule. One who has awakened, experienced the emergence of the creative self, and understood the power of generosity and humility is ready to struggle, come what may, to convert dreams to reality.

Ambition that arises from your authentic self is different from the mere lust for money and power as ends unto themselves. True ambition understands that no one lives forever. In claiming your ambition, you dedicate yourself to a quest. You refuse to let life drift by. You become determined to contribute what is yours and yours alone to give. Whatever your specific goal, when you have claimed your real ambition, your heart's desire, then you grow in influence, attract the creative energies of others, and focus the creative passion in your world.

FACING DOWN FEAR

ALTHOUGH FACING FEAR has been the subtext of your work to this point, we now turn to it directly, asking you consciously to muster courage to continue to the end. This is a crossroads. There is grief at the old self you are leaving, as well as anxiety about the new self you are becoming. Do not allow these variables to abort your completion of the process. Hang tough.

You are at a volatile and vulnerable point in your creative emergence. Although you have unearthed and defeated a number of hidden adversaries, you are about to face down the central creative

monster that lurks beneath many of our lives. That creative monster is fear—the opposite of faith.

Although we seldom experience our fear directly, we are adroit at feeling it and naming it by other names. "You're so lazy," we say when our fear causes us to procrastinate. "You've got no discipline or character," we say when our fear causes us to avoid something we need to face.

This week we will focus the spotlight of our attention directly on fear itself. We will gently probe our past for the times when our fear led us to take creative U-turns. We will work with tools for dismantling our fears and moving ahead on our goals and dreams. Above all, we will work on a major attitude adjustment: the shift from self-loathing into compassion whenever our fear rears its head.

To cast it in spiritual terms, this is a week centered on the healing balm of forgiveness. In order to move forward, we must look back over the damaged past and bring to it the clarity of compassion. We must forgive ourselves for the fear and confusion that kept us from fully claiming our hearts' desires, for allowing ourselves to be ashamed of our ambitions. Rather than harden our hearts, we must soften them. We must dare to care for the vulnerable part of ourselves that longs—and dares—to create.

As actress Julianna McCarthy reminds us, "If you lose your vulnerability, you lose your capacity to be an artist." Whether your art form is sculpting a statue or sculpting a corporate vision, whether it's writing a novel or writing a new ad campaign, it takes courage to allow yourself the risk of creative action. In this week we will focus on our fears, using our compassion to understand, forgive, and move past them.

> Where most of us end up there is no knowing, but the hell-bent get where they are going.
>
> —JAMES THURBER

■ Tool: Clearing Fear

THERE IS NO movement without stuckness. There is no possibility of movement without the temptation of remaining where you are.

This is a behavioral tool that many of our students have used effectively. It works whether you are a believer or a nonbeliever. This is true even though it involves an item commonly referred to as a God jar. A what?

You are asked to choose or make a box, jar, or container whose

symbolism appeals to your sense of the transcendent: Julia's God jar is an old Chinese vase twined with dragons. Daniel uses a large mahogany humidor.

Now take a blank sheet of paper, and tear or cut it into ten strips. On each strip, write a fear, concern, or worry you are currently harboring. Fold the paper into parts, and place the fear in the God jar, or magic box—call it what you will:


Man is asked to make of himself what he is supposed to become to fulfill his destiny.

—PAUL TILLICH


- My relationship
- Finding a new assistant
- Tomorrow's meeting
- A strategy for the new client

David Bohm, the physicist, might have referred to this as a totem exercise in participatory thought, but Matthew simply says, "I put something in the jar whenever I am tempted to obsess."

Although simple-seeming, this tool transforms us through the powerful action of nonaction. As we release our worry to whatever benevolent power we can conceive of—even the mere passage of time—we open our minds to receive solutions, insights, and support. Some of our students call this "turning it over."

SUPERMAN

ONE OF THE primary fruits of creative emergence is a growing sense of personal autonomy and objectivity. Through work with media deprivation, our tools regarding the corporate environment, and our daily expectations such as morning pages and exercise, we enter a space of inner clarity that allows us to observe the images and ideas projected onto us by the group mind. Increasingly we find ourselves able to be self-defining; increasingly we find ourselves able to deflect and dismantle the projected identities that no longer serve us.

Our society is saturated by images. As businesspeople we are the target of a massive propaganda campaign. Open the pages of any glossy magazine and you will see impeccably groomed, beautifully attired men and women striding across the page. Chins jutting, hair swept back, they stare fearlessly into the camera. They are dressed for success, and that success does not include the fear many of us routinely feel.

The only thing necessary for the triumph of evil is for good [people] to do nothing.

—EDMUND BURKE

As pictured in our media, the business world is a land of chiseled cheekbones, hawk-eyed glances, and aggressive posturing. Normally photographed from a low angle so that the images loom like that of Superman against the city skyscape, our media-genic businesspeople are an impossible standard for us to live up to. In the media, businesspeople are hip, slick, and cool.

In real life we may feel otherwise.

In real life businesspeople come in all shapes and sizes. We are seldom as sleek or as slick as our magazine counterparts. In real life we experience raw nerves over important client meetings, clenched shoulder muscles over evaluations from the boss, dread about the future, butterflies in the stomach over sales conference presentations. Conditioned by the media to believe that like Superman, "real businesspeople" have nerves of steel, we often beat ourselves up for being fearful.

"You're such a chicken," we snarl at ourselves.

Blocked by fear, we often hesitate to take risks in business. We focus on the busyness of business and never get around to writing the confidential memos on proposed personnel changes.

"You're so lazy," we hiss at ourselves then.

But are we lazy? No. What we are is fearful.

Most blocked creative people expend enormous amounts of energy on being blocked. Our self-attacks alone take energy. So does the worrying we expend on what might happen if we took a creative risk.

"I could look like a real fool," we tell ourselves. We ask, "What do they think?" instead of "What do I think?"

Accustomed to grandiose images of business heroics—the Armani suit, the private helicopter, the chauffeured town car—we often miss altogether the myriad small moments when business change is possible.

It is remarkably helpful to begin thinking of careers not in terms of product but in terms of creating a body of products over time. The minute we allow ourselves a learning curve instead of insisting that we present ourselves always as finished products, we open the possibility for positive creative change.

"I had to retire my Superman fantasy and look at everyday reality," says Troy. "Instead of trying to leap tall buildings with a single bound, I began asking myself what the next small step was.

> The postponement of gratification is the hallmark of maturity.
>
> —SIGMUND FREUD

> I deal with things in seemingly random fashion, and my day always ends when I'm tired, not when I am done. A manager's work is never done.
>
> —ANDREW S. GROVE

For example, 'Salesman of the Year' begins with one more phone call."

For Karen, a marketing specialist, creative change began when she let her Wonderer into the workplace with the phrase "I wonder what would happen if we tried . . ." Approached in this inviting way, her colleagues entered creative dialogue with her, wondering together. The whole department changed tone.

"Before, I would try to figure everything out. I would say, 'If we do this, then this will happen.' I was constantly presenting people with conclusions and results that they did not necessarily buy. Now that I admit there's room for doubt and speculation, people actually join me in problem solving. We are colleagues instead of competitors."

In business mythology, business is often called a jungle. This image lures us into thinking of the workplace in terms of kill or be killed, an overdramatization that does not serve us and that definitely discourages teamwork.

Superman had a sidekick but no equals. When we try to play Superman in our work lives, we are acting out of grandiosity. People sense it and resent it.

"I was busy posturing—'I'll save the day.'" says George. "I didn't realize that implied 'I'll save the day because obviously *you* can't'"

In thinking of the corporate world as a struggle for life in which only heroics ensure survival, we overlook the many simple and humane actions that can make our environment a more habitable place and a more productive one.

Take entitlement, for example: the guy gets on the airplane, throws all his stuff in the middle seat, and never even asks the guy at the window if they should share it. Common courtesy often seems scarce.

Take manners. Who has time for "please" and "thank you" in a dog-eat-dog world poised on the brink of disaster? Siphon off some of the drama. Start saying, "This is difficult, but we're all in it together," and teamwork naturally emerges and increases.

What most of us yearn for is a sense of community and connection. We've mentioned before the proactive step of reframing the workplace as an ecosystem. Doing this frees us from being locked in adversarial thinking. When we begin asking, "How can I

What lies behind us and what lies before us are tiny matters, compared to what lies within us.

—RALPH WALDO
EMERSON

Every act of cover-up erodes the trust.

—CHRIS ARGYRIS

serve us?" instead of "How does this serve me?" we begin to be part of a team. It is a paradox of successful creative emergence that individual growth promotes teamwork.

Because we are trained to think of ourselves as competitors in the business world, an emphasis on service rather than on being self-serving can feel radical and even dangerously naive. The new way to frame our business as a comparison of other "best practices" or benchmarks in our field can help us stop acting like we have to "kill" the other team in order to survive. Connection and communication undertaken from a peer perspective actually form the basis for true leadership.

In other words, when we act out of a perceived common interest, that stance often results in leadership being thrust upon us as "first among equals." Far from hampering our ambitions and achievements, dismantling our Superman stance paradoxically gives us a humane way to achieve them.

> Every employer is always looking for men who really love to work. Yet work alone is not enough to make a man truly successful.
>
> —J. C. PENNEY

▓ Tool: Contacting Clark Kent

THIS IS A tool of connection as we seek to dismantle our Superman persona and find collegiality with our colleagues. Take a blank sheet of paper. List three business colleagues, close or distant, for whom you have feelings of warm regard. By card, call, or memo, contact each of them in a simple "thinking of you" context. Make plans to meet one of them socially.

BUSINESS BEIGE

STRIVING TO FIT into our corporate world, many of us mute our emotional palettes, rendering our personalities in what we like to call business beige. Business beige is middle-of-the-road, middlebrow, and middle-class. It goes with everything, conflicts with nothing, and expresses very little. Business beige is neutral and, for that matter, neutered. Truth be told, most of us are far more colorful and potent than business beige would allow.

"I was censoring myself unnecessarily," Arnold recalls. "I had a rigid set of rules about my emotional conduct that kept me from expressing a great deal of myself."

Working with morning pages, Arnold began admitting his true

feelings to himself. There were things he *loved* about his job and there were things he *hated* about his job. Business beige behavior kept him from expressing either his genuine likes or his genuine dislikes.

"I presented a blond brick facade like an early-sixties apartment building," Arnold laughs. "My emotional palette was what I call rental white, neutral, and impersonal."

Using morning pages to identify his emotions, using time-outs to pursue his enthusiasms, Arnold began to feel comfortable with a more colorful self. Little by little that self began to be a part of his working persona.

"I remember when I started saying, 'I love that and I hate that' instead of 'mmmmm' in meetings. People were startled, and they started expressing opinions too."

Opinions, some of us needed reminding, are legal commodities for us to own. Likewise we have a right to our enthusiasms. Our enthusiasms both fund and further our ambitions, and sharing enthusiasm in the workplace is contagious. If we admit to loving a project or idea, it makes it easier for others to commit their positive energy as well. As we have said before, creativity is contagious. When we put enthusiasm—a primary color—into our business palette, our work lives become more colorful. We are more authentically "there"!

Enthusiasm comes from a Greek word meaning "filled with spirit." We often notice a flow of what spiritual teachers call grace when we allow enthusiasm into our lives. Enthusiasm is the opposite of obsession. Enthusiasm naturally spreads to others. It is the creative contagion we've been talking about. Enthusiasm breeds generosity. It breeds an outflowing of sweetness because it is positive in nature. Sweetness, an element so often missing from the workplace, can work wonders in terms of willingness and productivity.

Kim, a construction projects manager, realized that her feedback to her workers consisted primarily of negative criticism. "I was very good at telling them what they were doing wrong and very bad at pointing out the many things they did right. I began trying to balance my negative comments with accurate enthusiastic ones for work well done. The results were amazing—like I had watered a languishing garden. People perked up and bloomed. I think they

Well begun is half done.

—ARISTOTLE

The trouble with being in the rat race is that even if you win, you're still a rat.

—LILY TOMLIN

felt safe. They began to try new ideas. My enthusiasm was definitely contagious."

▥ Tool: Local Color

ALTHOUGH WE SELDOM look at it directly, beauty is a powerful catalyst for creative thought. With this tool, we ask you to consciously and deliberately bring five pieces of natural beauty into your living environment. For Adam, it was a tiny table of African violets; for Ken, a simple stone fountain that filled his office with the sound of murmuring water. David chose to have a custom-made rosewood desk. Cal returned to a childhood love and established a serene aquarium with exotic saltwater fish.

> Nothing so needs reforming as other people's habits.
>
> —MARK TWAIN

THE RESENTMENT BLOCK

FOR MANY OF us, our enthusiasms snag on the resentment block. A person or situation stymies, annoys or blocks us, and we think, "If only they would . . . , *then* I . . ."

The minute we say, "If only they would, *then*," we have given away our power and autonomy. Our actions are reduced to reactions as we wait for others to trigger the freedom we desire.

The resentment block is a tricky one. It tells us that only when and if X changes and does what we want will we be happy and free. Only when X gets out of our way will we be able to achieve our goals. This focuses all our thinking on X. We narrow our field of vision to an intense scrutiny of X. Is X changing yet? Why not? Why the hell not? If only X would, *then* . . .

It is our experience that the resentment block can be dismantled by a three-part process, called the Resentment Résumé.

▥ Tool: The Resentment Résumé

IF THIS TOOL seems familiar, it should. Like all our housecleaning tools, it is employed periodically for best results.

Like the Jealousy Map, the Resentment Résumé is intended as another tough-love friend. It kicks us out of a victim posture and into action. We are rendered proactive in our behalf. We are ren-

dered more honest. Our resentment works like a compass, pointing us in the direction we want to go. It also shows us our perceived blocks to going in that direction. Our action antidotes help us jump over, evade, or remove that block.

First, we must identify whom or what we are "stuck" resenting. Second, we must ask why. Third, we must ask what action we can take.

I Resent	Why	Action
Our supplier	Is chronically late	Get other bids
My colleague, Jack	Steals credit	"Memo" my ideas
My wife, Lucille	Complains of inattention	Schedule "dates"
My boss, Alicia	Doesn't appreciate me	Ask for a meeting to talk about your role

Betty resented the scheduling conflict she frequently encountered with a key management person. This person was indispensable but also inconvenient. "I was going to fire her because I wasn't getting all my needs met by her. Instead I scaled back her hours, assigning her to do what she easily could do, and I hired a second part-time person who efficiently did the rest of the job. This was a far more creative solution than my black-and-white thinking of 'my way or the highway.' My Resentment Résumé gave me the ingenuity to work it out."

■ *Tool: Blasting Through Blocks*

FOR MANY OF us, creative U-turns take the form of procrastination. We know we should do something, and we decide we will do something, but somehow when it actually comes to doing that something, we feel stuck. This is when we turn to a potent tool — Blasting Through Blocks.

Before beginning a new project, a creative person must be at least functionally free of anger, resentment, and fear — or able to use these feelings as fuel. Yet many times these feelings are uncon-

Before I built a wall I'd ask to know
What I was walling in or out.

—ROBERT FROST

scious, or make us feel vulnerable, even childish, or overwhelm us to the point of procrastination. (For the truth of these emotions in action, think back to the last time you were outraged enough to write a letter to the editor. Did you write it? Many of us don't because the anger overwhelms us and we shut down as the tension gets too high.)

Our intellectual self wants expression, but our emotional self wants to sulk, whine, balk, strike out, or throw a tantrum. Ignoring these feelings and behavior doesn't work. Listening to them does. Before it can work freely, the emotional self needs an outlet for the tension created by the task—an official hearing in which to register gripes, grievances, and fears, or at least the recognition of the feelings that are perhaps repressed, overwhelming, or displaced.

When you begin any new project, particularly one about which you feel strongly, or where the risks are great, it is a shrewd idea to ask yourself a few pointed questions. These same questions, which clear the way initially, can be asked periodically when work grows difficult or slows down. This spot-check inventory, a quick emotional, intellectual, and spiritual housecleaning, will usually help focus the emotional energy on the task at hand.

1. List any resentments (anger, grievances) you have in connection with this project. It does not matter how picky or picayune they seem to you.

Some examples: "I have nine times the experience of my supposed boss on this project"; "I hate working with this supervisor; she never says what she really means"; "I always have to do more than my fair share; my partner is a real laggard."

2. List any and all fears connected to the project or to anyone related to the project. Again, these fears may seem childish and ill-founded. It doesn't matter; list them all anyhow. Remember, your creative child is not rational, nor are its fears. It does not matter that your adult self considers these fears groundless and inconsequential; to your creative child, they are huge, terrifying monsters.

Some examples: "I'm afraid my work will be good but unappreciated"; "I'm afraid my supervisor will sabotage this project by being too conventional in approach"; "I'm afraid I've run out of innovative ideas"; "I'm afraid my ideas are too radical to be accepted"; "I'm afraid to start, finish, or turn this project in."

Your list may be quite long.

It is not the going out of port, but the coming in, that determines the success of a voyage.

—HENRY WARD BEECHER

They sicken of the calm, who know the storm.

—DOROTHY PARKER

3. Ask yourself: "Have I left out any teeny fear? Have I included absolutely *every* anger?" Get these on the page.

4. Now ask what possible gain you see in sabotaging or not doing this piece of work.

Some examples: "If I don't do this work, no one can hate it"; "If I miss the deadline, my supervisor can get in trouble, which is just what I wish"; "If I don't commit myself, no one will know where I stand"; "If I don't rush completing this I won't be promoted, which means no more added responsibilities."

5. Make yourself a deal. The deal is: "Okay, creative force, you take care of the quality of my work. I will take care of the quantity." Sign this deal and post it where you work.

6. Do the Work.

SUCCESS: THE UNSEEN ENEMY

OTTO RANK SAID, "When the self feels unreal it becomes increasingly difficult to sort out what is real in the outside world." For this reason, success can be deeply disorienting.

As we noted early in this process, many of us undertaking this work for personal change are a lot more scared that it will work than that it won't. Success not only demonstrates that we are learning something new about ourselves but also shows us that we are capable and therefore more responsible for our own circumstances than we may have wanted to believe. This can be unsettling.

Though our drives for both success and learning are natural, innate, we must protect our new growth by understanding how fragile change can make us during these times. Change always represents the death of an old self and the birth of a new one that is vulnerable and in need of nurturing. This is why we have always called success the Unseen Enemy.

As we experience success, it is important to maintain an inner circle of support, of people who can provide us with reliable information about our present situation and our future prospects. As we pointed out earlier, many of us, when we perceive a threat, marshal great resistance to it. Some of our friends and colleagues may view our success as a threat, or carry some of our own ambivalence about it. For instance, they may resist or deny it in direct proportion to

When we are unconscious of a thing which is constellated, we are identified with it, and it moves us or activates us as if we were marionettes. We can only escape that effect by making it conscious and objectifying it, putting it outside of ourselves, taking it out of the unconscious.

—CARL JUNG

The awareness of the ambiguity of one's highest achievements (as well as one's deepest failures) is a definite symptom of maturity.

—PAUL TILLICH

the degree of threat they perceive—to either their own positions, their sense of self-importance, or your sense of self-importance.

Success is not often appreciated; in fact, it is often greeted with confusing feelings, ranging from contempt to sadness. This is why it is crucial to identify your inner circle of trusted advisers. (This is not as common as we would like.)

Success is the Unseen Enemy because we aren't taught to prepare for it the way we are taught to prepare for failure. Think about it: It seems that friends are only too happy to help us when we are having trouble. They take us to coffee, listen to our woes, try to encourage us. In thinking about your inner circle of support, you might ask yourself which of your friends who would help you move to a smaller house would also help you move to a bigger one?

Our success may make our friends feel that we are passing them by. They may feel they are not living up to our standards or doing as well as they should. This can bring about an even deeper sense of alienation if we are not aware enough to turn the stress of success into opportunity by facing and freeing the emotions involved.

Reassuring your friends (or they you) of continued loyalty during these times can be difficult because of all the unconscious fear that change brings with it. (Remember, positive change is still change.) Old friends may seem a little distant, needy, or discouraging as they try to reassure themselves that you are still okay with them and they are still okay with you. Yet old friends can be especially valuable allies if both of you can face the threat of the other's success.

This dynamic is true in any family *or* work setting. It is a part of any group's dynamic. Being aware of the undercurrents stirred by your success may help you maintain equilibrium in your environment. Expect that in the short term everyone will tend to regress a bit to less desirable behaviors. Our joke for this is "Under stress, we say yes." We tend to say yes to behaviors in ourselves and others that we would not otherwise condone.

Paradoxical as it may seem, self-destructive behaviors are likely to appear just as success rears its beautiful head. Many successful people in the arts, entertainment, and corporate worlds have actually sought help just to keep from killing themselves. (Many well-known performers have not survived their stardom.)

There are two aspects of individual harmony: the harmony between body and soul, and the harmony between individuals.

—HAZART INAYAT KHAN

How do you cope with the stress of success? Are you aware of your own behavior and emotional responses? Have you noticed any changes? Do you sit stupefied, wondering how you got there? Are you able to claim it at all? Think back to old successes. How did you handle them in the past? Drank too much? Worked too hard? Spent too much? Relied too much on your spouse? Too little?

What do you need to feel grounded? Time alone? Time with friends? Time with a spouse to work it out? It will benefit us to remember to be grateful and proud for the win and to try to appreciate it fully.

Once we have owned it for ourselves, it is good to look back and see how our success was the result of the efforts of many interconnected people and the convergence of many people's interests, agendas, and efforts.

The gratitude owed to all those who helped give us our break can help keep us humble, and connected. Going out of our way to tell them will help reflect to us our own contribution. In doing so, we will have learned a great deal about ourselves as well as about the larger ecosystem of which we and our success are an integral part.

> The worst part of success is trying to find someone who is happy for you.
>
> —BETTE MIDLER

▪ Tool: Succeeding with Success

IT IS OUR experience that the root cause of failure in the midst of success is isolation. Success separates us from our previous sense of self. It may also confuse and even alienate our friends as they too must grapple with the powerful undercurrents of change.

Take a blank sheet of paper. List ten people whom you love who would love to hear from you. Send each a card.

Next, list ten activities that ground and comfort you. In the immediate throes of success, do one a day.

Roger, a student who shot to stardom in his field, claims that returning to cleaning his house and folding his laundry gave him a renewed sense of stability.

Simple tasks like these, "chopping wood and carrying water," serve a more than worldly purpose.

■ *Tool: Framing Our Lives*

IT HAS COME time for you to read your morning pages. You have written for nine weeks, and left a word trail of your actions, thoughts, and feelings. This record of your inner and outer life provides a potent tool for self-awareness and transformation.

> You have to accept that no matter where you work, you are not an employee; you are in a business with one employee—yourself.
>
> —ANDREW S. GROVE

This coming week, read back through your MPs, noting any important patterns of behavior, emotions, or thoughts that recur. You can mark with colored pencils or markers the relevant passages—for instance, yellow for concerns about work, red for concerns about personal relationships, green for any great new ideas, and so on. Look for patterns of dramas and calm. Use the knowledge to weather future storms.

The important thing for now is that you are able to look at your own life, bracketed as if by a frame, and see it in a new way. No need to change anything or to worry about the prose; just be aware of who you are, what you do, how you treat the important people in your life, and how they treat you.

CHECK-IN: WEEK NINE

1. Have you been consistent with the morning pages? Remember, they are both the river and the boat.
2. Are your time-outs in place? Are you using them to explore authentic interests?
3. What synchronicity have you experienced this week? Is your Skeptic still your inner ringmaster? Has your skill improved at positive self-talk? Are you better able to turn aside self-critical inner attacks?
4. Have you become better at taking care of yourself?

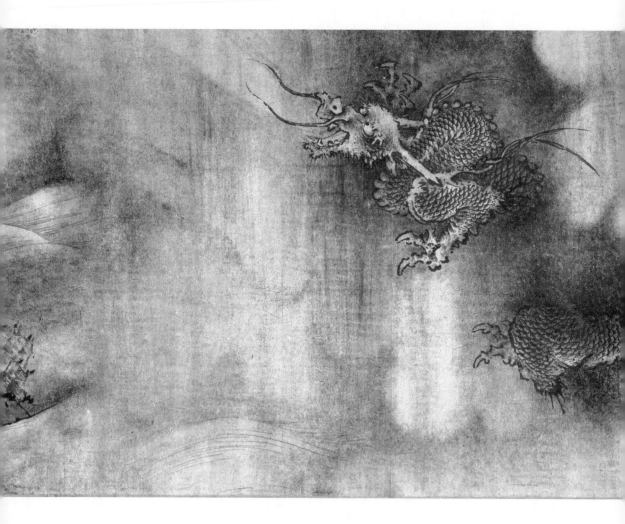

THE EIGHTH TRANSFORMATION
LIVING WITH PASSION

ONCE AGAIN THE dragon soars in the heavens, this time trailing fire, its luminous intensity plain for all to see. With uninhibited access to its own creative energy, the dragon crosses the firmament alive with joy, purpose, and the glorious knowledge of its own power.

No longer frightened by either failure or success, you are free to live your dreams unfettered by the opinions of others or by self-imposed limits. You know what you are about and have taken the further step of embodying your aims, principles, and values in everything you do. A confident spontaneity now arises from your deliberate, conscious transformation—you are living each day with a degree of passion hardly imaginable until now.

COMPARISON VERSUS COMPETITION

IN GREEK MYTHOLOGY, sailors were endangered by needing to sail between two dangerous perils, Scylla and Charybdis. Either one could cause shipwreck, loss, and heartbreak. In business the twin perils are fame and competition.

Like fame, competition is a spiritual drug. Instead of asking, "How am I doing?" competition asks, "How am I doing compared with how so-and-so is doing?"

Competition deflects our attention from self to others. It can be fatal to true accomplishment. As great athletes will tell you, the only truly authentic form of competition is the passion to better the self, our own track record. False competition tells us the lie that winning is about beating others.

Make no mistake, we live in a competitive society. But in business, as in life, competition doesn't truly serve us. When a business is merely focused on what the competitors are up to, it becomes reactive instead of proactive; it copycats instead of developing originality. A business that asks, "What can I do to serve?" instead of "What can I do to win?" stands a stronger chance of winning in the long run.

"How can I beat the competition?" is the sprint mentality. "How can I build a better product or better service?" is the marathon mentality. In business, as in life, we want to be in it for the long haul, for the big picture, not the quick hit. The spirit of competition, as opposed to the spirit of creation, often urges us to act rashly and to sort our ideas and impulses too quickly, before they have a chance to mature. Competition encourages snap judgments: "Is this a winner? Where will this project get me?" Competition discourages gestation, speculation, and the necessary ambiguity of the ripening time that seedling ideas, projects, and plans need to mature.

It is the vain and childish ego that demands that we be first rather than finest. It is the ego's demand that we be "better than" instead of excellent. Always it is a question of focus, of pulling in

our energies and turning the light of our thinking on the real question, "What can I do better?" rather than "What can I do better than they can?"

Jason, a real estate mogul, tells us that prior to his creative emergence his life was all about numbers. "I felt like a zero unless I was number one, the biggest, the best, better than everyone else. I was driven, and I drove myself and others crazy."

As part of Jason's creative emergence he turned his attention off competition and toward creativity. "I began asking, 'What do they need?' and, 'How can I help them?' I took the pressure off my clients to buy a house, any house, and began trying to help them to really find a home. When my focus changed to service, my sales actually increased. I was no longer competing, but I was certainly winning."

We realize that many people believe that what they would call healthy competition lies at the core of business. We prefer another term, "comparison." Comparison asks us to look at our competition and judge how we can better serve the market. Comparison allows us to respond rather than merely react. Comparison allows us to take in the reality of our place in the market while holding true to our vision for ourselves, our services, and our products.

"Compare, don't compete," we urge our students. "Learn from the competition how to be yourself better and more truly."

When we spend our time ogling the accomplishments of others, resenting them and critiquing them, we lose sight of our own through lines. The desire to be "better than" chokes off the desire simply to be. We ask ourselves the wrong questions and arrive at the wrong conclusions.

Competition is about fad and fashion. Comparison is about discernment, selection, and self-improvement. Competition is about quantity. Comparison is about quality. Quality leads to quantity. Winning is a by-product of working well.

In short, we are arguing for the winning power of the longer view: "Are my actions and attitudes today taking me where I'd like to go in the future?"

> Real learning comes about when the competitive spirit has ceased.
>
> —J. KRISHNAMURTI

> If a man aspires to the highest place, it is no dishonor to him to halt at second, or even at the third.
>
> —CICERO

■ *Tool: Positive Inventory*

TAKE A BLANK sheet of paper. Number from one to fifty. Yes, *fifty*. Moving through your life in five-year increments, list fifty things you are personally proud of.

THE DESERT

THERE IS A false and persistent myth that "truly creative" people are persistently, perpetually, perennially creative. These people, so the story goes, never experience self-doubt. They never experience creative dry spells. The truth is such people may not exist.

Typically, a creative life is seasonal. There are creative springs, summers, harvests, and winters. Seasons of chill and seasons of drought are part of the creative life. They are to be expected, and like all seasons, they will pass.

When we are in a creative drought, morning pages feel futile, as though we were trekking across a trackless waste. Time-outs seem like Herculean tasks; who remembers fun? Droughts tell us pages are worthless and time-outs are pointless. Droughts tell us they themselves are endless, that they will never pass, and that yes, truly, we should despair.

Do not believe your creative drought.

As much as anything else, creative droughts are creative doubts. We find ourselves lacking in faith, in hope, and, above all, in charity to ourselves.

Gentle, consistent kindness is the antidote to creative drought: continued pages, continued time-outs, and vigilance toward any negative self-talk that may sound like this: "You'll never have another really great idea . . . You're washed up. You're tired and your ideas are tired . . . You might as well throw in the towel."

Don't throw in the towel. Use it to swab your forehead gently. Creative droughts often precede creative breakthroughs. Perhaps they cannot be avoided, but they can be softened.

The key to surviving them is to treat them for what they are: long hikes through the desert. You will need water—spiritual, emotional, and intellectual nurturance—and you will also need to keep moving. "This too shall pass" must be our mantra during droughts.

I was seldom able to see an opportunity until it had ceased to be one.

—MARK TWAIN

For a man to be perfect there are two qualities that he should develop equally. Compassion and wisdom.

—BUDDHA

We mention droughts as part of our discussion about living with passion because for many of us, droughts occur after a period of conspicuous productivity. Our ideas seem to dry up "just when everything was going so well." We need to realize that they often dry up *because* they were going so well. We have overfished our stock ponds and must consciously take time and energy to refill them.

Creative droughts, time in the desert, are actually windows for the grave temptation of despair, said to be the deadliest sin of all. Droughts tell us that they will never end, that we will always be both dreamless and drained. Nothing could be further from the truth.

> The task of the best teacher is to balance the difficult juggling act of becoming vitally, vigorously, creatively, energetically, and inspiringly unnecessary.
>
> —GERALD O. GROW

Droughts build stamina, and they encourage compassion. As we learn to be gentle and self-loving during periods of drought, we learn the very qualities that allow us to connect more deeply to others. Droughts are difficult seasons of deepening, ripening, and maturation. They render us sweet, although their flavor is bitter.

"Droughts make me far more human," Sam told us ruefully. "I am normally on hyperdrive, relentlessly productive and creative. I burn other people out. Droughts teach me tenderness for both others and myself."

The poet Theodore Roethke tells us, "In a dark time, the eye begins to see." If we look at our droughts squarely, we will see not a trackless waste but a new horizon line.

■ Tool: Laugh or Lament

WE HAVE A choice about how we experience life. In almost any situation we can laugh or lament. Think of three current areas in your life that you could choose to go either way. Now think of three more. Now look back through your list and choose. Write about them this week in your pages. What makes the difference?

A PROPHET IN YOUR OWN LAND

YOU MAY HAVE heard it said that a prophet is without honor in his own country. This adage is all too true in today's business world. After all, change threatens the existing order. In the corporate bu-

reaucracy with its hierarchies and fiefdoms, the commitment to change and to the free expression of ideas is often more rhetorical than real.

When you promote change or offer new ideas, you may be viewed with hostility by your colleagues, not because the changes or new ideas are without merit but because people in hierarchical structures are conditioned to see change as threatening. For all the lip service to new ideas, strategies, and technologies, most businesses are pretty conservative.

The prophet is one who understands that change is inevitable and tries to rally others to meet the new challenges the future will soon present. If you find yourself in this role, buckle your seat belt, you're in for a bumpy ride.

Prophets are the innovators, the people who challenge the myths of the corporation. They are often unheard or discredited because they challenge the status quo. It takes a great deal of courage to stand firm in your opinions when you're going against the tide. It can mean losing of your position, being overlooked for promotions, and feeling isolated and ignored. It can be lonely.

Companies that are experiencing success in the present don't like to hear that it might not last. Their motto could be, "If it ain't broke, don't fix it!" After all, they're making money, right?

Paradoxically, those businesses willing to learn while at the height of their success—to take risks, to entertain and implement new ideas—are the ones that are most successful over the long haul. This is because conditions can always be counted on to change.

As you use the tools of *The Artist's Way at Work*, you will find it increasingly necessary to be authentic in how you view things and forceful and clear in communicating what you see. Your support may evaporate as you become more of a prophet of things to come. This is why we advocate finding a select group of trusted friends or colleagues with whom to do this work.

People may perceive you differently and react to you differently, especially if you are saying things that conflict with the norms or myths of the organization. Try not to take it personally; instead understand that it is part of the normal process of change. Keep centered. Stay focused on your ideas, and capture others' reactions in your MPs so you can observe the process as it unfolds.

Seek out mentors and supporters who can benefit from your

The truth is more important than the facts.

—FRANK LLOYD
 WRIGHT

To dispose a soul to action we must upset its equilibrium.

—ERIC HOFFER

ideas and elicit their buy-in. Real success comes when others adopt your ideas and run with them. This is where it's important to be realistic about your ideas becoming the organization's. This means giving up control and sharing ownership. There are ways to do this without losing credit, a real danger in competitive environments.

Know your boundaries in order to maintain the integrity around your ideas and self-concept. Think through a marketing plan for your ideas just as you do for your organization's products and services. What benefits accrue to the company, to individuals? Who are the target markets for these ideas—e.g., senior management, the CEO, the industry? Which are the constituencies that will be affected negatively? Who will lose turf or revenues? Who will look bad? How will you build a case for adopting your new concept?

Jason, a senior vice-president at a large financial institution in the West, says, "We had a group we called the 'guerrillas in the midst' who were innovators from across the entire business. We were our own support group and we helped one another understand the forces arrayed against our innovative ideas. We would strategize our marketing plans to senior executives and act as sounding boards for each others' ideas."

> All of life is the exercise of risk.
>
> —WILLIAM SLOAN
> COFFIN

■ *Tool: Box Seats*

IMAGINE THAT YOUR workplace is actually a sports arena. There are two teams at play, each in differing jerseys. The first team, conservers, plays the game of maintaining the status quo. The other team, expanders, plays the game of change.

Take a blank sheet of paper, and draw a vertical line in the middle: label the left-hand column "Conserver" and label the right-hand column "Expander." Place the people from your work environment in their appropriate columns. Some people, like double agents, will play both sides.

TURNING HEARTBREAK INTO A CAREER MOVE

NOWHERE IS THE benefit of a creative emergence more clear than in the gift it confers of alchemizing catastrophe into opportunity. Sometimes the calamity is corporate: loss of a key account, a glitch in materials or supply. Other times, equally catastrophic, the calam-

ity is a personal one, which must somehow — creatively — be turned to a good account.

Caroline was an educated and talented woman recently married to a successful advertising executive named Phil. Although she had a graduate degree and a good job, Caroline put Phil and his career first; after all, he earned three times what she did, and she didn't want her career to interfere with starting a family.

Caroline's job, in public television, had much to recommend it. The pay was good, the work interesting. Because it was not overly demanding of her psychic energy and allowed for a good degree of flexibility, Caroline thought of it as the perfect mommy track job. She was content.

Until that February 14 that she's since come to call the St. Valentine's Day Massacre. On that day she'd finished a project at work and left early to shop for the dinner party she was hosting that evening for a few of Phil's clients. As she drove along the parkway, she spotted Phil's car in the breakdown lane with a flat tire and Phil rummaging through the trunk for the jack. She pulled over to help.

Phil was more than surprised to see her. Flustered, he told her to get back in her car and drive home. He insisted he could handle this himself and even took her roughly by the arm and tried to walk her back to her car. As Caroline, confused and alarmed, broke free of his grasp, she spotted a woman whom she recognized as a colleague of Phil's in the front seat of the car. Phil didn't bother to make an excuse. Caroline was heartbroken.

The next day Phil moved out of their apartment. None of Caroline's tears would bring him back.

Devastated, Caroline sat in front of the television each evening with a glass of wine and a heart torn by betrayal. She tried to throw herself into her work, but the sad truth was that the job didn't mean that much to her. She felt she had nothing. Then Caroline had a revelation. She had nothing to lose. Her old life was gone, nothing she could do would bring it back, and she started to burn with the desire to build a new life that no one could take away from her.

Caroline came to understand that her anger at Phil's betrayal could fuel her efforts to make a new life for herself. After all, the anger wasn't simply going to go away. Either it would burn inside

We are not weak if we make a proper use of those means which the God of Nature has placed in our power.... The battle, sir, is not to the strong alone, it is to the vigilant, the active, the brave.

—PATRICK HENRY

Nothing contributes so much to tranquilize the mind as a steady purpose—a point on which the soul may fix its intellectual eye.

—MARY SHELLEY

her and reduce her to bitterness and misery, or she could turn it into available energy.

Caroline took stock. The morning pages had made her suspect that she wanted to do more creative work, but in the entertainment industry, that meant a move to Los Angeles. Scary! She made a list of all the people she knew in L.A. and called them one by one to ask for advice. Then she asked her boss for a few days off for a scouting trip. She thought out every move, kept her eye on the details, weighed the potential pros and cons. She began with small steps; too much change at once, and she would have felt overwhelmed. She was just exploring possibilities, after all. She pushed past the limits of her comfort zone a little bit at a time.

When she arrived in L.A. with only enough money to last a few months, she had to readjust her lifestyle. She got a funky furnished apartment and was charmed by the palm trees outside her window; her chic Manhattan apartment seemed stodgy by contrast. Then instead of beating the sidewalks alone or poring over the help-wanted ads and waiting for her life to start, she found a group of friends with similar aspirations, got herself into the flow of things, and became eligible for something to come her way. She and her new friends, five people with the commitment to follow their dreams, met regularly to pitch ideas to one another and to support one another's ambitions. They served as one another's "believing mirrors."

Within six months two of them were staff writers on a hit sit-com, one sold a feature film script, one got a job at a major cable network, and Caroline became a development executive for a major producer.

On that first, rather low-paying job, Caroline found a mentor, a woman with a passion for her work. Her mentor told Caroline to "resolve to be of service to others" and success would naturally follow.

Caroline says that she was able to hear that message—that she should seek to serve, not to get—only because her heartbreak had emptied her of all her previous assumptions and opened her to trying to live a new way.

Along with trying to live her mentor's advice, Caroline sought out industry functions and seminars, collecting business cards and

> It is not that you must be free from fear. The moment you try to free yourself from fear, you create a resistance against fear. Resistance, in any form, does not end fear. What is needed, rather than running away or controlling or suppressing or any other resistance, is understanding fear; that means, watch it, learn about it, come directly into contact with it. We are to learn about fear, not how to escape from it, not how to resist it through courage and so on.
>
> —J. KRISHNAMURTI

new contacts everywhere she went. She networked constantly to re-main "in the loop," redirecting all the social energy she had lavished on Phil's clients toward her own career goals.

There were many lonely weekends at first, but Caroline used the time to read every script she could get her hands on. Within a year she had an encyclopedic knowledge of writers, and dates had started to crowd out her reading time.

It had taken several months for Caroline to find that first job, but once she got her foot in the door, there was no stopping her. Within four years she had become a film producer, working with some of the biggest stars in Hollywood.

Today, seven years after the St. Valentine's Day Massacre, she owns two houses in L.A. and earns well into six figures. And most important, when she fell in love again, it was as a vibrant and pow-erful woman with her own identity.

Heartbreak is an equal opportunity destroyer. Men as well as women have their hearts and lives shattered, to be built anew.

A handsome man, Michael had always been lucky with women—until they got to know him. He seemed to have little am-bition. He was building no future. He was a wonderful lover, a romantic and a sensualist, but he lived for the pleasures of the mo-ment. He hadn't pursued an education or a career. He had had a succession of passionless jobs.

Whenever a girlfriend expressed her dissatisfaction with his fi-nancial position, Michael would complain to his friends, most of whom were also going nowhere farther than the tavern where they met, "All they want is a guy with money in a three-piece suit." His buddies would nod sagely and agree that women were selfish and shallow.

Instead of looking at himself and what he needed to change, Michael blamed women as a gender. He even held them respon-sible, on some less than fully conscious level, for the way the world of work is constructed.

Michael tallied up his good qualities: He was kind; he was funny; he was loyal. Did he have to be rich, too? As he watched with growing resentment, one by one his former girlfriends married men who had saved some money, fulfilled their educations, bought homes, invested in their futures. What Michael refused to see is that

women the world over prefer men with two key qualities: resources and drive. Anthropologists tell us that although these qualities are defined differently from culture to culture, this preference is universal. This is a fact that Michael, like many other men, refused to face.

"One day," he fantasized, "I'll meet a woman who will accept me for who I am."

One day, instead, Michael met a woman who changed him forever.

It happened when he was thirty-seven, dating a beautiful woman named Barbara, and working as a salesman. The job wasn't very demanding, and it paid well by the standards of Michael's old neighborhood. He was, as always, content to get by, working only as hard as he needed in order to maintain his lifestyle.

Barbara, however, was used to finer things. She was recently divorced from a well-to-do lawyer, who had been educated at an Ivy League school—the kind of guy Michael had resented since his boyhood in the projects. Some months into their relationship, Michael asked to borrow money from Barbara. He'd lost his most important client and had no savings to fall back on. It didn't seem like a big deal to Michael—he'd borrowed from girlfriends before—but Barbara soon became distant and unhappy. She had seen clearly what Michael had never confronted—his financial irresponsibility.

It wasn't that she wanted Michael to be rich; rather it was that she intuited from this incident all the ways that Michael was stuck and afraid to grow and change. What she saw scared her away. She lost respect for Michael, and by Christmas that year she was gone.

Michael raved like a wounded beast. She was shallow. She was spoiled. She had betrayed him. She was further proof that women were fickle and unreliable. The trouble was that he missed her. She was beautiful, funny, cultured, and sexy. He'd always thought of himself as a kind of diamond in the rough that she would polish as time went on. Now he felt small and insignificant. He began to wonder, finally, what she had found lacking in him. Screwing up his courage, he invited her to lunch to ask her. Fortunately Barbara was lovingly candid with Michael, and although the truth was painful to hear, it put a fiery resolve in Michael never to lose another

> Most do violence to their natural aptitude, and thus attain superiority in nothing.
>
> —BALTASAR GRACIÁN

> Creative functioning—full creative functioning—is a basic human capability.
>
> —NED HERRMANN

relationship to his carelessness or lack of motivation regarding money.

Heartbreak *always* represents a new beginning if we have the courage to avail ourselves of it. Michael made the commitment to explore his attitudes, feelings, and behaviors regarding money in Mp's. Then his therapist suggested that some men choose to remain financially insecure for the same reason that some women choose to carry extra pounds: It keeps them out of the running for a serious relationship.

Michael felt stunned by the truth of this statement. He found himself wrestling with the questions of worth, of what he felt he deserved and didn't deserve, of his potential to build a viable future. He stopped blaming his former girlfriends—and women in general—and began to see their responses to him as lessons to learn, as a road map to a new life.

An interesting postscript to Michael's story concerns a situation that arose a couple of years after his turnaround. He had been steadily advancing in his career by redirecting his energies from romantic relationships to his work. One day he got a call from Barbara. She was herself brokenhearted over a breakup and her financial situation had deteriorated to the point where she had called to ask Michael for a loan. He agreed to give her the money only if she would accept it as a gift, an expression of his heartfelt gratitude for the lesson she had taught him.

■ Tool: Heartbreak Hotel—Loss as a Lesson

THIS IS ANOTHER tough-love tool, a kind of ouch energy. We all know he/she was wrong to leave you, but what perceived lack did the loss cause you to identify? Is it true? Is it lack of money or education? Is it workaholism that keeps you unable to focus on the person you are having dinner with? Do you have a drinking problem? Are you really a nitpicky pessimist? Are you really a dreamy romantic without proper financial grounding? What can you do about this?

Ask yourself honestly, "Is there an area of my life that requires remedial attention?" Give yourself the gift of using your ouch energy as fuel.

Answer the following questions:

There is strong shadow where there is much light.

—JOHANN WOLFGANG
VON GOETHE

1. What kind of person do you think is your former lover's perfect partner? What do you imagine his or her new lover has or does that you didn't?
2. Why did your lover say that he or she was leaving?
3. What part did you play in that assessment?

 Assign yourself and your partner each a percentage of the responsibility—romantic heartbreak is always a two-person dance. If your part is 0 percent, look again; if your partner's part is 0 percent, look again.
4. What traits did you list in (1) that you think are yours? What traits did you list in (1) that you don't think you currently possess?
5. Buy yourself flowers.

> Management was an integrated discipline of human values and conduct, or social order and intellectual inquiry . . . a liberal art. Free enterprise cannot be justified as being good for business, it can be justified only as being good for society.
>
> —PETER DRUCKER

SURVIVING THE FALL

THERE ARE MANY kinds of heartbreak. Restructuring, delayering, mergers, and bankruptcies are a fact of business life. State and federal government agencies have cut back as well. Even companies that offered long-term employment have recently announced cutbacks, often targeted at senior positions. We tend to underestimate how much of an impact losing one's job or profession has on the individual as well as on his or her family and friends.

The following story exemplifies how a very powerful man came out on the other side of a fall better off than he (or others) ever thought he would.

Alex was a fast tracker, a high flier, a mover and shaker in the entertainment industry in New York, Los Angeles, and Washington, D.C. He had graduated from an Ivy League university with a doctorate, had taught, and eventually had started a well-respected publication in his field. His intelligence and analytical capabilities drew corporate attention, and he soon ended up at a senior level in a corporation considered a financial giant.

In the early 1980s he was recruited to a very senior position in the entertainment field, working directly for the chairman, with responsibility for strategic planning, corporate communications, government relations, and new businesses. He had his own limo and driver, private dining room, and huge offices and staff—typical of the executives of the 1980s.

He traveled by corporate jet and had an expense account that included entertaining all the most influential people in the United States. He was on a first-name basis with movie stars, musicians, corporate executives, and senior government officials. He dined at the White House, and he had good seats at the Grammy Awards.

Joan, Alex's wife, was from an old-money family and fell into the role of corporate spouse gladly. She reveled in their entertaining as much as he. They built an extraordinary home in New York, filled with valuable art and antiques.

From the outside it looked like a professional's dream, but there was an increasingly heavy toll to pay. Alex began to have chest pains and migraine headaches. He drank too much. He said he felt as if an ax were at the back of his neck.

With new advances in technology, the corporation's revenues began to slip. It went from its best year ever to its worst. Something had to give. It wasn't long before a hostile takeover attempt triggered a series of events that left Alex as a sacrificial lamb for his chairman, who later was fired himself.

Alex landed temporarily on his feet with a high-profile consultant group. By the end of his second year, however, he was out in the cold because of personality and philosophical differences with the chairman and a major financial benefactor.

What happened over the next few years is typical of what happens to many people whose identities are tied to their organizations:

Some of Alex's so-called friends and business colleagues dropped out of sight and offered no help. Catherine calls this the pariah effect: Insecure people disassociate from you when you no longer have power because of their fear that your fall may somehow be contagious.

Alex's wife reacted negatively to their fall in social prestige. She was angry that her life had changed because of him. He was angry that she wasn't supportive. They separated.

Alex went through a period of self-doubt and depression. He failed at several halfhearted attempts to get back on top. He floundered.

Today Alex owns three companies that earn more than twenty million dollars annually in revenues. He is healthy and fit; he works from his home as well as from modest but nicely decorated offices

With the catching end the pleasures of the chase.

—ABRAHAM LINCOLN

Opportunity, for most of us, doesn't knock just once; she raps a continual tattoo on our doors. The pity is that much of the time we're either too preoccupied to hear or too lethargic to answer.

—BENJAMIN F. FAIRLESS

in Manhattan. He and his wife are back together. He says he is happier than he has ever been. How did he get there?

Part of it was luck, but most of it was changing his attitude and finding more balance. Alex began to become more self-aware and found some things he needed to change. He began to work out, cut out heavy drinking, and eat better—all of which helped him maintain a healthy outlook on life. He wrote to record his thoughts and reached out to a professional counselor as well as to friends (the real ones). He and his wife went to counseling together, and as she learned to define herself by her own accomplishments, she became less angry at Alex's life change.

Alex was smart and adaptive. He got interested in new technologies and set out to learn them, though he was even computer illiterate. He helped large companies develop their strategies. He and a few others invested in two start-ups, and he keeps busy managing them and consulting. He was helped by the fact that with the advent of technology-driven issues, the power locus in New York changed (this was the luck part) from who you know to what you know. Realizing this, Alex positioned himself so that his doctoral training and experience with new business ventures made him a prime candidate to be "preferred adviser" to a number of key officials. Today, instead of entertaining them, he is educating them.

Alex's careful climb back to success reveals that balance is the key to surviving a fall.

The observation skills developed in morning pages and the tools we've discussed to balance your life will be most useful should the fall happen to you. And, given the odds, it will happen to all of us someday. However, you can turn the situation into something positive. You can and you must. Think of yourself as intellectual capital, as an individual who has a broad range of skills and expertise and the capacity to adapt and grow.

The skills and experiences you will need for the next phase of your career are not new ones. You already possess them in some measure. They include:

Adaptability
Comfort with change and ambiguity
Intelligence

> Greater dooms win greater destinies.
>
> —HERACLITUS

> Until we accept the fact that life itself is founded in mystery, we shall learn nothing.
>
> —HENRY MILLER

Wisdom
Balanced perspective
Knowledge
Computer literacy

Most people in white-collar positions identify with their professions or organizations. This is healthy when people's lives are in balance, but sometimes people or their spouses forget who they are outside of work. This is especially a problem for men because our society idealizes the provider role. Women are also increasingly defining themselves by this role, and as a result, they too sometimes suffer an identity crisis when shifting professions or jobs. The following tool asks you to find a "before, during, and after you" beyond your job. Through the balanced expression of your energies and interests, you build yourself a safety net.

■ *Tool: The Net of Nurturing*

THIS TOOL IS old-fashioned. It asks you to emphasize both imagination and self-care. When we are faced with a painful ending, we need the healing of a new beginning. We're asking you to do what your mother always told you to do.

Find a hobby, something to focus your energies. Many students report joyously reconnecting to a hobby they had years ago set aside. Daniel returned to active sports; Carol returned to sewing. Derek built an intricate wooden ship. Tracy took up quilting. Henry bought a broken-down Harley and restored it to glory.

CHECK·IN: WEEK TEN

1. It is often at this time in the course that anxieties about closure and moving on keep us from finishing this work. Think a bit now of how you have handled good-byes in the past. Do you just walk away? Or pick a fight? Or slowly fade away without a word? Discovering our pattern for closure and good-bye is an important tool in learning to express the feelings and ambivalence we have as we enter something new or leave something we love. As Tom Stoppard once said, "Look at every exit as an entrance somewhere else." Does any of this feel true for you? Is it hard to continue? You are almost done. No need to run, or pick your life's work. Just finish one day at a time.

2. This week in morning pages, list the things you have enjoyed. What are you grateful for in your life? What do you think will give your life more meaning in the coming years? What do you have in your life now that you might be overlooking? Can you give yourself the win of getting this far? Hold a small celebration in your honor now—a movie, a dinner, a night with friends. You have already won.

3. Any patterns about celebration come to mind? How do you compare your performance with what you had hoped you would do?

4. How are you at wondering?

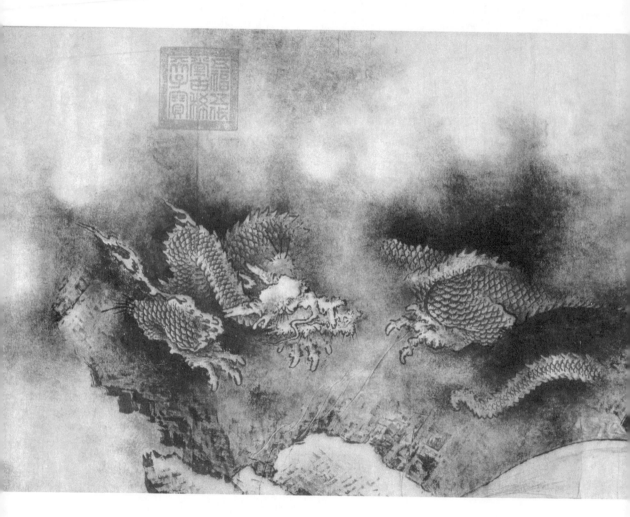

THE NINTH TRANSFORMATION: PART TWO
RESTING IN AUTHENTICITY

THE DRAGON IN repose, enjoying solitude and calm, savors the sublime vista that the ledge of authenticity affords. The ledge is a place where neither striving nor defending is necessary, a place of precious stillness removed from the din and contention of the world. From its vantage on the ledge the dragon can see into the distance. It can see storms rolling in from afar, travelers on their way from a great distance. Serene in its knowledge of the Way, the dragon renews itself, preparing to venture forth once again.

■

THE

LEDGE

OF

AUTHENTICITY

■

CREATIVE U-TURNS

DURING THESE WEEKS you have explored many areas of self-mastery, including money, work, and relationships, examining everything from burnout to success, from monsters to mentors, from fear to fame. In the throes of powerful revelations it is often tempting to return to our smaller self, to some imagined safe harbor from the past. The bad news is, there is none.

The good news is that you have reached a resting place—the inner peace of a more authentic self. This new feeling of competence is also a potential danger point in our creative emergence. Now that the damage and difficulties of the past have been faced and forgiven, we turn to embracing the present—again searching out the dangers of the trail that may ambush you from internal as well as external sources.

The internal risk is this: Success and the excitement of the celebration often hold the seeds for our first real trial. As we feel the surge of power and the velocity of our own creative energy, we are often tempted either to turn away and return to our familiar smaller self or to comfort ourselves in counterproductive ways: overwork, overeating, sexual compulsivity, alcohol, drugs, or immersion in the personality or agenda of another. Any of these—or a potent cocktail of several—can serve to keep us from moving forward.

Creativity requires autonomy, the willingness to act alone and on one's own initiative, a healthy, alert independence of thought and perspective. Time-outs deepen our autonomy, giving us glimpses of the larger picture, the longer view. Nonetheless, when our autonomy moves into action—like a deer stepping into a forest clearing—we sometimes freeze or flee, back to the safety of hiding. This last-minute retreat is a creative U-turn. Think of such retreats as shunning the spotlight.

Typically, creative U-turns are brought on by attention, *either* negative *or* positive:

- An idea is shot down nastily in a meeting. We volunteer no more ideas. We turn into "the mummy."
- A memo is highly praised and an expanded draft is requested. We "forget" to do the draft.
- Our grant proposal makes it to the "final consideration stage." We are asked for supporting materials. We don't supply them. We're "too busy."

As you can see, creative U-turns are a form of self-sabotage. They often occur just as we are experiencing a big win or a creative breakthrough. We have stepped out of what pop culture calls our comfort zone, and feeling as exposed as that deer in a clearing, we race for the cover of relative anonymity.

For most of us, the frustration of thwarted ambition is more comfortable then the free fall of change. Rather than experience the panicky vulnerability of change, we commit a creative U-turn, snatching defeat from the jaws of victory.

Additionally, we may be facing external interpersonal challenges in the form of competition or fame. Because creativity and authenticity are spiritual issues—we must have the faith to move out and ahead.

This is the precise moment when we need active intervention. We suggest that you redouble your efforts at self-care—maintain your exercise routine, the morning pages, time-outs, visiting with friends. In other words, treat a success or a creative U-turn as a potential disaster. Protect yourself from the tendency to sabotage by staying centered in the techniques that got you there.

Faced with a U-turn, ask yourself, "Whom can I ask for help?" Then start asking.

All of us have favored ways of blocking our creative flow when tapping into the full potency of our creativity makes us feel out of control. We feel the flow and velocity of energy and think, "Uh-oh, where is this taking me?" We want to slam on the brakes, rein in the horses, hose down the creative fire.

Many of us use relationships, or the lack of relationships, to block our creativity. We obsess, and the obsession becomes the channel for our creative speculation. "I wonder" becomes "I wonder if she/he loves me."

> Creativity is a spiritual action in which a person forgets about himself, moves outside of himself in the creative act, absorbed by his tasks.
>
> —NIKOLAI BERDYAEV

Clarisse's dreams of creative fulfillment always took a backseat to her romantic fantasies. "I dreamed of graduate school, but instead of my application I wrote a long letter to Mr. Wrong. I'd spend an hour a day writing to a guy who didn't want to hear from me in the first place."

Josh, a software salesman, found himself hooked on Internet pornography. "I'd start to work on a creative project, and then I'd decide just to 'check out' a porn site. I'd tell myself I was just going to take a peek, but hours later I'd come to, exhausted and disgusted."

"It was food for me," confessed Candace. "I'd get a great idea, and then I'd get a great big bowl of ice cream. I'd numb out on the sugar and never get anything much actually done. 'Food for thought' was actually 'Food for thoughtless' in my case."

Most of us can name our favored block. Some of these blocks are clearly self-destructive, and we may be honest enough to admit it. Other blocks, however, are more subtle to diagnose. Naming them may require a step-up in honesty.

For many businesspeople, overwork is the block of choice. We stay busy, busy, busy—too busy for creative thinking or useful introspection.

Darryl is a highly paid television producer. His life is a constant round of meetings, travel, more meetings, more travel. Darryl is successful but feels that his work is less substantial than he would wish. He'd like to deepen his work. He'd like to change his lifestyle, but he's just too busy to do anything about it.

"I really need to think about all this," Darryl tells us. "I swear to God I'd like my life to slow down and to stop doing such formula work, but I've got so many irons in the fire right now . . ."

For Darryl, "right now" is a permanent condition. His days start at six and end at midnight. He's got a wide network of superficial friendships and no time or space for deeper intimacy. Whenever anyone draws close, Darryl piles on the projects. He sabotages relationships that he actually craves.

"My work comes first," Darryl admits, but his work actually comes first, second, third, and fourth. For Darryl, workaholism stands between him and real creative work.

"I don't look blocked," he says, "but I sense there's something deeper that I'm avoiding."

All of us are avoiding the "something deeper" when we pick

Nothing unless first a dream.

—CARL SANDBURG

If writers had to wait until their precious psyches were completely serene, there wouldn't be much writing done.

—WILLIAM STYRON

up a block. We need to learn how to feel our creative energy and contain and express the anxiety without reaching for something to block it.

"I decided to try just not blocking," says June. "My big block was unrequited love. I decided to ask myself, 'What was I thinking of doing, right before I began thinking of him?'"

June discovered that she used the thought of her scornful lover just like smoking a joint. "I'd think about a new idea, and—wham!—I'd suddenly start thinking about Mr. Wrong instead. I began catching myself and forcing myself back to the creative thought. When I did that, my creativity really took off."

Feeling our creative energy and learning not to sabotage it are learned skills. Creativity may at first feel like anxiety or restlessness. Recognizing that our itchiness may be an itch to do something creative is a first step.

Channeling the itch into immediate creative action is the second step. Creative energy is inner fuel. Learning to use it to arrive at our desired destination is a matter of gentle discipline.

"I would feel restless, head for the refrigerator, and then stop, asking myself, 'What can I do with this feeling besides eat?'" Candace told us. "By asking that question, I began to do all sorts of things: clean the pantry, make new curtains, paint the bookshelves, call for information about dancing lessons."

For Candace, formerly a passive loner embroiled in food addiction, making a phone call was a creative act. For Jeannette, who poured her energy into the lives of others, staying away from the phone was a creative act. "I'd start to think about my life, and then I'd think, 'I wonder how Jimmy or Marina or Ellen is doing,' and I'd call them to find out. On the surface this looked virtuous and healthy, but it was really self-avoidance, and deep down I knew it."

Most of us know in our hearts if we "love too much." Giving up overloving, like giving up overworking, is something that begins with the admission that we are using our "virtuous" behavior to block our authentic growth.

Janice worked in employee relations, a job tantamount to being a counselor. Day in and day out she listened to the woes of her beleaguered coworkers, offering many of them her home number, lest they feel too stressed in the evenings to wait until the next day to speak with her.

Even the promiscuous feel pain.

—WARREN BEATTY

But creators not only can imagine or envision, they also have the ability to bring what they imagine into reality. Once a creation exists, an evolutionary process can take place. Each past creation builds a foundation for the next creation.

—ROBERT FRITZ

"Talk about stress! My own evenings were exhausting," she recalled. "I'd come home to messages stacked up like airplanes waiting to land."

By the time Janice returned her evening calls, she'd put in nearly a second day's work.

"I look at it now and see it as being dually addicted, to work and to other people," she says. "My own creativity was completely drained. I learned from my morning pages that I yearned for a real life of my own. I need to draw boundaries and keep them. When I did, I suddenly thought, 'My God, what shall I do with all this energy?' "

"What shall I do with all this energy?" is the question we most want to be asking. With attention and practice, we can feel our U-turns as we start to make them. We can stop—mid-sabotage—and gently walk ourselves back on path. We can:

- Feel our anxiety
- Use it as fuel
- Move forward productively

Anxiety is fuel. We can learn to use it to move ahead.

▪ Tool: Name Your Poison

TAKE FIFTEEN MINUTES of very private time. With pen in hand, candidly admit to yourself the toxic blocking behaviors you have recognized as your own. Do you need outside therapeutic support in arresting these behaviors? Are they chronic? What is your 100 percent honest personal assessment? (If students suspect themselves of having a drinking problem, eating disorder, gambling addiction, sexual addiction, or process addiction, they've usually got it.)

The good news is, help is available in myriad forms. By this point in your creative emergence it should be clear that blocks, however toxic, are only a part of who you are and can therefore be set aside as a more powerful you emerges. That old addicted self is old news.

Trouble will come soon enough, and when he does come, receive him as pleasantly as possible. Like the tax-collector, he is a disagreeable chap to have in one's house, but the more amiably you greet him the sooner he will go away.

—ARTEMUS WARD

Without discipline, there's no life at all.

—KATHARINE HEPBURN

■ *Tool: Creative U-turns*

ALL OF US — and we do mean *all* of us — have made creative U-turns in our career. Discouraging, dismaying, disillusioning, our U-turns must be faced and can often be undone or ameliorated by positive action. Viktor Frankl says that the act of taking responsibility for our own live results in what he labels "logo therapy" — that is, the seeking and creating of meaning. It is for this reason that undoing our creative U-turns yields us deep soul satisfaction.

Take a blank sheet of paper and make three vertical columns. Label the first column "U-Turns." Label the second "Action Antidote." Label the third column "Business Bottom Line." For example:

U-Turn	Action Antidote	Business Bottom Line
missed grad school deadlines	reapply	make deadline week early
didn't redraft sales memo	redraft	don't promise and not deliver

Many of us have found that with sufficient humility we are able to undo creative U-turns or at least exercise some effective damage control. Reward yourself for doing this tool with a nurturing time-out.

FAME

IT IS ONE of the central myths of our media-drenched society that fame is a cure-all that all of us should yearn to acquire. Fame has become a powerful addiction that drives everyone from talk-show guests to politicians to sacrifice their integrity or their discretion for their fifteen minutes in the spotlight.

Fame differs from honest recognition for work well done. Fame is larger than life and is largely unrelated to real accomplishment. Fame, to put it bluntly, can become a spiritual drug. There is no such thing as enough fame. Fame is addictive, in that we always want more. Fame produces the "How am I doing?" syndrome. Fame does not ask, "How well is the work going?" Fame asks, "How is

One of the ways that are recommended for reclaiming creative passion is to seek out experiences that confirm to you that the opportunity to be creative is actually available to you.

—NED HERRMANN

the work—and how am I—perceived?" Fame places us into that *competitive* mode we spoke of earlier, but now instead of comparing ourselves with the competition, we compare ourselves with, well, everyone! Fame separates us from others, isolates us. It is a golden cage. Its spotlight can be blinding.

"I began to get some recognition," Gerald told us, "and I found that I wanted a whole lot more. My projects became a means to an end: 'Think more of me, think more about me.' I began to be hooked on winning attention instead of on doing good work. I started believing my own reviews."

Fame is about star turns, not teamwork. Fame can also be an addiction to revenge: "I'll show them," which deletes the sweetness from the victory even when it is well deserved. Like the grandiosity of the wounded, fame can take the focus off the solid satisfaction of a job well done and change it to the more fleeting satisfaction of a job well noticed.

"I won Salesman of the Year in my division," Andrew reveals. "Suddenly my eye was on winning it again, not on serving my customer or actual selling. I became obsessed with being perceived as a superstar. I started demanding special treatment, more and more perks. I discovered I had an appetite for fame, and I couldn't do enough to keep it fed. I went from being a pretty happy guy to being a son of a bitch. Fame went to my head and didn't help once it got there."

Fame tells us that if we haven't made it yet, we never will. Fame is about being glossy, larger than life, heroic, and admired. Fame is not about solid accomplishment. It is about the appearance of accomplishment. Fame, in short, rests in other people's hands and perceptions rather than in our own. Fame gives our power away to others and leaves us begging for more. It robs our creative power and displaces it.

"I landed a million plus," Jack told us, "and the fallout almost killed me. I was suddenly famous within my company. I was a man to be watched. That feeling of being watched drove me crazy. I found it very hard to settle down and just get on with the work at hand."

If fame is a spiritual drug, a sudden hit of fame requires a conscious detox. As we have said, we advocate doing small daily things: wash dishes by hand, clean out some closets, do the mending. Do small, doable, durable acts of deliberate humility. Repot

Property has its duties as well as its rights.

—BENJAMIN DISRAELI

If a man does not make new acquaintances as he advances through life, he will soon find himself left alone.

—SAMUEL JOHNSON

your houseplants. Use them as a metaphor. Plants suffer trauma when they are suddenly hit by a change in conditions.

The glare of the spotlight is a sudden and severe change of conditions. Treat yourself gently. Do some spiritual reading. Take deliberate actions to bring yourself right-sized. Help your kids with their homework. Call an old friend, and listen to his or her life. Clean out the garage. In other words, rejoin humanity. Remind yourself that stars are bright, beautiful, and lovely in the dark. Treat fame as a toxin, and clear it from your system by focusing on work as process, not product.

"Fame is like heroin," Allie tells us. "I get a bit of fame and I remind myself, 'Wait a minute, I'm the *heroine*.' It's nice to be appreciated, but it's more important that I appreciate myself."

At its root, fame is a shortcut, a cheap substitute for self-respect. Our ledge of authenticity is flimsy indeed if it is constructed from the stuff of fame.

> Men of integrity, by their very existence, rekindle the belief that as a people we can live above the level of moral squalor. We need that belief; a cynical community is a corrupt community.
>
> —JOHN W. GARDNER

Tool: Ten-Minute Time-outs

ONE OF THE best ways to stay centered during times of attention — cameras, reporters — or just excitement or success is to stay grounded in your own experience by doing brief breaks from the hubbub. (Observe your CEO and senior management — the most effective ones carve out periods for brief time-outs.) Try several ten-minute time-outs a day this week as a preparation for the times you may really need them to avoid the paparazzi:

- Walk to work by a museum or park.
- Close the office door and listen to music.
- Bring a travel book and make vacation plans.
- Read poetry or a short story.
- Look through art or design books stored in your office.
- Walk to the roof or find a room with a view.
- Walk around the block, or duck into a store.
- Write in your journal.
- Get a massage.
- Meditate.
- Pray.
- Cut up magazines to create collages of your dreams.

· Do one of *The Artist's Way at Work* exercises.
· Do something, however small, toward your long-term goals.
· Surf the Internet (ten minutes only!) for new ideas.
· Make up some brief time-outs of your own. Do them.

You don't have to compromise your integrity to sell. You simply have to find and emphasize the things that unite you instead of the things that divide you.

—JOHN J. JOHNSON

■ *Tool: Valuing Our Values*

AT THE VERY CENTER of each person's being is a deep yearning for meaning. When we work in alliance with our value system, this yearning is satisfied.

This tool builds upon an earlier tool, Practicing the Present. Taking pen in hand, please list twenty-five work concerns or values—you might want to call them ideals—that matter to you. If you run out of work-related ones, then do them as ideals to live by. For example:

1. Justice in the treatment of subordinates
2. Support for continuing education
3. A sense of community
4. Day care for mothers and fathers
5. Flex-time so that I can pick up the kids
6. An active mentoring program that keeps us connected
7. Access to the leaders and their vision
8. Freedom of religious expression
9. Separation of church and state
10. The First Amendment
11. Handgun control

No need to be politically correct. The goal is authenticity, finding out what *you* really think and feel.

A handmade life is a hands-on life. Choose one area of your values in which to take a positive action.

AUTHENTICITY

SEVERAL YEARS AGO, we came upon a book by noted psychiatrist James Masterson, entitled *The Search for the Real Self*. In it he describes what he feels are the ten key capacities of the real self, as opposed to the false self.

What struck us was how much his list reminded us of the changes that we had watched in our students during our creativity work together. Dr. Masterson's list gave us new insight into the application of our work. We paraphrase it for you below because these capacities are the heart of what you have been engaged in during these weeks.

The real self has the capacity:

1. To experience a wide range of feelings deeply with liveliness, joy, vigor, excitement, and spontaneity.
2. To expect appropriate entitlements—we expect to master our lives.
3. To identify one's unique individuality, wishes, dreams, and goals and to be assertive in expressing them autonomously.
4. To acknowledge self-esteem.
5. To soothe painful feelings.
6. To make and stick to commitments.
7. Creativity. As Dr. Masterson defines it: the ability to replace old, familiar patterns of living and problem-solving with new and equally or more successful ones.
8. To express the self fully and honestly in a close relationship with another person with minimal anxiety about abandonment or engulfment—that is to say, intimacy.
9. To be alone, without feeling abandoned or the need to fill up our lives with meaningless sexual activity or dead-end relationships.
10. To know the continuity of self—that the "I" of one experience is continuous and related to the "I" of all other experiences. At the end of life, it is the same "I" who was born many years ago who passes on.

Do you recognize the authenticity in these key capacities?

■ *Tool: The Ledge of Authenticity*

SCROLL DOWN MASTERSON'S list of key capacities and list in what ways you have been engaged in the furthering of each of those capacities during your life. During this work? How has each changed? Which are your strengths and weaknesses? Why?

Can you see any patterns in your blocked areas? Can you see how you might change them for the better? Wonder about these ten capacities through the coming week.

ACKNOWLEDGING YOUR GROWTH

Success isn't permanent and failure isn't fatal.

—MIKE DITKA

THE KEY TO remaining creatively authentic is remembering that creativity is not a linear process—and neither is personal growth. When we accept the fruitful formlessness of creativity, allowing the shape and structure of our lives to alter as they are inwardly directed, we can also examine in what ways we need to grow in order to achieve our dreams. Doing so requires trusting the creative impulses we receive, not second-guessing them and not ruling them out because they do not appear to make sense. There will be time to test our thinking.

Creativity and change are about incremental process—two steps forward, one step back. Every new skill brings about regression in the behavior until the new skill is learned. Because of this tendency to regress when we learn, we say that creativity is about process, not merely about product.

When we center ourselves in the flow of our ongoing evolution, allowing ideas to emerge, alter, and evolve, resisting the cash-on-the-barrelhead, shortsighted stance of "Will this idea get me anywhere?" we begin to take command of where we are, as well as where we are going.

Living *and* leading our own lives, by our own lights, is a place of power—focused on where we want to go, rather than whence we have come. This is what the ledge of authenticity is—the place of power, surveying all below, without the need for grandiosity, obsequiousness, or weakness. Creativity is about the considerable freedom all of us can exercise within the structures of our lives as they currently exist.

ACCEPTANCE

SELF-CARE IS THE oxygen of creativity. Self-love is the healing rain and nurturing sun. Self-care and self-love begin with self-acceptance, and that is grounded in self-knowledge. Morning pages and time-

outs teach us who we are, what we value, and what we need to feel valued ourselves.

Each of us is unique. Each of us is important. Each of us brings to the world a specific treasure box of talents and gifts that we are charged with bringing to fruition. Because we are unique, because we each require specific nutrients to grow, our lives cannot be mass-produced. They must be handmade to handle our personal needs.

Carolyn, an advertising copywriter, has a deep love for music. For her, twenty minutes a day of playing her guitar reminds her that life has beauty and grace and continuity beyond the stress, pressure, and deadlines of her work.

"I'm not a great guitar player, but I am a joyful guitar player. Playing daily works for me as medicine," Carolyn says. "I have learned to give myself my medicine."

Harry, a regional sales manager, has discovered that when he exercises, he exercises better judgment. He travels frequently and always carries his workout gear and running shoes.

"If I don't work out, I get too speeded up and heady," says Harry. "It's the difference for me of feeling like a caged animal or a serene monk in my hotel room."

For Allison, a systems manager, twenty minutes daily of Buddhist reading and sitting meditation give her a sense of grace and perspective.

"My Buddhism balances the hurly-burly of my business life," Allison says. "I find balance by adding an Eastern thought to my Western lifestyle."

Jerome began his creative emergence as a network television executive. He was good at his job but felt bad about doing it. "Everything I did felt disposable to me. I had been there and done that. I wanted something new."

Using creative tools to steady himself, Jerome began asking what he wanted next. Why was he doing what he was doing?

"I realized that my large paycheck was the primary, if not the sole, attraction of my job. I began working to separate my worth from my net worth and see what I really valued. That's when I hit on the idea of teaching."

Jerome is now half a decade into a new career as a grammar school teacher. Last year he won "Teacher of the Year."

The generation of really new ideas is in the depths of human nature. . . . It is deep in the sense that ore is deep. It's deep in the ground. You have to struggle to get at it through surface layers.

—A. H. MASLOW

"True, I don't make as much money as I once did, but I *feel* far richer," Jerome says. "I am doing work I respect, where I use my creativity in ways that can have a lifelong impact on the children I teach. This to me is success."

Many of us, like Jerome, must learn to distinguish for ourselves what is valuable. We often stop making the dollar sign the only road sign we follow in steering an authentic path.

Creative authenticity is a twenty-four-hour-a-day proposition. Some of our creative work will be paid for—even handsomely—and some will not. Once we begin to allow ourselves to create for the joy of creating and not merely to make a living, all sorts of opportunities unfold for us.

Brian, a successful book editor, began to allow himself spare time to paint. At first he felt guilty. "I always felt I should be reading someone's work, but I reminded myself that I had a right to a personal life, and in that life I was a beginning painter."

From a beginning painter Brian evolved over a decade into an accomplished painter. In time he found himself happily juggling two careers, one in which he was paid as a book editor and another in which he was now paid as a painter.

"I loved both my lives," Brian told us. "Both of my lives were real and grounded in my true interest."

Brian's story brings us to a very important point. In our cultural mythology, in order to be a "real" creative, we must devote full-time to our creativity and be paid for it handsomely. Nothing could be further from the truth.

Even many of our now-acknowledged artistic greats were not so acknowledged in their lifetimes. Gauguin, Van Gogh, author Raymond Chandler—these men worked for years without having their work recognized or bought. The point is, work they did, defining for themselves, by their own light, their own creative paths. Think of all the great inventions and conveniences we appreciate without knowing the men and women who made them possible.

For a creative being, self-respect comes from being creative. Using our morning pages to determine what we like and what we don't like, we begin to shape lives by our authentic desires. Business life may confer on us a certain level of apparent external conformity, but the range of small daily choices in which freedom and self-expression are employed remains immense.

The same man cannot well be skilled in everything; each has his special excellence.

—EURIPIDES

During [these] periods of relaxation after concentrated intellectual activity, the intuitive mind seems to take over and can produce the sudden clarifying insights which give so much joy and delight.

—FRITJOF CAPRA

"My external life looks unchanged," Tracy, an airline executive, told us, "but my inner life is radically different. Music has come to the fore. I exercise. I've taken a watercolor class and joined a church choir. I express my feelings more freely, and my home is now filled with plants and a beautiful aquarium. My outer life may look conventional, but my inner life is rich and varied. I always wanted an exotic life. In many ways now I've got one."

As creative beings we ask ourselves creative questions. "Why?" and "Why not?" replace "Oh, all right" in our vocabulary. We learn to "play" with an idea. We begin to experiment with unconventional solutions within structurally conventional lives.

Annie, a Chicago-based executive, lived for ten years in an apartment with a large living room decorated for company that seldom came and a small bedroom where she spent 80 percent of her at-home time. One week she came to an Artist's Way class and announced, "I now have a large beautiful bedroom I just love and a small sitting room, should anyone care to come visit."

Arthur, a deskbound executive, missed the active life he'd enjoyed before his work life became a booming career. "I needed a sense of adventure. I missed my own physicality. People thought I was nuts when I first began biking to the office; it was a fifteen-mile trip, twice daily. I quickly found that I processed my life in those trips: I came up with solutions to sticky problems as well as came happily back to an Iron Man self-image."

Flaubert said, "Be conventional as a bourgeois in your life so you can be radical in your work."

The willingness to find a personal path, even if it's eccentric, is one of the fruits of creative emergence.

"I think of it as having a customized life," says Dan, an automobile designer. "My life is aerodynamically shaped to meet my needs. It may not look like everyone else's life, but it looks good to me."

"To me": Those are the key words of creative emergence.

> [When asked late in life why he was studying geometry] If I should not be learning now, when should I be?
>
> —LACYDES

BODY OF WORK

WE USE THE phrase "a heady success" without realizing how literal it is. "A dizzying success," we say without noticing how precise we are being. Business is a heady, dizzying affair. The velocity of events,

the often turbulent flow of personalities—all these can leave us feeling rushed, disoriented, and dismayed. Like survivors of bad accidents, we may suffer out-of-body experiences. We become dissociated from ourselves, our emotions, our true bearings.

"I need to find solid ground," we say. "I need to see where I stand." What we are saying, with phrases like this, is that we intuitively sense our need to get out of our heads and into our bodies. We need our bodies if we are to establish solid, workable, long-range careers. Not only must we exercise our judgment . . . but we must exercise, period. Exercise clears the mind, steadies the emotions, alters not only our serotonin levels but also our perspective.

David, a tall, rangy executive, found that days at his desk left him feeling dazed and dull. He took decisive remedial action.

"I got a treadmill, a speakerphone, and a stationary bike. I find I can talk and walk, think and jog, cycle and recycle my ideas."

Arthur, who had put on pounds as well as titles, joined a health spa and began taking his lunch hour to slim, not swell, his waistline.

Richard, a lawyer, can be seen Rollerblading to work through Central Park, complete with suit, tie, and briefcase.

For Natalie, exercise is a yoga video and a fifteen-minute workout on her living room floor. For Maureen, it's bike riding three times a week right after work.

No matter what shape you take your exercise in, exercise will put you in better shape.

"I think of it as exercising my options," says Emil. "I'm taking an option on a healthier and happier life."

Craig, like many of our students, believed he had no time to exercise. His career was all-consuming, and he didn't see where he would find the time.

"Try a twenty-minute walk at lunch," we told him. "Try to get out three days a week."

Complaining all the while, Craig nonetheless tried our prescription.

"All right. You were right," he reported. "I got a whole lot of good ideas and had much more energy all through my afternoon. In a funny way I actually gained time—or at least speed. I didn't have an afternoon slump anymore."

Many enlightened companies are installing company exercise

Go confidently in the direction of your dreams! Live the life you've imagined. As you simplify your life, the laws of the universe will be simpler.

—HENRY DAVID THOREAU

A sound mind in a sound body is a short but full description of a happy state in this world.

—JOHN LOCKE

rooms. They have found that employee fitness and employee morale are closely interconnected.

"There seems to be more camaraderie now that we sweat more than just deadlines," David, a marketing executive, told us. "And I get a lot of my best ideas on the rowing machine."

Any regular repetitive activity sets up the brain to cross over from left-brain linear thinking into the more freewheeling, associative, and creative thinking of the right brain. Skating, swimming, rowing, riding—all these exercises stimulate the mind as well as the body.

The basic building block of management, for me, is goal setting. You must have a goal in order to know what direction to take.

—TOM MONAGHAN

"I take my problems to the track and my solutions home from it," says Robert, who runs three times a week at a small cinder track around a reservoir near his office. Self-employed, he says he took proximity to the track as a key criterion for renting office space.

Karen, an accomplished account executive, ice-skates three times a week. "I knew I needed exercise, and I knew I would absolutely hate aerobics. As a kid I was a great skater, and I still remembered the soaring feeling of gliding across the ice. 'If I could skate, I'd exercise,' I said. My secretary called my bluff by finding me an indoor rink near the office. Frankly I'm in heaven whenever I'm on ice. I'm not a middle-aged lady with a lot on her mind. I'm a teenager again, sailing across the rink."

Like Karen, Chuck couldn't see himself at the gym. "I wanted something to fire my imagination. I did not see myself sweating for sweat's sake."

Like Karen, Chuck had a long-ago childhood love—in his case, horseback riding. "I found a stable fifteen blocks from the office in a converted motorcycle factory. I went over after work one night for a trial lesson, and I was instantly hooked. I go twice a week, and now I share board on a big bay thoroughbred. I never think about work while I'm riding, but I find I think better about work after I've ridden."

As these examples illustrate, exercise is a matter of exercising the imagination. We suggest finding a form of exercise that inspires your imagination as well as tones your body.

"I've become a true walker," reports Toni, a senior corporate consultant with a dancer's form, "I see a world full of life, color, and interest. It reminds me that there is a world out there that's bigger than whatever problem I'm wrestling with. In that sense walk-

ing brings me down to scale—and down to earth—but in a positive, affirming way."

Exercise often creates an experience of "falling in love again"—most often with ourselves.

"I'd never realized I was interesting," Roger told us, "until I took up jogging. I get these really fascinating ideas, notions, flights of fancy. Call them what you will, they are different from my normal thoughts and interesting as hell—at least to me."

It is our experience that if we will allow the "body of our experience" to enter our lives, we enrich our "body of work" and also "embody" fuller, richer, and more satisfying lives.

> The world of reality has its limits; the world of imagination is boundless.
>
> —JEAN-JACQUES ROUSSEAU

■ *Tool: Exercising Our Options*

IT IS OUR experience that few tools strengthen our self-esteem, our will, and our optimism like physical exercise. It cannot be replaced.

In most urban areas, exercise comes in as many shapes and forms as people. Running tracks, Nordic tracks, the fast track, community pools, sports centers, dance classes, aerobics classes, tennis lessons, Rollerblading, horseback riding, bicycling—any and often all of these are available to us.

Choose an exercise that appeals to your soul as well as your body. One that is fun. Your likelihood of sticking to a regime is far higher if it engages your imagination as well as your image. Deidra took up fencing. Arthur, an asthmatic, swims laps. Michael rows the Charles River. Andrea cycles daily. Elizabeth practices yoga. All swear by the chosen form. Pick one and focus, or pick several and experiment.

> The most beautiful thing we can experience is the mysterious.
>
> —ALBERT EINSTEIN

CREATIVE CENTER

WRITER VIRGINIA WOOLF argued that in order to lead a creative life, everyone needs "a room of one's own." In our intense and overcrowded lives, a room of one's own is not always possible. For many of us, morning pages become our portable solitude. We enter a room within ourselves and there experience an inner dialogue with many diverse parts of ourselves.

It is our experience, however, that a small, consecrated physical space—what Julia calls an artist's altar and Mark calls a creativity

center—is an important personal touchstone. The space can be as small as a windowsill or a bookshelf. It can be a bedroom corner, a niche of unused space under a staircase, a small table next to your favorite reading chair. What matters is not the size or shape of the dedicated space but the fact that it is dedicated to you and to your inner imaginative life.

As we've said before, the part of you that creates is young, whimsical, and imaginative. Your creative center should contain objects that speak to this "magical" part of yourself.

Eric's artist's altar has bells, candles, some beautiful pieces of jade, and a small ivory Buddha. Kathleen's creativity center has a velvet cloth, a pot of trailing ivy, a crystal apple, and a small leather-bound book for writing down spiritual requests.

Fresh flowers, a long-burning candle, beautiful stones, a treasured memento, a small carving, a bell, a tiny figurine—any and all of these indicate that our creativity centers are sacred space to which we pay careful attention. Remembering to care for our creative centers reminds us to care for our creative selves.

> The creation of something new is not accomplished by the intellect but by the play instinct acting from inner necessity. The creative mind plays with the object it loves.
>
> —CARL JUNG

▥ Tool: Creativity Center

BUILD A CREATIVITY center. Allow magic, whimsy, and inspiration to enter your choices. Choose objects whose beauty and power of association speak to your creative core. Allow yourself to add, alter, and update your creativity center often.

THE SPIRIT MENTOR

WE'VE NOTED THAT creativity requires a sense of play. More than that, it requires a sense of drama—and the conviction that we are worthy, leading players. By casting our lives in mythological and somewhat-larger-than-life terms, we enable ourselves to achieve attitudes and actions larger than our fears. In other words, we play a potent and benevolent form of make-believe. We act "as if."

When faced with a difficult situation, Judith, a publishing executive we know, always asks herself, "What would Katharine Hepburn do?" You're probably wondering, "What on earth does that have to do with making a business decision?" Actually, quite a bit. By invoking the image Judith holds of Katharine Hepburn—for her

the very epitome of refinement, sophistication, and elegance—she can get in touch with the part of herself that is also refined, sophisticated, and elegant. Holding that vision, she then can make the choice she believes will be of most benefit.

A bond broker we know invokes the figure of Genghis Khan—for his "take no prisoners" approach to getting what he wants. (That approach may net him the results he's after, but a word of caution about whose essence you invoke: If you live by the sword, you may die by the sword.)

Some spirit mentors are chosen for their actions; others, for their wisdom. A lawyer who is now a district court judge envisions herself as Solomon, trying to be fair, wise, and willing to walk in the other person's shoes.

By choosing role models, we can draw into ourselves the essence of what we perceive these mentors to be, helping us reach beyond our present personas and toward larger, expanded selves.

Lynn, a former purchasing agent, recalls a time not long after her marriage ended when she was terrified about her future. "I had quit my job when I was pregnant with my second child because working long hours combined with having a toddler at home was putting a strain on everyone.

"My husband and I decided we would do the best we could with just one income, and as it turned out, we did fine. But then, a few years later, when our marriage fell apart, I had nothing to fall back on. My husband was helping financially, but it wasn't enough to live on, and I was absolutely terrified about trying to work again and having to be a single mom.

"Then one day, while I was in a waiting room, I started reading this magazine about Jacqueline Onassis. I remember thinking, 'She probably never had to worry about money in her life.' And the article noted how after John F. Kennedy was killed, she and the children had a trust fund but that it wasn't enough for Jackie and that she worried about always having to depend on the Kennedy family. The article also noted that she used to bite her fingernails and sometimes chain-smoke, but that she tried not to do those things in public. I was shocked. I just always imagined her as someone who had it made, but who knows what kind of fear she had?"

By identifying with someone she held in high regard, Jane in effect called in a spirit mentor. She looked at this mythical figure,

If I have seen further it is by standing on the shoulders of Giants.

—SIR ISAAC NEWTON

Imagination has always had powers of resurrection that no science can match.

—INGRID BENGIS

Jacqueline Onassis, and saw her as human, a woman with talent *and* fear just like herself.

"I love the way she handled her life with such dignity and grace. When I found out that she had fear and showed up anyway, it just made me admire her more. I decided I would try to emulate her, that I would try to live through my fears with dignity and grace, just as she did. She got me through many job interviews."

Tool: Choose a Spirit Mentor

THE APPLICATION OF the spirit mentor can be a powerful tool. You can invoke the power of your ancestors or create your own list of the people and qualities you admire. Is it the spirit of Chuck Yeager for his daring, courage, and no-frills approach to life? The discipline of Martina Navratilova? The humanism of Albert Schweitzer or Jimmy Carter? The idealism of King Arthur? The ruthlessness of Roy Cohn? The soul of Martin Luther King, Jr.? The charisma of Mae West or Errol Flynn? Whatever your vision of expanded self is, whether composed of one ideal person or of a committee of persons, they all contribute something.

We can call on those spirit mentor(s) to guide us through the tough times and help us grow up, grow into, and fully realize our larger selves. Whatever your vision of yourself is, clarify it, break it down, use the spirit of mentors who have what it takes to get there.

> History is the witness that testifies to the passing of time; it illumines reality, vitalizes memory, provides guidance in daily life, and brings us tidings of antiquity.
>
> —CICERO

Tool: Spirit Mentors

1. Make a list of those whom you respect, and write why you admire them. Who do you call on when you need help or when you want to celebrate? What qualities do you admire in them that would help you or your job?
2. How do you imagine that they lead *their* lives? Is there anything in your life that is similar to that description?
3. What habits do you believe they have that you would like to adopt? How would they benefit you?
4. What are they doing that you would like to do? Write five small steps you can take in that direction.
5. How would this feel: to play Beethoven's *Moonlight Sonata*

> Wishing is a great tool.
>
> —GEORGE M. PRINCE

on the piano? To order food in a foreign language? To run a marathon? Whatever your vision of yourself is, clarify it, break it down, use the spirit of mentors who have what it takes to take a concrete step toward it.

CHECK-IN: WEEK ELEVEN

1. Are your morning pages firmly in place? Resist the temptation to abandon them.
2. How are your time-outs? Are you still planning your expeditions? Anticipation and execution both are important parts of the process. Did you list your authentic capacities?
3. What synchronicity have you noticed related to emerging interests? Are you almost ready to say good-bye?

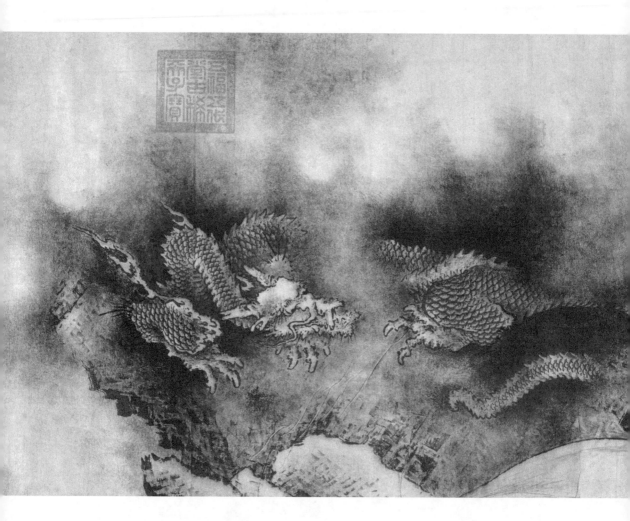

THE NINTH TRANSFORMATION: PART ONE

THE LEDGE OF AUTHENTICITY

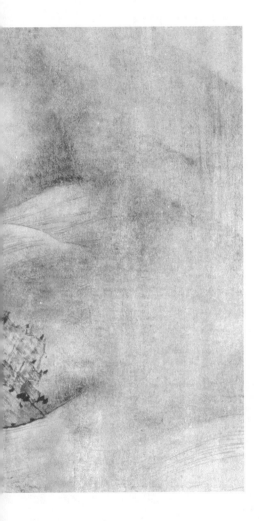

RESTING ON ITS ledge and gazing into the distance, the dragon can see the future taking shape. It is not so much prophecy as prospect: From here one can see ships coming over the horizon, caravans on the roads, highwaymen lying in wait. Having successfully experienced the transformations that have given it this opportunity to repose, the dragon knows what all these things mean.

When the time comes, soon, the dragon will return to the cycles of transformation, bearing in mind all it has learned from this vista, knowing that renewal is possible only when the world's challenges are engaged.

RESTING

IN

AUTHENTICITY

SECURE ENOUGH TO RISK JUSTICE

AS WE END this course in creative emergence, we discover that we are paradoxically at what feels like a new beginning. Through our work with a few simple tools we have changed, and changed profoundly. We have learned that creativity is an act of faith, and we have learned to act upon that faith.

We now address the fact that at the very heart of creativity is the mystery of spiritual strength. Through our inner work, we have touched our capacity for justice, encouraged now by a deepened self-knowledge and the courage to speak truth to power. Secure enough in the great mystery, the guidance of ancestors, God, or the universe, worldly success is now only part of the payoff for the authentic self. The capacity to be of service to the greater good requires that we have the security to risk our image, our position, and our pride in the search for greater justice—at the workplace, in our families, and in our community at large.

This security is a palpable, spiritual experience, expanding our ways of knowing beyond the merely intellectual, bringing multiple forms of intelligence to our awareness. And this new vision demands that we look forward with an eye to how we can best serve.

In this final week we take a look at the nature of creative trust and creative mystery. We set our sights and take a preventative look at one last-minute sabotage that we wish to avoid. Finally, we renew our creative commitment to the continued use of *The Artist's Way at Work* tools.

"Faith without works is dead," we know. It is at this point that we acknowledge the deep and productive work we have done on our own behalf.

TRUST

DEEP WITHIN EACH of us is an inner calm, a sort of meadow of the soul where we feel peaceful, guided, and relaxed. Contacting this

inner quiet on a more and more frequent level is a primary gift of this work. When we go to this deep inner place, we know what to do and how to do it.

This inner knowing, this "still, small voice," does guide us. Sometimes we are guided a step at a time, inching our way forward in seeming darkness. At other times, sudden bolts of insight, like sheets of lightning, illuminate sweeping savannas of our experience. One way or another, sometimes slowly and fitfully, sometimes quickly and decisively, we are led. We can count on it.

Every really new idea looks crazy at first.

—A. H. MASLOW

You might want to think of this guidance as being like an Inner Compass. As we become more and more honest and authentic internally, we move closer and closer to our heart's desires. As mythologist Joseph Campbell advised his students, "Follow your bliss and doors will open where there were no doors before."

As we commit to being true to ourselves as a way of life, we trigger the commitment of the universe to be supportive of our dreams and goals—as the implicit order of the universe unfolds.

Our outer flow is dependent upon our inner clarity. Our ambivalence triggers ambivalence. Our steadiness triggers steadiness. We are the valve through which the current of our lives must flow. As we consciously set the tone of our thoughts and interactions on a positive note, we experience life on deeper and deeper levels of satisfaction. Whatever you choose to call it, living consciously is to live creatively and vice versa.

When we choose to see situations as opportunities, when we look within for answers and guidance, we find our outer worlds reflect our inner conditions. As we become more gentle and harmonious, so do our worlds. As we become more adventurous and expansive, so do our worlds.

We are co-creators, not victims of circumstances. As we recognize our creative power to choose and act expansively on a moment-by-moment basis, we become able to open first our hearts and then our lives to verdant growth.

Do not be afraid.

—JESUS

▓ *Tool: Trusting Trust*

THIS TOOL LOOKS to your immediate creative future. Take a blank sheet of paper, and number from one to five. List five areas of emerging interests.

1.

2.

3.

4.

5.

No act of kindness, no matter
how small, is ever wasted.

Now list five things you *might* do if you had the faith.

—AESOP, "THE LION
AND THE MOUSE"

1.

2.

3.

4.

5.

Choose one action. Do it.

SECURE ENOUGH TO SERVE

PETER WAS A very successful doctor in Chicago. He graduated from
a top-ranked medical school, and was a partner in a prosperous
practice. He and his wife traveled to Europe and had a wonderful
home for entertaining, and his children attended the best private
schools.

It all came crashing down when an investigative reporter wrote
a front-page story for the daily newspaper about how this "high-
flying" doctor was being suspended because of a problem between
a patient and Peter. The fact that he was later exonerated made no
difference whatsoever.

In Chicago, Peter was dead. He was let go from the practice.
He could not practice medicine until the matter was cleared up,
and he was the primary wage earner for the family. He had few
financial reserves, and the lawsuits were horrendously expensive. His
wife tried to make up some of the financial difference, but their
monthly expenses were too high. By drawing down all their savings,
they were able to keep the children in school.

Peter got involved with a small business, but it has been a long
road back to financial success. For several years they lived on the
edge of ruin.

What finally brought things into perspective and eventually al-

lowed Peter and his family to build a new life turned out to be community service. Peter was an avid reader and began to read Thomas Merton, the Catholic monk who advocated public service. He began volunteering at local Catholic charity for the poor and homeless. One day each week he gets up at 4:00 A.M. and goes to bathe and dress the men, many of whom have AIDS or are mentally ill. He is "bossed around" by the nuns, as he says, and loves every minute of it. He brings his children to help from time to time, and he instructs them by example.

For unto whomsoever much is given, of him shall be much required: and to whom men have committed much, of him they will ask the more.

—LUKE 12:48

This is a story of synchronicity and service at play. As Peter gave more of himself to others who had less than he, his wife's law practice took off, giving them more of a financial cushion. Soon after, his own business started to earn profits.

Peter suffered many of the same adversities and emotions we all do during the abyss, including shame, anger, depression, and the desertion of so-called friends. He didn't know what direction his new life would take, but he stayed committed to his efforts and open to new avenues. Eventually his reward was both financially and emotionally grounded—and well deserved. Now he's happier than he's ever been because he became secure enough to serve.

MYSTERY

OUR CONSUMER SOCIETY thinks in terms of product. We like things neatly boxed and labeled. We like things categorized, priced, and explained. We want linear cause and effect. Action A produces Effect B. Creativity is not so neat as all that.

When we nurture our creativity, we are engaged in a great fruitful mystery. We speak of the "seed of an idea" without realizing what an accurate term that is. Seeds germinate and grow in darkness, in ambiguity and formlessness. We may speak of having "bright ideas," but creativity requires both darkness and light, both sudden bolts of inspiration and time for gestation.

Something we were withholding made us weak
Until we found it was ourselves.

—ROBERT FROST

As we have noted, there is a cyclicality to creative life that mimics the cyclicality of nature. There are seasons of showy harvest, but there are also the more mysterious seasons of deep inner growth. Attunement to our personal creative cycles requires a habit of deep inner listening and the willingness to live consciously in the void— those periods of nonknowing when ideas form like frost on the

windowpane of consciousness, appearing mysteriously in all their intricate tracery after the deep dark of night.

Our production-minded society, pushed by deadlines and driven by clocks, does little to attune us to the mysteries of the creative process. Its haunting ebb and flow must be surrendered into. It can be invited but not forced.

I live and love in God's peculiar light.

—MICHELANGELO

Yet we can nurture, encourage, and cajole our creativity. We can coax it out to play. Like a youngster, the creative part of ourselves responds to safety, gentleness, and an engaging play of ideas. Think magic. Think merriment. Think mischief, and you will soon be thinking creatively.

Mystery has at its heart a trickster quality: Now you see it; now you don't. Learning to play peekaboo with our creative selves can coax our creative natures into more and more frequent sightings.

Some of us use candles; some music; others scent. The pathways of the senses short-circuit the mind and speak to the soul. Creativity is just an act of the intellect, but of the soul. It is a heartful, artful act that begins in mystery and ends in magic. To be fully, freely creative, we must welcome mystery rather than fear it. We must respect magic rather then dissect it. We must, in the poet Rumi's words, "sell our cleverness and buy bewilderment." Bewilderment is the beginning of wonder, and "I wonder" is the threshold of the creative world.

■ *Tool: Mining Our Mystery*

WHETHER YOU CALL it learned optimism, or cognitive restructuring or grace, whether you consider it your patron saint or your totem animal, both intellectual and spiritual traditions recognize the power of invoking the mysterious in our lives. List five times you have experienced the mysterious.

Everywhere I go, I find a poet has been there before me.

—SIGMUND FREUD

Choose for yourself an image, an animal, a saint to use as a touchstone, a totem. Many students report deep satisfaction in collecting images that they use as symbols for their identities in the workplace. One executive collected small owls; a top trader and mountain climber filled his office with pictures and paraphernalia of the slopes; a lawyer on behalf of the underprivileged chose Saint Michael as his icon and keeps a sword above the mantel.

■ *Tool: Building a House*

FOR THIS TOOL you will need a sheet of poster board, some crayons, Magic Markers, glue, glitter, and stick-on stars—and your imagination!

Without aspiring to art, draw a child's stick house in the center of your poster board. This is your home. Using lists, images, and anything that comes to mind, fill your house with the people, things, and attitudes you desire. Travel room by room, visualizing a peaceful, harmonious, and exciting environment for your creative self.

In our teaching experience, this is a very potent tool for clarifying what we now as adults find acceptable and unacceptable in our lives. It is also one of the most fun. Dream houses are often filled with music, laughter, and friendship, while our current lives are filled with overwork and worry. The mere act of conceptualizing our positive visions moves them a notch closer to reality.

> For me, creation first starts by contemplation, and I need long, idle hours of meditation. It is then that I work most. I look at flies, at flowers, at leaves, and trees around me. I let my mind drift at ease, just like a boat in the current. Sooner or later, it is caught by something. It gets precise. It takes shape . . . my next painting motif is decided.
>
> —PABLO PICASSO

REDEFINING SUCCESS

IT IS SAID that the rich and famous know something that few of us ever have the chance to find out—that being rich or famous won't "fix" us. However, neither will poverty or failure. We want success in our lives, or we would not be doing this work. Yet we have to remember that success is not a panacea. It alone does not alleviate our insecurity.

True success is an inner sense of satisfaction about work well done—an external success. Yet in the business world, once successful, we are suddenly dealt with not as beings in process but as finished products: a "successful person."

As outer perks and accolades accumulate, the inner self can feel a sense of panic and abandonment. "What about me? Where am I in all this? I'm more (although I may feel less) than my accomplishments."

> Give me a place to stand and I can move the world.
>
> —ARCHIMEDES

The more focused we are on internal growth, on small daily shifts in the quality of living, the better able we will be to weather what we sometimes call the storm of success.

"When megasuccess hits a person's career, it's like a tidal wave personally," says Kevin, a movie executive.

Success does change how people relate to you, and if the velocity of your life changes abruptly, your sense of yourself can become extremely shaky, lost in the blur of people and events.

Success brings with it a frequent and unpleasant traveling companion, the Accuser. This nemesis is fond of inducing the "Fraudian slip," the return of the conviction that our success is a fluke, something we don't deserve, which will soon be removed from us when we are "found out."

On a rational level, the "Fraudian slip" is ludicrous, and we know it. On an emotional level it sandbags us, leading to the hair-trigger temper that causes us to explode mysteriously at our hapless spouses or at coworkers. It takes time to get used to success. It is our suggestion that you not change too much too quickly.

"I landed a fabulous promotion, moved to a corner office, and decided to dress the part," recalls Ralph. "I gave all my clothes to my younger brother, bought a hip designer wardrobe, and nearly went crazy missing my old corduroy pants and jacket. I didn't know the stranger I saw in the mirror, and none of my new clothes felt comfortable on weekends. No wonder the 'Fraudian slip' hit me."

"Make new friends, but keep the old/One is silver and the other gold." So goes the old Girl Scout song. We think it is excellent advice for the success-stricken executive. Yes, we said "stricken." Success, like the flirt it is, creates chills and fevers, makes you light-headed, weak in the knees, and disoriented.

These symptoms are normal, and they do pass, but we consider it "doctor's orders" to treat yourself tenderly in the meantime. Stay in touch with old friends, familiar routines. Remember to eat well, sleep well, and drink lots of "extra" water. Yes, really. Success is a stressor that floods the system with adrenaline. Keeping your system primed and flushed will keep wear and tear to a minimum.

We ask our students to try to remember that who they already are is what brought success to them. They don't need to change everything, or anything, in the face of new success. All they really need to do is find their sea legs, keep balanced, and carry on. Surviving a sudden upward shift is less a matter of doing than a matter of avoiding undoing our new good fortune.

On a daily basis, success is doable and durable. If we do "the next right thing," all will be well—or perhaps even better.

I want to do it because I want to do it. Women must try to do things as men have tried. When they fail, their failure must be but a challenge to others.

—AMELIA EARHART

I consider every individual to be located somewhere on what I call an infinite continuum of creative accomplishment.

—A. H. MASLOW

■ *Tool: Succeeding at Success*

THIS TOOL ACCESSES the wisdom of "steady as she goes." Set aside forty-five minutes of private time. Take pen in hand, and write from the persona of your Inner Mentor. Listen first for that sagacious inner elder available to advise you. Address the letter to yourself in your current work situation. What would this Inner Mentor say you could do to support yourself? How can you alleviate some of the stress and tension? What can you do to reclaim a sense of personal safety and continuity?

> Dreams and play have to do with developing the new, whereas maturity, like it or not, has a lot to do with maintaining the status quo.
>
> —GEORGE VAILLANT

PLAY

WE TELL OURSELVES we need to work on our creativity. Nothing could be further from the truth. What we need to do—and this is not just semantics—is to play with our creativity. This isn't *art* with a capital A. The ABCs of even the highest levels of creativity are best characterized, Carl Jung tells us, as "the creative mind at play with the things it loves." Many of the fathers in the early days of our workshops thought that they became better parents because they learned to play with their kids with a childlike mindset.

What things does your mind love? That is the interesting question, the one that yields us pay dirt. Some minds love to play with words. Other minds enjoy music. Still others love color, shape, and form. As children we played make-believe, and the worlds we made up featured the things that we loved.

"All right, we're on a desert island, and I have a cool black Arabian stallion, and you have a snow-white Arabian mare . . ."

"Okay, we're on another planet where they speak music and they don't wear clothes. They wear colors . . ."

Children love hobbies as process—the art of building. They build with blocks, build castles in the sand, build houses made of cards. Children are not concerned with greatness. They are concerned with having great fun. When we concern ourselves likewise, we awaken the creative urges within us.

Because we are product—not process—oriented, the notion of having childlike fun does not come to us easily. The notion of hob-

bies, of creative outlets pursued out of sheer love seems foolish and even counterproductive. Shouldn't we be working?

Yes. And hobbies "work."

Evelyn, a hard-pressed executive, took up needlepoint. She found that the regular, repetitive stitching mended her thoughts and her moods and triggered her into creative reveries.

> One must not lose desires. They are mighty stimulants to creativeness, to love, and to long life.
>
> —ALEXANDER A. BOGOMOLETZ

"I solved many a production problem over a needlepoint pillow," she says, laughing. "And my office began to look as if I'd had an expensive designer decorate it for me. I make throw pillows so lovely that clients always remark on them. When I say they are my own, the clients react like I'm some highly evolved spiritual person. I have to laugh. The needlepoint doesn't spring from serenity, but it does cause it."

Andrew, a deskbound executive with an urge to travel, began by getting cable so he could watch the Discovery Channel. A community college offered a geography course, and he enrolled. Next he discovered the Complete Traveller, a Manhattan store specializing in travel books. Without leaving his job or his home, he has used his hobby to expand his mind and enrich his life. Although officially his hobby bears no connection to his day job, Andrew finds that it fills him with insights and ideas.

"I think of myself as an anthropologist exploring the corporate world. This gives me a new level of humor and detachment and allows me to strategize far more effectively, to shrink my world to size by gaining a larger, more clear-eyed perspective."

Marty joined a chess club and reports that his chess game improved his corporate game as well.

> The best way to have a good idea is to have lots of ideas.
>
> —LINUS PAULING

Wendy, an advertising copywriter, turned first to window gardening and then to finding an apartment with a terrace for her gardening. "I think I repot myself as much as the plants," she laughs. "Whenever I feel pinched or stuck, I repot something to give it more growing room, but the minute I get my hands in the dirt, I seem to grow."

It is a paradox of creative life that part of taking ourselves seriously is learning to play. At our jobs we may be experts, authorities, and powers to be reckoned with. At play we get to be beginners, novices, amateurs. The release into humility is refreshing and invigorating. It is always a gateway to freedom when we can allow ourselves the grace of beginners.

Dick, a corporate lawyer, was expert in his high-pressured work. His mental machinations were quick and sharp. He had a reputation for cunning, and his friends and enemies alike sometimes called him the Silver Fox.

"I felt like a race car driver, always accelerating into curves," he told us.

We suggested he try slowing down, even develop a hobby.

"I'm not the model shipbuilding type," he replied. "And I'm too competitive to relax at playing cards. Of course, in my fantasy life, I'm a Renaissance man, a sculptor."

We suggested Dick take his sculpting dream both more seriously and more lightly. "Let yourself play at it," we said.

On his next time-out Dick went to an art supply store and ordered clay.

"I love the feel of it," he reported. "It's like touching a beautiful woman."

That was five years ago. To his surprise (not ours), Dick the lawyer has developed into an accomplished sculptor of sleek, sensuous nudes.

"When I was little, my mother told me that if I was bored, it was because I lacked inner resources," Connie said to us. "Well, I was highly successful and highly bored. Maybe, I decided, my mother was right. My life had no music to it."

We took Connie's phrase "no music" to be a hint from her creative core.

"Are you interested in music?" we asked.

"I've always wanted to play the piano, but I'm too old," she admitted.

"Start," we urged.

"Do you know how old I'll be by the time I learn?" she wailed.

"Yes. The same age as if you don't," we replied.

Connie found a piano teacher through her local choir. "My teacher was a revelation. Snow-white hair. I don't know how old she is, but she has the energy of a young girl. And she makes me feel like her favorite student, not too old at all!"

"I used to be like a camel, trekking between vacations, my only official fun," Aaron told us. "Now I use my hobby—furniture refinishing—as a miniature vacation. I love the adventure of scouring

> Consistency is the last refuge of the unimaginative.
>
> —OSCAR WILDE

> Like all weak men he laid an exaggerated stress on not changing one's mind.
>
> —SOMERSET MAUGHAM

the flea markets for promising pieces to refurbish. I love the satisfaction of restoring a piece to its former glory."

We too feel restored to our former glory when we allow ourselves the necessary, practical luxury of learning to play. By becoming completely absorbed in the creative and dynamic realm of play, we loosen the adhesions that have bound us and kept us from moving ahead in the first place.

▪ Tool: Playing at Play

GO TO A toy store. Spend an hour. What favorites from your childhood are still around? What sections seem the most fun? Allow yourself to acquire one "something." Remember creativity is the imagination at play in the field of time.

ESCAPE VELOCITY

ESCAPE VELOCITY IS the necessary speed and power required to put a career into solid orbit. For many of us it is as we reach Escape Velocity that we falter, experiencing sudden dips in confidence or seeming to draw into our lives sudden influxes of draining, unwelcome drama, what we often refer to as the Test.

All of us know the Test: We're on our final approach to a sales conference at which we are required to make a pivotal presentation. All eyes will be on us, and we want to be at our best. Suddenly our significant other decides we need to have a talk, with a capital T. Drama on the domestic front is the last thing we need, and it is precisely where we feel ourselves most vulnerable.

At the risk of sounding callous, we suggest that all emergencies occurring as we are nearing Escape Velocities are not emergencies at all. They are unconscious sabotage designed to keep us from breaking free from the gravitational pull of our known lives.

"My girlfriend has a positive genius for throwing emotional blackmail my way whenever a project is really taking off," Robert told us. "I don't know what to do about it."

"Keep the focus on you and your work," we advised. "Know that you are experiencing the Test and that if you can allow yourself not to buy into passing drama, the drama will pass and your success will remain intact."

The worst kind of management seeks a single optimum, a one-scale index of efficiency, like the mindless scales of 1 to 10 for grading a woman's beauty or one to four stars for a movie's appeal.

—JAMES FALLOWS

"When you feel yourself approaching Escape Velocity," we advise our students, "realize that you are in a window of vulnerability. You will attract attention, and some of it will be negative. Hold steady as she goes."

"Once I knew my window of vulnerability was a passing phase," Michael told us, "I found I was able to ride it out. Previously I'd always either folded or blown up under the pressure of Escape Velocity. Now I think of it more like G forces—an unpleasant, highly intense force that will pass."

In Julia's phrase, the job at this point in creative emergence is to "keep the drama on the page." Use morning pages as a safety valve. Force yourself to take time-outs.

"Think of yourself as being on a secret mission," Mark advises. "Keep your own counsel, practice containment, and your window of vulnerability will be transformed to a window of opportunity."

The stress of impending success, once acknowledged, can lead to protective self-care. This heightened vigilance allows us to attain Escape Velocity successfully. Catherine calls it "grace under pressure."

Success is a learned skill. You can practice it. This fact is a cause for celebration. You can increase your energy, steady yourself and your trajectory. Celebrate the freedom you have won.

> Some people will never learn anything...because they understand everything too soon.
>
> —ALEXANDER POPE

▪ Tool: Every Picture Tells a Story

SET ASIDE TWO full hours. You will need a large poster board, glue, tape, Magic Markers, scissors, and a stack of ten to twenty magazines.

Spread the magazines over the floor or worktable and take thirty minutes to go through the magazines, cutting out pictures that appeal to you and represent what you would like your life to be like in five years. Don't limit yourself to the realistic, to the possible. What *would* you want if you could have anything?

> Nothing else can quite substitute for a few well-chosen, well-timed, sincere words of praise. They're absolutely free—and worth a fortune.
>
> —SAM WALTON

▪ Tool: Gratitude

YOU HAVE WORKED a very rigorous program of self-awareness. No one does it perfectly. Yet there is still much to celebrate. The ten capacities of the authentic self, the games of creativity, the prepa-

rations for success, the experience of loving candor among your colleagues, the justice within your company vision, the connection of the current with the future should all be more apparent to you now.

They say that if you get bored enough with calamity you can learn to laugh.

—LAWRENCE DURRELL

List the many things you are grateful for about this work. What did you learn? What were the most important ah-hahs? Looking to the future, how do you think it will change over the next two years? Please write this in your notebook and keep the answers to these exercises to excavate in about twenty-four months. The trajectory of your life has changed.

CHECK-IN: WEEK TWELVE

1. Are you willing to recommit to your morning pages? Many students have now practiced them for years and swear by their continuing effectiveness.
2. Are you willing to recommit to time-outs? Have you seen the value of consciously nurturing your creative self?
3. Are you alert for ongoing synchronicity or support from unexpected sources? Are you willing to act on opportunity?
4. Celebrate—really. Throw a party, go dancing, or get away for the weekend or a month, whatever. Take some friends along.

EPILOGUE

CREATIVITY IS, LIKE life, not a linear journey. The dragon soars, arches, drops, and soars again. It does not follow a trodden path, though it is indeed a spiritual pilgrimage to distant lands—one step leads to another. The dragon has circled ever higher over increasing vistas, land that seems familiar and then strange, sometimes invoking the sense of being lost in familiar places, only to find something constant that was not seen before.

As in all our work, whether the upward spiraling journey of the sacred mountain of the Artist's Way, or the flight and fall and renewed flight of the beautiful dragon, Tao remains as our companion, a force behind us, ahead of us, leading us in humility and strength. Our journey, like yours, continues.

It is our experience that your work with personal creativity will create a shift in interpersonal creativity. As deeply grounded creative beings sourced in considerable power, we are of ever greater service to our colleagues, our friends, our families and our communities. It is our hope that you will both use these tools and share them. We can—and will—build a better world, better work environments, and better lives.

SUGGESTED READING

We have listed below just a few of our favorite authorities and books. Although we want you to focus on experience rather than theory, our work on this text has been so influenced by the following thinkers that we would like to recommend them strongly to those of you who wish to pursue further reading and study: Chris Argyris, David Berg and Kenwyn Smith, Wilfred Bion, Peter Drucker, Albert Ellis, Kurt Fischer, Viktor Frankl, Carol Gilligan, Leston Havens, Ned Herrman, Bill Isaacs, Robert Kegan, Robert Fritz, James Masterson, Edward Shapiro and Wesley Carr, Martin E.P. Seligman, and George Vaillant.

Argyris, Chris, *Overcoming Organizational Defenses: Facilitating Organizational Learning*. Englewood Cliffs, NJ: Prentice-Hall, 1990.

Bohm, David. *On Dialogue*. London: Routledge, 1996.

———. *Wholeness and the Implicate Order*. London: Routledge, 1980.

Bryan, Mark, and Julia Cameron. *The Money Drunk*. New York: Ballantine Books, 1992.

Cameron, Julia. *The Artist's Way*. New York: Tarcher, 1992.

———. *The Vein of Gold*. New York: Tarcher, 1992.

Cytrynbaum, Solomon, and Susan A. Lee. *Transformations in Global and Organizational Systems: Changing Boundaries in the Nineties*. Jupiter, FL: A.K. Rice Institute, 1993.

Feng, Gia-Fu-Tzu and Jane English. *Lao Tsu Tao Te Ching*: New York: Vintage Books, 1972.

Fischer, Kurt W., and June P. Tandgrey. *Self-Conscious Emotions*. New York: Guilford Press, 1995.

Gardner, Howard. *Creating Minds: An Anatomy of Creativity*. New York: Basic Books, 1993.

Goleman, Daniel. *Emotional Intelligence*. New York: Bantam, 1995.

Havens, Les. *Making Contact: The Use of Empathic Language in Therapy*. Boston: Harvard University Press, 1988.

———. *A Safe Place*. New York: Ballantine Books, 1989.

Hillman, James, and Michael Ventura. *We've Had a Hundred Years of Psychotherapy, and the World's Getting Worse.* San Francisco: HarperSanFrancisco, 1993.

Jongeward, James. *Born to Win.* New York: Addison Wesley, 1971.

Kegan, Robert. *The Evolving Self: Problem and Process in Human Development.* Cambridge: Harvard University Press, 1992.

————. *In Over Our Heads: The Mental Demands of Modern Life.* Cambridge: Harvard University Press, 1994.

Krass, Peter. *The Book of Business Wisdom.* New York: John Wiley and Sons, Inc., 1997.

Malan, David H. *Individual Psychotherapy.* London: Butterworth-Heinemann, 1979.

Masterson, James F. *The Search for the Real Self.* New York: The Free Press, 1988.

Parnes, Sidney J. *Source Book for Creative Problem Solving.* Buffalo, NY: Creative Education Foundation Press, 1992.

Perkins, N. *The Mind's Best Work.* Cambridge: Harvard University Press, 1981.

Rahula, Walpola. *What the Buddha Taught.* New York: Grove Press, 1974.

Rank, Otto. *Art and Artist: Creative Urge and Personality Development.* New York: W. W. Norton, 1932.

Schein, Edgar H. *Organizational Culture and Leadership.* San Francisco: Jossey-Bass Publishers, 1997.

Seligman, Martin. *Learned Optimism: What You Can Change and What You Can't.* New York: Pocket Books, 1990.

Shapiro, Edward R., and A. Carr Wesley. *Lost in Familiar Places.* New Haven: Yale University Press, 1991.

Smith, Kenwyn, and N. David Berg. *Paradoxes of Group Life.* San Francisco: Jossey-Bass Publishers, 1987.

Vaillant, George E. *The Wisdom of the Ego.* Cambridge: Harvard University Press, 1995.

ACKNOWLEDGMENTS

We wish to thank our editor, Toni Sciarra, and publisher, Paul Fedorko, for their faith, vision, and patience; our agents David Vigliano and Susan Schulman; Jacqueline Deval, Sharyn Rosenblum, Richard Aquan, Fritz Metsch, Michael Murphy, and the entire William Morrow team; Richard Hoffman, Whitney Post, Leslie Fleming-Mitchell, Maureen Mueller, Mel Dahl, Dori Vinella, and Erin for taming the dragons and last-minute saves; Deborah Blackwell for her insights; Peggy Griffin at Lucent Technologies for her extraordinary mix of practicality and vision in building the Financial Leadership Development Program into a world-class educational experience; Bill Isaacs, Otto Scharmer, and Jim Saveland of the Dialogue Project at MIT; Kathleen Lilly at Penn State Engineering School; Linda Powell and Ron David for their introduction to Tavi; Dr. Susan Arlen, Denise Allocco, and Fred Kessler for their help at Lucent; Rev. James Forbes for his sermons "Secure Enough to Risk Justice" at Harvard Memorial Church; the staff at Interface, Esalen, Learning Annex, and the Open Center—particularly Adele Heyman, Toby Berlin, and Nancy Lunney; Pamela Burton and Scott Matalan of Stumpworld for website design and support; Nancy Rose at Frankfurt, Garbus, Klein and Selz for guidance; Colleen O'Rourke at Citibank; Bob Earll, Carl Fritz, Jamie Frankfurt, Fred Miller, Tim Collins, Jamie Young, Sheila Flaherty, Richard Rosen, Les Havens, Ann Gurian, Neal Romanek, Jim Miller, Gavin de Becker, Jeff Crosthwaite, Theda Real, David Binder, Claudia Highbaugh, Tom Malone, Mark Gerstein, Pamela Hanson, Scott, Peake and Domeinica—and our other friends and family members: To all of you many thanks and much love.

MARK BRYAN and JULIA CAMERON

I wish to acknowledge, first and foremost, Julia and Mark for introducing me to *The Artist's Way*—a book and process that began the changes in my life that have led to greater awareness and understanding of individuals in the business environment. I want to thank my friends and colleagues who have supported me and shared their wisdom and insights for this book: Bill Barr, Cheryl Charles, Mary Cirillo, Linda Donnels, Gary Johansen, Teresa Lindsey, Ellen Morrell, Beverly Myers, Angie Salazar, and Ron Schultz. I wish to especially thank my best friend and adviser, John Burke, who has provided support, wisdom, and counsel.

CATHERINE ALLEN

HOW TO REACH US

For inquiries about *The Artist's Way at Work* workshops, seminars, or consulting—or to contact the authors about our individual projects—please write us care of: The Artist's Way at Work, P.O. Box 381590, Cambridge, MA 02238-1590, or visit our website at http://www.artistswaywork.com, which will connect you to each of our E-mail addresses.

HOW TO START A STUDY GROUP

Plan on a twelve-week process with a weekly gathering for one to three hours.

The morning pages and time-outs are required of everyone in the group, including facilitators. Do not share your morning pages with the group or anyone else. Work the tools and then share your answers, going around the group one by one. Any member has the right to "pass" at any time.

▨ *Listen*

We each get what we need from the group process by sharing our own material and by listening to others. We do not need to comment on another person's sharing in order to help that person. We must refrain from trying to "fix" someone else. The circle as a form is important as we are meant to witness, not control, one another. If the group becomes too large, small clusters of four within the larger groups can be effective. Remember, this is a deep and powerful internal process. There is no one "right way" to do this.

▨ *Expect Change in the Group Makeup*

Know that many people will—and some will not—fulfill the twelve-week commitment. There are often rebellious or fallow times during the twelve weeks

(and afterward), with people returning to the disciplines later. You cannot do this work perfectly, so relax, be kind to yourself. Many groups have a tendency to drift apart in week ten because of the feelings of loss associated with the group's ending. Face that truth as a group; it may help you to stay together — and learn about closure.

A Word to Therapists, Teachers, and Human Resource Professionals

Thank you for using our books in the many contexts in which they have been helpful, and thank you for the wonderful work you do in important and often difficult professions. Please remember to nurture yourselves as you struggle to help others find their truth.

INDEX

ABCDEs (Adversity, Belief, Consequence, Disputation, and Energizer), 119–120
abundance, 100
abyss (week four), 72–90
 Admitting Our Emotions in, 76–77
 Anger as Map in, 78
 anger release in, 77–78
 Bottom Line in, 87
 check-in for, 90
 Countering Our Critics in, 80
 criticism in, 79–81
 Define Your Inner Wall in, 83–84
 emotions in, 74–77
 false self in, 88–90
 Footholds for Optimism in, 79
 "Fraudian Slip" in, 89–90
 Inner Wall rebuilding in, 81–84
 Metabolism in, 78–79
 reality check in, 74
 Signposts in, 87
 surviving, see surviving the abyss
 True Confessions in, 80–81
 workaholism in, 84–87
 Workaholism Quiz in, 85–86
Accuser, 258
Adams, Abigail, 168
addiction:
 E-mail as, 121
 to money, 95
 see also workaholism
Adler, Alfred, 108
Admitting Our Emotions, 76–77
Adult Self, 80
Aeschylus, 80
Aesop, 254
Affirmations and Blurts, 41–43
age, change and, 130–132
Allen, Catherine, xvii–xviii, 152, 222

Allen, Robert E., 104
ambition, 33, 146, 229
ambition, owning our (week nine), 192–207
 Blasting Through Blocks in, 202–204
 business beige in, 199–201
 check-in for, 207
 Clearing Fear in, 195–196
 Contacting Clark Kent in, 199
 facing down fear in, 194–196
 focusing our power in, 194
 Framing Our Lives in, 207
 Local Color in, 201
 resentment block in, 201–204
 Resentment Résumé in, 201–202
 Succeeding with Success in, 206
 success in, 204–206
 Superman in, 196–199
ambivalence, 2, 171, 204–205
American Dream, 101
anger, xxi, 75–78, 169, 175, 255
 in morning pages, 4, 10
 releasing of, 77–78, 202–204
Anger as Map, 78
anxiety:
 creative blocks and, 45
 group, 160
Anxious Andrew, 11
appreciation, of work, 45–47
Archaeology:
 Round One, 34
 Round Two, 36–37
Archimedes, 257
Argyris, Chris, 139, 140, 148, 162, 198
Aristotle, 97, 138, 200
Armour, J. Ogden, 172
Artist's Way, The (Cameron), xvii
Artist's Way workshops, xvii

Ash, Mary Kay, 148
assembly line mentality, 59–60
attention:
 creative U-turns and, 228–229
 paying, 65–67
At the Wheel of a New Machine, 114
Aubrey, John, 136
authenticity, xvi, xviii, xxi, 1, 9, 23, 88, 139
 ambition and, 194
 inventory of past and, 30
 luxury and, 98–99
 sex role expectations vs., 31–32
authenticity, ledge of (week eleven), 226–248
 acknowledging your growth in, 238
 capacities in, 236–237
 check-in for, 248
 Choose a Spirit Mentor in, 247
 creative center in, 244–245
 creative U-turns in, 228–233
 Creative U-turns (tool) in, 233
 Creativity Center (tool) in, 245
 exercise in, 241–244
 Exercising Our Options in, 244
 fame in, 233–235
 Ledge of Authenticity in, 237–238
 Name Your Poison in, 232
 self-acceptance in, 238–241
 spirit mentor in, 245–248
 Spirit Mentors (tool) in, 247–248
 Ten-Minute Time-outs in, 235–236
 Valuing Our Values in, 236
authenticity, resting in (week twelve), 250–264
 Building a House in, 257
 check-in for, 264

authenticity, resting in (continued)
 escape velocity in, 262–263
 Every Picture Tells a Story in,
 263
 Gratitude in, 263–264
 justice in, 252
 Mining Our Mystery in, 256
 mystery in, 255–257
 play in, 259–262
 Playing at Play in, 262
 security in, 252, 254–255
 service in, 254–255
 Succeeding at Success in, 259
 success in, 257–259
 trust in, 252–254
 Trusting Trust in, 253–254
autonomy, 118, 149, 161, 196, 228
Avalon (Cameron), 133
awakening, roar of, see roar of
 awakening
awareness, 12, 15, 32

Baez, Joan, 30
bankruptcy, 143
Barnum, P. T., 78, 96, 97, 100
Beatty, Warren, 231
Becoming Right-Sized, 146
Beecher, Henry Ward, 203
Being a Beginner, 132
Bengis, Ingrid, 246
Berdyaev, Nikolai, 229
Berg, David N., 118, 138, 183–184
Beyond Price, 126
Bhagavad Gita, 37
Big Deal Chaser, 95, 96
Binge Spender, 95
Bion, Wilfred, 159–160
Biosketches, 163–164
Blake, William, 36, 75
blaming, 12, 36, 44, 124, 175,
 182
Blasting Through Blocks, 202–204
body English, 112–114
Body English (tool), 114
Bogomoletz, Alexander A., 260
Bohm, David, 14, 104, 146–147,
 196
bookcases, antique, 68
Bottom Line, 87
boundaries:
 Inner Wall, 81–84
 setting of, 52–53, 183, 215
Box Seats, 215
brainstorming, 39

Bryan, Mark, xvii, 8, 96, 119–120,
 152, 162–163, 244–245
Buck, Pearl S., 59
Buddha, 27, 138, 212
Buffett, Warren, xiii
Building a House, 257
Bully, 166, 169
Burke, Edmund, 196
burn out, 47
business:
 downsizing of, xviii
 as forest environment, 149–153
 grandiosity trap and, 143–144
 see also specific topics
business beige, 199–201
Bystander role, 161–162

Caesar, Julius, xx
Cage, John, 160
Cameron, Julia, xvii, 8, 96, 133, 151–
 152, 162–163, 244
Campbell, Joseph, 118, 253
Camus, Albert, 142
candor, 63–64, 160, 170
Capra, Fritjof, 240
careers, career change:
 age and, 131–132
 catastrophe turned into, 215–221
 family influences on, 31–33, 48
 jobs vs., 34
Caretaker, 168
Caretaker/Controller, 166
Carlyle, Thomas, 12, 88, 113, 120,
 185
Carnegie, Andrew, 137, 185
Carr, Wesley, xvi, 11, 136, 141, 151,
 163
cars, 62
Cash Codependent, 96
catastrophe, see heartbreak
Cather, Willa, 9, 189
Censor, see Critic
Chandler, Raymond, 240
change, xviii, xx, 160
 age and, 130–132
 clothing and, 61, 66
 corrosive colleagues and, 169–
 172
 fear of, xvii, xx, 67
 filling the form and, 67–69
 living in the present and, 151–
 152
 Metabolism and, 78–79
 perceptual, 45

prophets and, 213–215
 small vs. large, 67
 success and, 204–206
chaos, 166–167, 183
Charmer, 166
Cheerleader, 115
Chen Rong, xv–xvi, 2, 52
childhood, child, 29–37
 natural, 28
 office compared with, 29–30, 164,
 166–167
Child Self, 80
Chinese proverb, 190
Choose a Spirit Mentor, 247
Cicero, 211, 247
Clearing Fear, 195–196
clothing, inner change and, 61, 66
Clown, 165
Coffin, William Sloan, 215
Colette, 29
colleagues:
 corrosive, 169–173
 Creative, 10
 see also groups, group dynamics
comfort, 64–65, 139, 229
common sense, 161
communication:
 risk taking and, 116–117
 see also language; listening
comparison vs. competition, 210–
 211, 234
compartmentalization, xvi
compassion, 195, 212, 213
competition, xvi, xix, 88, 117, 198
 adaptation and, xviii
 comparison vs., 210–211, 234
 fame and, 234
 Prince syndrome and, 173–177
computers, 7, 35, 171
confidence, xxi, 14, 58, 134
Confucius, xiii, 121, 181
Congreve, William, 126
Conrad, Joseph, 101
conserver mode, 118–119
Contacting Clark Kent, 199
Containment, 172–173
Controller, 166
Coolidge, Calvin, xv, 58
cooperation, 152
I Corinthians, 46
Countering Our Critics, 80
Counting, 97–98
courage, 76, 176–177
crazymakers, 181–184

creative blocks, 44–45, 77, 112, 229–233
 crazymakers as, 181–184
 intelligence as, xx, 135–137
 relationships as, 229–232
 resentment as, 201–204
 workaholism as, 84–87, 230
creative center, 244–245
creative champions, 36
Creative Colleague, 10
creative contagion, xx, 67, 117, 150
creative emergence, *see* emergence
creative monsters, 36, 48, 194–195
creative U-turns, 195, 202, 228–233
Creative U-turns (tool), 233
creativity, creative spirit:
 as energy flow, xix–xx
 inner reservoir as source of, 24
 intellectual capital as, xv
 myths about, 33–34, 45, 67, 212
 premises about, xxi
 see also specific topics
Creativity Center, 245
Creativity Contract, 20
Creativity Quiz, 134–135
Critic (Censor, Sniper), 8, 11, 13, 14, 115, 118–121
 Affirmations and Blurts and, 41–43
 morning pages and, 8, 41, 136–137
critical thinking, 135–136
criticism:
 abyss and, 79–84
 creativity and, xix
 Inner Wall rebuilding and, 81–84
 parental, 31, 35–36
 by teachers, 35–36
Cumberland, Richard, 131
Customized Affirmations, 43

Dalai Lama, 106
Das, Rameshwar, 41
daydreamers, 35
"Dear Boss," 186
defenses, 170
 dysfunctional, dismantling of, 139–141
Define Your Inner Wall, 83–84
Deming, Edward, xix
denial, end of, 52–53
depression, xix, 74, 255
detachment, 115
Dewey, John, 8

dialogue, self, 14, 16, 30–31
Dialogue (tool), 30–31
Dickinson, John, 16
Dictator, 165, 168
discovery, xvii
discretion, 64–65
Disraeli, Benjamin, 234
Ditka, Mike, 238
doing, 4, 113
 filling the form and, 68, 69
 thinking vs., xx–xxi
doubt, 13, 41, 54
downsizing, xviii
dragon metaphor, xv–xvi
 abyss and, 73
 creative emergence and, 1
 learning (and teaching) and, 129
 ledge of authenticity and, 227
 living with passion and, 209
 owning our ambition and, 194
 pearl of wisdom and, 111
 resting in authenticity and, 251
 riding the dragon and, xviii–xx
 roar of awakening and, 23
 soaring and, 51, 52
 surviving the abyss and, 93
 teaching (and learning) and, 157
Dream Account, 103
Dreamer, 13, 62–63
dreams, 134, 149, 230, 242
 funding of, 101–103
drought, creative, 212–213
Drucker, Peter, 62, 98, 125, 221
Dumping the Albatross, 47
Durrell, Lawrence, 264
Dutiful Dan, 11, 14

Earhart, Amelia, 258
Edison, Thomas Alva, 13
ego, leadership and, 58
Einstein, Albert, 25, 42, 45, 116, 120, 244
Eliot, T. S., 4, 60
Ellis, Albert, 119
E-mail, 121, 122, 123, 174
emergence (week one), xxiii, 1–20, 35–36, 132, 149, 196
 authenticity and, xvi, 139
 check-in for, 20
 color and, 61–62
 Creative Colleague in, 10
 Creativity Contract in, 20
 Entering the Gate and, xxi
 honesty and, 30–31

Inner Mentor in, 2, 15–16
Inner Mentor (tool) in, 16
Listening to the Chorus in, 14
Morning Pages in, 5
Secret Selves in, 11
synchronicity and, 55–57
see also morning pages
Emerson, Ralph Waldo, 6, 29, 54, 159, 164, 173, 176, 198
Emotional Solvency, 96
emotions, emotional development, 8, 17–18
 abyss and, 74–77
 admitting of, 76–77
 being out of touch with, 12
 volatility of, 64–65
English proverb, 95
enlightenment:
 collective, xvii
 Jung's view of, 41
 of Lao-tzu, xv
 wisdom vs., 11
Entering the Gate, xxi
enthusiasm, 200–201
entitlement, sense of, 198
environment, corporate:
 ecology of relationships in, 149–151, 160, 169–172, 198–199
 living in the present in, 151–152
Epictetus, 68, 145
Ernst, George, 132
Escape Velocity, 262–263
ethnic diversity, 162–163
Euripides, 240
Every Picture Tells a Story, 263
exercise, 9, 49, 112, 113, 196, 241–244
Exercising Our Options, 244
expander mode, 118–119
experience:
 learning from, 136, 143
 mistakes as, xviii
Explore a Sacred Space, 62
Explore Your Feelings About God, 106
extreme language, creativity and, 37–39
extroverts, 16–17

failure, xviii, 3, 204, 205, 238, 258
Fairless, Benjamin F., 222
Fallows, James, 262
false self, 88–90
fame, 210, 233–235

family dynamics, 30–33, 205
 career choices and, 31–33, 48
 office dynamics compared with,
 30, 164, 166–167
 word wounds and, 35–36
Family Functions, 169
fantastic self, 13
fear, xx, xxi, 12, 149
 of change, xvii, xx, 67
 facing down, 194–196
 fraud complex and, 88
 of groups, 160
 jealousy and, 132–133
 Prince syndrome and, 175–176
 releasing of, 202–204
 resistance and, 217
fear/trust spiral, 186–187
Feel, Think, Wish, 137–138
femininity:
 creativity associated with, 31–32
 toughness and, 37
figure ground reversal, 53–54
filling the form, 67–69
Filling the Form (tool), 69
Financial Sobriety, 96
Flaubert, Gustave, 241
Flesch, Rudolf, 116
focusing, 45, 52, 63, 65–67, 102,
 194
Follower role, 161–162
Footholds for Optimism, 79
Forbes, Malcolm S., 25, 190
Ford, Henry, xvii, 55, 104
forest environment, business as,
 149–153
Forest Environment (tool), 152–
 153
forgiveness, 195
Fox, Emmet, 115
Framing Our Lives, 207
Frankl, Viktor, 233
Franklin, Benjamin, 47, 99
fraud complex, 88–89, 258
"Fraudian Slip," 89–90
freedom, 31, 34, 149, 260
Freud, Sigmund, 54, 122, 197, 256
friendship, 100, 123, 171, 255
 success and, 204–205
Fritz, Robert, 77, 231
Fritz, Sharon, 18
Frost, Robert, 202, 255
frustration, 75, 171, 174–175, 229
Fuller, R. Buckminster, 144

Fuller, Thomas, 188
fun, see play
future, xvi, 9–10

Galileo, 18
García Márquez, Gabriel, 119
Gardner, Howard, 3, 152
Gardner, John W., 57, 235
Gauguin, Paul, 240
Genghis Khan, 246
German proverb, 184
Geschka, Horst, 124
getting current, 77, 138–139, 141
Getting Current (tool), 139
Gidlow, Elsa, 175
girls, see women and girls
glass ceiling, 171
goals, personal vs. business, xix
God, 103–108
 money vs., 103–106
Goethe, Johann Wolfgang von, 3,
 31, 45, 220
going sane, 53–54
Going Sane (tool), 184
Going to Take a Miracle, 106
good, doing, 48
Gracián, Baltasar, 219
graffiti, 28
grandiosity of the wounded, 142–
 146, 189
gratitude, 206, 220
Gratitude (tool), 263–264
grounding techniques, 112–114
 see also meditation; morning
 pages; time-outs
groups, group dynamics, 158–173
 ambivalence about, 2
 Bion's model of, 159–160
 cultural baggage and, 162–163
 information age and, 158
 Kantor's view of, 161
 role reversal and, 164–169
 roles and, 159–162
 success and, 204–205
Grove, Andrew S., 197, 207
Grow, Gerald, 213
growth, acknowledging of, 238
guilt, 105, 172

Hamlet (Shakespeare), 174
Hammarskjöld, Dag, 114
happiness, 27, 29, 94, 171, 206,
 242

Harman, Willis, 19
Harvey, William, 136
Havens, Leston, 46, 169
heartbreak, 215–224
 survival of, 221–224
 turned into career move, 215–
 221
Heartbreak Hotel—Loss as a Lesson,
 220–221
Hegel, Georg, 20
Henry, Patrick, 216
Hepburn, Katharine, 232, 245–246
Heraclitus, 223
Herbert, George, 61, 134
Hero, 168
Hero/Dictator, 30, 165
Herrmann, Ned, 219, 233
Hidden Résumé, 141
hobbies, 259–262
 reemergence of, 61–62, 125–126,
 224
Hoffer, Eric, 214
home life vs. work, xvi, 31, 33
honesty, 30–31, 59, 79–80, 175
hope, xxi, 3, 5, 9, 137, 139
Horace, 95
Hormann, John, 19
Horton, Robert, 88
Hugo, Victor, 15
humor, 63
Huxley, Aldous, xxi

Iacocca, Lee, 35, 79, 149, 150
"I cannot do it in my present
 situation" myth, 45
ideas, 15, 160, 239
 conflict as clash of, 19
 as money, xv
 play of, 24, 39
 thwarted selves and, 32–33
identity, cultural baggage and, 162–
 164
Imaginary Lives, 39–40
imagination, 11, 13, 32, 42, 63,
 244
Implicate Order, 104
"I'm a self-made man" syndrome,
 144–145
incubation, time for, 25
Indian proverb, 76
inferiority, feelings of, 38
information age, 158
information pollution, 120–121

Inner Adult, 81
Inner Compass, 253
Inner Explorer, 28, 29
Inner Fortress:
 building of, 29–30
 morning pages as, 10–11
 securing of, 52–53
Inner Mentor, 2, 16
 criticism and, 80
 listening to the chorus and, 15–16
 Succeeding at Success and, 259
Inner Wall:
 defining of, 83–84
 rebuilding of, 81–84
innovation, xvi, xviii, xx, 10, 214
insecurity, 139–140, 149, 189
 financial, 218–220
integrity, 59, 78, 141, 159
 grandiosity trap and, 142–143
intellectual capital, xv
Intellectual Tyrant, xx, 6–7
intelligence, 164
 as creative block, xx, 135–137
 multiple, 152
Intelligence Block, 135–137
Internal Rebel, xx, 6–7
introverts, 16
intuition, xxi, 15, 61, 240
isolation, success and, 206
"I want my own business" trap, 143–144

James, William, 18
Japanese proverb, 78
jealousy, 112, 132–134
Jealousy Map, 133–134
Jeffers, Susan, 142
Jefferson, Thomas, 68
Jester, 168
Jester/Clown, 30, 165
Jesus, 253
jobs:
 careers vs., 34
 dream, 32, 35
Johnson, Edward C., III, 60
Johnson, John J., 236
Johnson, Samuel, 234
Jong, Erica, 40
Jordan, Michael, 25
journals, morning pages compared with, 4, 8
Julius Caesar (Shakespeare), 139

Jung, Carl, 5, 15, 41, 106, 117, 140, 162, 204, 245, 259
justice, security and, 252

Kant, Immanuel, 171, 178
Kantor, David, 161
Keats, John, 171
Kegan, Robert, 19, 180, 189
Keller, Helen, xxi
Kennedy, John F., 246
Khan, Hazart Inayat, 205
Kierkegaard, Søren, 25, 76
King, Billie Jean, 32
Kinnell, Galway, 134
knowledge, xx, 14, 42
 personal, 147
 professional, 147
 self-, 168, 238–239, 252
Krishnamurti, J., 131, 211, 217

Lacydes, 241
ladder of inference, 162
La Fontaine, Jean de, 42
language:
 extreme, 37–39
 word wounds, 35–39
Lao-tzu, xv, 11, 117
Lapping Up Luxury, 100–101
La Rochefoucauld, 167
La Russa, Tony, 24
Lauder, Estée, 37
Laugh or Lament, 213
Leader/Charmer, 166
Leader role, 161–162
leadership, xvi, 165, 199
 females and, 35–36
 reclaiming our potential for, 57–59
Leadership Quiz, 59
learning (and teaching) (week seven), 128–154
 age and time in, 130–132
 Becoming Right-Sized in, 146
 Being a Beginner in, 132
 check-in for, 154
 Creativity Quiz in, 134–135
 ecology of relationships in, 149–151
 Feel, Think, Wish in, 137–138
 Forest Environment in, 152–153
 getting current in, 138–139, 141
 Getting Current (tool) in, 139

grandiosity of the wounded in, 142–146
 Hidden Résumé in, 141
 Intelligence Block in, 135–137
 jealousy in, 132–134
 Jealousy Map in, 133–134
 lifelong, 130
 living in the present in, 151–152
 negative conditioning in, 134–135
 nurturing nutrients in, 151
 show off and suffer in, 139–141
 Taking Note in, 148–149
 understanding what is really being said in, 146–149
Least Heat Moon, William, 159
Lec, Stanislaw, 80
ledge of authenticity, see authenticity, ledge of
Ledge of Authenticity (tool), 237–238
Le Guin, Ursula K., 102
Letter to the Self, 117
Lincoln, Abraham, xvi, 89, 222
Lindbergh, Anne Morrow, 143
listening, 58, 112
 inner, 112–117
 questions to keep in mind when, 147
 understanding what is really being said and, 146–149
listening to the chorus, 13–16
 Inner Mentor and, 15–16
Listening to the Chorus (tool), 14
living with passion, see passion, living with
Local Color, 201
Locke, John, 242
logo therapy, 233
Longfellow, Henry Wadsworth, 7
loss, sense of, Metabolism and, 78–79
Luke, 255
luxury, 98–101, 105
Luxury (tool), 100
lying, 141, 144
Lynch, Peter, 17

Macaulay, Lord, 107
McCarthy, Julianna, 195
Machiavelli, Niccolò, 132
McNelly, Jeff, 34

Maintenance Money Drunk, 95
make-believe, *see* Imaginary Lives
managing up, 184–186
manners, 198
Mark, 186
Maslow, A. H., 27, 31–32, 239, 253, 258
Masterson, James, 236–237
Matisse, Henri, 61
Maugham, Somerset, 261
May, Rollo, 25
Measure for Measure (Shakespeare), 48
media, business images of, 196–197
media deprivation, 120–124
Media Deprivation (tool), 124
meditation, 9–10, 100, 112, 141
walking as, 49
Meeting the Inner Rebel, 126
Melville, Herman, 153
men:
anger of, 77
creativity in, 31–32
heartbreak of, 218–220
Menander, 63
Mencken, H. L., 89
Mentor Magic, 180–181
mentors, 214–215, 217–218
as monsters, 178–180
spirit, 245–248
see also Inner Mentor
Merton, Thomas, 100, 152, 255
Metabolism, 78
Michelangelo, 256
Midler, Bette, 206
Miller, Henry, 101, 223
mindfulness, 115
Mining Our Mystery, 256
Mirror/Scapegoat, 30, 165
mistakes, as experience, xviii
Moltke, Helmuth von, 12
Monaghan, Tom, 243
money, 88, 94–98
counting of, 96–98
dreams and, 101–103
God vs., 103–106
heartbreak and, 218–220
as ideas, xv
"money drunk," 95
Money Drunk, The (Bryan and Cameron), 96
Money Man, 94
Moore, Leo B., 64
morality, 171

morning pages, 2–11, 24, 26, 46, 49, 62, 85, 102, 112, 113, 170, 196, 223, 238–239
as body of knowledge, 17–19
connectedness vs. individuality in, 2
Critic and, 8, 41, 136–137
guidelines for, 5
handwritten, 7
as inner fortress, 10–11
as Inner Mentor, 15–20
journaling compared with, 4, 8
Listening to the Chorus and, 14
optimism and, 117–118
past, present, future and, 9–10
privacy of, 5, 19
reading of, 207
reason for timing of, 7–9
resistance and, 3
self-disclosure and, 64–65, 199–200
social individuation and, 16–17
spiritual chiropractic and, 11–14
three, reasons for, 7
warning about, 6
Morning Pages (tool), 5
Mueller, Maureen, 85
music, 9, 77, 121, 125
mystery, 152, 244, 255–257
myths:
about creativity, 33–34, 45, 67, 212
"I cannot do it in my present situation," 45
about success, 33–34

Nagarjuna, 1
Name Your Poison, 232
Nasty Rules, 101
natural child, 28
negative conditioning, 134–135
negative voices, 13
as learned voice, 41
see also Critic
Net of Nurturing, 224
Newton, Sir Isaac, 246
Nicholson, Jack, 114
Nietzsche, Friedrich, 83
Nigel, the critic, 11, 14
Nine Dragons (Chen Rong), xv–xvi, 5
Nurturing Nutrients, 151

objectivity, 196
O'Brien, Bill, 8

observer self, Observer, 10, 13, 118, 119
office as ecosystem, 149–153, 160, 169–172, 198–199
office behavior, childhood behavior compared with, 29–30, 164, 166–167
Ogilvy, David, 58
Onassis, Jacqueline, 246–247
openness, 81, 146
criticism and, 79
self-disclosure, 62–65, 126, 158, 199–200
Oppenheimer, J. Robert, xvii
Opposer role, 161–162
optimism, 12–13, 30–31, 47, 79, 117–118, 137, 160
learned, 118, 119
resentment and, 46
time-outs and, 27, 28
Osborn, Alex, 25
owning our ambition, *see* ambition, owning our

Paige, Satchel, 25
pain, *see* heartbreak; suffering
Paradoxes of Group Life (Berg and Smith), 118
pariah effect, 222
Parker, Dorothy, 203
passion, living with (week ten), 208–225
Box Seats in, 215
check-in for, 225
comparison vs. competition in, 210–211
droughts in, 212–213
Heartbreak Hotel—Loss as a Lesson in, 220–221
Laugh or Lament in, 213
Net of Nurturing in, 224
Positive Inventory in, 212
prophets in, 213–215
surviving falls in, 221–224
turning heartbreak into a career move in, 215–221
past:
inventory of, 29–30
morning pages and, 9–10
roar of awakening and, 29–37
shadow of, 31–34
Pasternak, Boris, 166
patience, 122
Pauling, Linus, 29, 260

pearl of wisdom, *see* wisdom, pearl
 of
Penn, William, 75
Penney, J. C., 199
perceptions:
 attitude changes and, 45
 extreme language and, 37–39
 of job vs. career, 34
 soaring and, 52, 53–54, 65–67
perfection, 212
perfectionism, 6, 112
Perls, Fritz, 46
Persian proverb, 183
Personal Accounting, 96
pessimism, xxi, 30–31, 137
Petronius, 33
photography, 98–99, 125
Picasso, Pablo, 257
Pickens, T. Boone, 165
Picture Woman, 94
Pines, Ayala, 47
Pitino, Rick, 24
Plato, 133, 145
play, 85, 117–118
 authenticity and, 259–262
 time-outs and, 24–26, 29
Playing at Play, 262
Pope, Alexander, 263
Positive/Negative Poles, 120
Positive Inventory, 212
poverty, 133
Poverty Addict, 96
Power Dance, 173
Practicing the Present (tool), 177,
 236
presence, practicing the, 115
present, 9–10
 acceptance of, 46
 living in, 151–152
 practicing the, 41–43, 177, 236
pride, 140
Prince, George M., 247
Prince, The (Machiavelli), 173
Prince syndrome, 173–177
prioritizing, 5, 9, 130
procrastination, 202, 203
prophets, business, 213–215
Proust, Marcel, 115
proverbs:
 Chinese, 190
 English, 95
 German, 184
 Indian, 76
 Japanese, 78

Persian, 183
Russian, 98
Sufi, 4
Zen, 16
Publilius, Syrus, 181
purpose, sense of, 216

Quick Nick, 11, 14
Quiet One, 169
Quiet One/Victim, 165–166

Radio Kit, 2, 18, 24, 25, 112
Ram Das, 55
Rank, Otto, 103, 204
reality:
 crazymakers' effects on, 182
 of money, 94–96
 reframing of, 176
 success and, 204
reason, rationality, 3, 13, 41
 anger and, 78
Rebel, 13, 115
receptivity, 112
Reconnecting the Pots, 124–125
reflection, daily, 3, 9–10, 118, 141,
 189, 190
 see also morning pages
reflective technology, 9, 49
 see also morning pages
Releasing Resentments, 190–191
resentment, 44, 46, 75–76
 as creative block, 201–204
 releasing of, 188–191, 202–204
Resentment Résumé, 201–202
resistance:
 to criticism, 80
 fear and, 217
 resisting of, 3
resting in authenticity, *see*
 authenticity, resting in
retreats, 69
Richards, M. C., 29, 102
Rilke, Rainer Maria, 83
risk avoidance, 112
risk taking, 28, 33, 62, 64, 116–119,
 214
 communication and, 116–117
 justice and, 252
roar of awakening (week two), 22–49
 Affirmations and Blurts in, 41–43
 albatross vs. life support in, 44–49
 Archaeology, Round One in, 34
 Archaeology, Round Two in, 36–
 37

check-in for, 49
Customized Affirmations in, 43
Dialogue in, 30–31
Dumping the Albatross in, 47
extreme language in, 37–39
Imaginary Lives in, 39–40
Inner Fortress building in, 29–
 30
practicing the present in, 41–43
shadow of the past in, 31–34
Time-out (tool) in, 29
time-outs in, 24–29
Us and Them List in, 38–39
Walking Your Wisdom in, 49
word wounds in, 35–39
Rockefeller, John D., 10
Rodman, Dennis, 25
Roethke, Theodore, 213
Rogers, Carl, 13
role models, 245–248
role reversal, 164–169
roles, 158–162
Roles (tool), 161–162
Roosevelt, Eleanor, 38, 179
Rousseau, Jean-Jacques, 244
rug purchases, 60–61
Rumi, 177
Russell, Mary, 139–140
Russian proverb, 98

sacredness, sense of, xvi–xvii, 9, 80–
 81
sacred space, exploration of, 62
safe place, safety, 161
 childhood and, 29–30
 disarming the critic and, 41–43,
 136
 morning pages as, 10–11, 14
Sagan, Carl, 108
Saint-Exupéry, Antoine de, 149
Sandburg, Carl, 230
Sartre, Jean-Paul, 31
savings, 102, 103
Scapegoat, 165, 166, 167
Scharmer, Otto, 124
Schiller, Friedrich von, 56
Schweitzer, Albert, 137
Search for the Real Self, The
 (Masterson), 236–237
Secretly, I'd Like to . . . , 65
Secrets, 53
secret selves, 11–14
 listening to the chorus of, 14
 spiritual chiropractic and, 11–14

Secret Selves (tool), 11
security, 88, 106, 141, 146
 justice and, 252
 service and, 254–255
 see also safe place, safety
self, selves:
 authentic (real), see authenticity;
 authenticity, ledge of;
 authenticity, resting in
 collective life and, xvi–xvii
 comfort with, 64–65
 communication of, 2
 dialogue of, 14, 16, 30–31
 false, 88–90
 fantastic, 13
 innermost, see Inner Wall
 observer, 10, 13, 118, 119
 rational, 13
 secret, 11–14
 thwarted, 31–33, 38
 see also specific selves
self-acceptance, 13, 238–241
self-awareness, 12, 15, 32
self-destructive behaviors, 205,
 230
self-disclosure, 62–65, 126, 158,
 199–200
self-doubt, 13, 54
selfishness, 52, 170, 172
self-knowledge, 168, 238–239, 252
self-punishment, 101
self-sabotage:
 creative U-turns and, 229–232
 success and, 104–105
self-serving attitude, 165, 166,
 199
self-sufficiency, myth of, 144–145
Self-talk, 119
Seligman, Martin E. P., 119
Seneca, 28, 82, 84
Senge, Peter, 119, 150
service, 199, 254–255
 leadership and, 58, 199
 roles and, 164–165
sex role expectations vs. sense of
 authenticity, 31–32
Shakespeare, William, 48, 82, 139,
 174
Shapiro, Edward, xvi, 11, 136, 141,
 151, 163
Shaw, George Bernard, 123
Shelley, Mary, 216
Shelley, Percy Bysshe, 79

Shinn, Florence Scovel, 182
"show off and suffer," 139–141
Siebert, Muriel, 44
Signposts, 87
skepticism, xx, 6, 120, 160, 171,
 172
Sloan, Alfred P., Jr., 67
Smith, Kenwyn K., 118, 138, 183–
 184
Sniper, see Critic
soaring (week three), 50–70
 boundary setting in, 52–53
 check-in for, 70
 color in, 59–62
 Explore a Sacred Space in, 62
 figure ground reversal in, 53–54
 filling the form in, 67–69
 Filling the Form (tool) in, 69
 leadership in, 57–59
 Leadership Quiz in, 59
 paying attention in, 65–67
 Secretly, I'd Like to . . . , 65
 Secrets in, 53
 self-disclosure in, 62–65
 support in, 55–57
 Watching the Rapids in, 55
 Watch the Picture Without the
 Sound in, 67
 Wish List in, 57
social diversity, 162–163
social individuation, 16–17
Sockman, Ralph, 14
solitude, 6, 24–29, 114–117
Solon, 65, 96
Sophocles, 186
Soros, George, 132, 146, 152
Spielberg, Steven, 25
spirit mentors, 245–248
Spirit Mentors (tool), 247–248
spiritual chiropractic, 11–14, 158
spirituality, 229
 Explore Your Feelings About
 God, 106
 Going to Take a Miracle, 106
 surviving the abyss, 103–106
Star Wars (movie), 2
Stein, Gertrude, 161
stereotypes about creative people,
 37, 38
Stevenson, Robert Louis, 86
Stopping the Spiral, 188
strengths, xix, 3
 moving into, 37

stress:
 behavior during, 44–45
 of success, 204–206
Styron, William, 230
Succeeding at Success, 259
Succeeding with Success, 206
success, 31–34, 60, 132, 228, 238
 cultural myths about, 33–34
 fraud complex and, 88
 optimism and, 46
 redefining of, 257–259
 self-sabotage and, 104–105
 as Unseen Enemy, 204–206
 of women, 31, 32, 33, 48, 88
suffering, 80
 showing off and, 139–141
Sufi proverb, 4
Superman, 196–199
support, 214–215
 success and, 204–206
 synchronicity as, 55–57
surprise, 29
survival, 40
surviving the abyss (week five), 92–
 109
 abundance in, 100
 check-in for, 109
 Counting in, 97–98
 counting money in, 96–98
 Dream Account in, 103
 dream funding in, 101–103
 Emotional Solvency in, 96
 Explore Your Feelings About God
 in, 106
 Going to Take a Miracle in, 106
 Lapping Up Luxury in, 100–101
 luxury in, 98–101
 Luxury (tool) in, 100
 Nasty Rules in, 101
 Personal Accounting in, 96
 reality of money in, 94–96
 spiritual faith in, 103–106
 Wonderer in, 107–109
 Wondering in, 108–109
surviving the fall, 221–224
synchronicity (yellow Jeep
 syndrome), 15–16, 55–57, 113,
 255

Taking Note, 148–149
Talmud, 86
Tame, David, 116
Tao (the Way), xv

Taoism, xv
Tao Te Ching, 88, 113, 122, 164, 177
teachers:
　men as, 31, 48
　task of, 213
　word wounds and, 35–36
teaching (and learning) (week eight), 156–191
　Biosketches in, 163–164
　check-in for, 191
　Containment in, 172–173
　corrosive colleagues in, 169–173
　crazymakers in, 181–184
　"Dear Boss" in, 186
　Family Functions in, 169
　Going Sane in, 184
　identity issues in, 162–164
　information age in, 158
　managing up in, 184–186
　Mentor Magic in, 180–181
　mentors in, 178–181
　negative energy release in, 188–191
　Power Dance in, 173
　Practicing the Present in, 177
　Prince syndrome in, 173–177
　Releasing Resentments in, 190–191
　role reversal in, 164–169
　roles in, 158–162
　Roles (tool) in, 161
　Stopping the Spiral in, 188
　trust/fear spiral in, 186–188
　Unmasking Machiavelli in, 177
team players, xviii, 117, 151
Tehyi Hsieh, 218
television, 121, 122
Tempest, The (Shakespeare), 82
Ten-Minute Time-outs, 235–236
Tesla, Nikola, 116
thinking:
　critical, 135–136
　doing vs., xx–xxi
　Intelligence Block and, 135–137
　"off the beaten track," 124
　reflective, 189
Thomas, Dylan, 104
Thomas à Kempis, 5
Thoreau, Henry David, 17, 87, 194, 242

Thurber, James, 49, 77, 195
Tillich, Paul, 196, 204
time, 130–132, 145–146
Time-out (tool), 29
time-outs, 24–29, 46, 60, 66, 85, 112, 118, 238–239
　autonomy and, 228
　Ten-Minute, 235–236
Tocqueville, Alexis de, 66
"to lay track," 162–163
Tolstoy, Leo, 69, 160
Tomlin, Lily, 200
toughness, 37
travel clocks, 68
triangulation, 182
True Confessions, 80–81
trust, 116–117, 162, 252–254
trust/fear spiral, 186–188
Trusting Trust, 253–254
truthfulness, truth, 9, 31, 140, 144, 146, 158–159
　facts vs., 214
　trust/fear spiral and, 187
Tsao, Nina, 26
Twain, Mark, 32, 38, 53, 63, 81, 201, 212
Tyrant, 13

unconscious, 202–203, 204
understanding, 195
　listening and, 146–149
Unmasking Machiavelli, 177
Unseen Enemy, 204–205
Us and Them List, 38–39

Vaillant, George, 3, 26, 33, 170, 259
Vain Vanessa, 11
Valuing Our Values, 236
Van Gogh, Vincent, 240
velocity formula, 88–89
Victim, 165–166, 168
victim role, 32, 36, 47
Voltaire, xx, 144
vulnerability, 81, 171–172, 186, 194, 195, 263

walking, 49, 100, 242, 243–244
Walking Your Wisdom, 49
Walton, Sam, 187, 263
Ward, Artemus, 232
Warrior/Bully, 166
Watching the Rapids, 55

Watch the Picture Without the Sound, 67
we, from "I" to, xvi–xvii
Wellington, Arthur Wellesley, Duke of, 39
Wesley, John, 48
white-water rafting, rocks vs. flow in, 18–19
wholeness, Jung's view of, 5
Wholeness and the Implicate Order (Bohm), 104
Wilde, Oscar, xviii, 261
will, 4, 137
wisdom, 3–4, 15, 29, 80, 164, 212, 246
　enlightenment vs., 11
　walking your, 49
wisdom, pearl of (week six), 110–127
　ABCDEs in, 119–120
　ABCs of, 117–118
　At the Wheel of a New Machine in, 114
　Beyond Price in, 126
　body English in, 112–114
　Body English (tool) in, 114
　check-in for, 127
　detective work in, 124–125
　Letter to the Self in, 117
　media deprivation in, 120–124
　Media Deprivation (tool) in, 124
　Meeting the Inner Rebel in, 126
　other voices in, 118–120
　personal touches in, 125–126
　Positive/Negative Poles in, 120
　Reconnecting the Dots in, 124–125
　rhythmic intelligence in, 112
　solitude in, 114–117
Wish List, 57
women and girls:
　anger of, 77
　glass ceiling and, 171
　heartbreak of, 216–218
　leadership qualities in, 35–36
　money attitudes of, 218–220
　success of, 31, 32, 33, 48, 88
wonder, 5, 14, 29, 229
Wonderer, 19, 107–109, 114, 115
Wondering, 108–109

Woolf, Virginia, 27, 244
word wounds, 35–39
 extreme language and, 37–39
work:
 as albatross vs. life support, 44–
 49
 home life vs., xvi, 31, 33
 life's, as intimidating idea, 44

see also careers, career change;
 jobs
workaholism, 84–87, 230
 Bottom Line and, 87
 Signposts and, 87
Workaholism Quiz, 85–86
Wright, Frank Lloyd, 214
Wright, Richard, 53

yellow Jeep syndrome
 (synchronicity), 15–16, 55–57,
 113, 255
yoga, 113

Zabor, Rafi, 105
Zen pages, 19
Zen proverb, 16